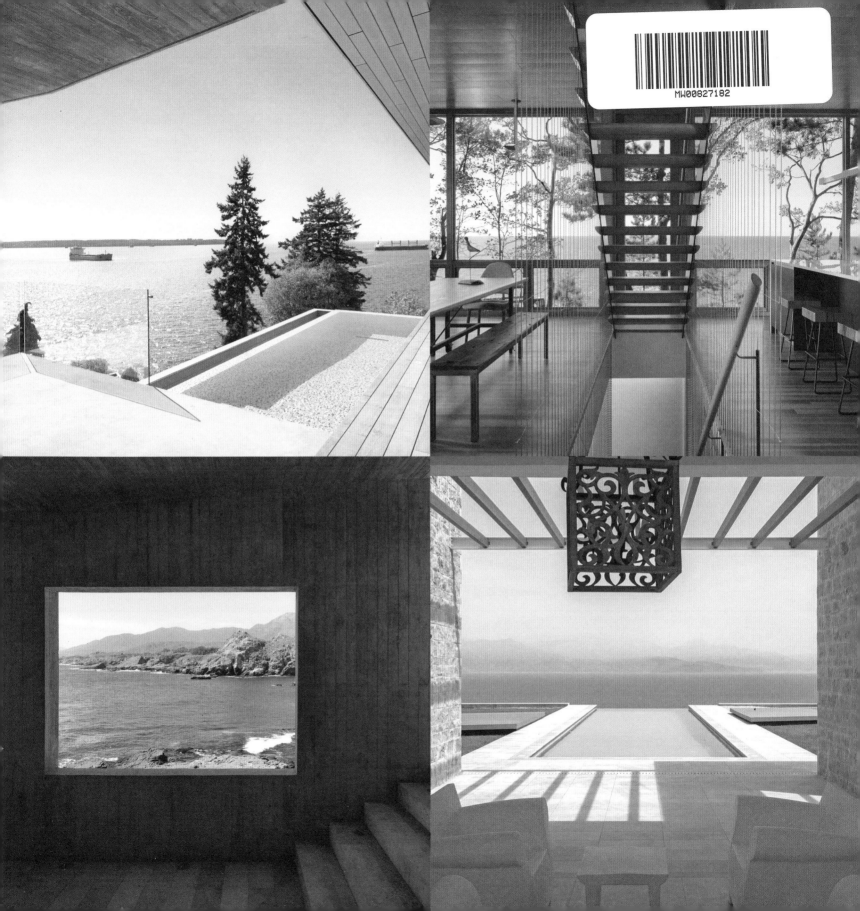

Houses by the shore

At Home with the Water—River, Lake, Sea | Oscar Riera Ojeda & Byron Hawes

Houses by the shore

At Home with the Water—River, Lake, Sea | Oscar Riera Ojeda & Byron Hawes

RIZZOLI
NEW YORK

New York · Paris · London · Milan

TABLE OF
CONTENTS

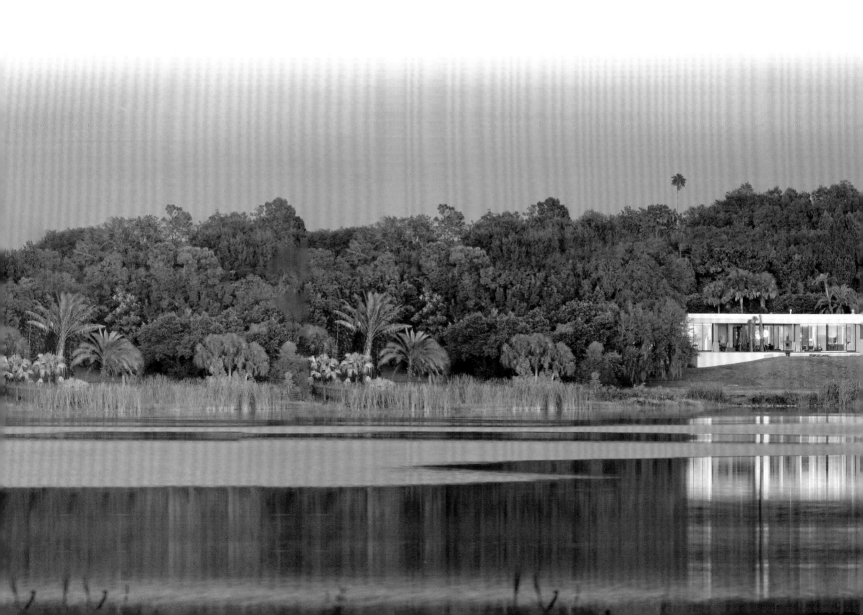

INTRODUCTION BY BYRON HAWES 8
PROJECTS 12
ARCHITECTS PROFILES 326

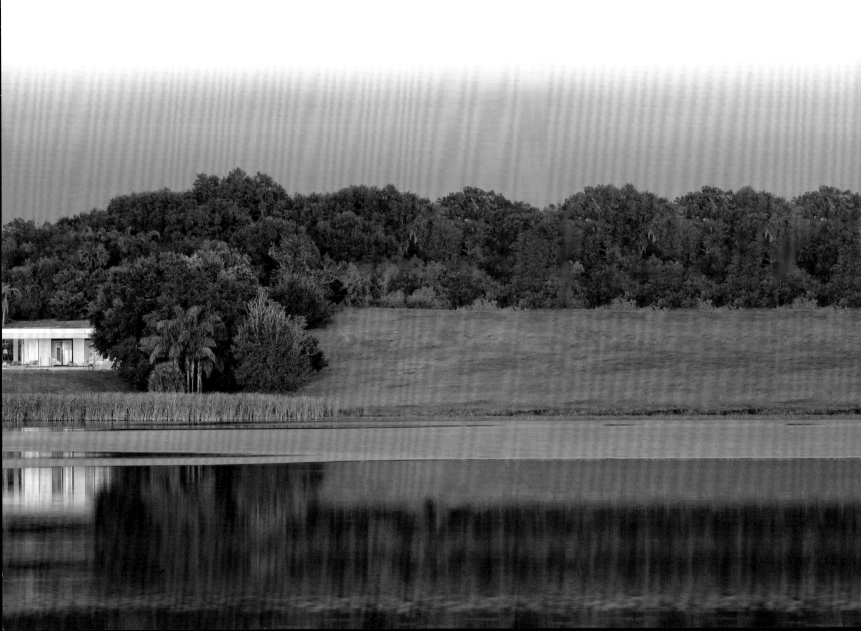

INTRODUCTION BY BYRON HAWES

For me, architecture is not just creating a space to protect people but to make them dream as well.

-Mario Botta

There are few universal truths in a world way too big for a singularity of ideals and ideas. Few common goals or pursuits that transcend age and sex; geography and religion. Health and happiness. The ability to protect and nurture one's loved ones. And maybe, just maybe, a little slice of paradise to one day call home.

Waterfront living is a pinnacle of aspirational lifestyle goals. Few experiences rate as highly as something so simple as waking up to the sight of a babbling brook, a crystal clear mountain lake, or the sight of ocean waves cascading gently onto the beach. It provides an innate sense of calm; of repose. I hesitate to use the term spiritual, as spirituality is one of those purely subjective terms, like 'art', that can mean all things to all people. However, the benefits to, for lack of a better term, psyche, all indescribable.

There are myriad differing waterfront experiences to be had, from sleepy beach towns to the edges of bustling metropoleis; from idyllic rural elysium to snow blown Nordic cabins. What they inevitably have in common is a oneness with nature; a pursuit of not juxtaposing with environment, but becoming one with it.

AIMS OF WATERFRONT ARCHITECTURE

I don't divide architecture, landscape, and gardening. To me, they are one.

-Luis Barragan

Waterfront architecture adheres to the general pursuits of those schools of residential architecture that are site-focussed. As the body of water typifies the site, architectural strategies must be responsive to the environment, rather than the more common strategy of designing a structure and then landscaping its environs to highlight and complement the architecture to best effect.

This book examines several types of waterfront residential architecture, across six of the world's seven continents, and a wide assortment of geographies and climates. As such, architectural intentions vary drastically.

SAOTA's two seminal examples of contemporary modernism featured here, both on the outskirts of South Africa's Cape Town at the base of the Lion's Head mountain range, are set back from the Atlantic Ocean, on a bluff providing spectacular panoramic views of both the city and the coast. In designing water-facing houses, it's the pervasive 'feeling' of the surrounding environs that drives design decisions. For these two residences, the focal point is the expansive views, which are highlighted to best advantage through staggered external terraces and vast outdoor pool areas, allowing the scenic vistas to 'seep' into the experience of being in the house.

Whereas, something like Kazunori Fujimoto's House in Akitsu manifests as a place of great quiet. Hyper-minimalist and utterly free of motion; it espouses the zen calm of its Seto Island Sea setting. Its brusque, Ando Tadao-esque material palette is perfectly in keeping with its intended feeling of respite from the hustle and bustle of the contemporary world.

Elsewhere, we see the tenets of Sarasota modernism artfully imbued into [Strang] Architecture's South Floridian Bass Residence. Sarasota modernism, much like Palm Springs Mid-Century Moderism, espouses a coalescence between indoor and outdoor spaces, using open floor plans, brise soleil, natural ventilation, and full-height sliding glass doors to utterly delineate the differentialisation between the building and grounds. The main indoor communal space opens fully to the extensive terrace and pool area, forming a communion of internal and external space.

OUTDOOR POETICS
Organic architecture seeks superior sense of use and a finer sense of comfort, expressed in organic simplicity.
-Frank Lloyd Wright

Waterfront architecture need not be in a warm weather setting, as with, for example, Unit Arkitektur AB's Plastic House II,

which strives to keep the design simple yet luxurious, in the vein of the mid-century Californian Case Study Houses, all the while being situated nearby to the western Swedish town of Gothenburg. It's Nordic positioning guarantees more than its fair share of snowfall in the winter months, while it's I, low-slung, inconspicuous modular design seems to sink into its surroundings in the summer, and its pure white colour palette camouflages it in the winter.

Mette Lange's Villa Buresø uses similar sleight of design; its single, ultra-low storey of local light woods allowing it to essentially blend into its forested Danish environment. A long glazed façade and seemingly endless Douglas Pine-clad floor-to-ceiling windows allow an inextricable commune with nature, while it combines an inexorably Scandinavian aesthetic with an impeccable understanding of mid-century modern bungalows.

MATERIALITY
Given the focus on setting and environment ingrained in this style of architecture, material palettes tend to be carefully selected to represent local climate and aesthetics. The majority of the houses featured in this book utilize as many local materials as possible, allowing the houses to truly feel at one with their location.

The Villa in Messinia, for example, uses local materials from the Peloponnese region wherever possible, including the predominant exterior palette of marble and stone, while walls are kept minimal in gloss white, which reflects light and highlights the juxtaposition of the primary materials. Selim Erdil's Ma Via La uses 5 primary materials: concrete, steel, stone, wood, and glass, in the pursuit of subtle aesthetics, while allowing a variety of open spaces that can be closed or opened depending on the wind and weather conditions.

Desai Chia's Michigan Lakehouse is clad in dying ash trees, using the traditional Japanese method of 'shou sugi ban'—scorching and blackening timber so it becomes resistant to rotting and bugs. The charred texture enhances the shadows across the façade as the sun rises and sets. The dying ash trees were reclaimed from the site, and milled down to be used as interior

cabinetry, flooring, ceiling panels, trim work, and custom furniture throughout the house. The interiors of the house embody the indigenous landscape that once thrived with old growth ash.

Titus Bernhard Architekten's sublime Private Holiday House endeavours to remain faithful to the traditional aesthetics and material palettes of the neighbouring structures, using a simple, subtle symphony of locally sourced dry-stone construction; allowing what is essentially an wholly modern design to seamlessly blend into its surroundings. Mimicking the area's overarchingly rough, haptic character, the house flawlessly conveys a warm, rustic character, while concealing a thoroughly contemporary interior.

TROPICAL MODERN NOTES

Essentially, tropical modernism is characterized by its adaptation of modern architecture to tropical climes, and to a furtherance of that minimalist aesthetic that has allowed modernism to highlight its environments. Promoting and expanding upon the correlation between built environments and natural ones.

Modern architects believe that 'reading' and 'interpreting' the site of any given project is of crucial importance. That landscape and environment must inspire a project. That a symbiosis between environment and architecture is paramount, and that a structure can and must become a part of its situation. As Charles Eames said, 'Recognizing the need is the primary condition for design'.

Mediterranean living provides a crystallization of warm weather waterfront living. Just the word mediterranean evokes images of a glass of rosé and a bowl of olives under a warm blue sky, looking out over the dazzling aquamarine of the Sea.

Four of the featured houses are located in Greece, a land that provides the sort of idyllic pastoral setting that simultaneously screams and whispers respite. Belgium-based Dwek Architectes' Silver House took, as their conceptual mantra, a quote from the legendary French artist Yves Klein: 'blue has no dimensions, it is beyond dimensions'. Somehow eerily fitting, given the particular, and peculiar, shade of blue that the skies and waters of Greece possess in abundance, and all the more so when considering just how reminiscent that blue is to Klein's most enduring legacy: a specific shade of lush and lurid blue now known simply as Klein Blue (or International Klein Blue).

The entirety of the house was built with panoramic Ionian Sea views in mind; the terraces, sitting room, dining room, kitchen, bedrooms, and even bathrooms were all designed to take full advantage of the gorgeous surroundings. The same can be said for MGXM Architects' Villa in Messinia. The building itself is comprised of two main volumes, which are linked via a large outdoor patio - functionuib as a living area during the summer. A narrow rectangular swimming pool is situated perpendicularly to the house, and is laid out in such a way that upon entering the house, guests are presented with a frame of the infinity pool leading the gaze to a strip of sea and the Taygetus Mountains beyond. Everything in its right place, entirely geared towards the spectacular vista beyond.

Warm-weather waterfront residences frequently display a minimalism of form, allowing indoors and outdoors to become one in perfect harmony. A particularly notable, and overt, example of this is Benjamin Garcia Saxe's Ocean Eye, which distills tropical residential architecture down to its very essence, staunchly adhering to Corbusian modernist tenets; its ocean-facing elevation manifesting as an entirely open-air space, covered by a massive pilotis-raised, overhanging roof. Ocean Eye is a pure distillation of indoor/outdoor tropical modernism; an almost wholly outdoor house that boasts entirely open living spaces in their purest possible form.

CONCLUSION

Perhaps the most famous thing Le Corbusier ever said, was that a house is 'a machine for living in. Essentially, that a house needs to be an all-encompassing surrounding environment for one's life. Interestingly, Corbu is often misquoted as saying that a house must be 'a machine for living'; that one missing word dramatically changing the perceived meaning of the statement to the suggestion that a house's purpose is to further one's ability to live their best life. A pursuit to which a little slice of waterfront is always helpful. 'Twas ever thus.

35 PROJECTS

17	NORTH AMERICA		181	EUROPE
18	SUNSET HOUSE		182	NESS POINT HOUSE
26	OPPOSITE HOUSE		190	BACKWATER
34	FALL HOUSE		198	G-HOUSE
44	CROSSING WALL HOUSE		206	VILLA BURESØ
50	MCELROY RESIDENCE		212	ORNBERGET SPINE/PRECIPICE
60	STINSON BEACH LAGOON		220	PLASTIC HOUSE II
66	HOUSE TO THE BEACH		226	SUNFLOWER HOUSE
76	MICHIGAN LAKE HOUSE		236	PRIVATE HOLIDAY HOUSE
84	SUNS END RETREAT		242	SILVER HOUSE
92	OCEAN DECK HOUSE		252	HOUSE IN ACHLADIES
100	FIELD HOUSE		260	VILLA IN MESSINIA
110	BASS RESIDENCE		268	HOUSE IN ZAKYNTHOS
120	MOUNTAIN LAKE RESIDENCE		276	MA VIE LA
131	CENTRAL & SOUTH AMERICA		287	AFRICA
132	CAL HOUSE		288	OVD 919
142	OCEAN EYE		298	CLIFTON 2A
152	GUNA HOUSE			
160	PARAVICINI HOUSE		307	ASIA PACIFIC
170	BAHIA AZUL HOUSE		308	HOUSE IN AKITSU
			316	GERRINGONG RESIDENCE

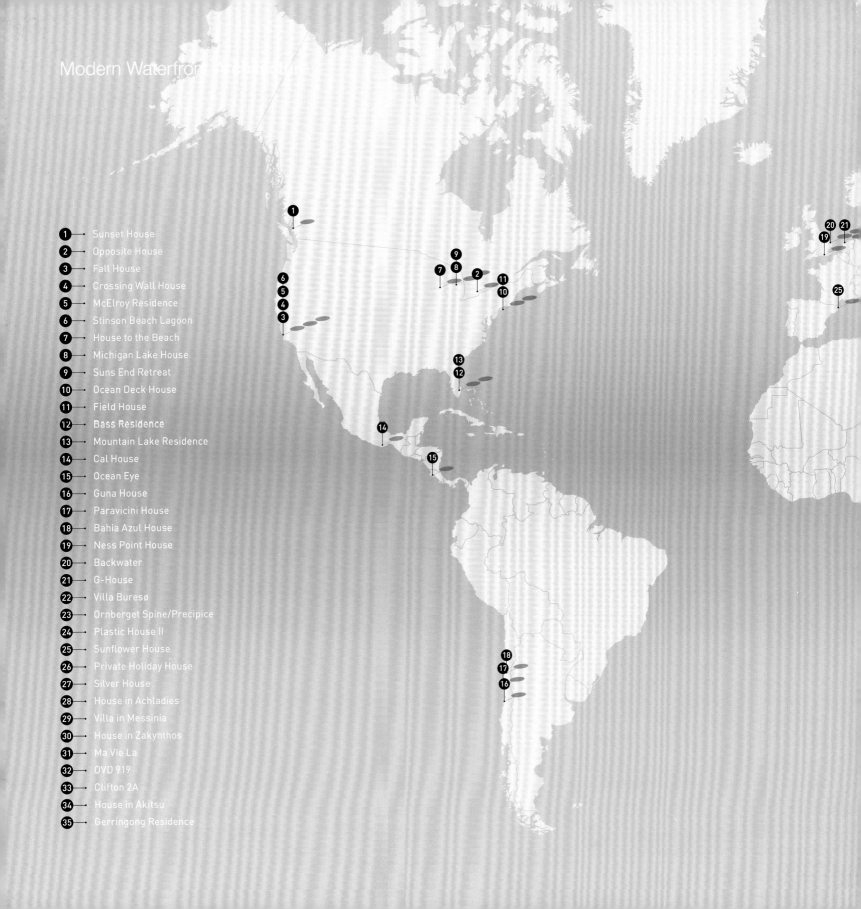

1 Sunset House
2 Opposite House
3 Fall House
4 Crossing Wall House
5 McElroy Residence
6 Stinson Beach Lagoon
7 House to the Beach
8 Michigan Lake House
9 Suns End Retreat
10 Ocean Deck House
11 Field House
12 Bass Residence
13 Mountain Lake Residence
14 Cal House
15 Ocean Eye
16 Guna House
17 Paravicini House
18 Bahia Azul House
19 Ness Point House
20 Backwater
21 G-House
22 Villa Buresø
23 Ornberget Spine/Precipice
24 Plastic House II
25 Sunflower House
26 Private Holiday House
27 Silver House
28 House in Achladies
29 Villa in Messinia
30 House in Zakynthos
31 Ma Vie La
32 OVD 919
33 Clifton 2A
34 House in Akitsu
35 Gerringong Residence

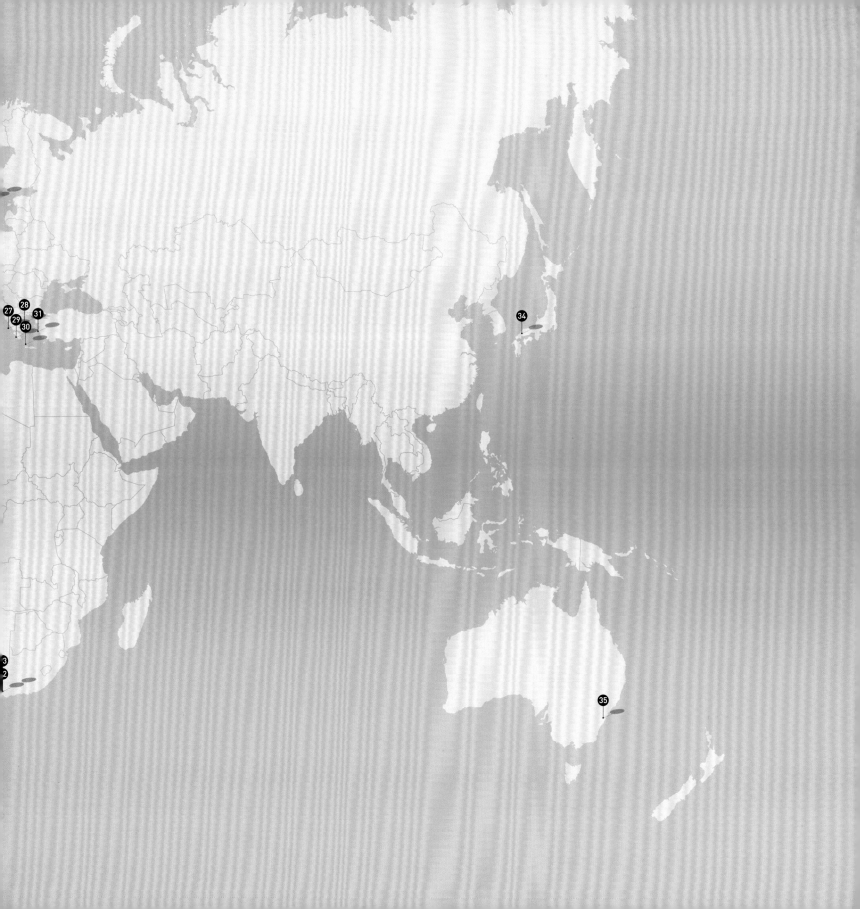

NORTH AMERICA

SUNSET HOUSE | MCLEOD BOVELL MODERN HOUSES

OPPOSITE HOUSE | ATELIER REZA ALIABADI

FALL HOUSE | FOUGERON ARCHITECTURE

CROSSING WALL HOUSE | MOBILE OFFICE ARCHITECTS

MCELROY RESIDENCE | EHRLICH YANAI RHEE CHANEY ARCHITECTS

STINSON BEACH LAGOON | TURNBULL GRIFFIN HAESLOOP ARCHITECTS

HOUSE TO THE BEACH | GLUCK+

MICHIGAN LAKE HOUSE | DESAI CHIA ARCHITECTURE

SUNS END RETREAT | WHEELER KEARNS ARCHITECTS

OCEAN DECK HOUSE | STELLE LOMONT ROUHANI ARCHITECTS

FIELD HOUSE | STELLE LOMONT ROUHANI ARCHITECTS

BASS RESIDENCE | [STRANG] ARCHITECTURE

MOUNTAIN LAKE RESIDENCE | [STRANG] ARCHITECTURE

1.
SUNSET HOUSE MCLEOD BOVELL MODERN HOUSES

BRITISH COLUMBIA, CANADA

House Area:
650 m²

Plot Area:
1,542 m²

Architect in Charge:
Mcleod Bovell

Project Team:
Matt Mcleod and Lisa Bovell

Interior Designer:
Mcleod Bovell Modern Houses

Landscape Designer:
Mcleod Bovell Modern Houses

Photographer:
Ema Peter – Martin Tessler

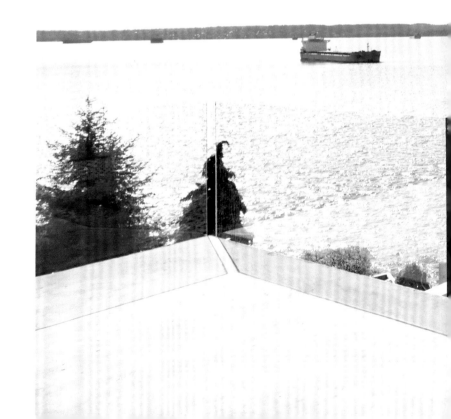

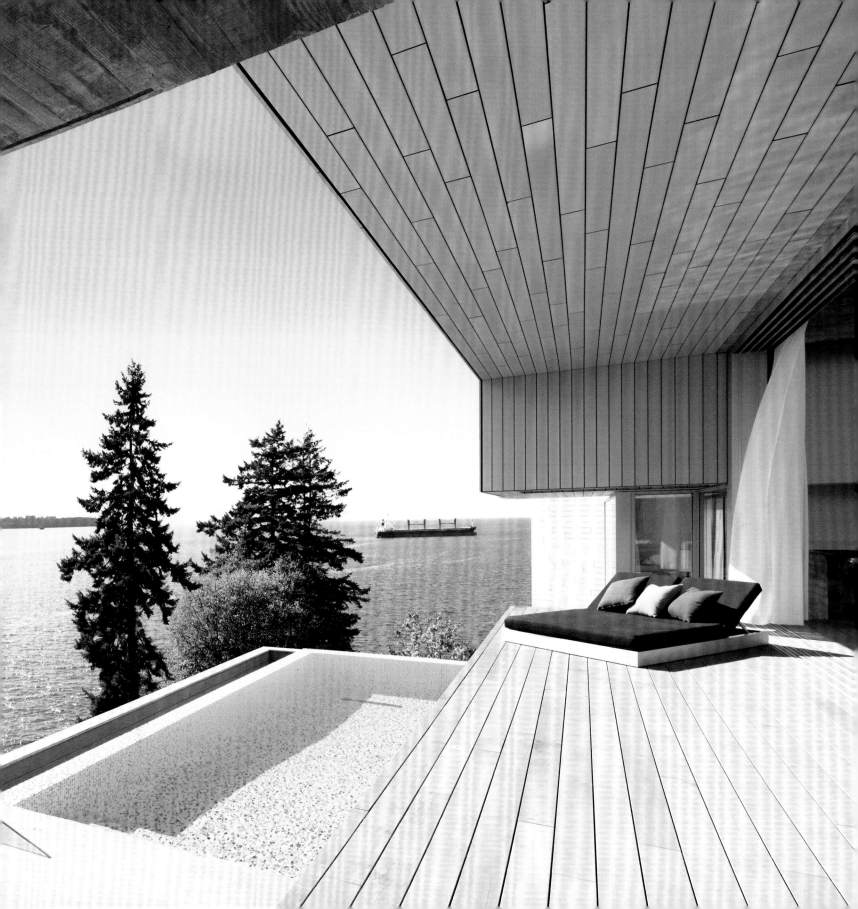

Ground Floor

First Floor

McLeod Bovell's Sunset House - situated on a steep and techni-cally challenging site that hugs a rocky hillside in West Vancouver - was designed to make the most of its views of the Salish Sea. Framing and capturing views of the active waterway was a guiding principal for the architects.

The home's irregular shape traces the site boundary, coming toan angled blinder that provides privacy from tight adjacent proper-ties. A natural, minimalist palate of raw concrete, steel, leather and wood creates a calm interior space that doesn't distract from the framed ocean view beyond, while simultaneously consisting of artfully arranged spaces and large expanses of glass that face the sea, offering sweeping views of the vistas beyond.

Movement into the house is carefully choreographed to disguise the considerable elevation change from street to living space - no individual stair run is greater than half a storey - allowing an unob-structed sightline from the oversized pivot entrance door through to the terrace. Similarly, the split level arrangement allows for gen-

erous volumes in the main living spaces and a closer connection between and main and upper floors, while also providing dramatic elements such as the 40-foot elevation drop from the suspended deck and plunge pool to the rear garden below.

Limited materiality creates a meditative and calming experience, with contrast between solid and soft elements throughout. Board-formed concrete mimics the texture of the wood siding both on the exterior and interior of the home, its directionality used to either elongate surfaces or emphasize double height spaces between floor levels. Leather pulls on white millwork panels are paired with carved wood handrails, and hand-scraped wide plank oak flooring. The palette has been stripped to the essentials, allowing the home to feel cohesive and solid.

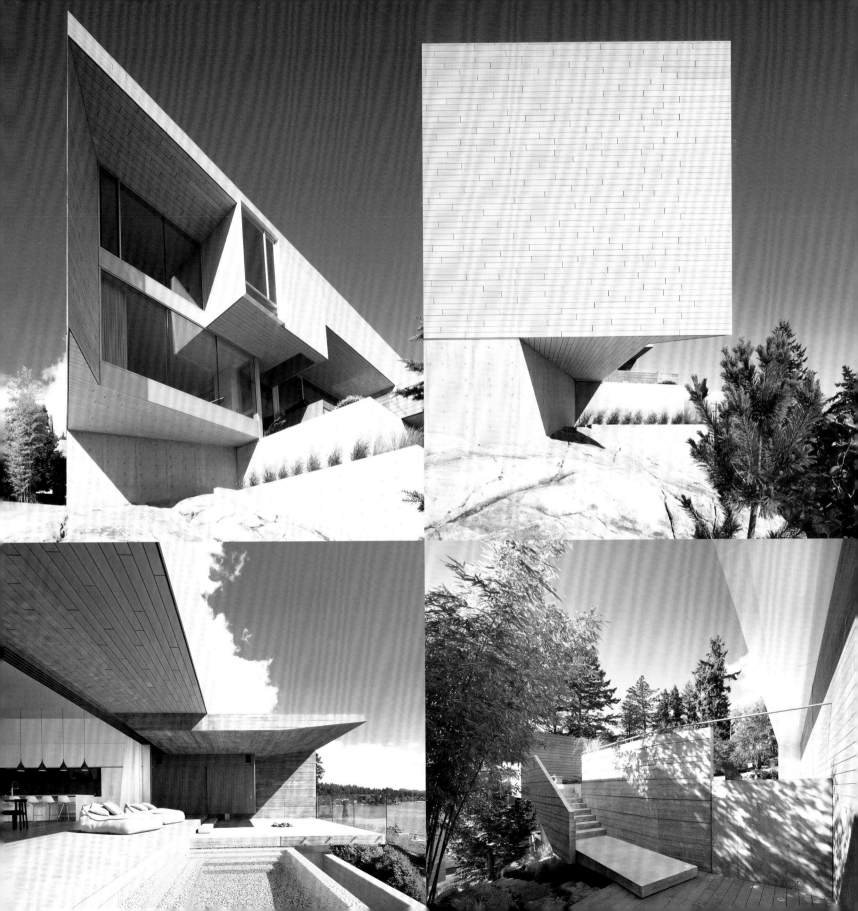

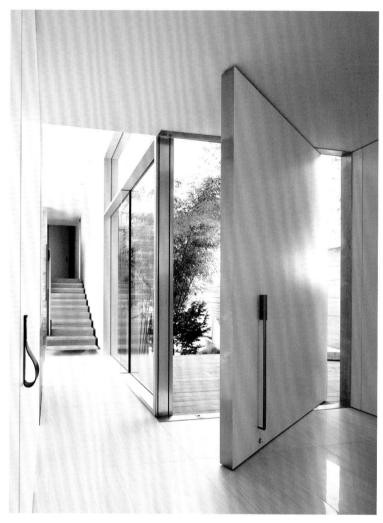

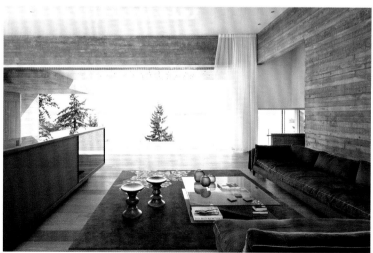

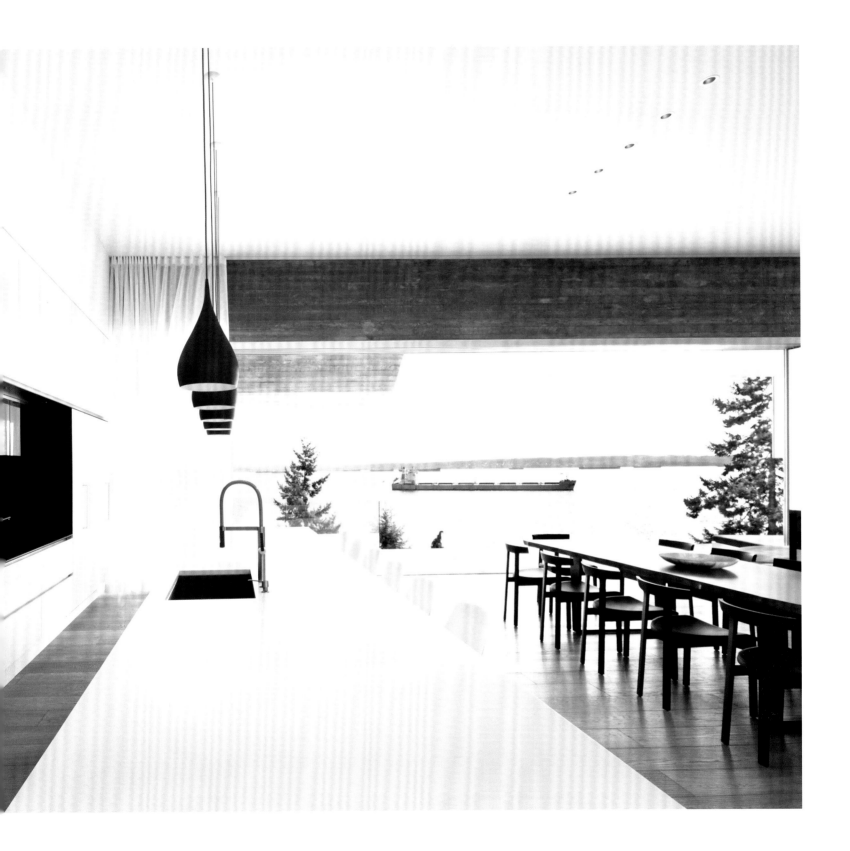

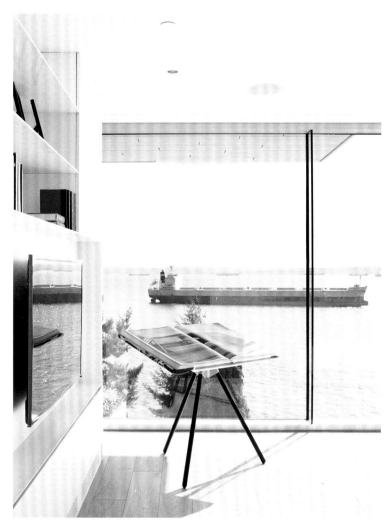

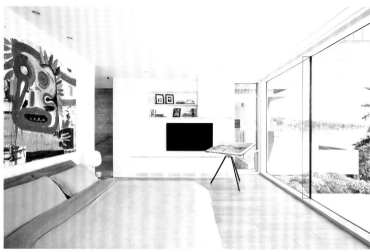

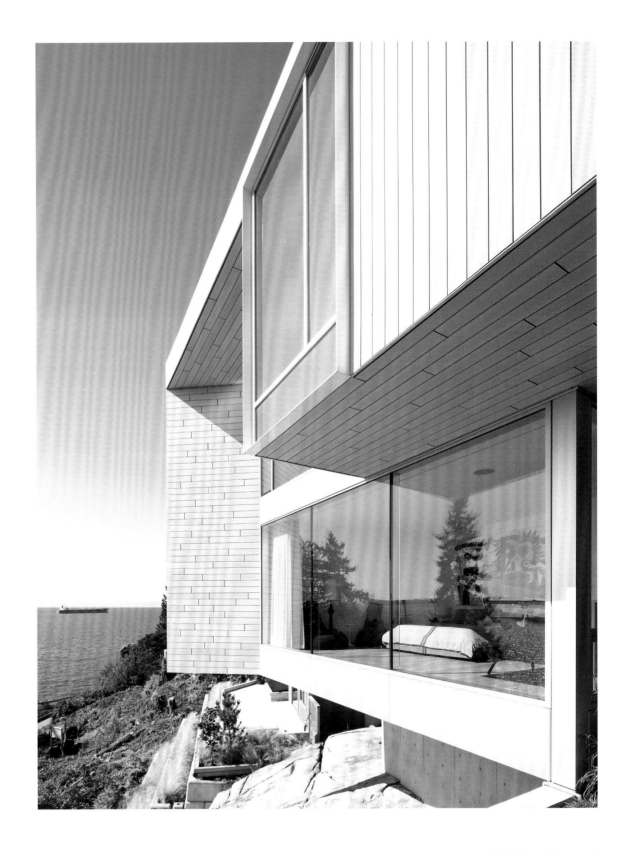

2.
OPPOSITE HOUSE
ATELIER REZA ALIABADI

ONTARIO, CANADA

House Area:
596 m²

Plot Area:
1,093 ha

Architect in Charge:
Reza Aliabadi

Project Team:
Reza Aliabadi, Egbert Engineering,
McCallum Consulting, Gunnell Engineering

Interior Designer:
Julia Francisco

Photographer:
Borzu Talaie

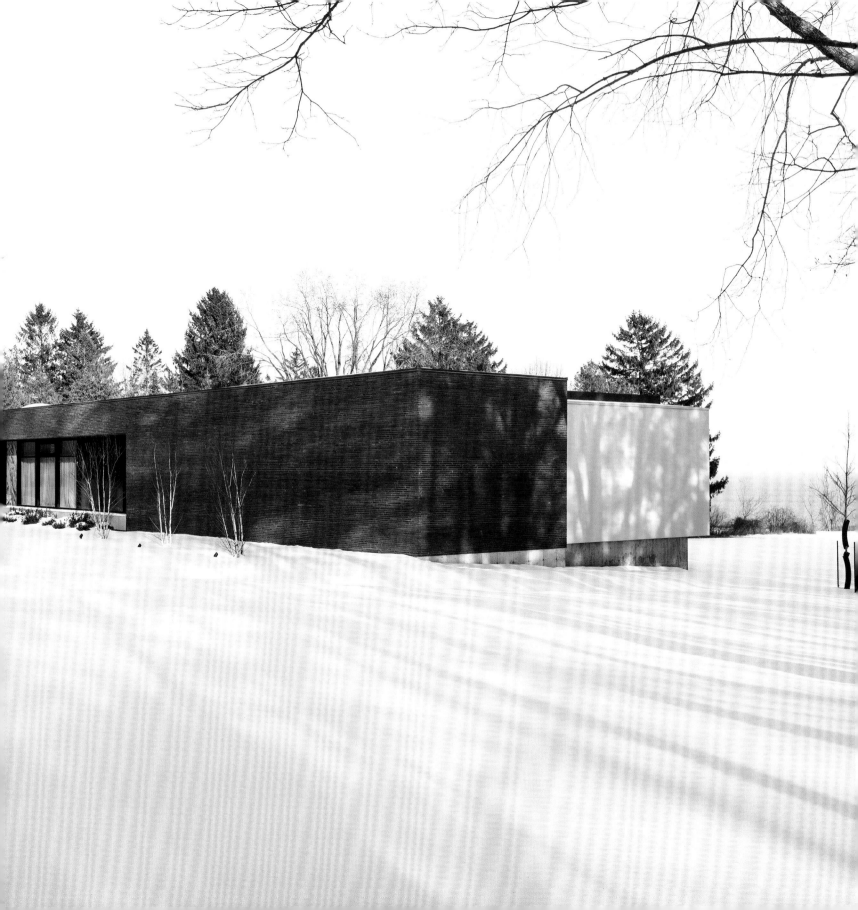

Basement

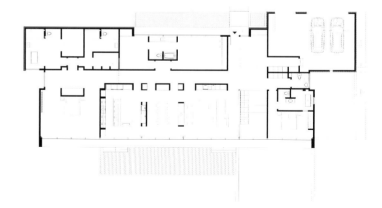

Ground Floor

Iranian-Canadian architect Reza Aliabadi's Opposite House is a private residence onthe outskirts of Toronto, which boasts two wildly differentiated parts, coming together to form a articulate and cohesive whole.

The new build sits partly on an old bungalow's footprint, on a 2.7 acre site sloping down to the shore of Lake Ontario. On the northern elevation the house presents a purposely low profile – just a single, unobtrusive 146-foot long storey (equal to the length of an Airbus A321), allowing for an unimpeded lake view from all points. On the southern, lakefront elevation, the home's face opens into a 10-foot curtain wall, lozenged in white. The house's 6,400 sq/f interior feels human in scale despite its size; the result of the space's precise geometric parsing, something the architect refers to as 'mathematical poetry'.

The Opposite House flaunts its dichotomy; manifesting as a study in subtly rendered juxtapositions. Two concepts are at play here in concert: Louis Kahn's 'servant andserved' maxim, where by private

functions are placed on one side, balanced by communal spaces on the other; and the 'phototropic' nature of plants, which remain rooted in the earth while their heads blossom towards the sun – interpreted here through a north side wrapped in dark-black textured brick, and a south side presented in bright glass and smooth white stucco.

The main hall of the Opposite House forms a central nave that runs like a spine, east-west, along the entire length of the structure, bracketed at either end by outsized windows. The foyer, with its 49 sq/f skylight, acts as a north-south transept, intersecting this main line, and descending via a stadium-stairway to the lower level. When entertaining, guests can lounge on the agora seating and either admire the view from a dropped 20 foot double-height curtain wall or watch a show on the roll-down movie screen.

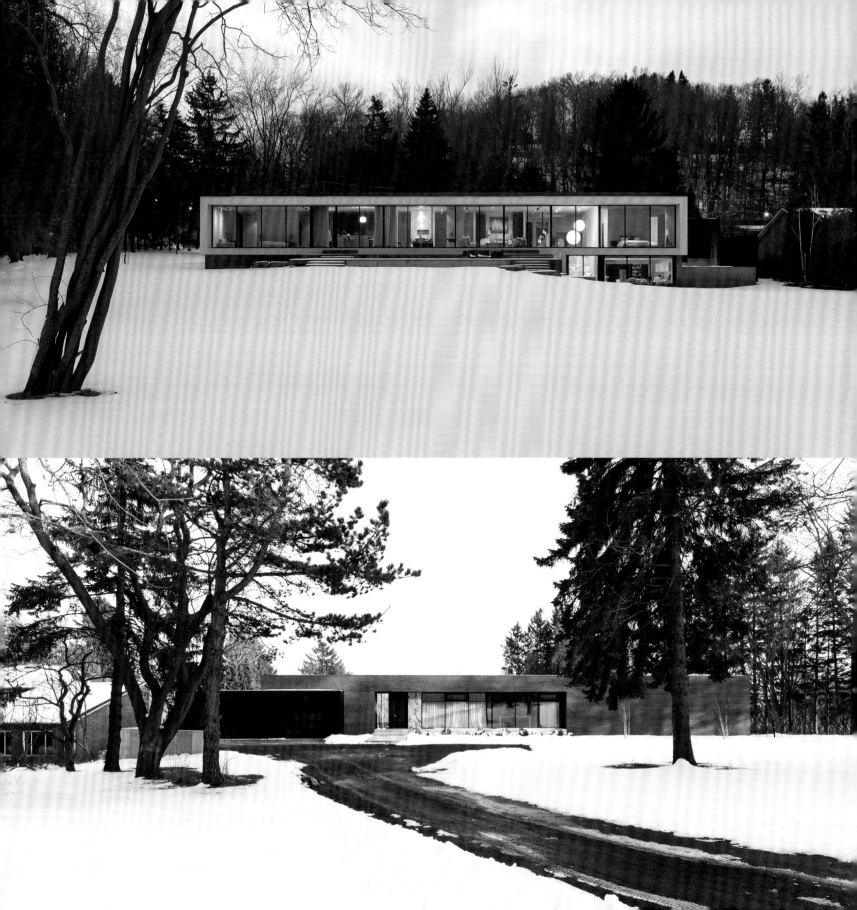

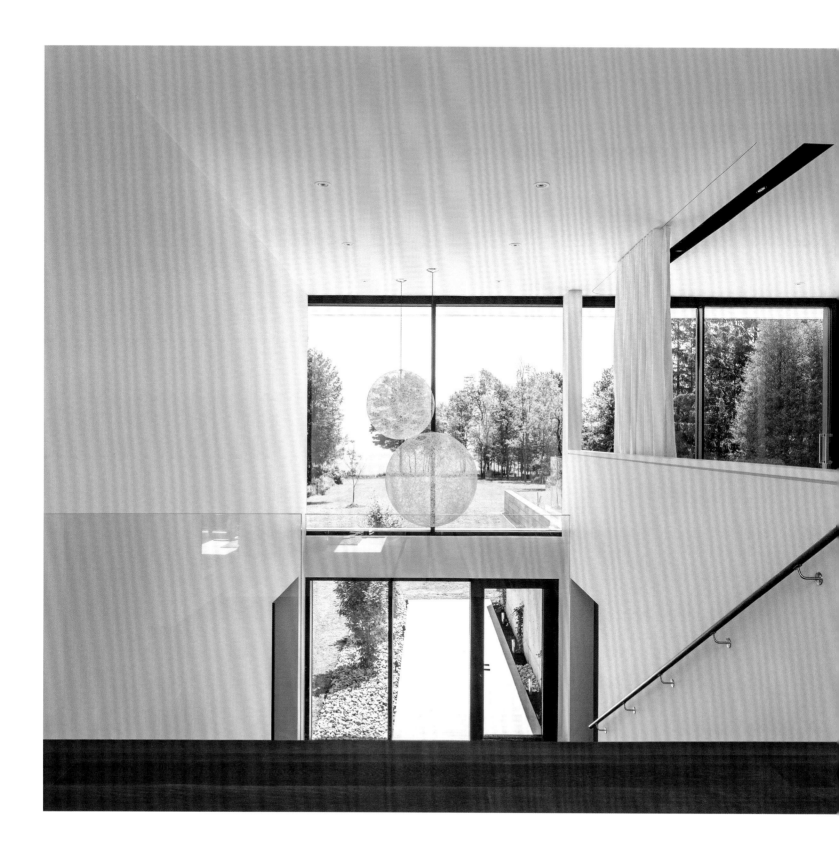

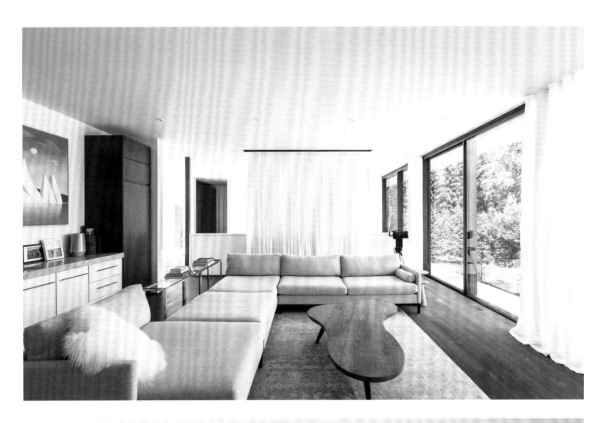
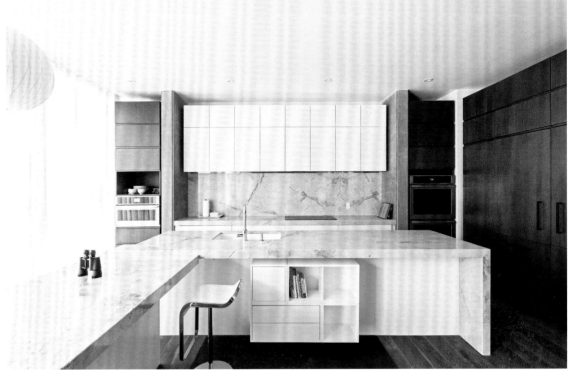

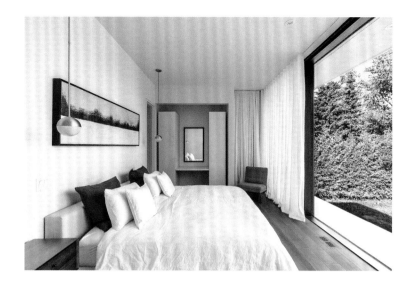

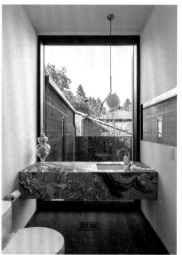

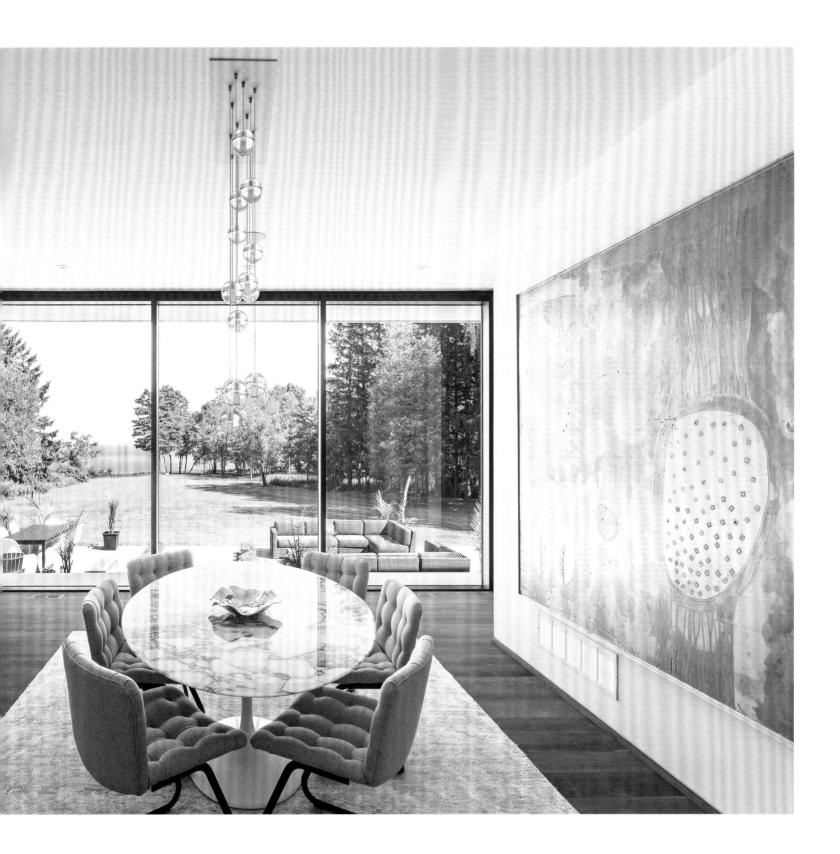

3.
FALL HOUSE
FOUGERON
ARCHITECTURE

CALIFORNIA, UNITED STATES

House Area:
353 m²

Plot Area:
5,139 m²

Architect in Charge:
Anne Fougeron

Project Team:
Ryan Jang, Todd Aranaz

Landscape Designer:
Blasen Landscape Architects

Photographer:
Joe Fletcher Photography

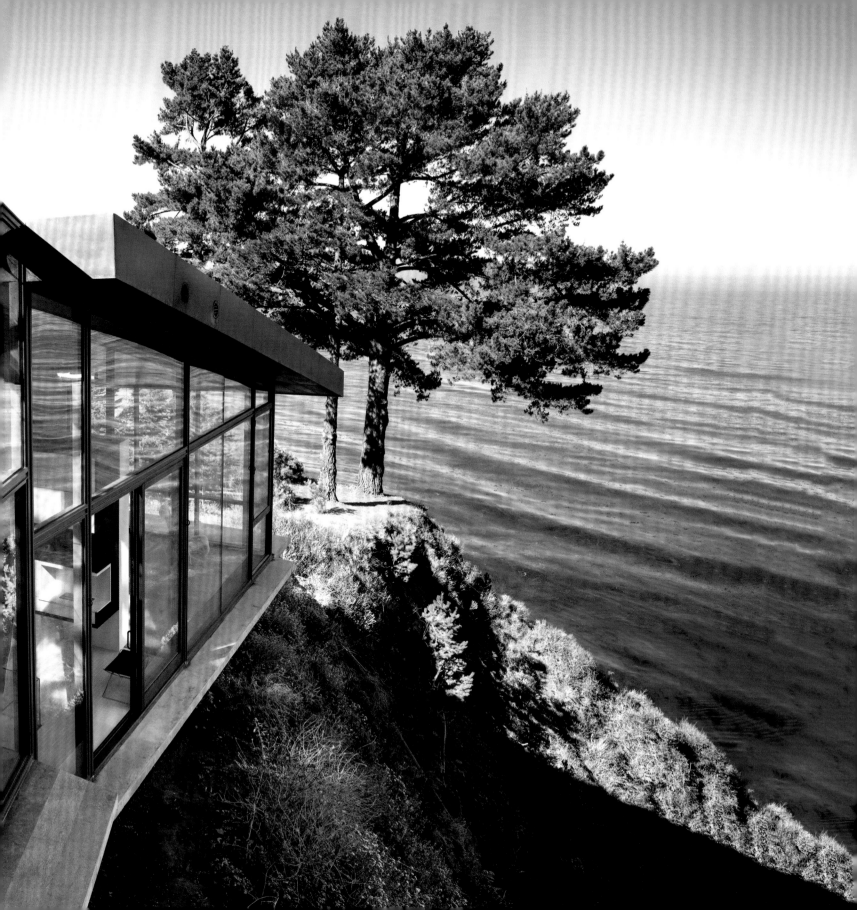

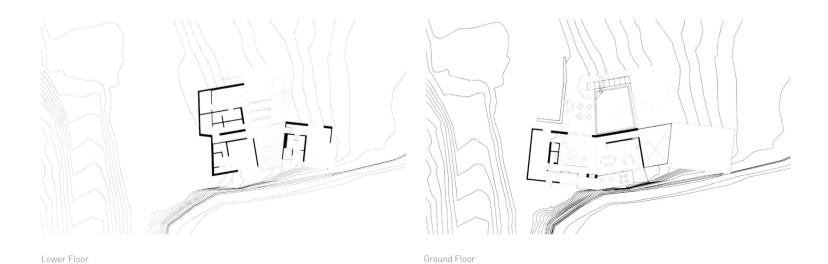

Lower Floor

Ground Floor

This three-bedroom home, on Big Sur's spectacular southern coast, is anchored in the natural beauty of its California landscape. Fougeron's design strategy embedded the building within the land, creating a structure inseparable from its context. The site offers dramatic views: a 250-foot drop to the Pacific Ocean along both the bluff and the western exposure.

The long, thin volume conforms and deforms to the natural contours of the land and the geometries of the bluff, much like the banana slug native to the region's seaside forests. In this way, the complex structural system applies and defies natural forms to accommodate the siting. The house is cantilevered 12 feet back from the bluff, both to protect the cliff's delicate ecosystem and to ensure the structure's integrity and safety. The interior is a shelter, a refuge in direct contrast to the roughness and immense scale of the ocean and cliff. The house also shields the southern external spaces from the powerful winds that blow from the northwest.

The main body of the house is composed of two rectangular boxes connected byan all-glass library/den. The main entrance is located at the top of the upper volume with living spaces unfolding from most public to most private. The lower volume, a double-cantilevered master bedroom suite, acts as a promontory above the ocean, offering breath-taking views from its floor-to-ceiling windows. The link between these two volumes is the glass library/den; itis the hearth of the house, a room that unites the house inside and out both with its geometry and its transparency.

The house has two main facades, the south one is clad in copper which wraps up the wall and over on the roof. Copper clad roof overhangs protect windows and the front door from the sun and wind off the ocean.The façade to the north is made all glass; clear expanses of glass open the house to the view.

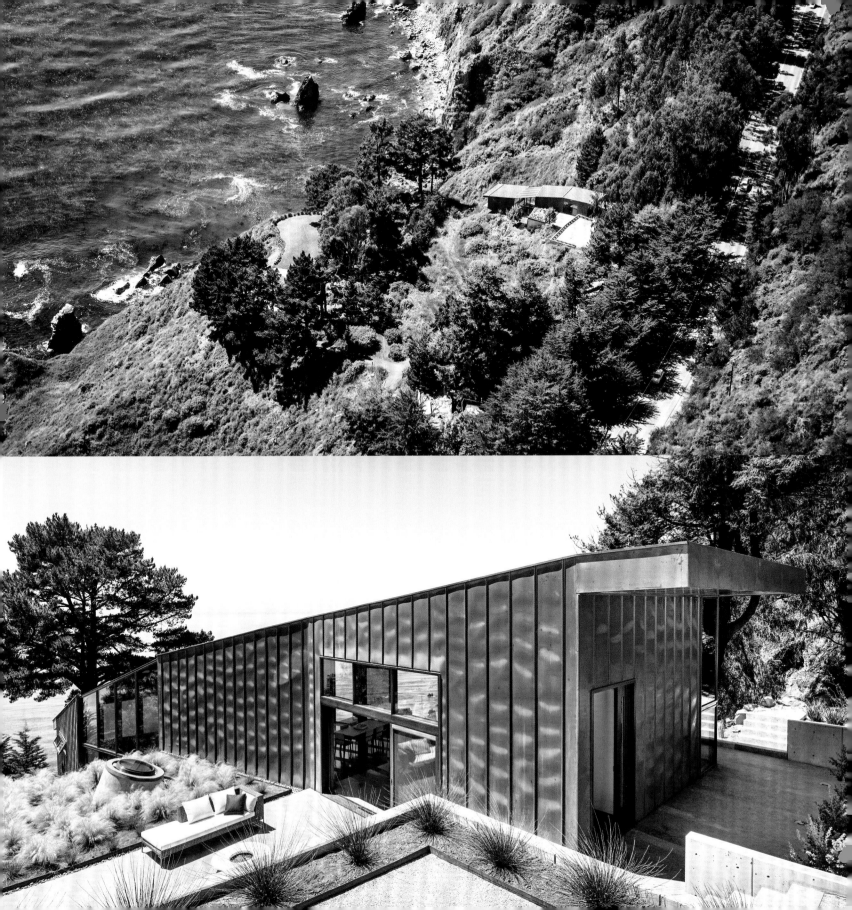

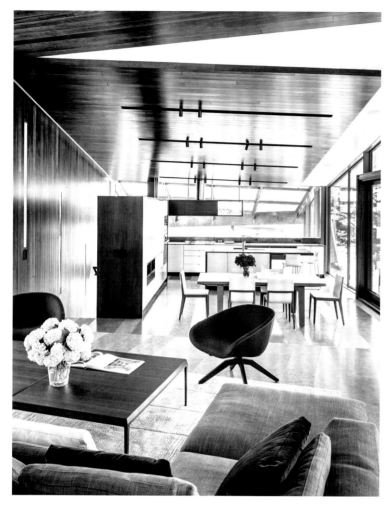

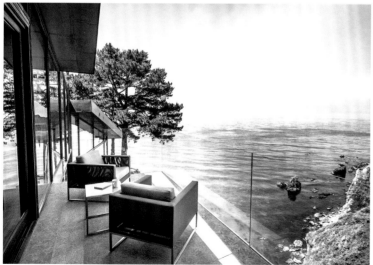

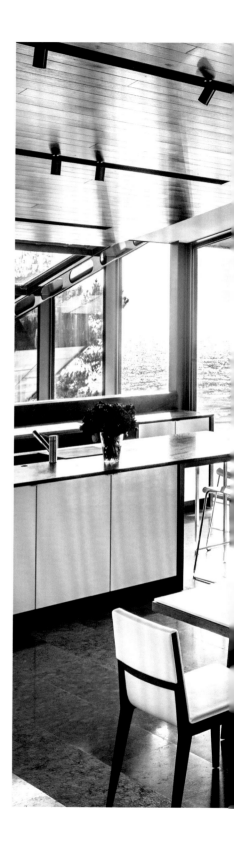

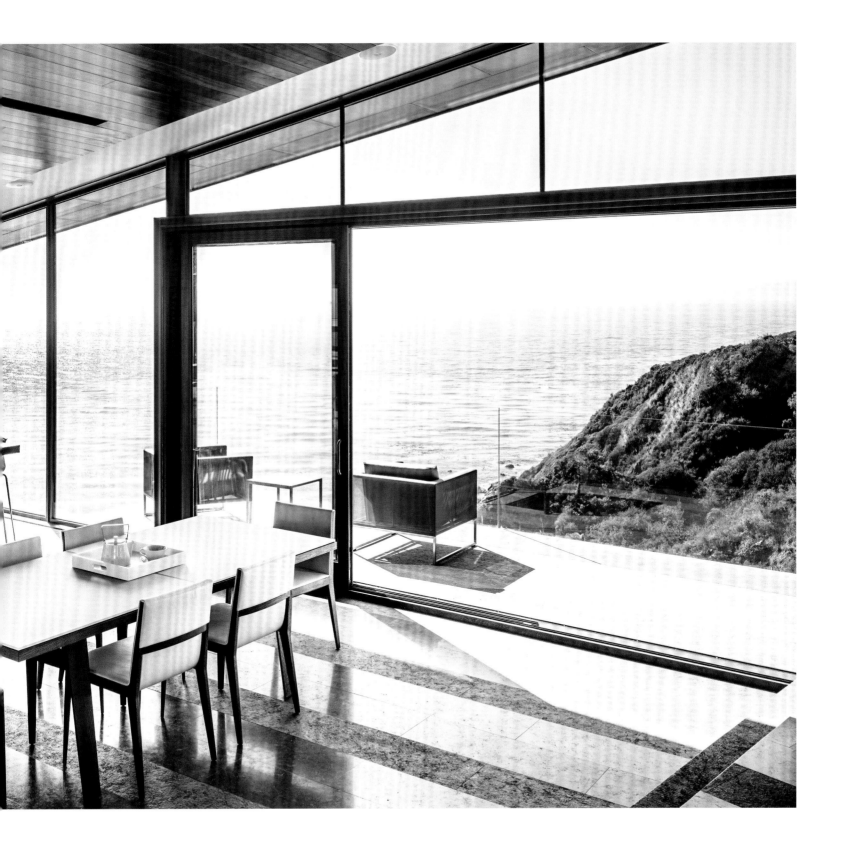

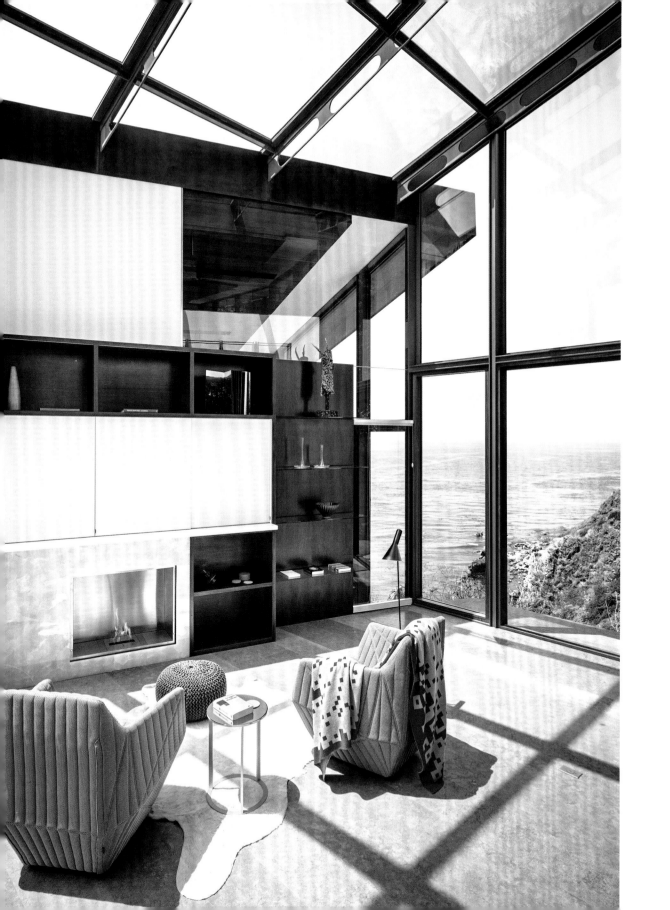

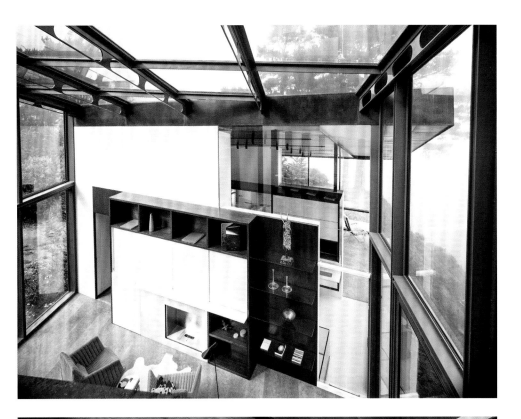

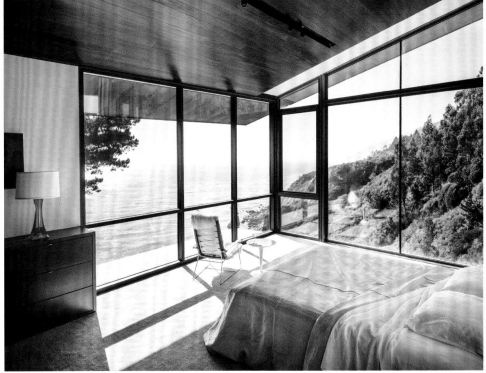

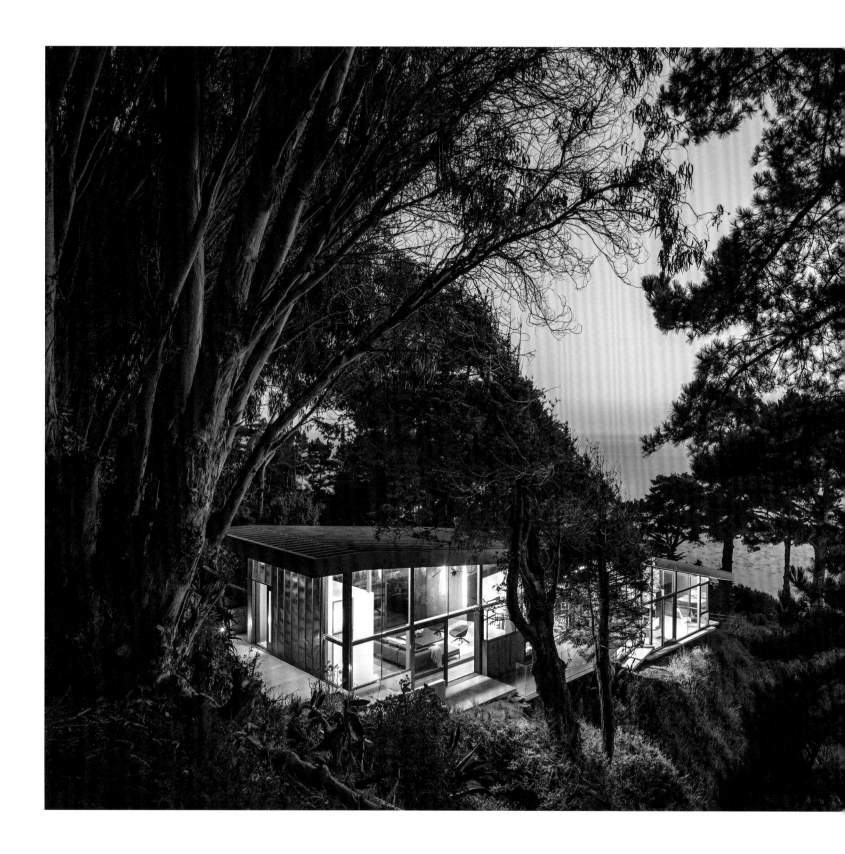

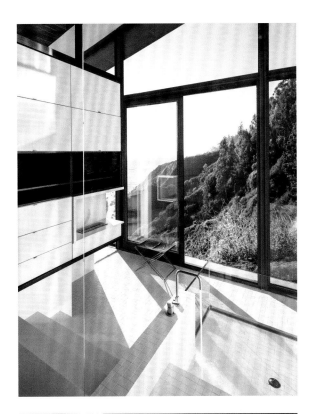

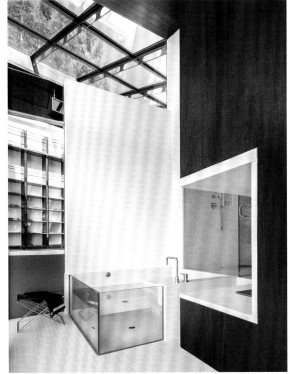

4.
CROSSING
WALL HOUSE
MOBILE OFFICE
ARCHITECTS

CALIFORNIA, UNITED STATES

House Area:
190 m²

Plot Area:
24,281 m²

Architect in Charge:
Dustin Stephens

Project Team:
Mobile Office Architects

Interior Designer:
Mobile Office Architects

Landscape Designer:
Zoe Stevens

Photographer:
Tyson Ellis, Amy Barnard, Dustin Stephens

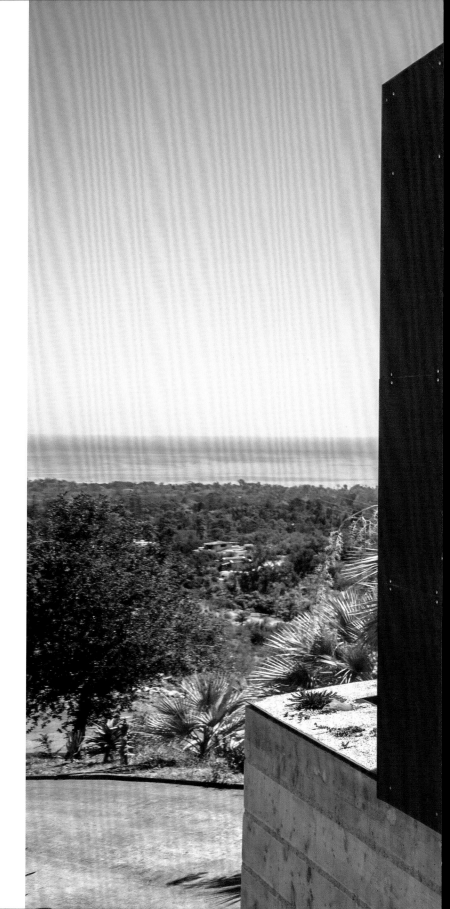

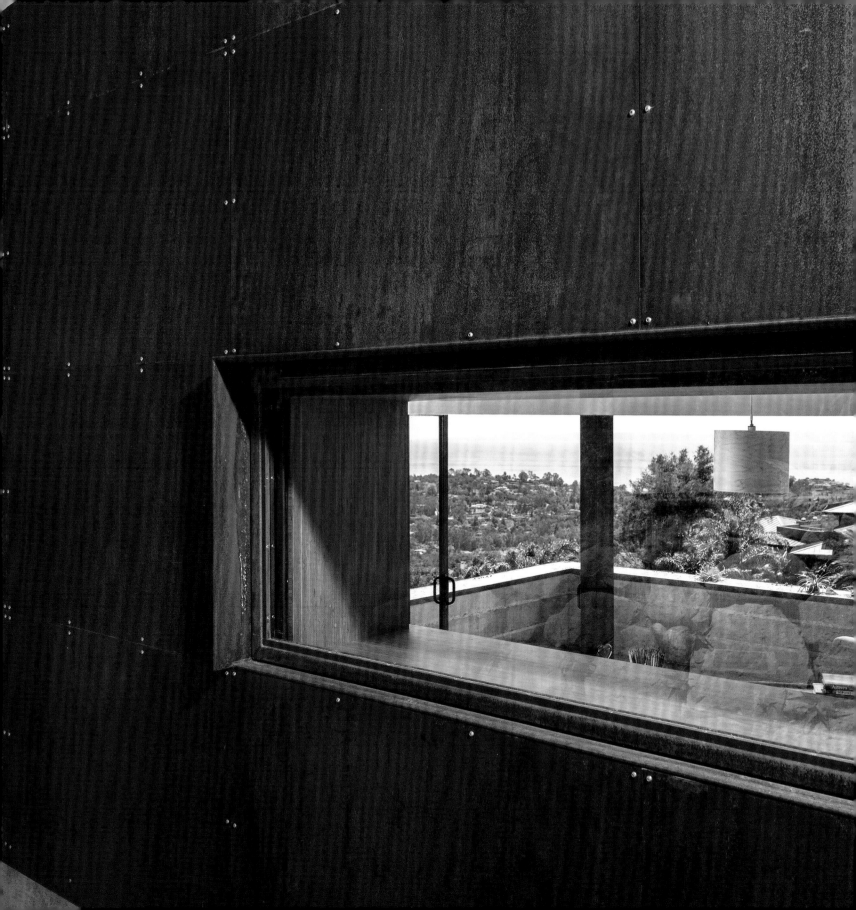

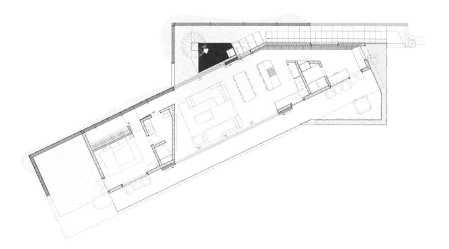

Ground Floor

The Crossing Wall House, designed and built by Mobile Office Architects (MOA), issituated at the intersection of the Santa Ynez Mountains and the Pacific Ocean, overlooking the City of Santa Barbara and the Channel Islands.

MOA believes that 'research and strategic thinking are central to each project's design process'. That 'each design problem is, therefore, surrounded by a unique context and is best served by an approach beginning with a rigorous understanding of that context'.

The Crossing Wall House's site put those beliefs to the trest; the parcel's steep grade necessitating careful site planning, and guiding the building form a sit utilized two narrow existing terraces. The two differing orientations of the terraces are expressed by a pair of geometric grids that come together in the home's central living space, andopen the house upto views of the ocean, islands, and lowlands. Two crossing retaining walls at the upslope side express the dual project geometries, and define the project's position on the site. At the back, one wall takes on an open and

porous tectonic, blurring the boundary between the constructed environment and the wild chaparral landscape.

The primary living space acts as an indoor-outdoor pavilion, adhering to the; opening fully at the back onto the entry courtyard, as well as to a deck at the front with down sloping views beyond. The raw corten steel and concrete exterior material palette was developed to create a building that ages and patinates with the landscape, and responds to localized threats posed by wildfires and wood-eating termites.

The project utilizes passive solar, thermal mass, passive ventilation, and solar hot water strategies to produce a fluid indoor-outdoor environment that operates at extremely high levels of energy efficiency, within the context of a functional, responsible, and beautiful dwelling.

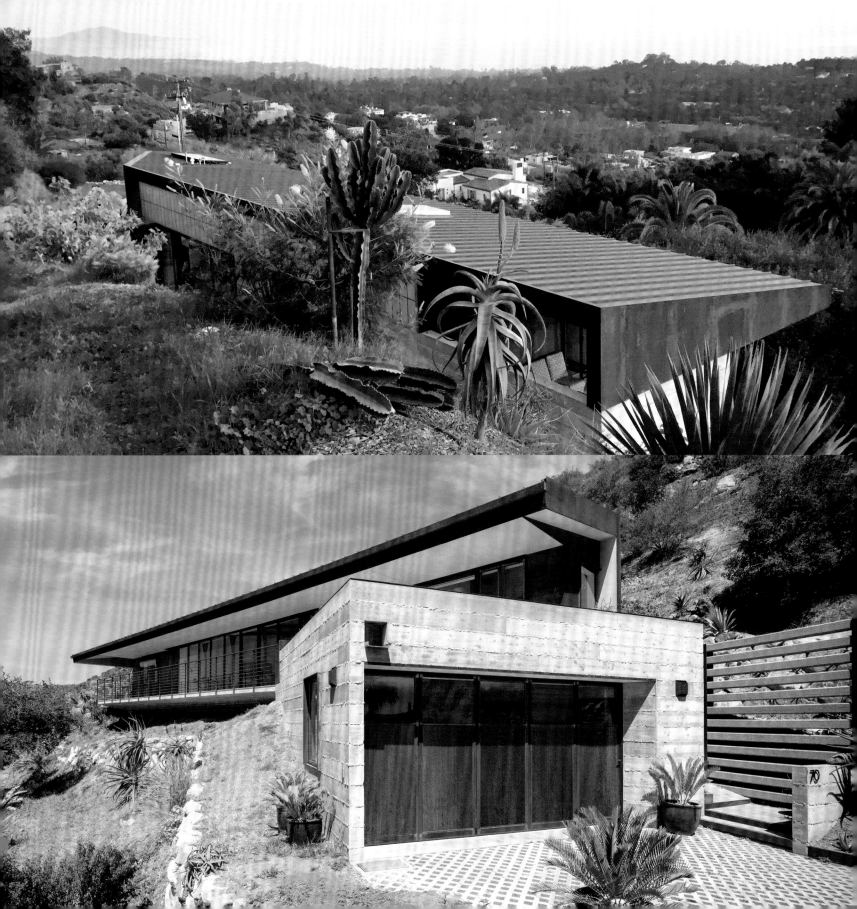

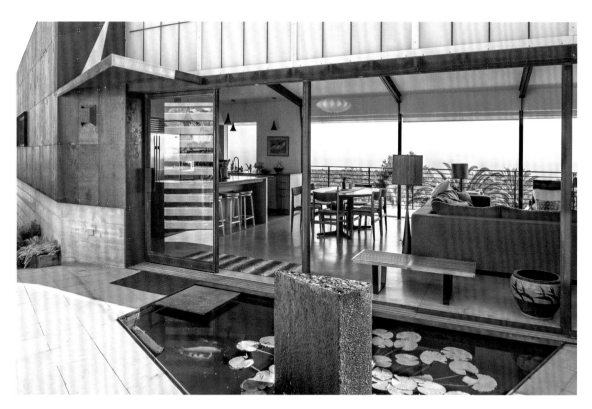

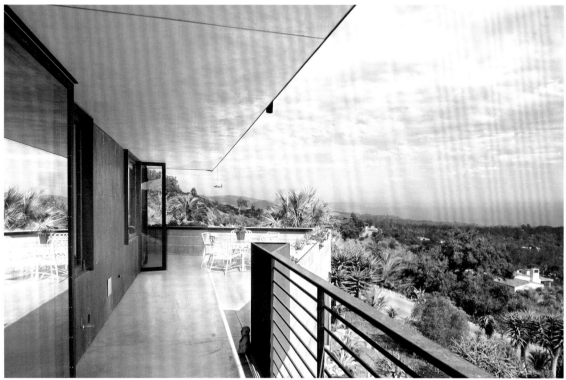

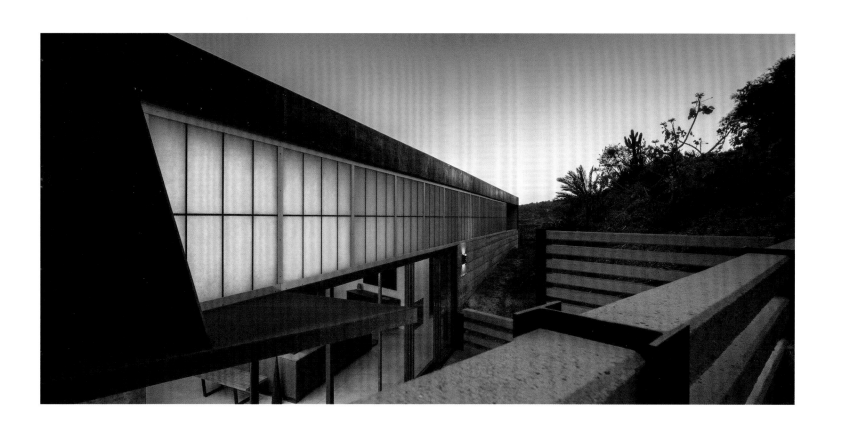

5.
MCELROY
RESIDENCE
EHRLICH YANAI
RHEE CHANEY
ARCHITECTS

CALIFORNIA, UNITED STATES

House Area:
700 m²

Plot Area:
1,700 m²

Architect in Charge:
Steven Ehrlich, Takashi Yanai

Project Team:
Brendan Canning, Ryan Lobello, Jackie Park

Interior Designer:
Ehrlich Yanai Rhee Chaney Architects, Sarah McElroy

Landscape Designer:
LA Studio - Larry Steinle

Photographer:
Roger Davies, Nicolas Marques and Miranda Boller

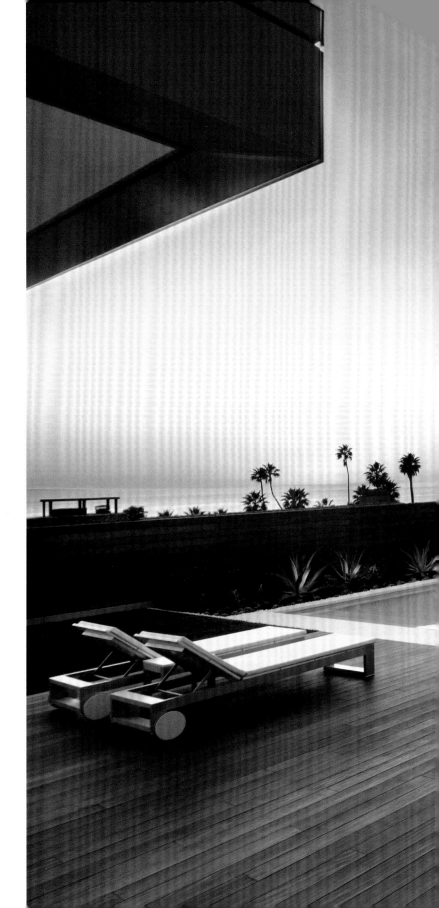

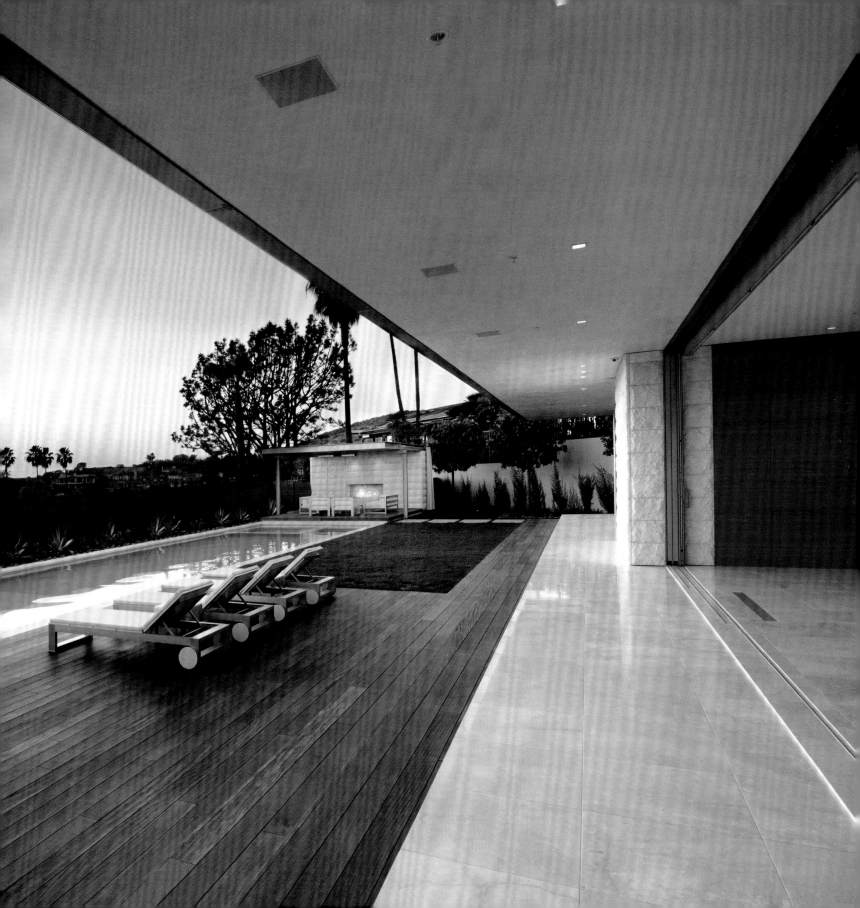

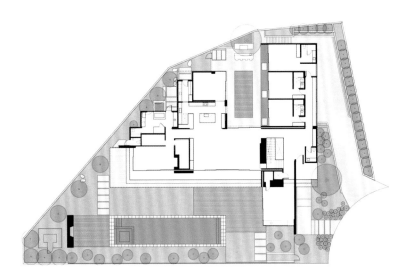

Ground Floor

EYRC designed the McElroy residence as a commission, for a couple and their two sons. The 7,800 sq/f house is nestled at the end of a cul-de-sac in a private community with spectacular views of the Pacific Ocean. One enters the compound along a fifty foot long teak-clad wall. Once inside, the house opens up dramatically, taking full advantage of the ocean views, as well as the Southern Californian climate. The challenge was to provide open and spacious living spaces, despite a restrictive eleven-foot height limit imposed by local regulations.

The solution was to create a series of horizontally expansive spaces beneath a floating horizontal plane, supported on stone masses, wood walls, and slender steel columns. Oversized sliding glass doors retract completely to literally dissolve the physical boundaries between the interior and the exterior, creating an uninterrupted flow from the rear courtyard to the main living space to the pool area, all against the backdrop of the Pacific Ocean.

The master suite commands a layered view over the swimming pool and the ocean, while the master bath opens onto a private meditative garden, nestled between the house and the topography beyond. A home office, and both guest and children's bedrooms open onto a protected central courtyard, which features an outdoor kitchen, dining area, and Koipond.

Stone floors extend from indoors to the outside, furthering the intermingling of internal and external spaces. While the combination of the external material palette of teak and concrete and the landscaped areas provide a variety of outdoor entertaining and living areas in which to enjoy the Southern California climate.

From an aesthetic perspective, the low-slung structure remains fidelitous to the essential tenets of mid-century modernism, commingling interior and exterior spaces to form an experiential seamlessness.

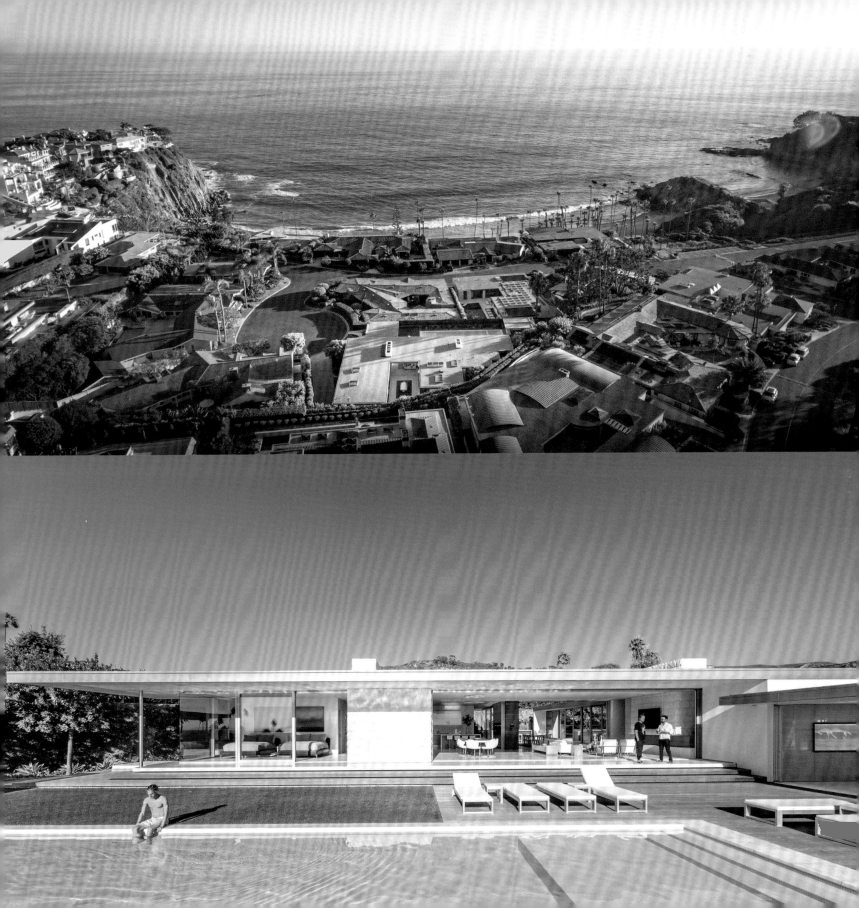

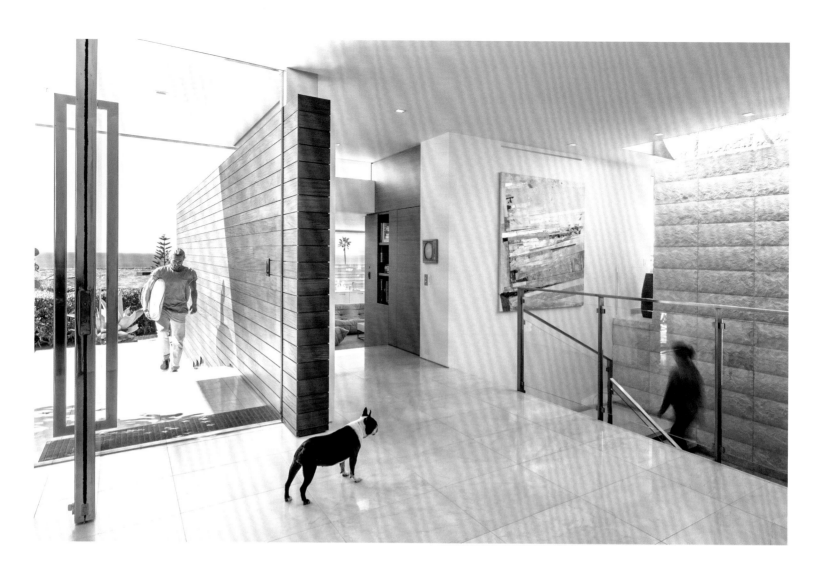

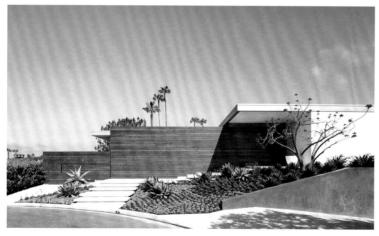

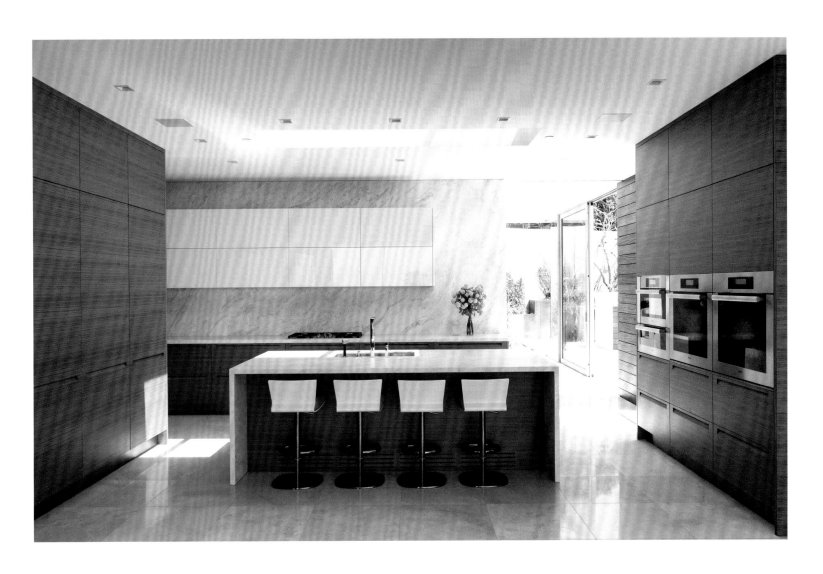

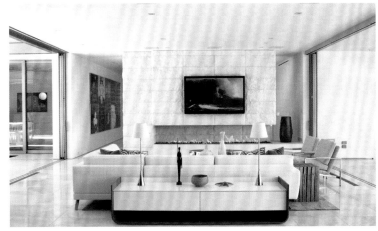

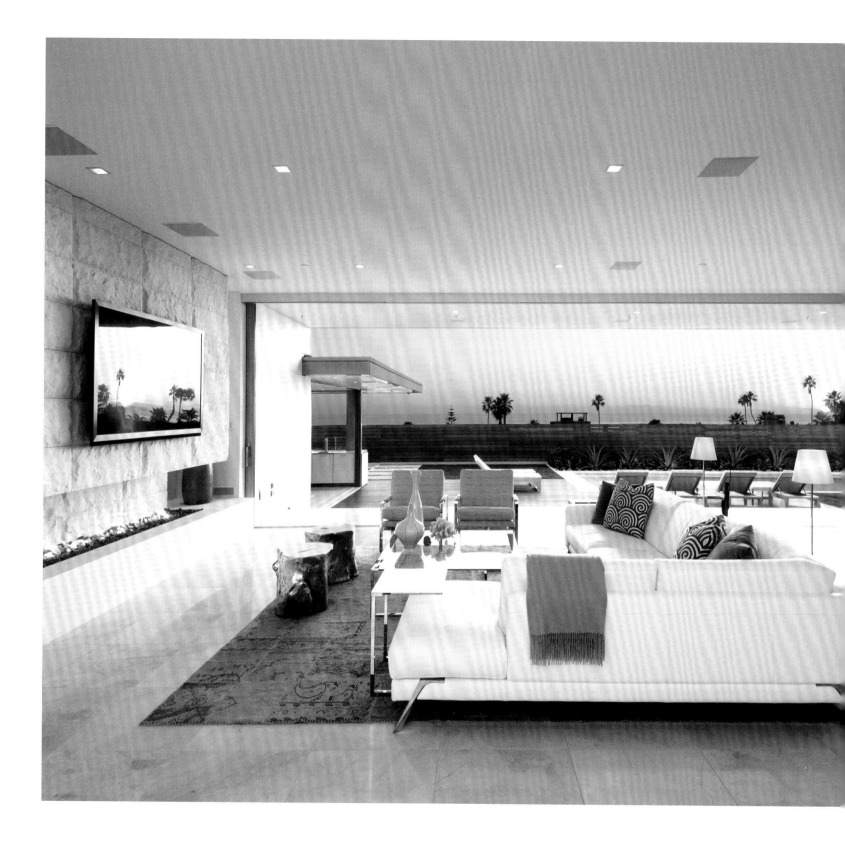

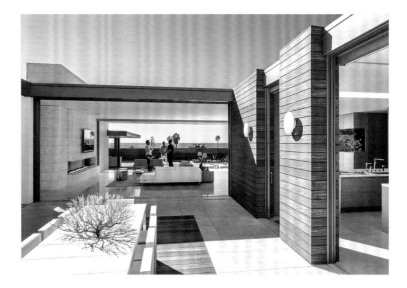
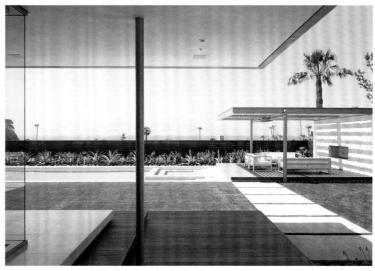

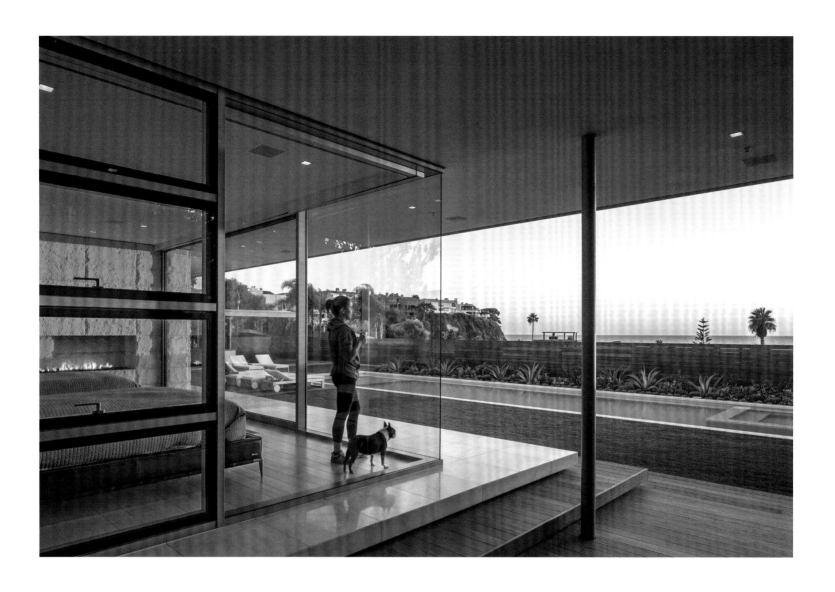

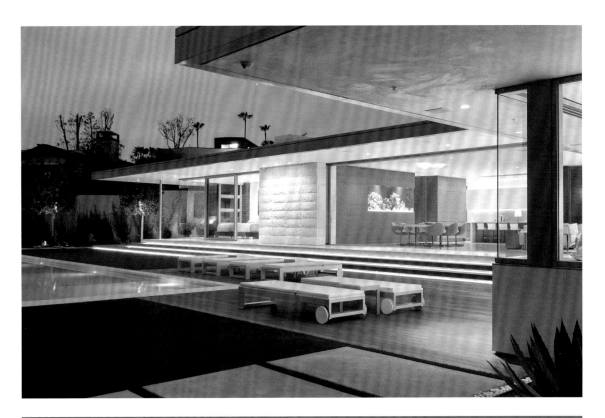

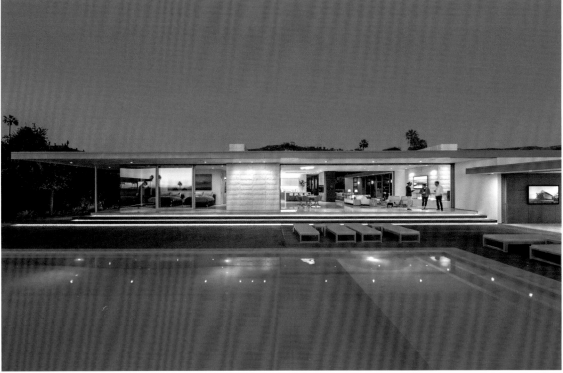

6.
STINSON BEACH LAGOON TURNBULL GRIFFIN HAESLOOP ARCHITECTS

CALIFORNIA, UNITED STATES

House Area:
260 m²

Plot Area:
1,394 m²

Architect in Charge:
Mary Griffin

Interior Designer:
Cleaveland and Kennedy Design

Landscape Designer:
Michael Bernsohn

Photographer:
David Wakely and Shaun Sullivan

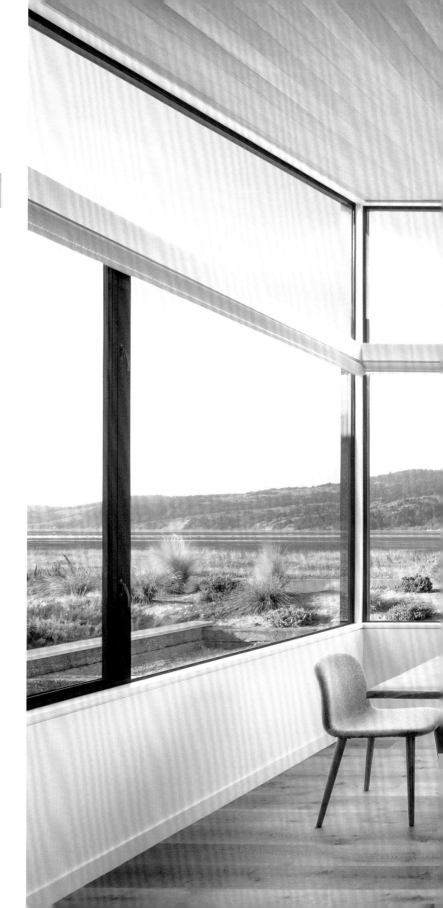

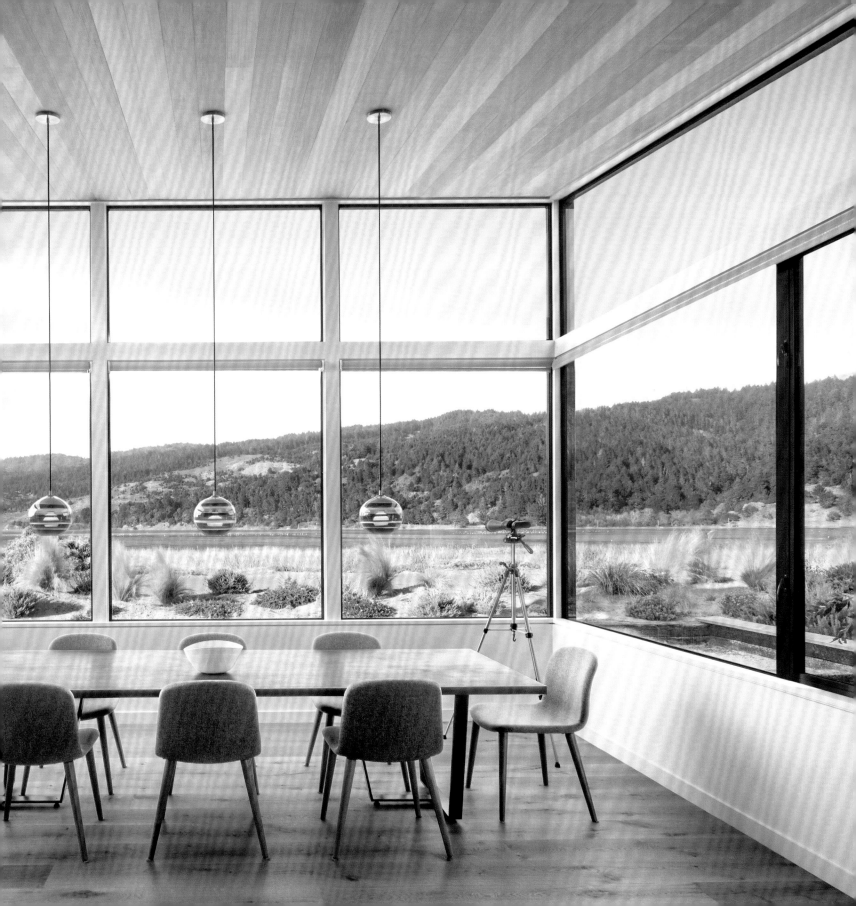

Ground Floor

Located in the minuscule Northern Californian enclave of Stinson Beach (population 632), the Stinson Beach Lagoon house manifests as a series of quasi-autonomous vertical board cedar volumes, which come together to form a broader aesthetic and spatial entity.

The property is nestled between Seadrift Lagoon on the south, and Bolinas Lagoon on the north, allowing a wholly private feeling ensconced in its surrounding. The house itself functions as an indoor/outdoor retreat, focussed on a courtyard to the south that captures the sun while blocking the California winds. The courtyard further creates privacy for the outdoor deck, fire pit, and hot tub. Personal living spaces open out onto the courtyard, while an interior dining bay angles slightly upwards in order to capture views of the Bolinas Lagoon and Marin Hills beyond.

One programmatic necessity was showcasing of the owner's superlative art collection. The entire house is reminiscent of a contemporary art gallery. In the living room, the walls are covered with paintings by Jenny Robinson, a local artist; pieces by James Grant, a Los Angeles–based sculptor; and Kim Curtis, a San Francisco-born painter.

Interior designers Cleaveland & Kennedy worked with the owners to design the house with natural fabrics and a preference for locally made objects, which accentuates the subtle palette of blonde woods and oversized glass.

The house is used primarily as a weekend getaway. As such, the kitchen area and the living room is a single open space, where the family can spend time together and entertain themselves inside as well as outside. Ultimately, the intention of the project was to take the advantage of the landscape. It has a butterfly roof which tips up to the south to catch the southern light, and tips up to the north to catch the view, both reinforcing and melding into the natural beauty of its surroundings.

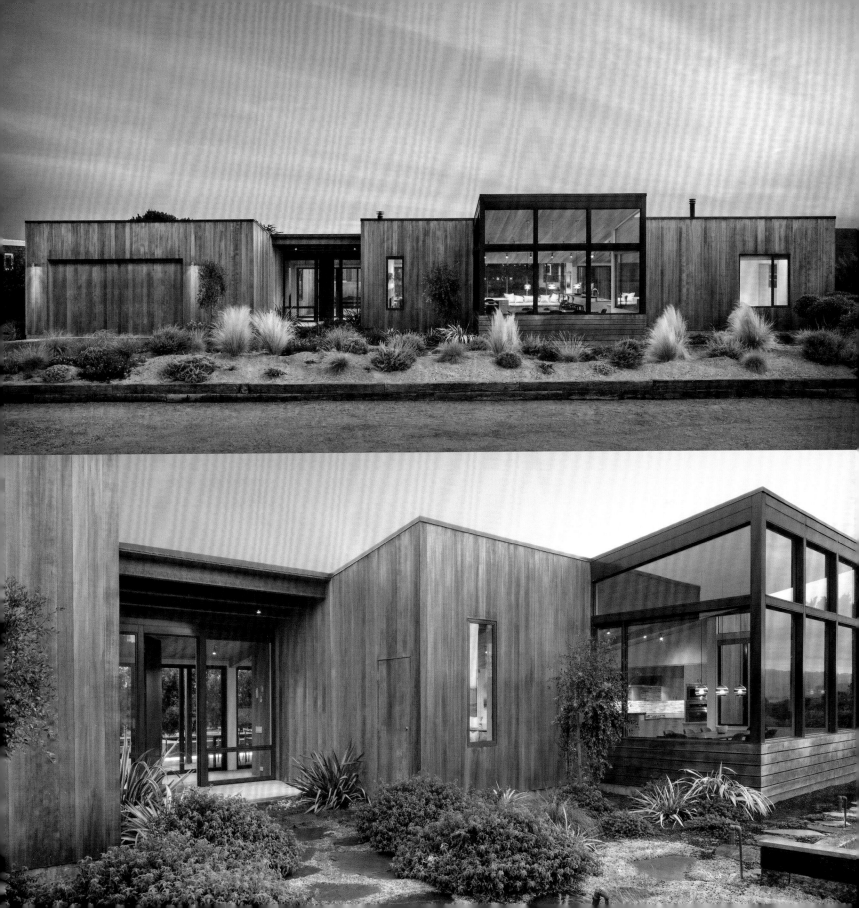

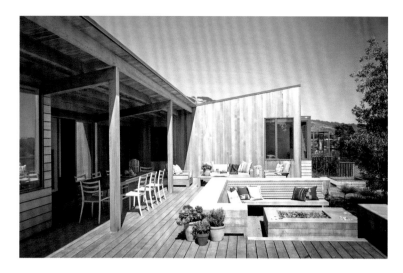

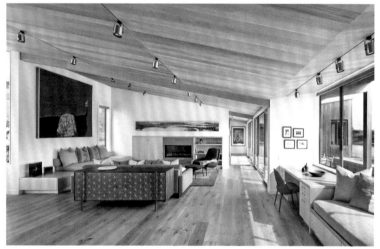

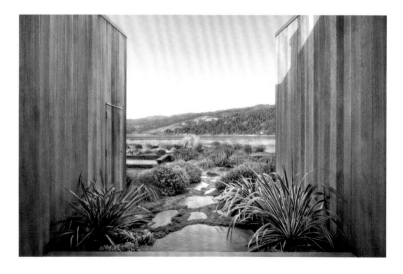

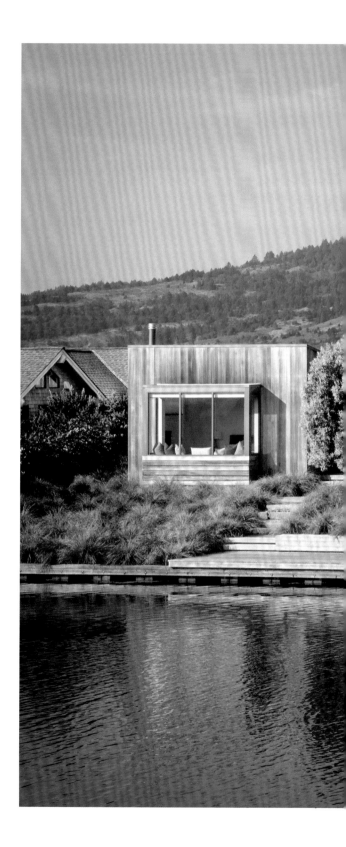

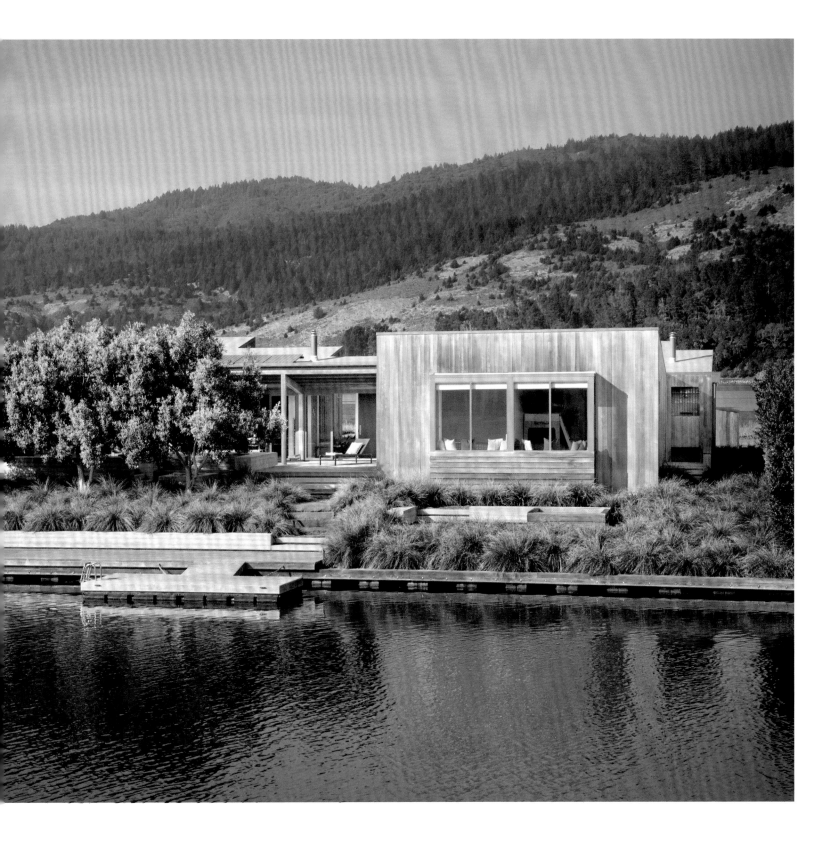

7.
HOUSE TO THE BEACH GLUCK+

ILLINOIS, UNITED STATES

House Area:
1,347 m²

Plot Area:
5,518 m²

Architect in Charge:
GLUCK+

Project Team:
Kathy Chang, Peter L. Gluck, Thomas Gluck,
Charles Gosrisirikul, Joanna Gulik, Marisa Kolodny,
Steve Preston, Wade Splinter, Jim True

Interior Designer:
Insight Environmental Design & FlepsDesigns, Ltd.

Landscape Designer:
Hoerr Schaudt Landscape Architects

Photographer:
Paul Warchol

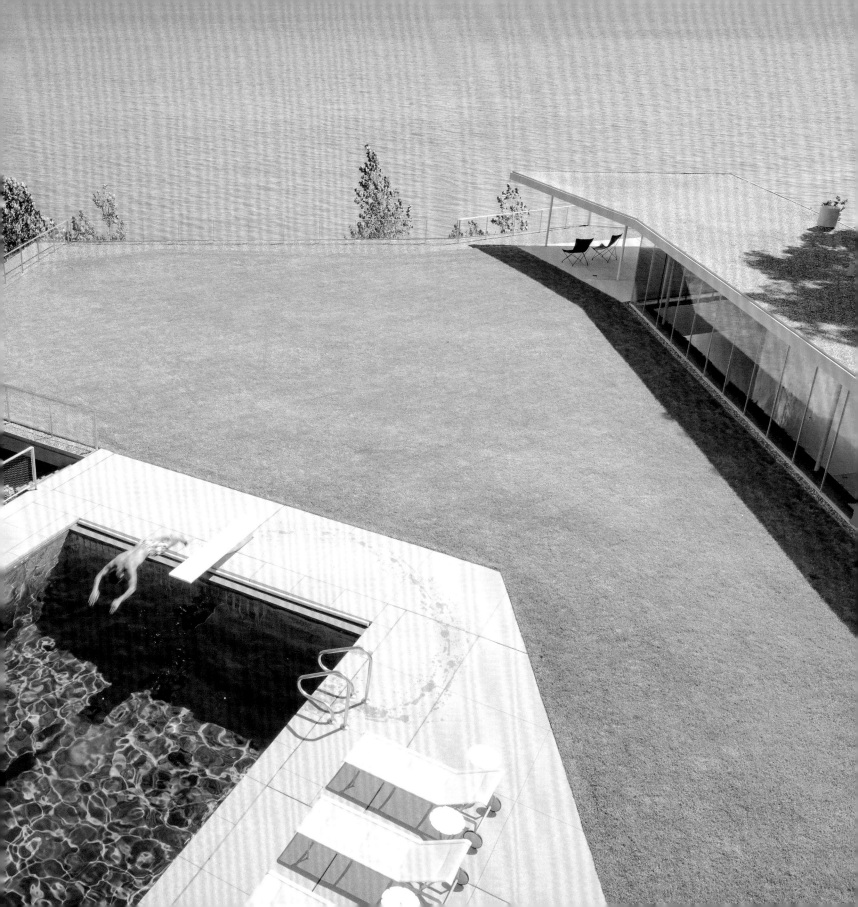

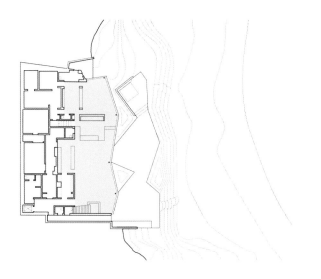

Ground Floor

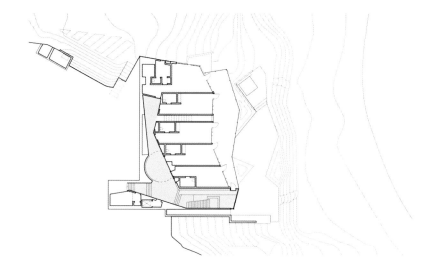

First Floor

Located in the northern suburbs of Chicago, Gluck+'s House to the Beach sits opposite a unique object: the world's oldest surviving Baha'i Temple; a 135 foot tall vision in white stone, symmetrically spherical, and monumental. The street-side face of the house must negotiate not only the scale and specificity of this alien architecture but, also, the eclectic nature of its suburban environment. Furthermore, the house must negotiate a 40 foot elevation differential between the road and the lake.

The house itself consists of four levels. A two storey structure, windowless to the street, contains the garage, a gym, and a guest suite. This façade is non-residential in scale, but acts as a sort of foil to the monument it faces. Manifesting as a near inversion of the opposing grand stairs that lead upto the temple entrance, the house's main entranceway is located at the top of a parallel stair, with the individual spaces of the house revealing themselves gradually, on the way down to the beach below. As one descends down the light-filled stairway the house reveals itself. The architecture creates an experience, where the whole is pieced together through one's mental landscape of moving down and through the house.

A largely subgrade building with oversized, operable windows facing the lake, the house requires less energy than similar buildings of its type and size; tempered by the earth both passively, through a combination of a green roof system and buried facades, and actively, by means of geothermal wells feeding heat pumps for heating and cooling.

The design of this entirely unique residence focusses on the transition from suburban streets to lakeside beach. There are overlapping journeys provided by the house, from community to privacy, from formal to informal, from reality to something much more dreamlike.

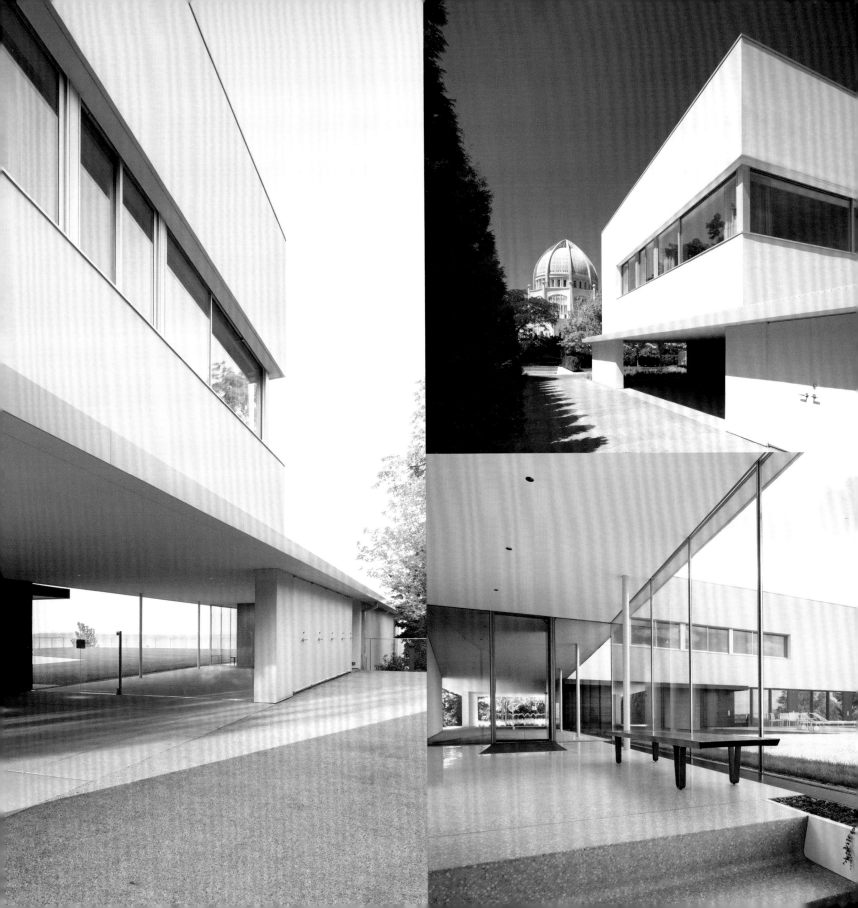

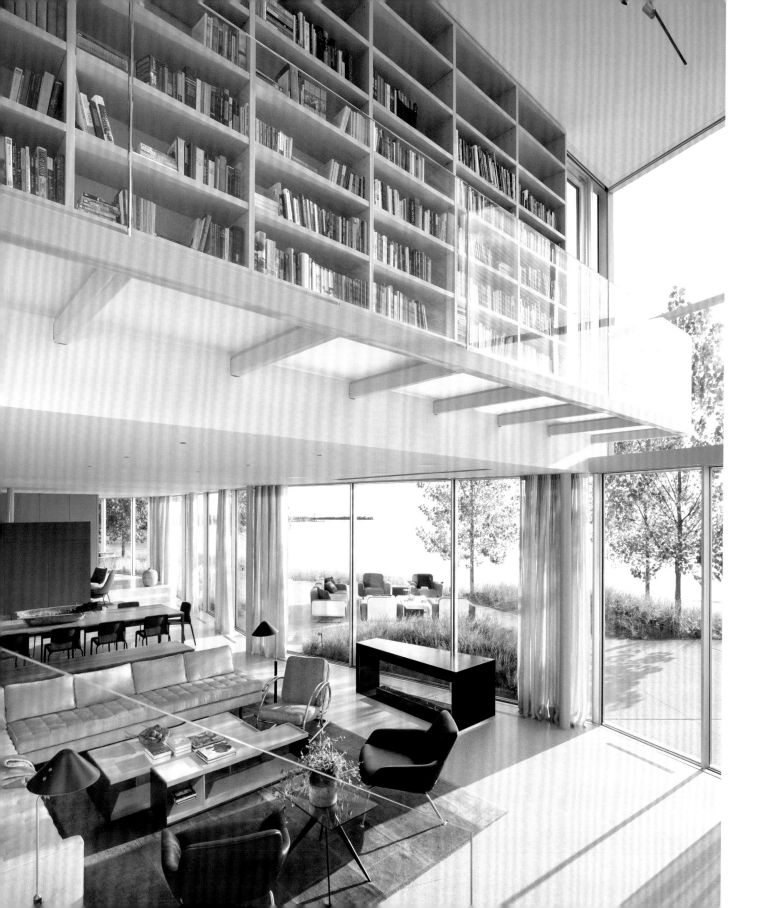

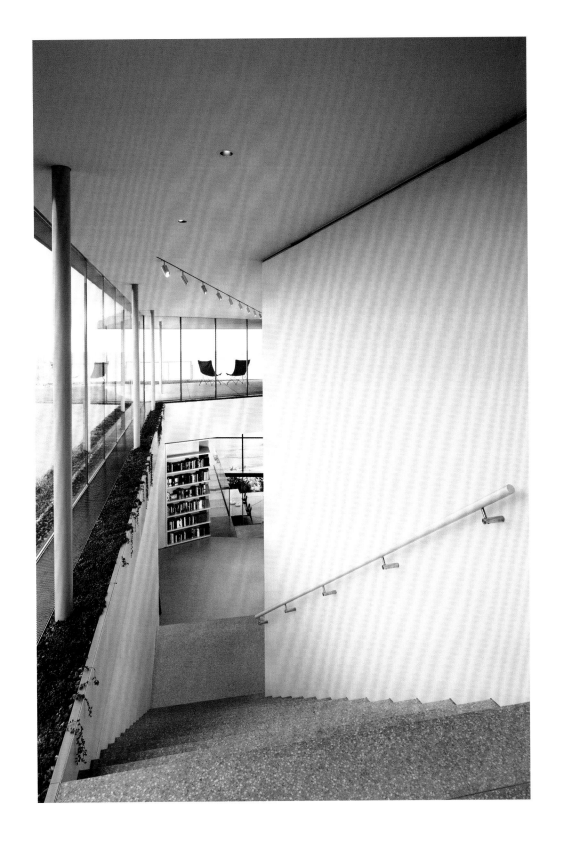

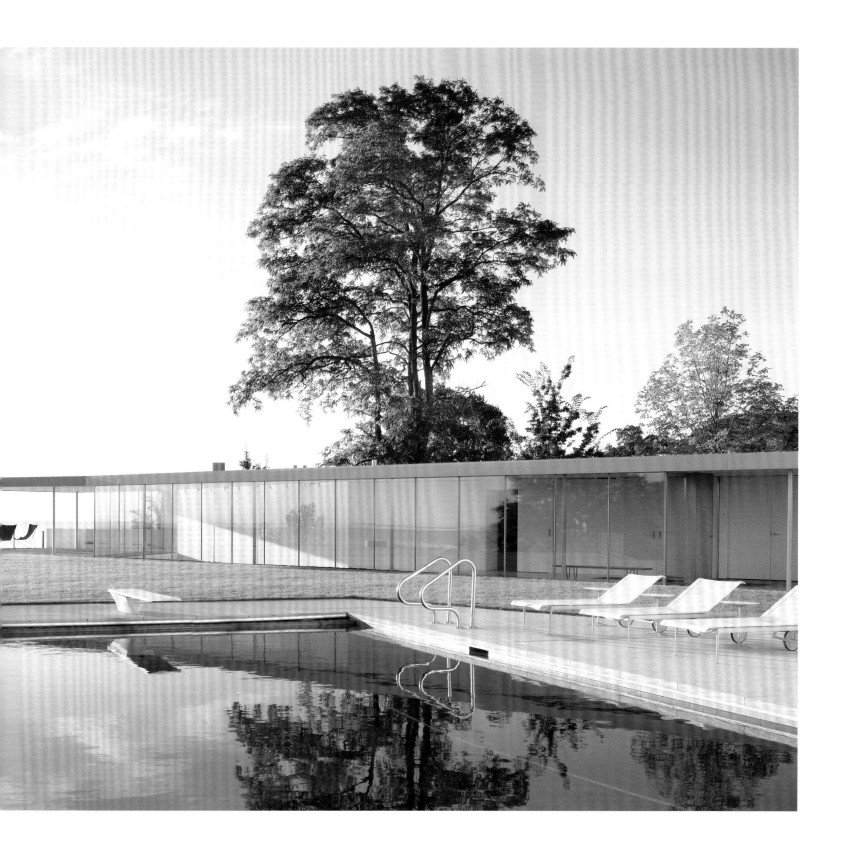

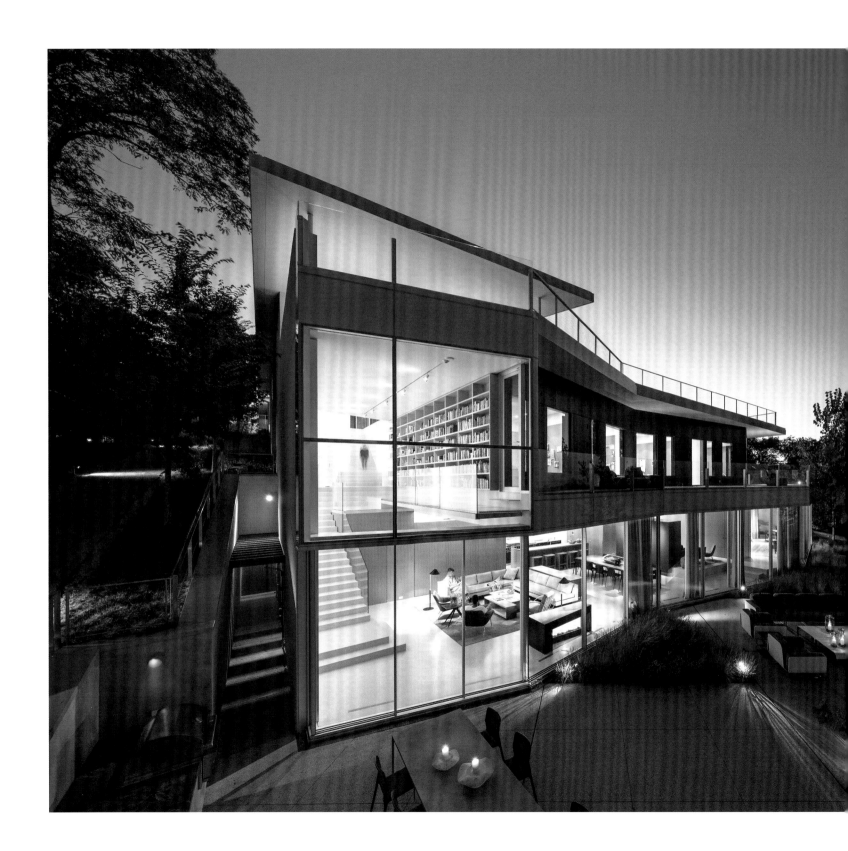

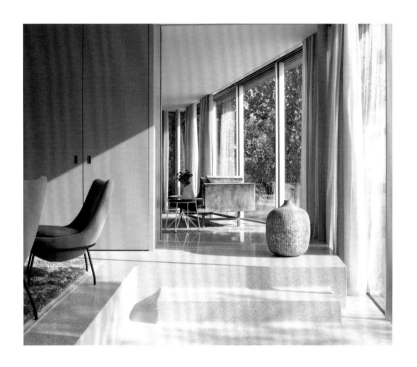

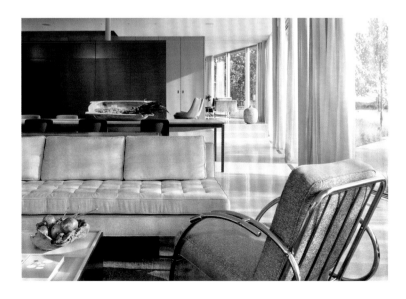

8.
MICHIGAN LAKE HOUSE DESAI CHIA ARCHITECTURE

MICHIGAN, UNITED STATES

House Area:
445,93 m²

Plot Area:
6 ac

Architect in Charge:
Desai Chia Architecture

Project Team:
Katherine Chia, Arjun Desai, Huy Dao

Interior Designer:
Desai Chia Architecture

Landscape Designer:
Surface Design, Inc., Darling Botanical Co.

Photographer:
Paul Warchol

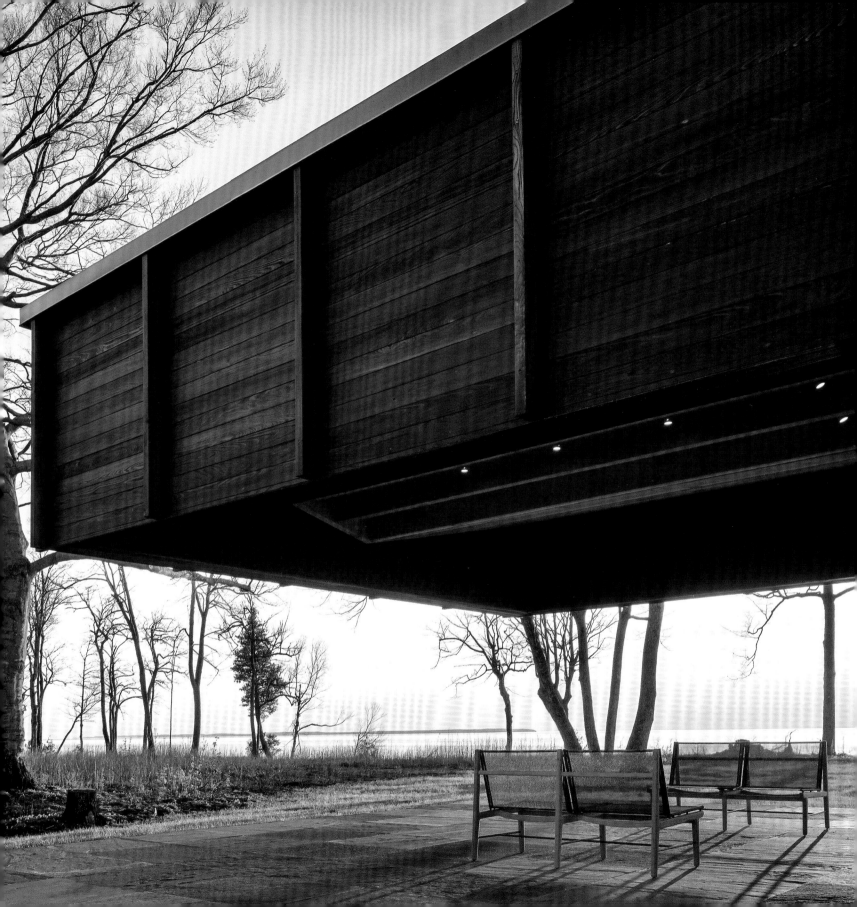

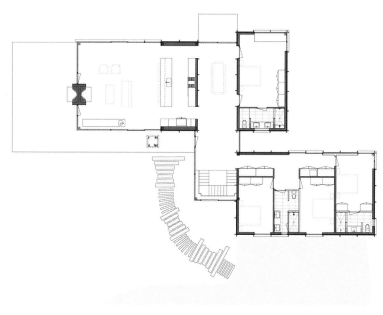

Ground Floor

Perched on a woodland bluff overlooking Lake Michigan, this home, designed incollaboration with Environment Architects (AOR) of Traverse City, MI, is an assemblage of three offset structures that play off each other - the 'gathering' structure contains the living room, kitchen, and a covered 'vista' seating terrace, while the two 'sleeping' structures house the master bedroom suite as well as three children's bedrooms. A dining area breezeway connects the three structures.

The roofscape has gentle undulations that trace the movement of the surrounding terrain and playfully reference the vernacular architecture of nearby fishing villages. The resulting rhythm of exposed wood beams provides layers of asymmetrical vaults throughout the interiors. At the southern end of the house, a 20 foot cantilevered roof extends over the terrace, providing a protected, unobstructed view of Lake Michigan and the surrounding woodlands.

The exterior of the house is clad in dying ash trees, using the traditional Japanese methodof 'shou sugi ban'-scorching and blackening timber so it becomes resistant torotting and bugs. The charred texture enhances the shadows across the façade as the sun rises and sets.

The dying ash trees were reclaimed from the site, and milled down to be used as interior cabinetry, flooring, ceiling panels, trim work, and custom furniture throughout the house. The interiors of the house embody the indigenous landscape that once thrived with old growth ash.

Landscape design strategies were closely tied to the design of the house. A tight palette of native vegetation highlights views, while also managing storm water run-off. Locally sourced stone creates outdoor seating areas, pathways, and steps, enhancing the subtle elegance of the residence.

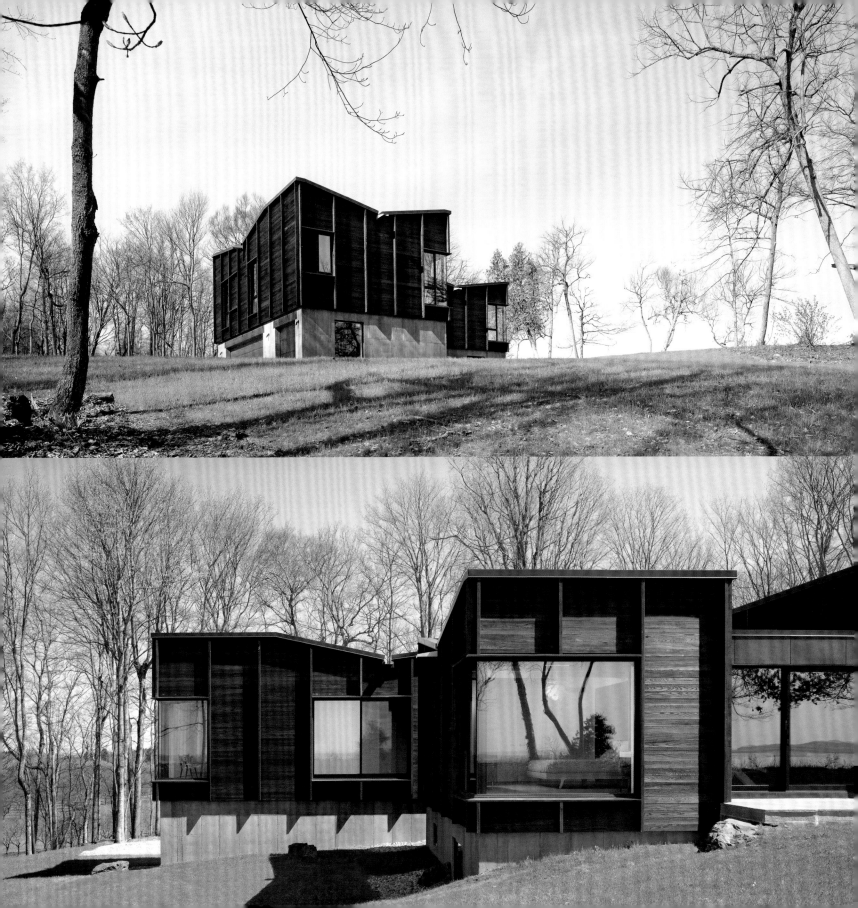

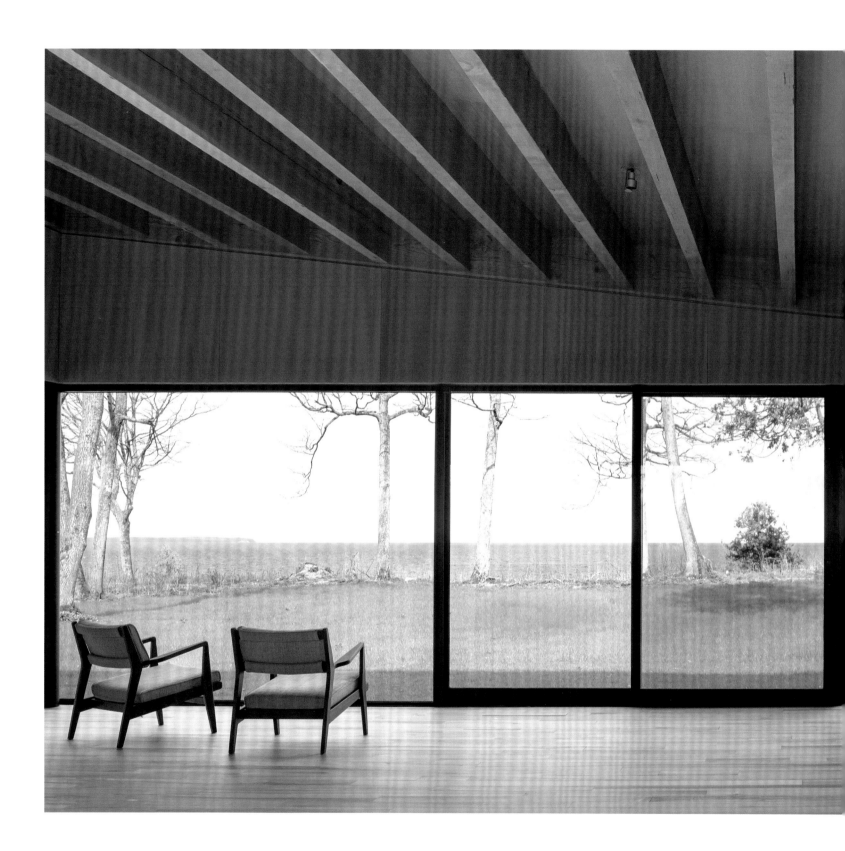

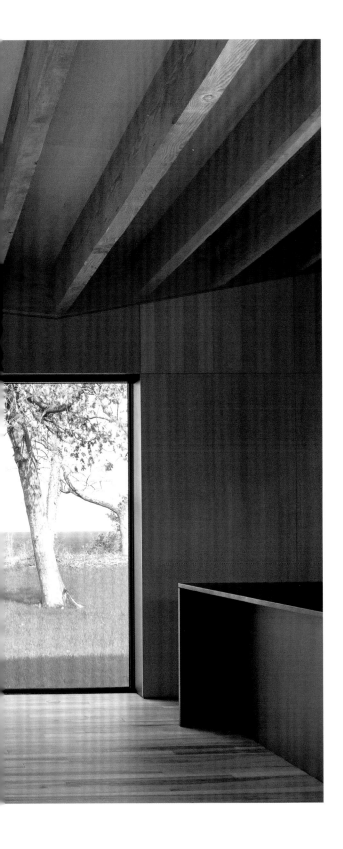

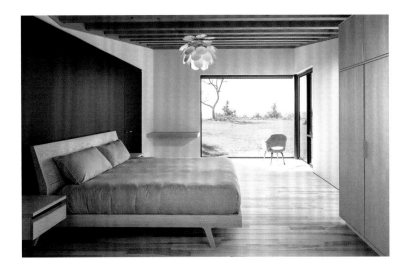

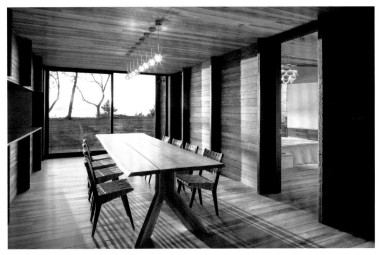

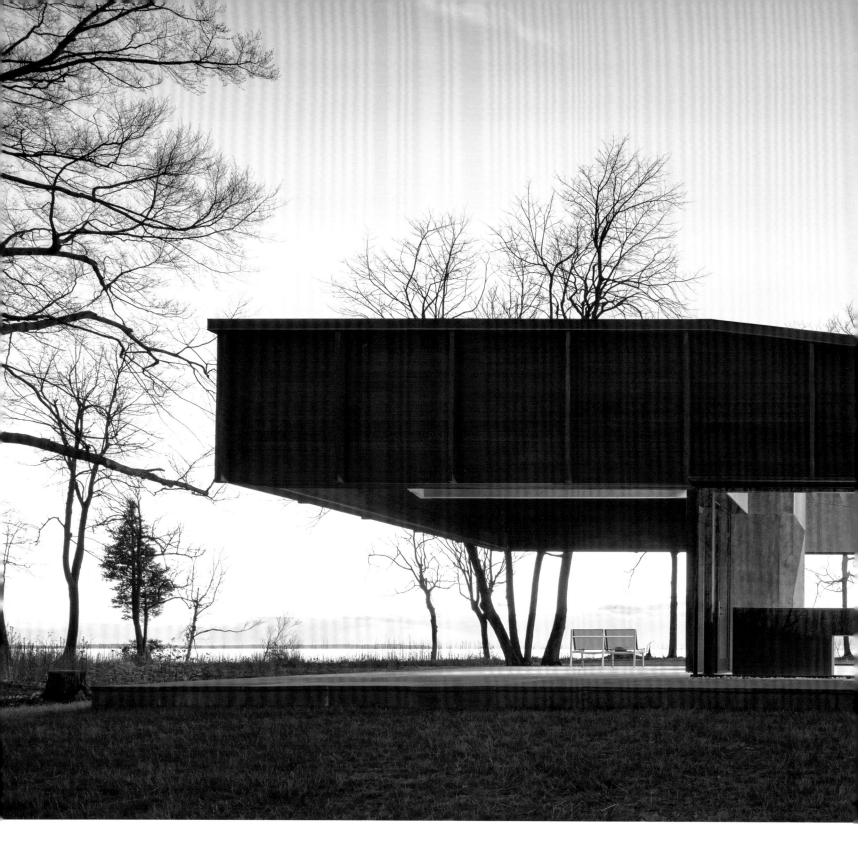

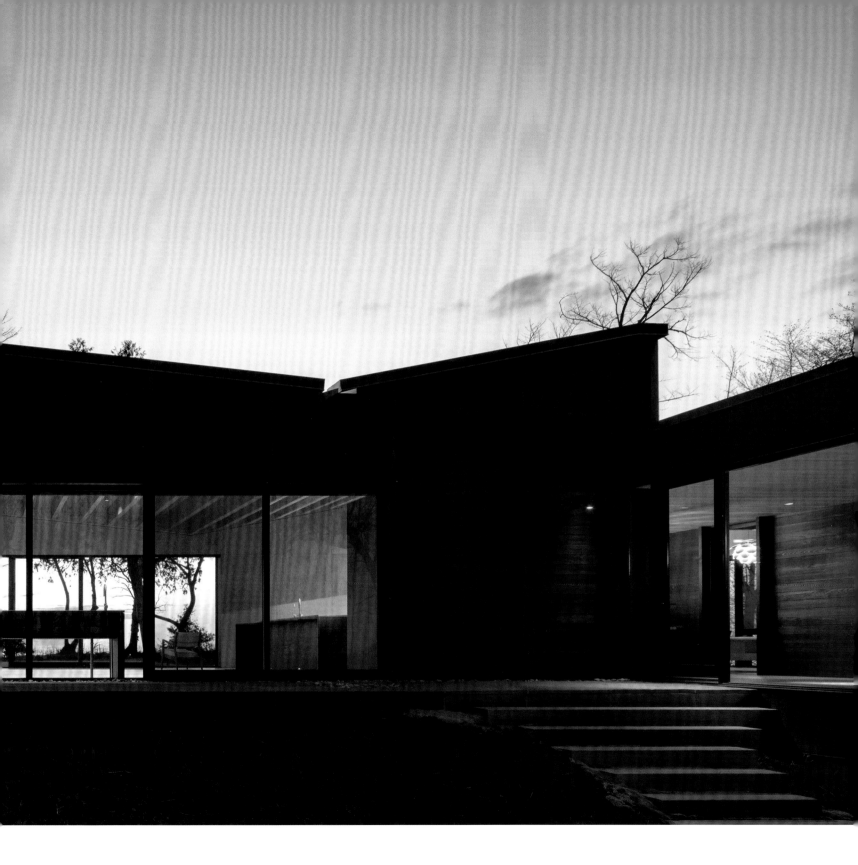

9.
SUNS END RETREAT
WHEELER KEARNS ARCHITECTS

MICHIGAN, UNITED STATES

House Area:
269 m²

Plot Area:
1,865 m²

Architect in Charge:
Mark Weber

Project Team:
Joy Meek, Dung Luu

Interior Designer:
Eleanor DeLeon

Landscape Designer:
Green Mansions

Photographer:
Steve Hall/Hedrich Blessing

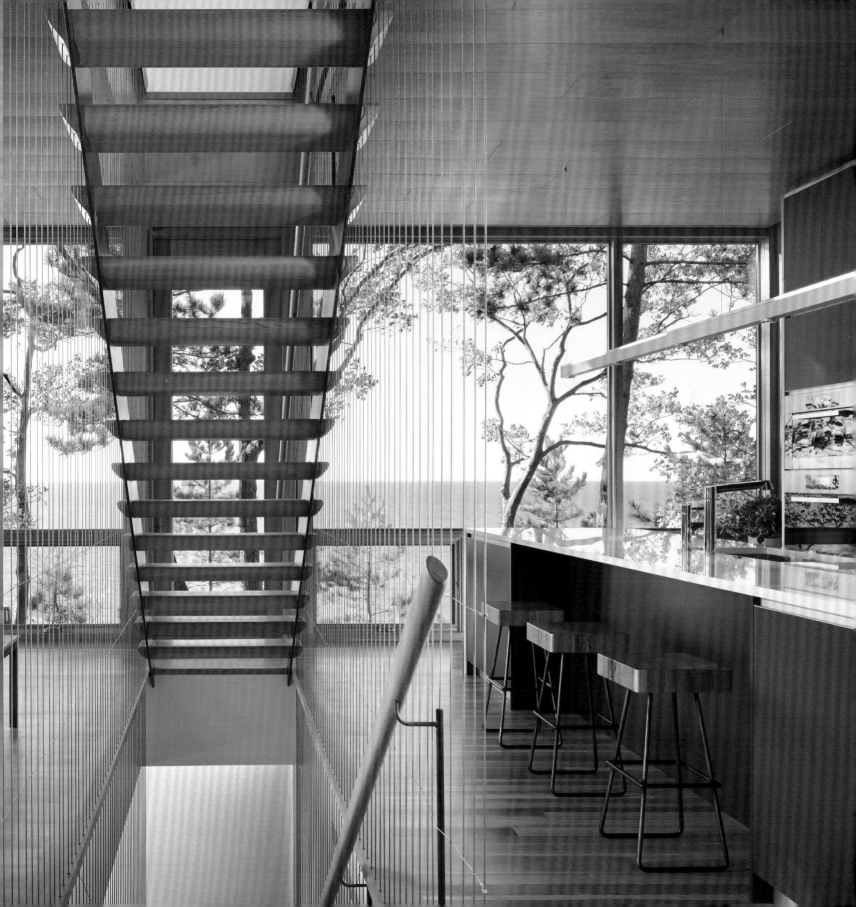

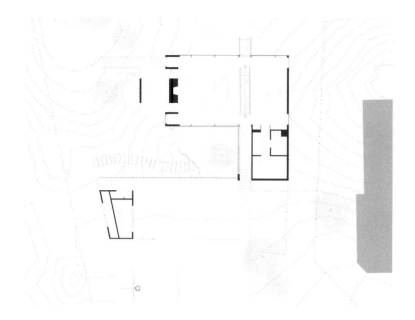

Ground Floor

First Floor

Tranquility and simplicity are at the core of this waterfront retreat. Overlooking Lake Michigan, the house is designed for a young family seeking respite from city living and immersion along the quiet beach. The blonde wood, Pacific Northwest-esque aesthetic of the project manifested out of the client's desire for an intimate and minimal refuge that can be enjoyed year round. Challenged by the pronounced sloping sloping, sand dune topography and imposing neighbouring house to the east, the design entails two shifting volumes that maximize southern exposure, creating a vertical 'sun court'. The house is positioned on the lot so that each room connects to the layers of surrounding landscape, both natural and man-made.

The house is approached as a sequence of layered spaces. A long, compressed walk to the entry amplifies the arrival experience. Defined by vertical louvers, the entry hall controls peripheral views to the sun court below, and frames views through the building and stairs to the panoramic view of the lake beyond. Upon entry there is a clear indication of the distribution of the programme.

The family and dining room is the heart of the home, connecting the different spaces visually and programmatically. Floor to ceiling windows are the predominant feature in the room, inviting the outside in and celebrating the movement of the sun throughout the day. Vertical circulation acts as the filter to divide public and private functions. The stairs are light and unimposing, supported by stainless steel cables to maintain visual continuity between the family room and kitchen. It's the juxtaposition of the kinetic lake and tranquil sun court that gives this retreat its distinctive character.

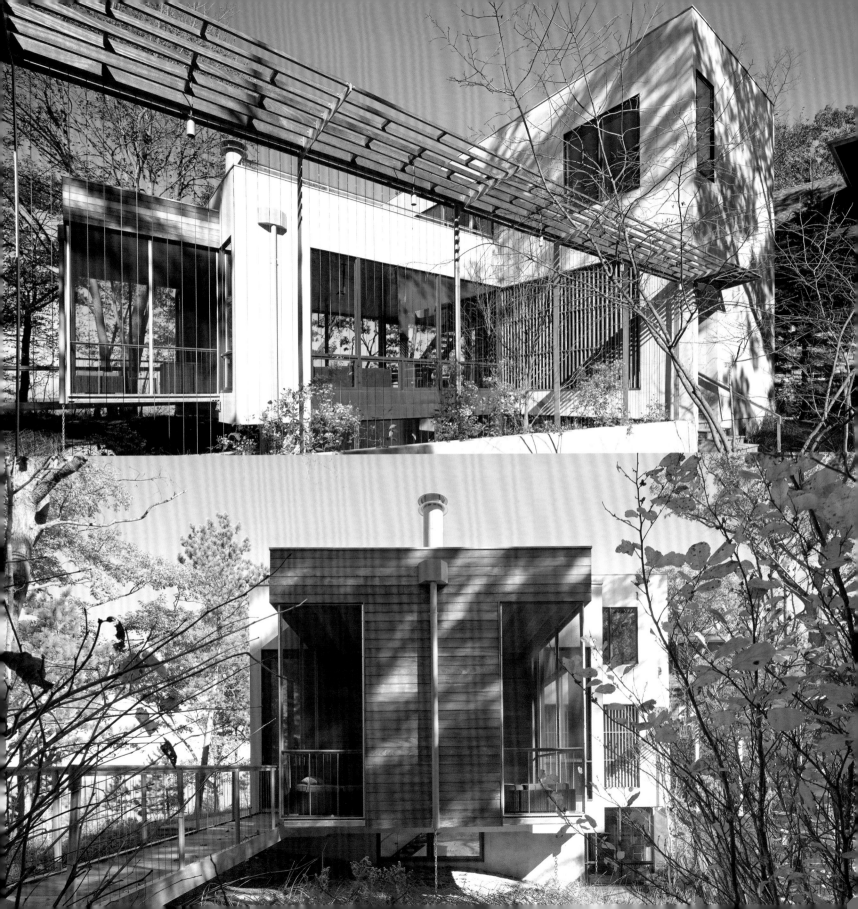

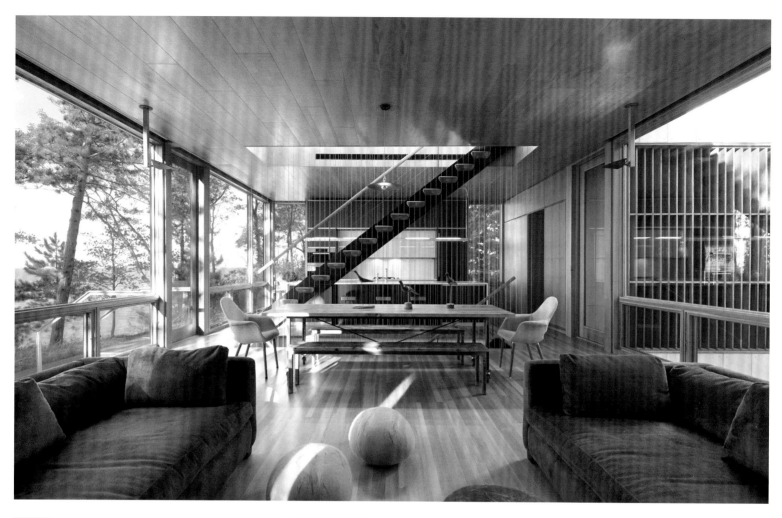

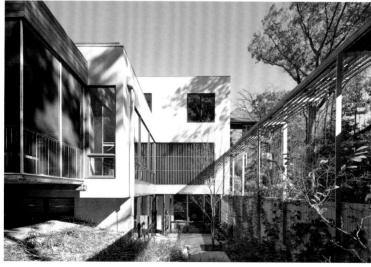

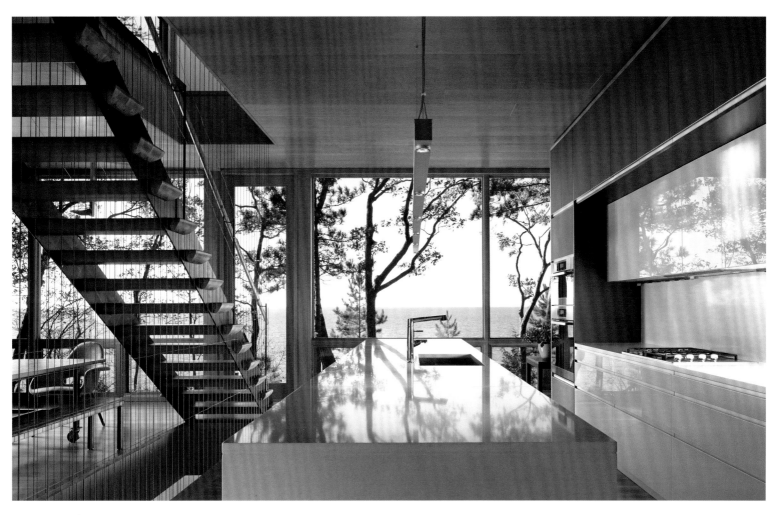

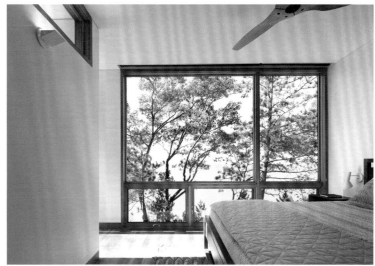

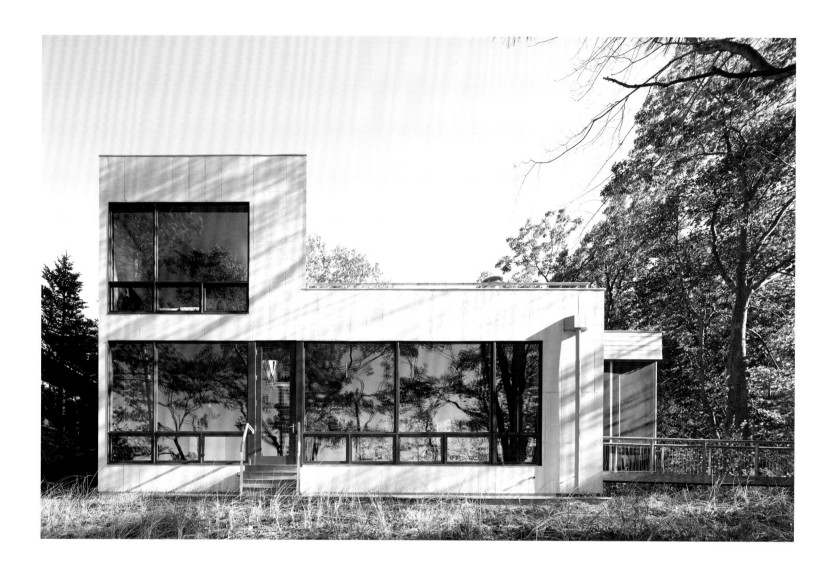

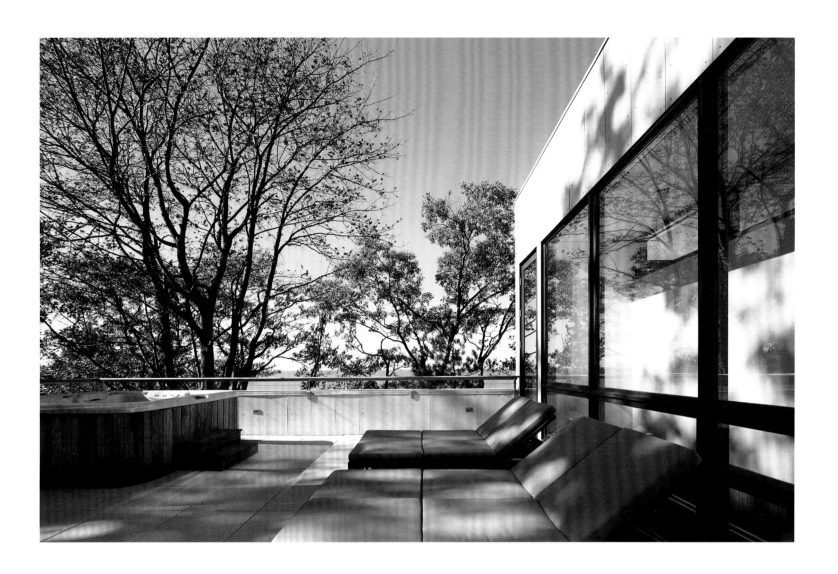

10.
OCEAN DECK HOUSE STELLE LOMONT ROUHANI ARCHITECTS

NEW YORK, UNITED STATES

House Area:
641 m²

Plot Area:
1,323 ac

Architect in Charge:
Stelle Lomont Rouhani Architects

Project Team:
Frederick Stelle, Viola Rouhani,
Luca Campaiola, Jessica Twiggs

Landscape Designer:
Edmund Hollander

Photographer:
Matthew Carbone

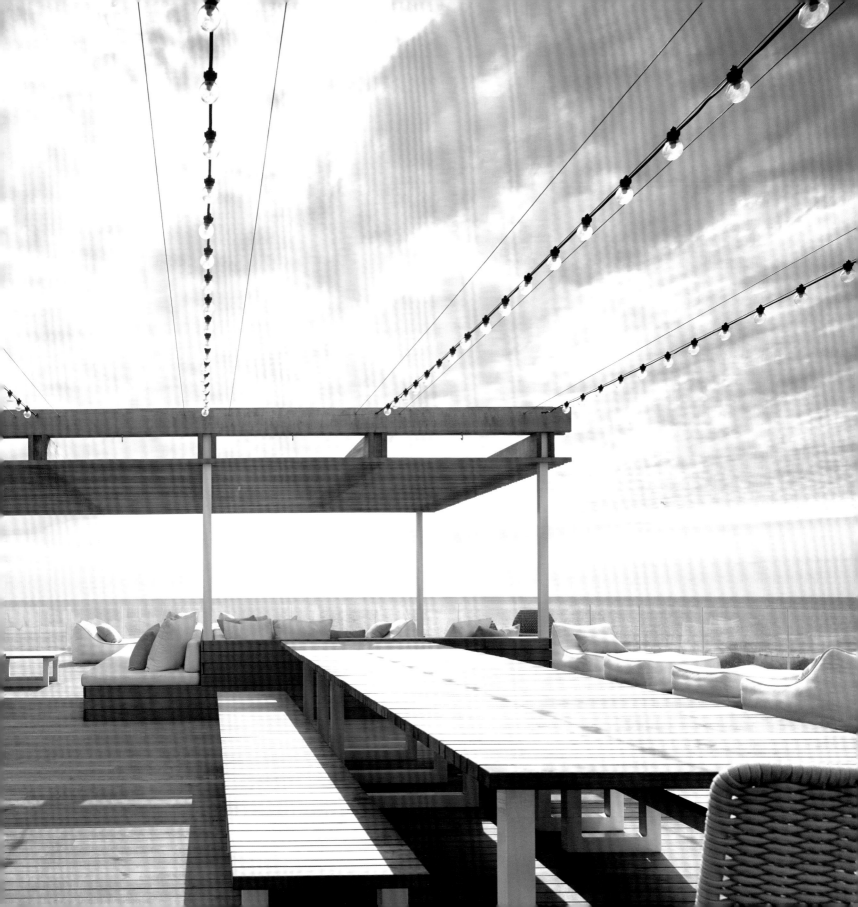

Ground Floor

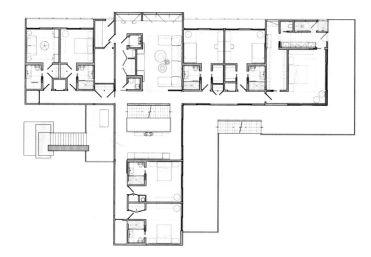

First Floor

This ocean-front residence espouses and expands upon the sense of indoor-outdoor beachfront living, through a staggered series of large cantilevered decks, and roof terraces. Designed as an original commission for an active family who loves to entertain, the ability todo so on each level was a defining element to the overall design.

Bright, open, and airy, the house speaks perfectly toneü-Hamptons residential architectural mores. An expansive open-air rooftop terrace of béton-brut and light woods features an over-sized communal dining table, kitchen and bar facilities, and a semi-covered lounge area.

In the interest of preserving the integrity of the dune, the house is pulled back from the beach, to create three distinct experiences, one on each level. The ground level is nestled behind the dune, and provides for a mixed wood and concrete paved patio with a pool, outdoor fireplace, and covered ping-pong area.

Areas on this level intended for storage and lower-level entry are enclosed by a combination of glass and concrete walls. The main floor is accessed from an exterior cantilevered stair that leads to a central, light-filled atrium. This main level houses all the bedrooms, as well as a centrally located family room.

This house is designed with an inverted programme, giving the most spectacular views to the living, dining, and kitchen spaces on the top floor. This floor takes full advantage of southern climactic exposure and views, while also providing for adequate solar control. The main deck allows for an extensive herb and vegetable garden, outdoor cooking, entertaining, and lounging, while a matched-material pathway tracks along the bluff, providing direct beach access.

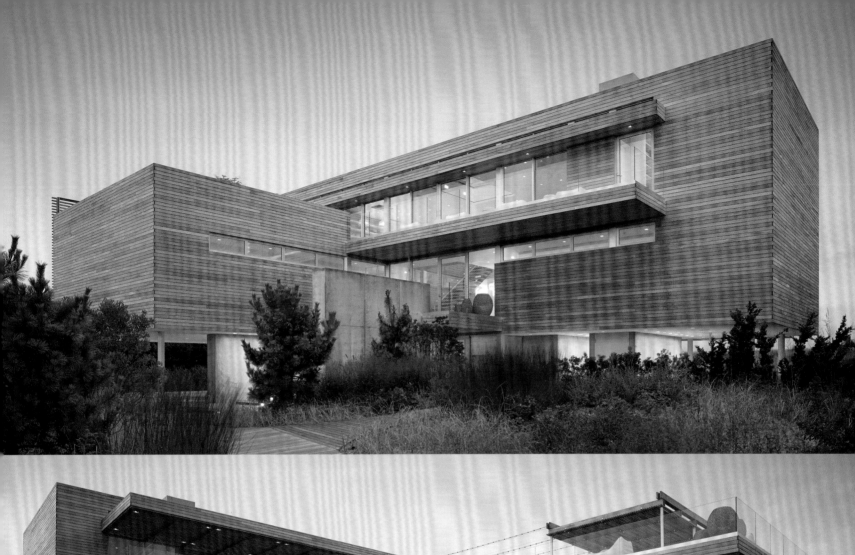
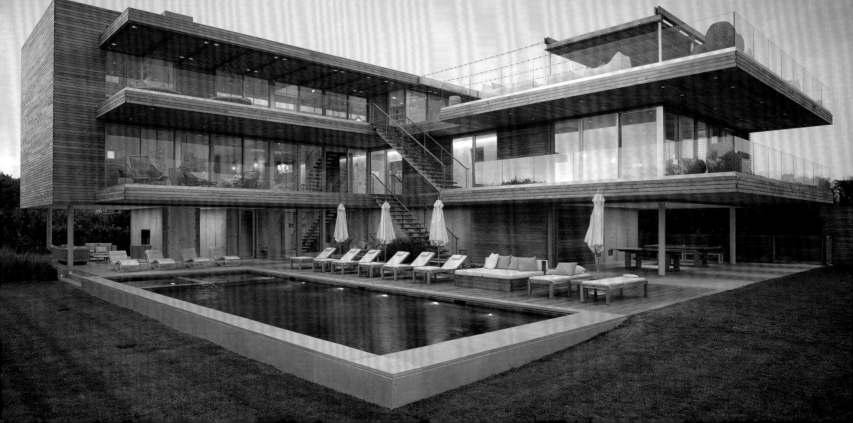

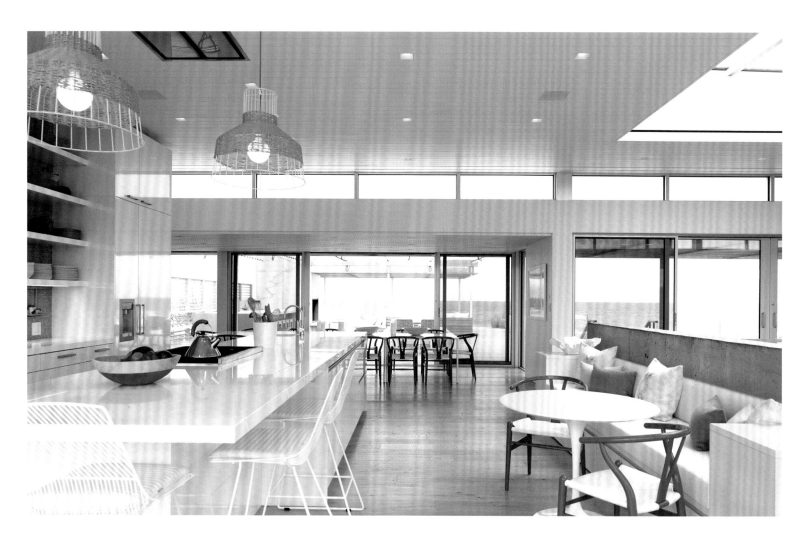

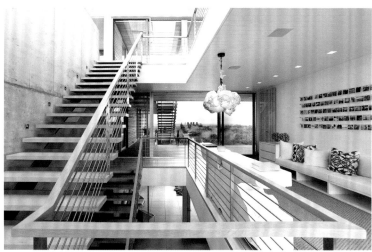

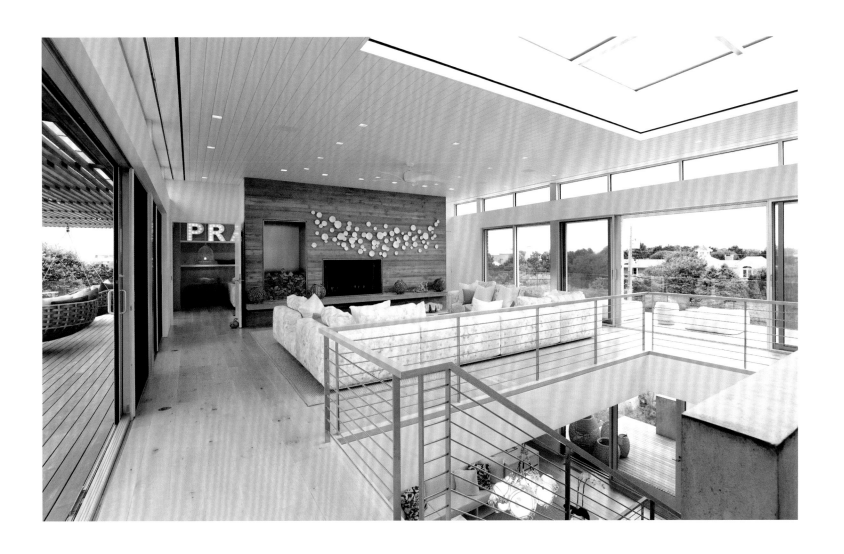

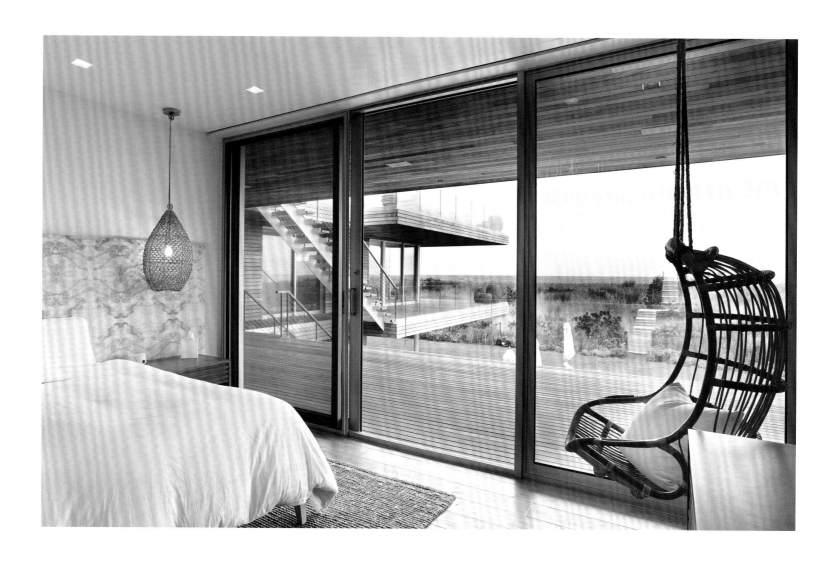

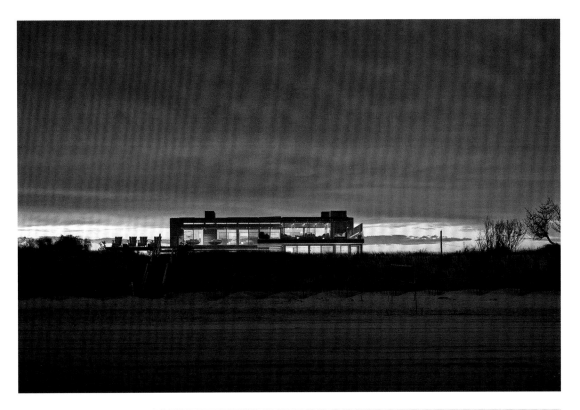

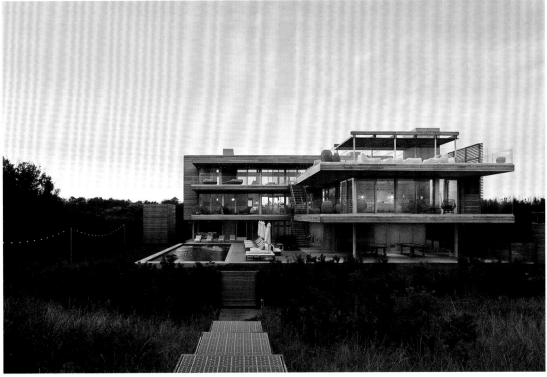

11.
FIELD HOUSE
STELLE
LOMONT
ROUHANI
ARCHITECTS

NEW YORK, UNITED STATES

House Area:
433 m²

Plot Area:
5,177 m²

Architect in Charge:
Viola Rouhani, Lucas Cowart

Project Team:
Viola Rouhani, Lucas Cowart, Toby Sherrard

Interior Designer:
Julie Hillman

Landscape Designer:
Laguardia Design Group

Photographer:
Matthew Carbone

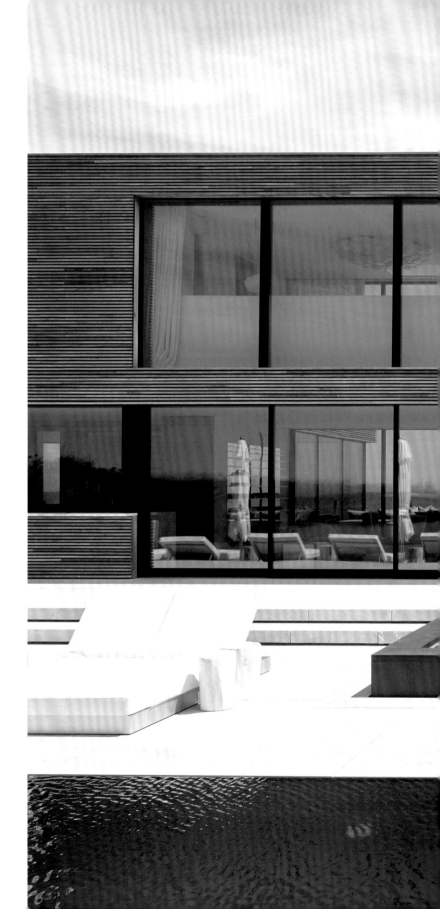

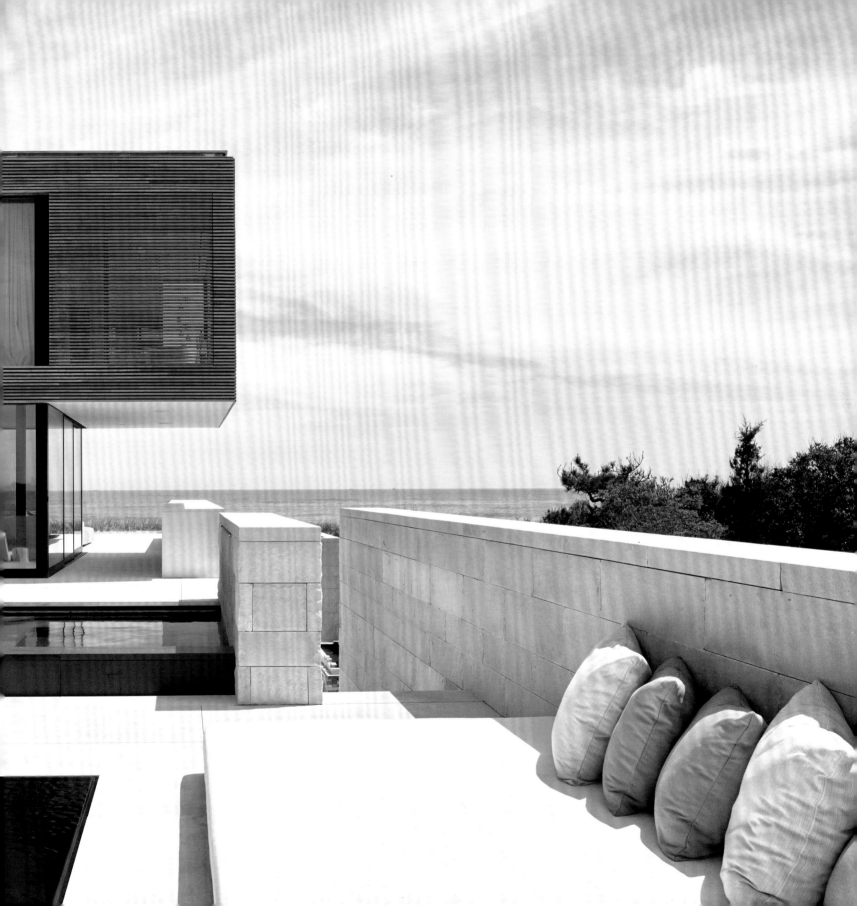

Ground Floor

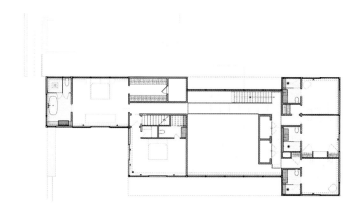

First Floor

Perched between ocean and pond, ensconced by water, Stelle Lomont Rouhani's Field House appears almost to allow its surrounding landscape to run directly through it. Acting as both an extension of its surroundings andas a shelter from it, the house is conceived with both wind and flooding in mind. Field House is constructed on piles, and is comprised of a steel frame clad in durable mahogany, with anodized aluminium-framed windows and doors, and high density limestone.

The lower level of the house opens up to a limestone-clad pool on the north-facing pondside, and to dune, grass, and ocean to the southern. Overhangs and operable screens limit heat gain during summer, but allow for the warmer rays to penetrate through in winter. The house offers a myriad of ways to experience its setting, from the 'floating' bridge in the double-height entry/living room to lower-level rooms that open up completely to become covered outdoor porches. A robust revegetation program allows the building to become an extension of the natural landscape that it inhabits.

The house is approached through a loosely terraced set of stairs, by passing the elevated pool, which at the entry level functions as a water element allowing the sound of water running over the edge to signify the arrival. Yet once up at the main level entrance, the pool and surrounding decks are screened through vegetation and low walls, providing the area privacy and an uninterrupted view out to the pond beyond. The moment of arrival at the entry takes you straight through the main space and out to the ocean ahead. The separated kitchen opens up to the pool terrace and pond view, literally with a large sliding window that allows for an old school concession counter relationship between kitchen and terrace. Throughout the lower level, limestone walls function to contain, guide, and define various areas.

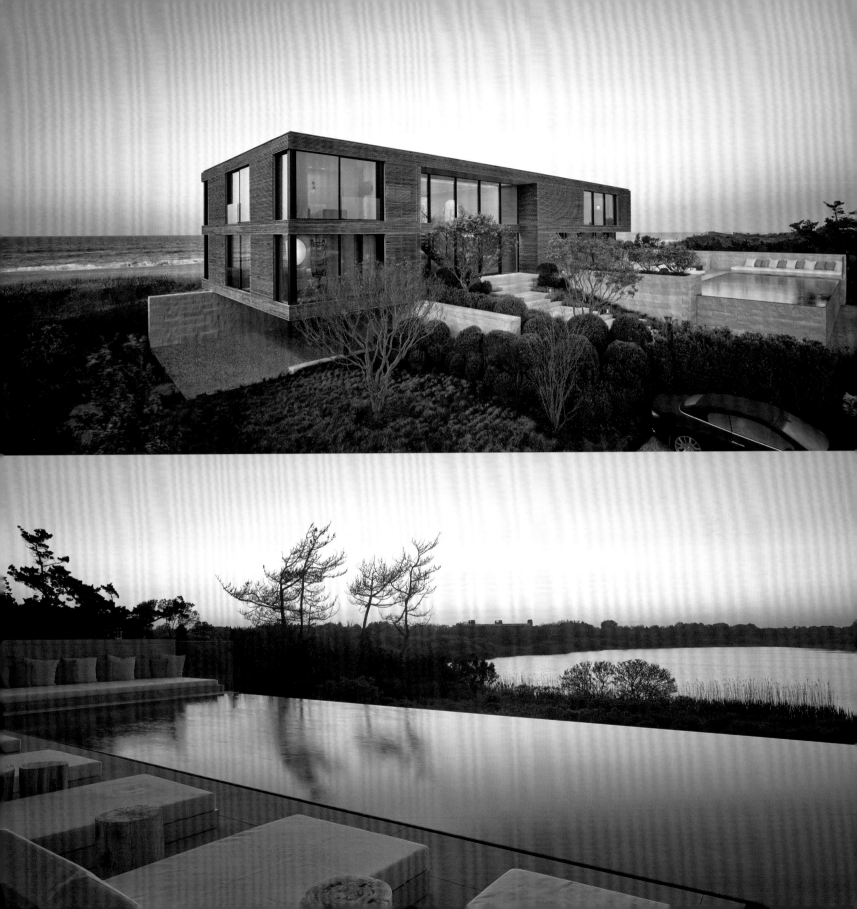

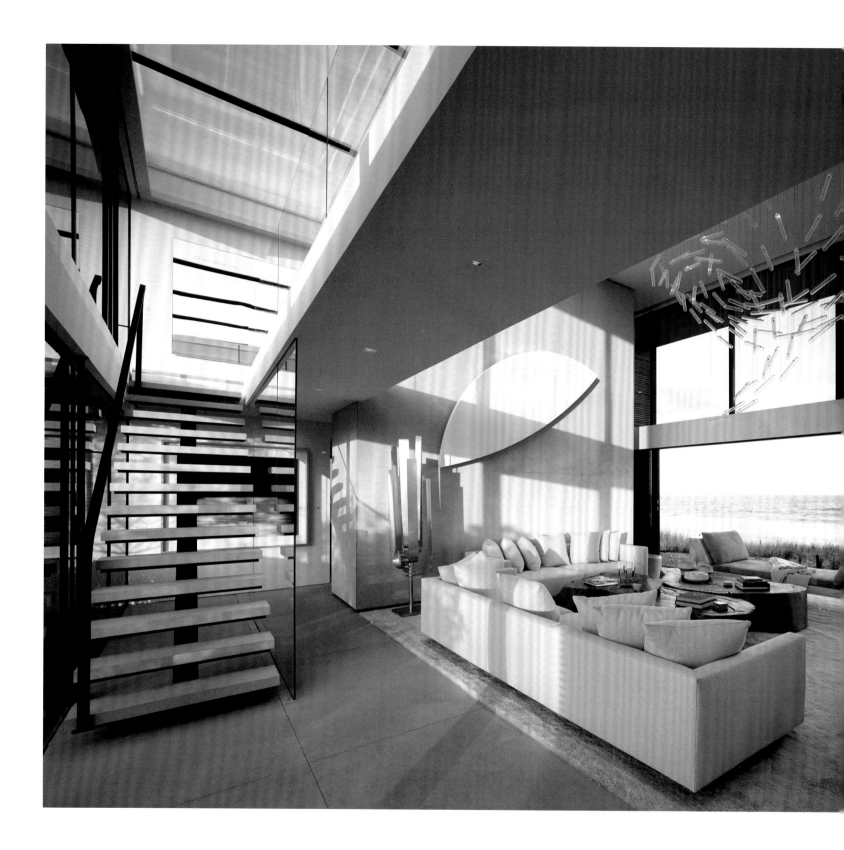

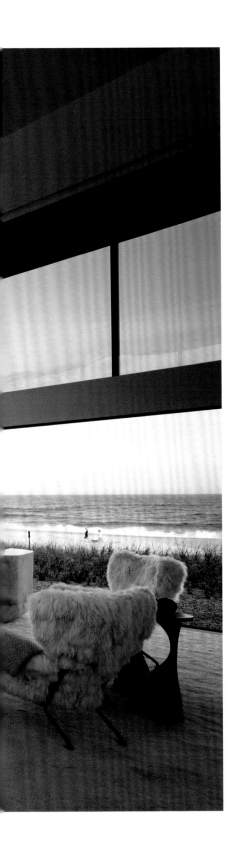

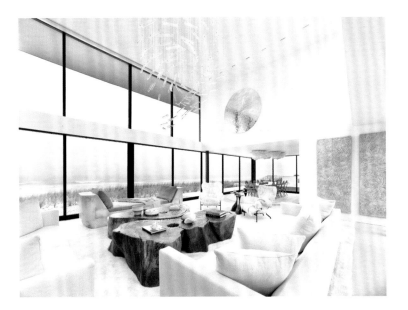

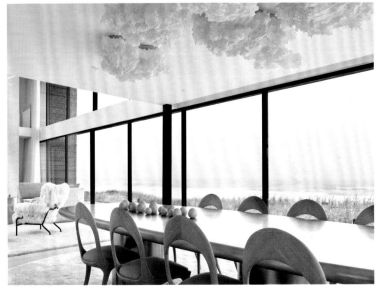

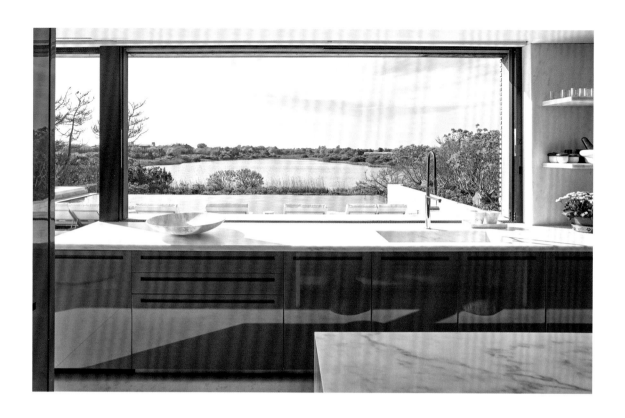

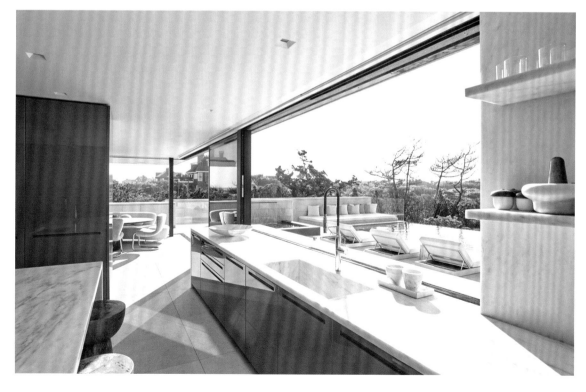

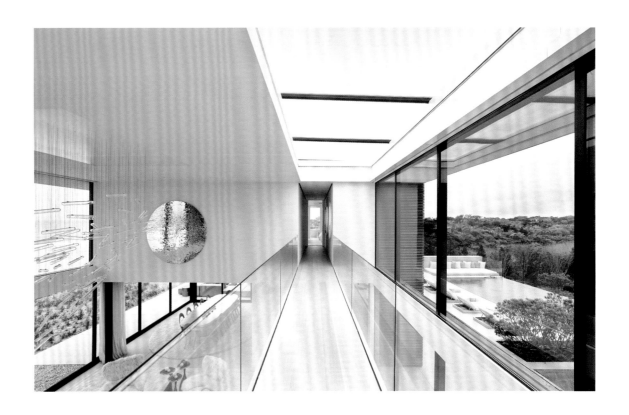

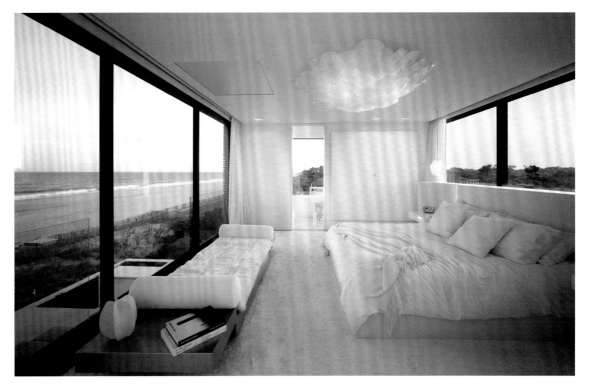

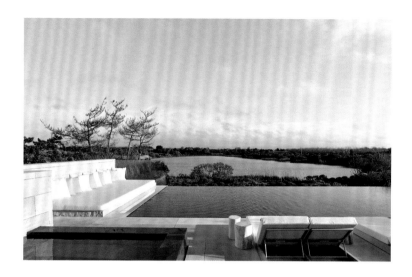

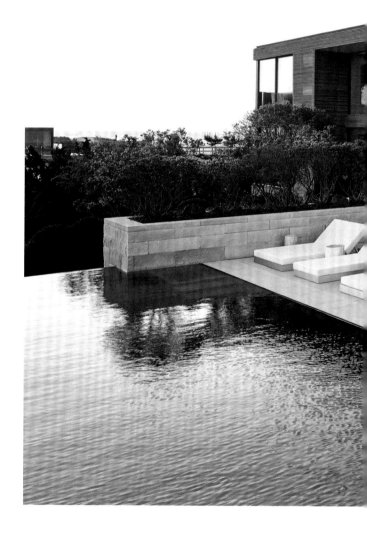

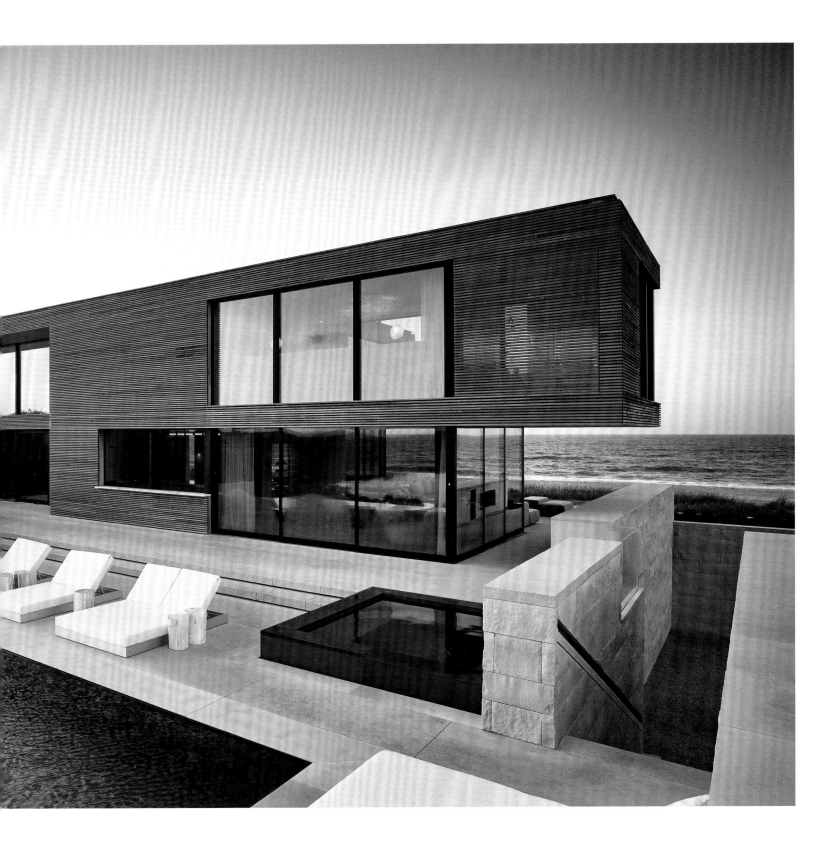

12.
BASS
RESIDENCE
[STRANG]
ARCHITECTURE

FLORIDA, UNITED STATES

House Area:
785 m²

Plot Area:
1,538 m²

Architect in Charge:
[STRANG] Architecture

Project Team:
Max Strang, Evelyn Alejo, Maria Ascoli,
Jason Adams, Adrian Heid, Benjamin Hale

Interior Designer:
Margret Marquez Interiors

Landscape Designer:
Mauricio Del Valle Design, Inc.

Photographer:
Claudio Manzoni

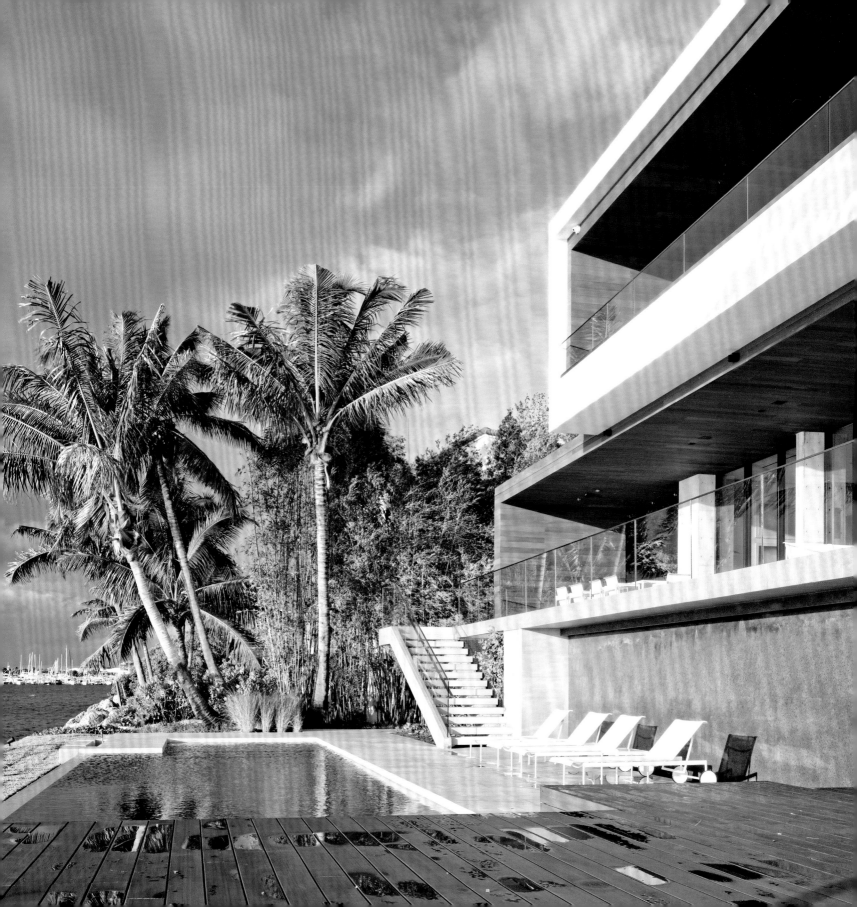

Ground Floor

First Floor

Located directly adjacent to Biscayne Bay, and immediately south of downtown Miami, [Strang] Architecture's Bass Residence underscores the firm's continued exploration of the concept of floating, rectilinear frames. Nodding in the direction of Le Corbusier's immortal Five Points of Architecture, the house utilizes aspects of free design of both the façade and ground plans, offering open, transitional, multi-purpose communal spaces.

In this case, however, the potential exposure to hurricane storm surges required that the home be raised substantially above the pre-existing grade. This wound up culminating in an impressive architectural composition, where the frame acts as a third-level volume which protrudes beyond the level below. The frame itself is offset in two different axes, while also expressing variable thicknesses. Taken together, all of these conditions allow for a playful, yet sophisticated, assemblage.

A massive pier of exposed concrete vertically penetrates and effectively anchors the home's two upper levels. This pier is accom-

panied by two smaller exposed concrete 'finns' that serve as additional structural supports. These 'finns' also effectively modulate and randomize the walls of glass facing the bay. Views of Biscayne Bay from within the home highlight and utilize the reflective qualities of the water, which echo through glass elements of the home itself, resulting in an intriguing interplay of light.

When building, the site's magnificent views were tempered by concerns of building within a 'Coastal AE Flood Zone'. As a result, the home's structural shell is built entirely of reinforced concrete and the lowest floor level is raised considerably above pre-existing grade. The panoramic waterfront views strongly influenced the organization of the spaces in the home.

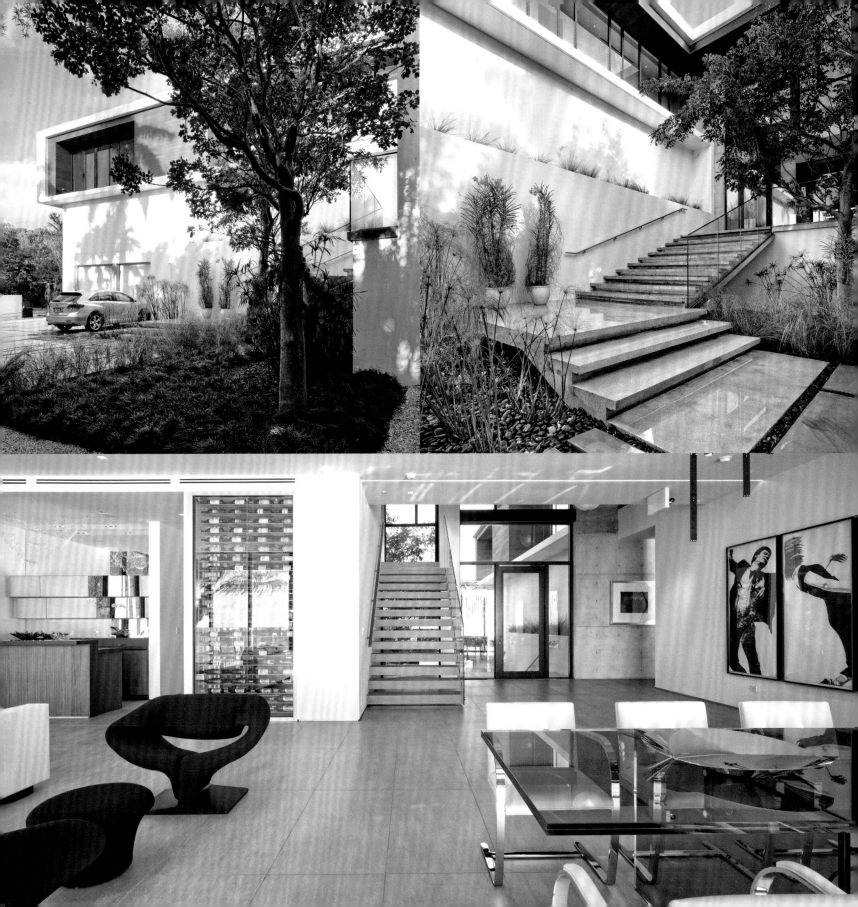

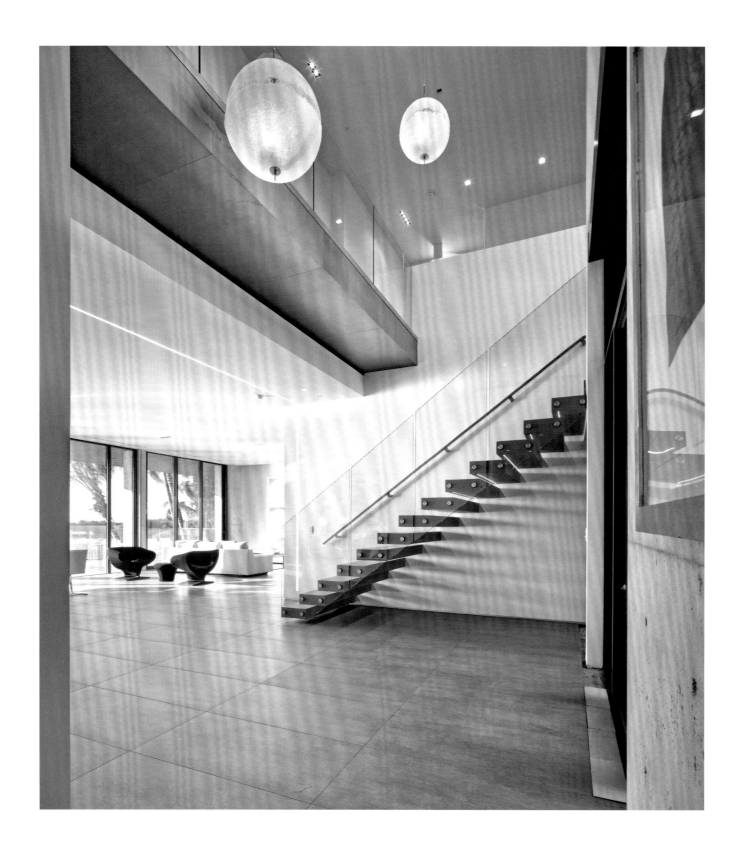

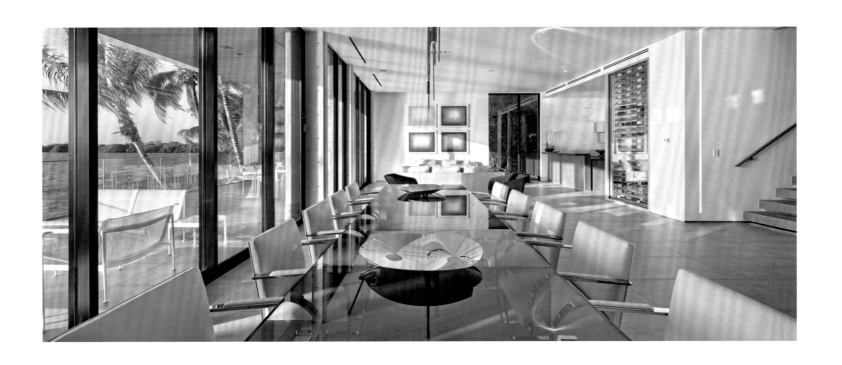

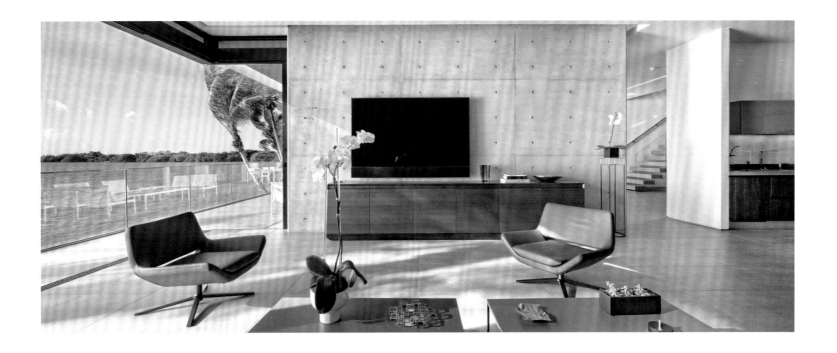

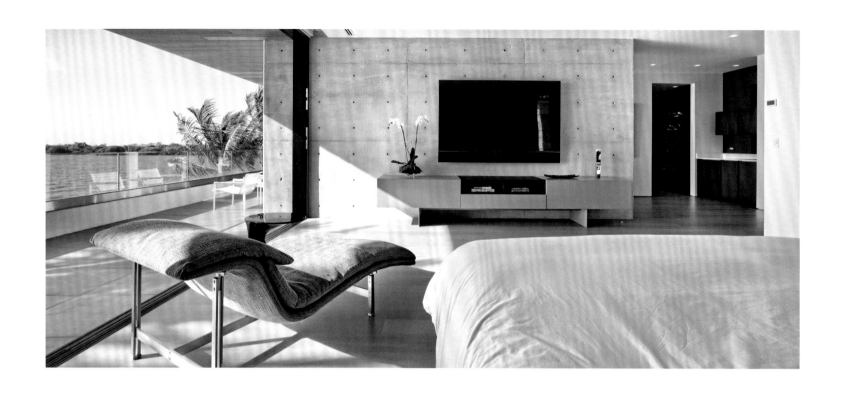

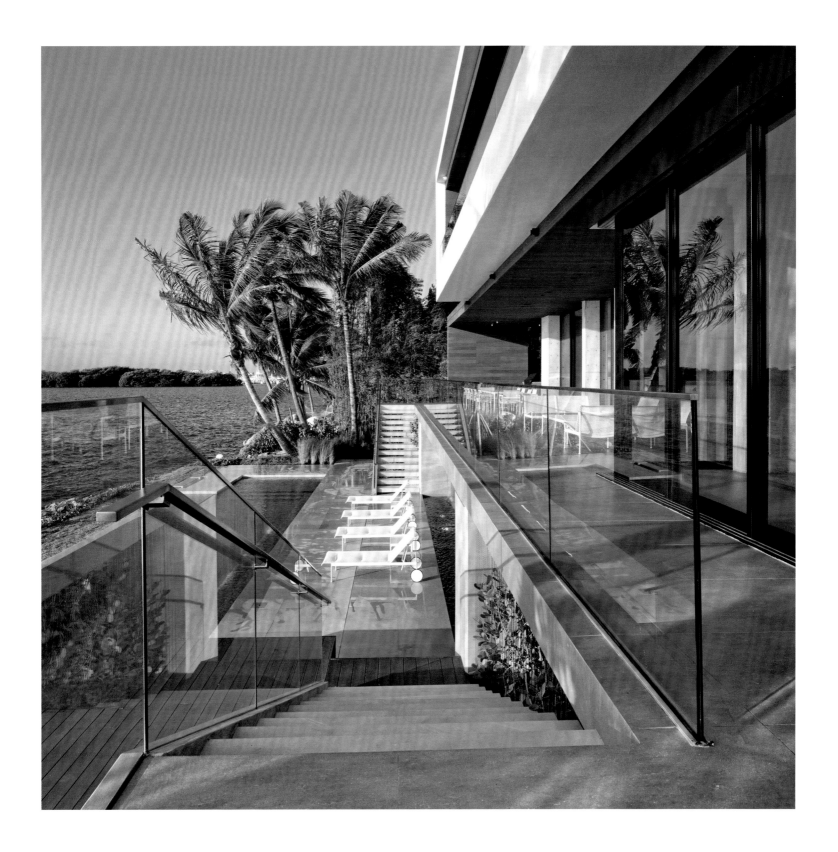

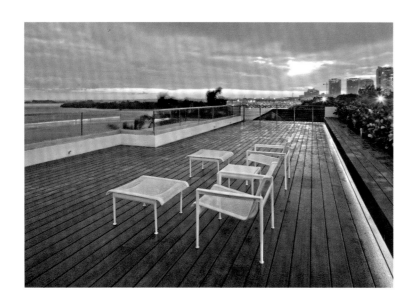

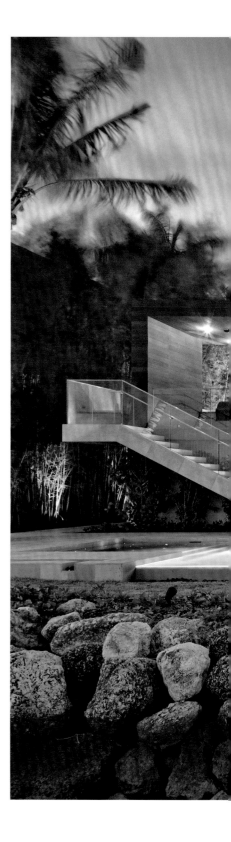

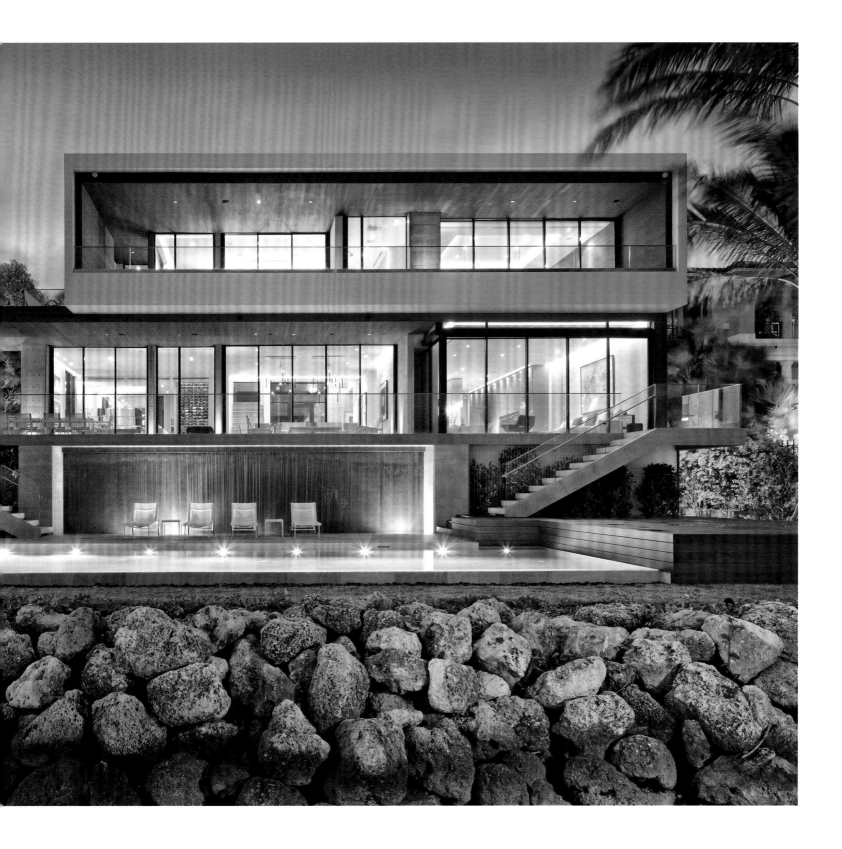

13.
MOUNTAIN LAKE RESIDENCE [STRANG] ARCHITECTURE

FLORIDA, UNITED STATES

House Area:
723 m²

Plot Area:
6,839 m²

Architect in Charge:
[STRANG] Architecture

Project Team:
Max Strang, Maria Ascoli, Evelyn Alejo

Interior Designer:
Studiofri Italiano

Landscape Designer:
Naturalficial

Photographer:
Claudio Manzoni

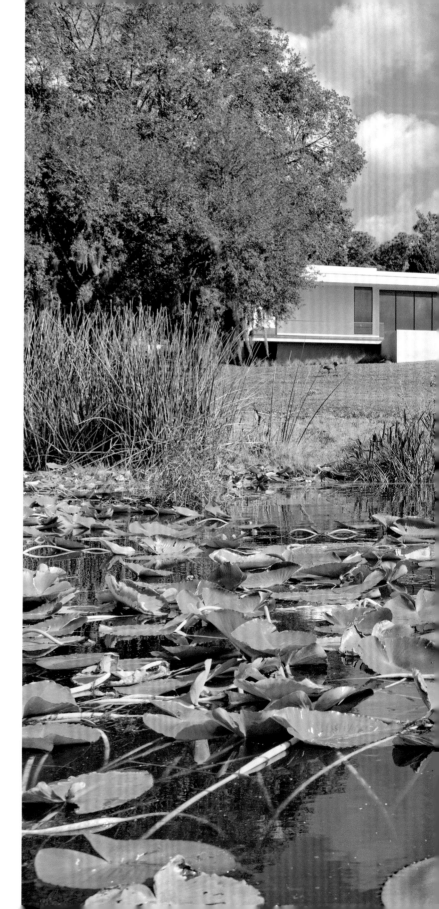

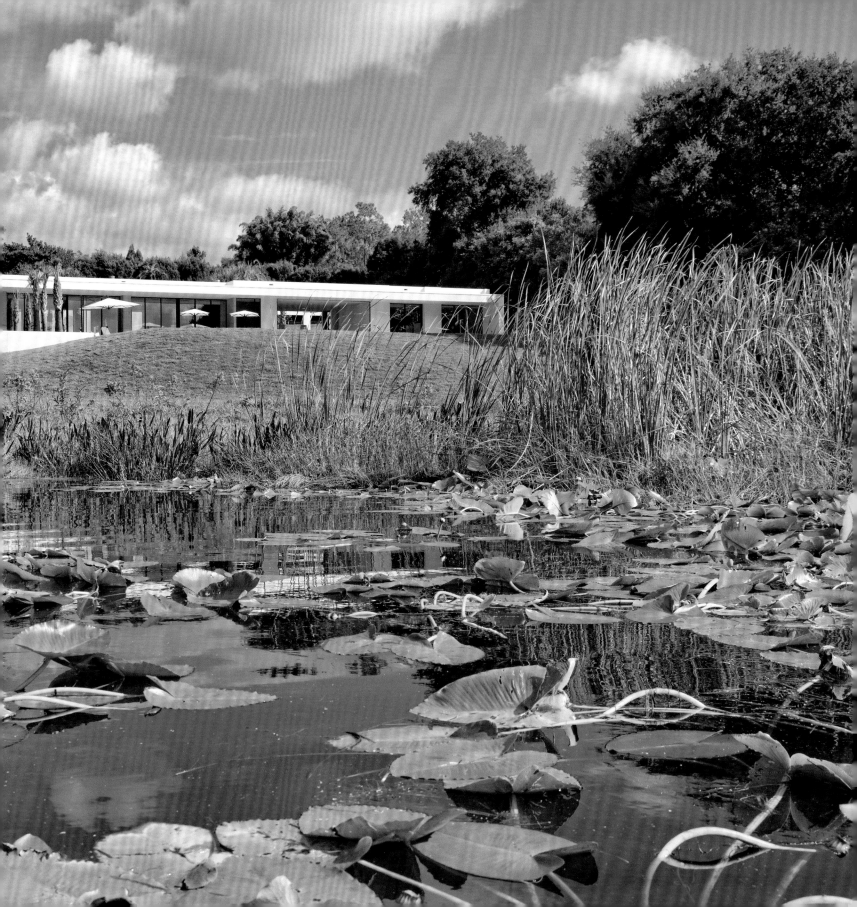

Ground Floor

Basking within bellshot of the historic Singing Tower Carillon in Central Florida's Bok Tower Gardens, the Bolsterli Residence is a sleek addition to the 'old world' enclave of Mountain Lake. This historic, resort-like community represents one of Florida's most significant collections of Mediterranean-Revival and other european styled residential architecture.

The Bolsterli Residence overlooks Mountain Lake's eponymous body of water. The house has been designed to make efficient use of its wide lot so that every significant room boasts lake views. The low-slung design continues the firm's experimentations with floating, rectilinear frames. While sharing similarities with Strang's preceding Lake House designs, the Bolsterli Residence internalizes its covered terrace and thus maintains a purer expression of the frame.

Incorporating elements of classical Floridian modernism, the house takes full advantage of the balmy local climate, boasting transitional indoor/outdoor spaces that allow communal entertainment and relaxation spaces to seamlessly blend the interior and exterior. Broad, wholly open plan dining and living spaces and double-height ceilings accentuate the house's expansive spatial dynamics, allowing for calming lake views from a variety of settings.

A wide terrace, featuring a fire pit, andan inset lap pool, seems to bring the lake directly into the house. Behind it, dining and living spaces open directly out through a wholly openable glass panel. A subtle palette of exposed concrete elements, white walls, and slate grey hardwoods, combined with modern furnishings of muted spot colours further highlight the crystalline waters and lush surroundings.

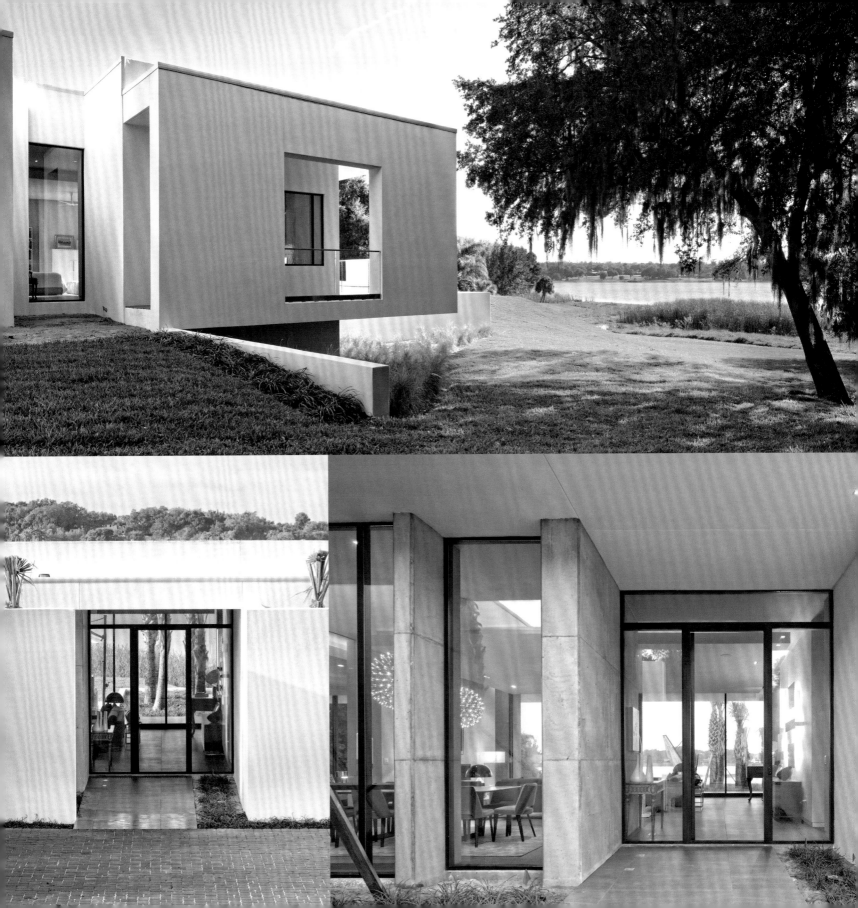

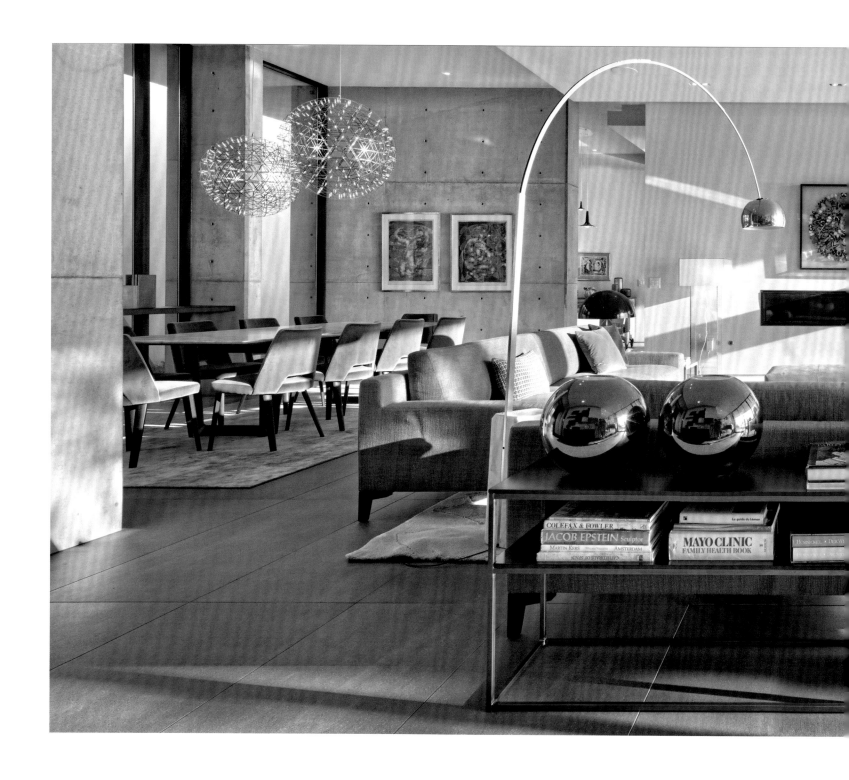

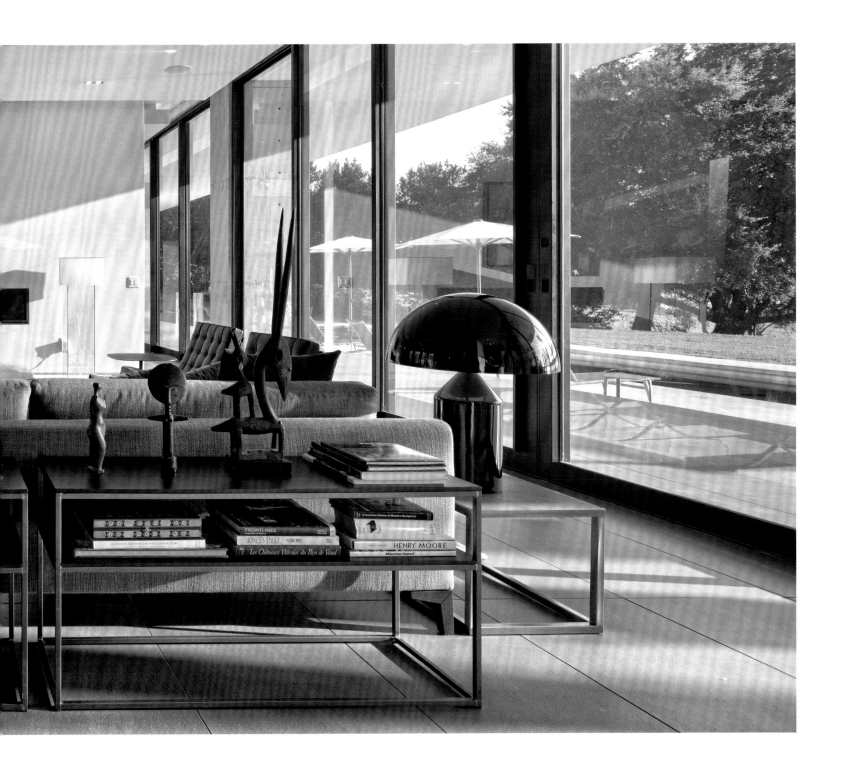

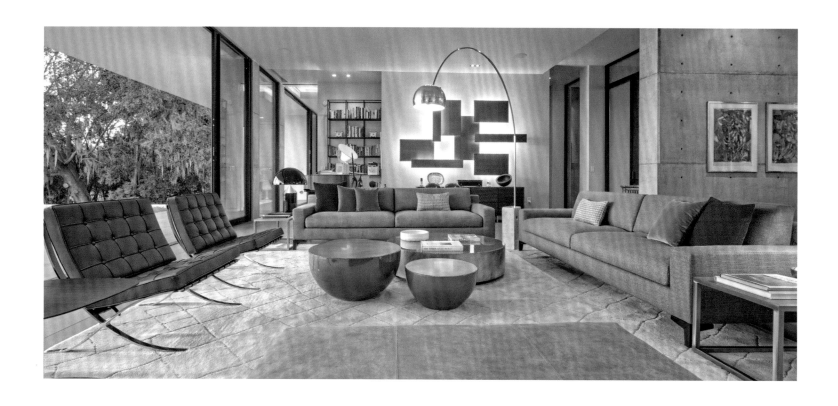

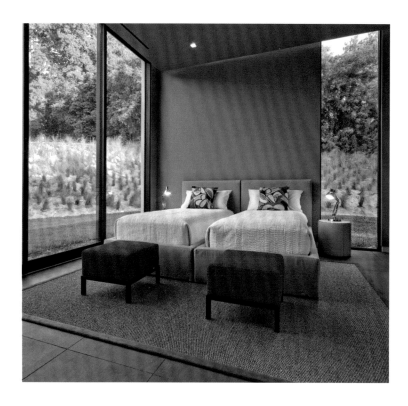

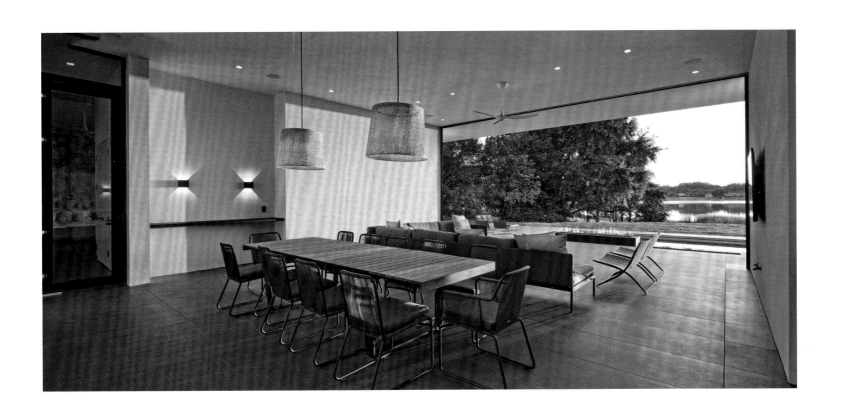

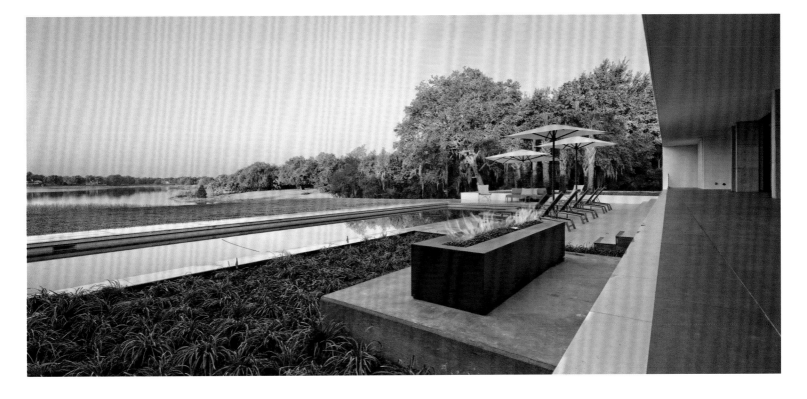

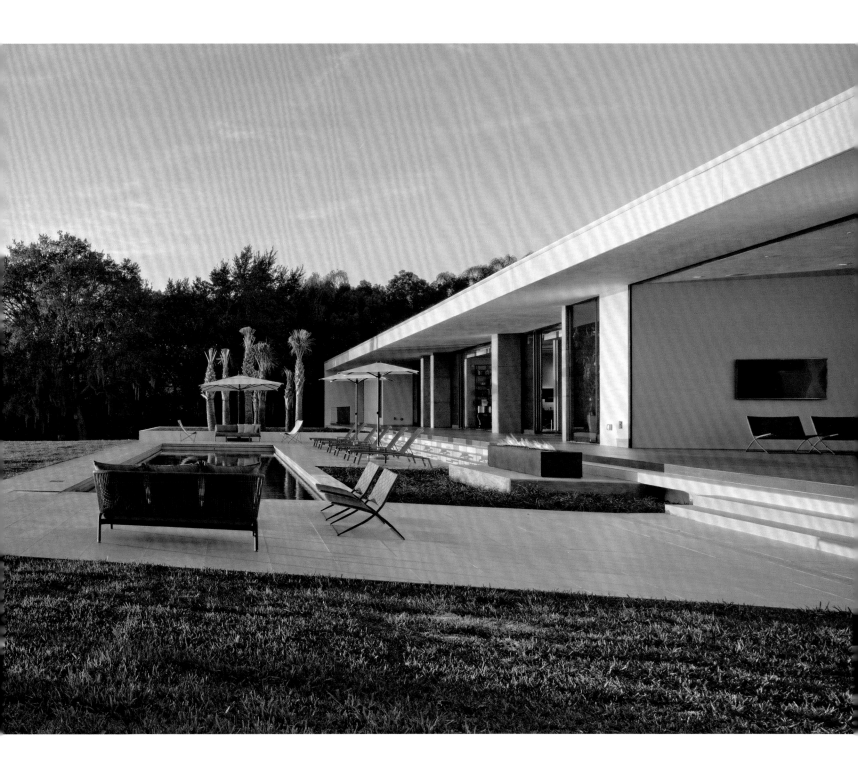

CENTRAL & SOUTH AMERICA

CAL HOUSE | BAAQ'

OCEAN EYE | BENJAMIN GARCIA SAXE

GUNA HOUSE | PEZO VON ELLRICHSHAUSEN

PARAVICINI HOUSE | CRISTIAN HRDALO

BAHIA AZUL HOUSE | FELIPE ASSADI + FRANCISCA PULIDO

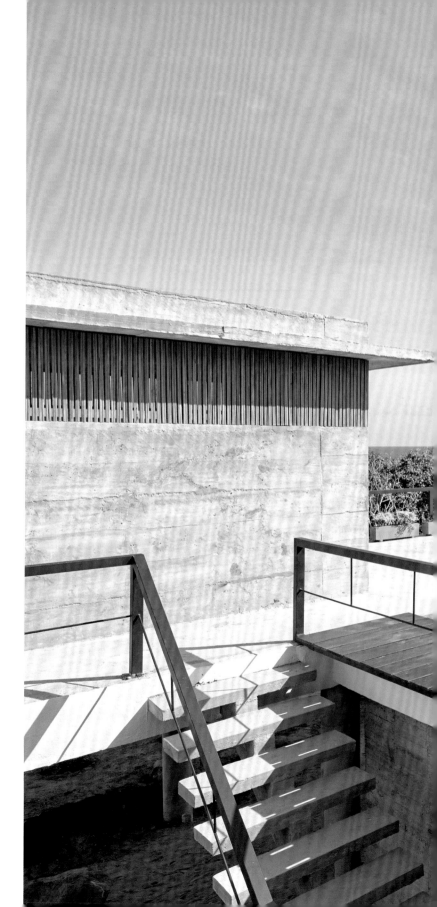

14.
CAL HOUSE
BAAQ'

OAXACA, MEXICO

House Area:
250 m²

Plot Area:
380 m²

Architect in Charge:
José Alfonso Quiñones

Project Team:
Inca Hernández, Daniel Barragan

Interior Designer:
DECADA - Lucia Corredor / Cecilia Tean

Landscape Designer:
Alejandro Sangines

Photographer:
Edmund Sumner

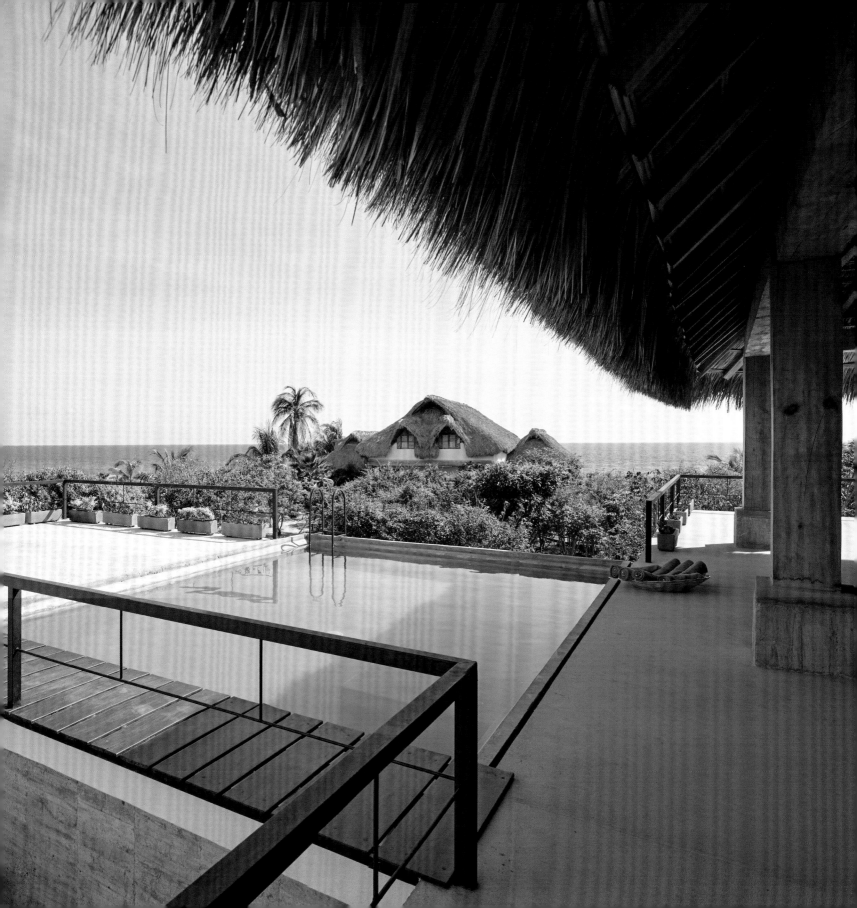

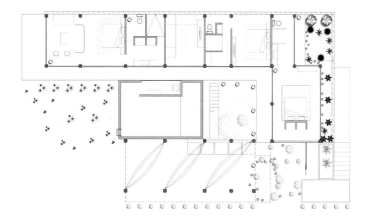

Ground Floor

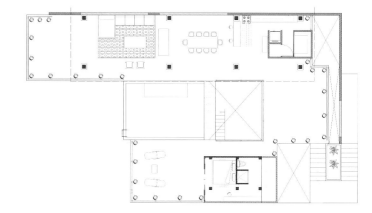

First Floor

Casa Cal belongs to a coastal community of 8 houses in an area near the mexican surf Mecca Puerto Escondido, in Oaxaca. BAAQ' took the already built foundations as a primer for this new build. The build site presented certain challenges; the view to the ocean from the ground floor was completely blocked by other houses, and the second floor could manage only partial views between the roofs of the other houses, as well as an unfettered view to the east.

Ultimately, BAAQ's design strategy was to place bedrooms and private quarters on the ground floor, and social areas on the second floor. The north and west elevations are flanked by a 5 metre white wall, decorated with locally handmade parametric lattice-work, which neutralizes strong sea winds, directing them through louvered carpentry opposing the external wall, which cools down the private spaces, allowing for comfortable temperatures inside the house without the use of air conditioning systems.

The wall also provides privacy, blocking the view from the common areas and paths ofthe community to the house's social area,

while enhancing the view towards the ocean, this gesture gives the project two contrasting façades, one totally open and the other totally closed. The roof is crafted in traditional Palapa style, which was made by local artisans with wood and palm leaves.

The pool is structured as an independent concrete cube inserted in the middle of the house, sub-dividing two patios on the ground floor. Additionally, a small studio was built on the top floor away from the palapa, designed as a cube but made of palm bones (stems) forming louvers, giving a sensation of light.

Casa Cal's materiality and design proves a fascinating and enlightening articulation of both traditional Mexican residential architectural strategies and contemporary tropical architecture, culminating in a sublimely subtle residence.

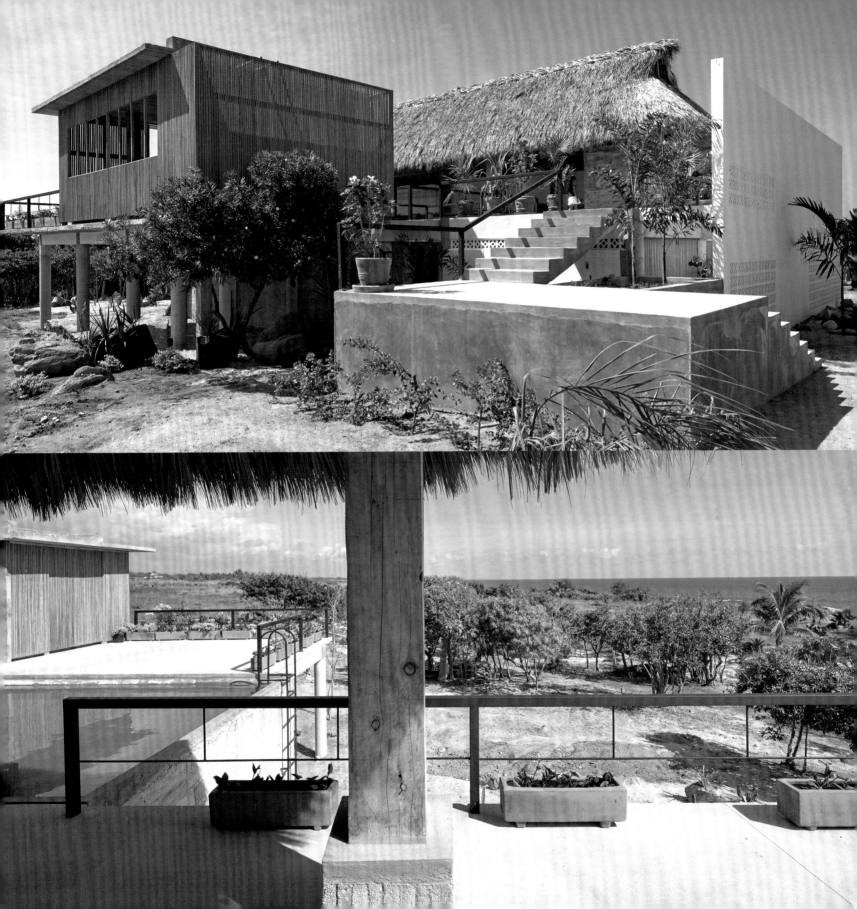

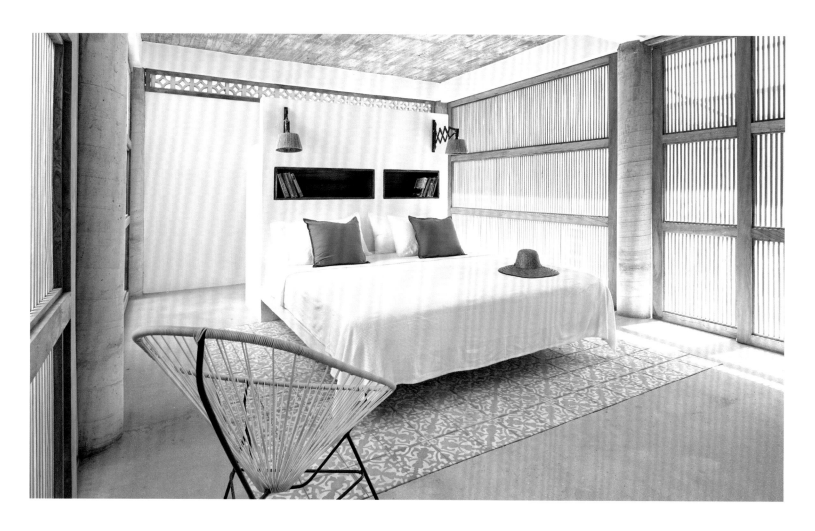

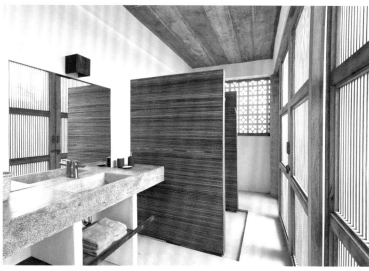

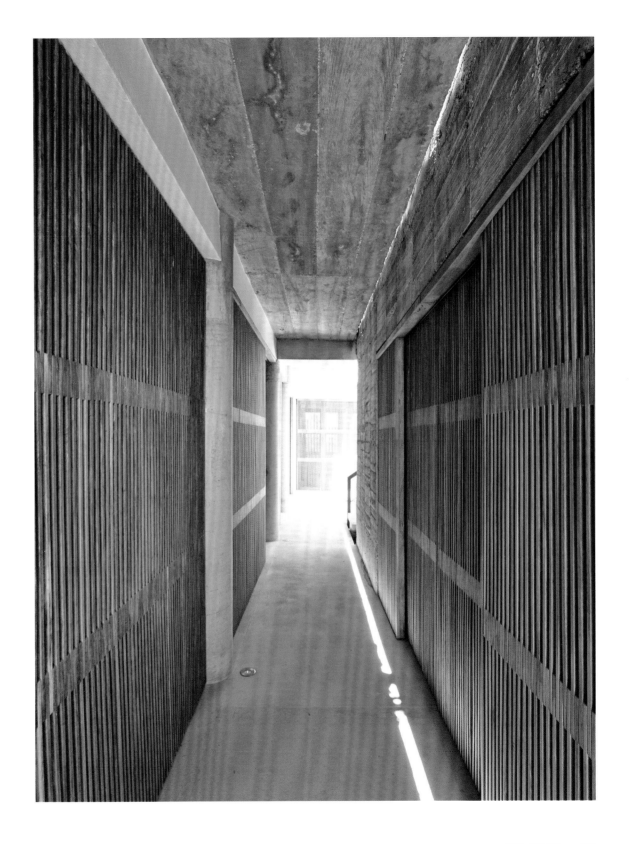

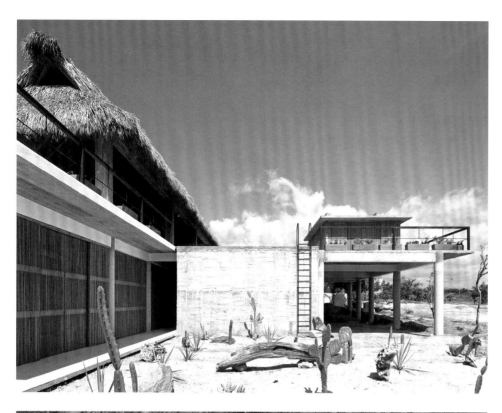

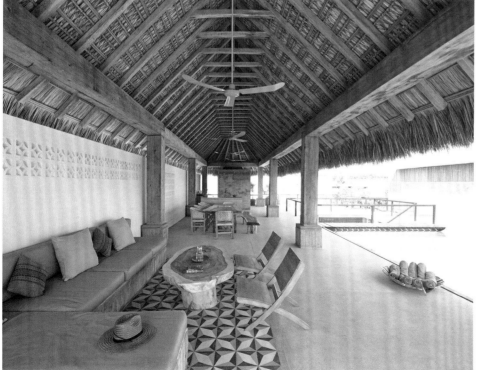

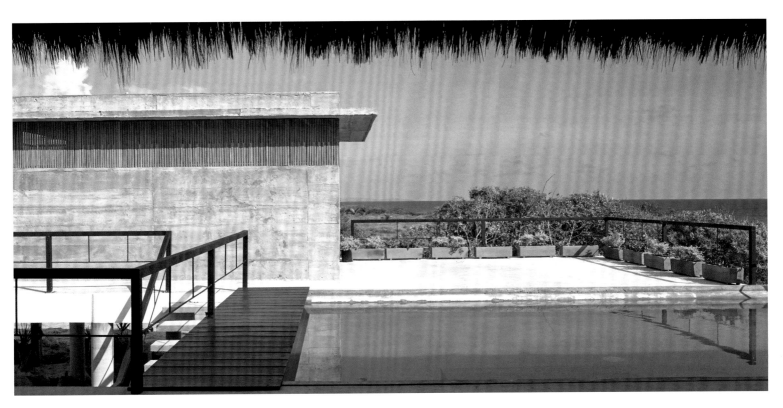

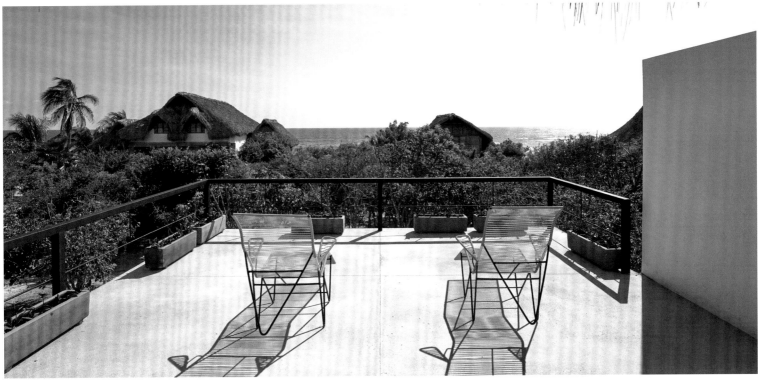

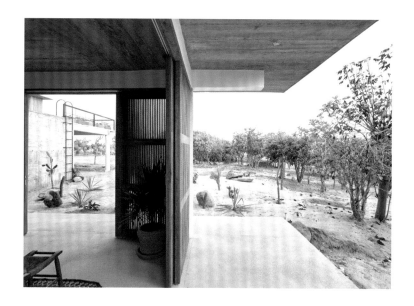

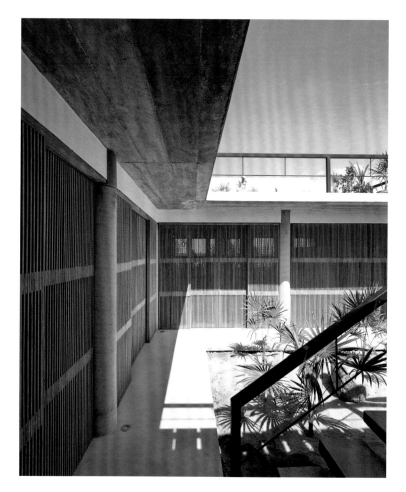

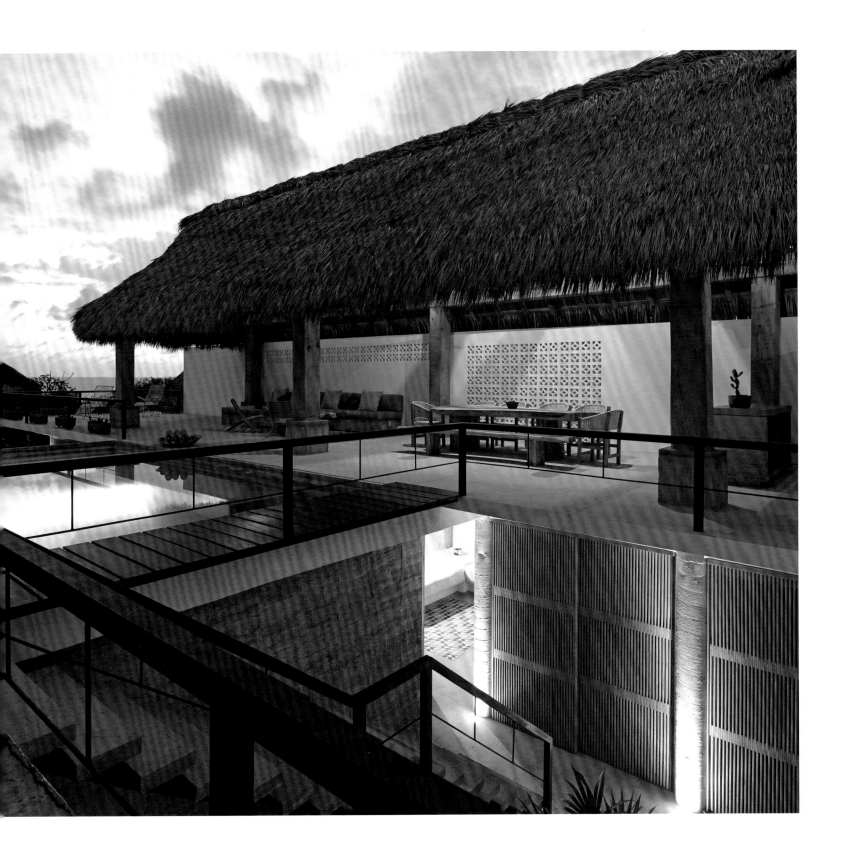

15.
OCEAN EYE
BENJAMIN
GARCIA SAXE

PUNTARENAS, COSTA RICA

House Area:
300 m²

Plot Area:
350 m²

Architect in Charge:
Benjamin Garcia Saxe

Project Team:
Cesar Coto, Rogelio Quesada,
Alejandro Gonzalez, Maribel Mora

Interior Designer:
Benjamin Garcia Saxe

Photographer:
Andres Garcia Lachner

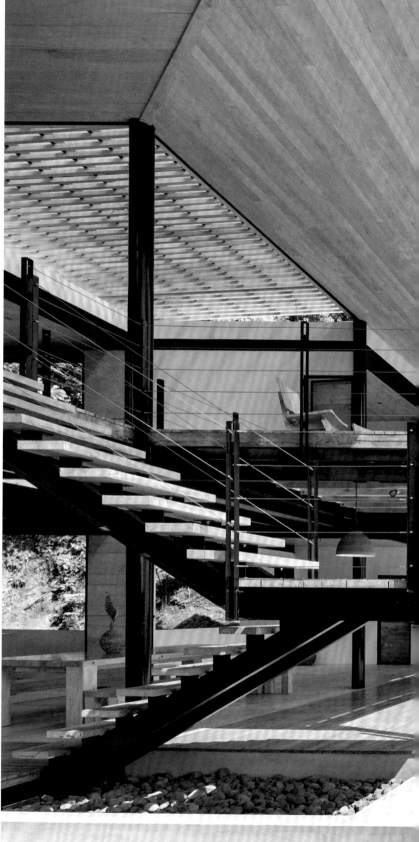

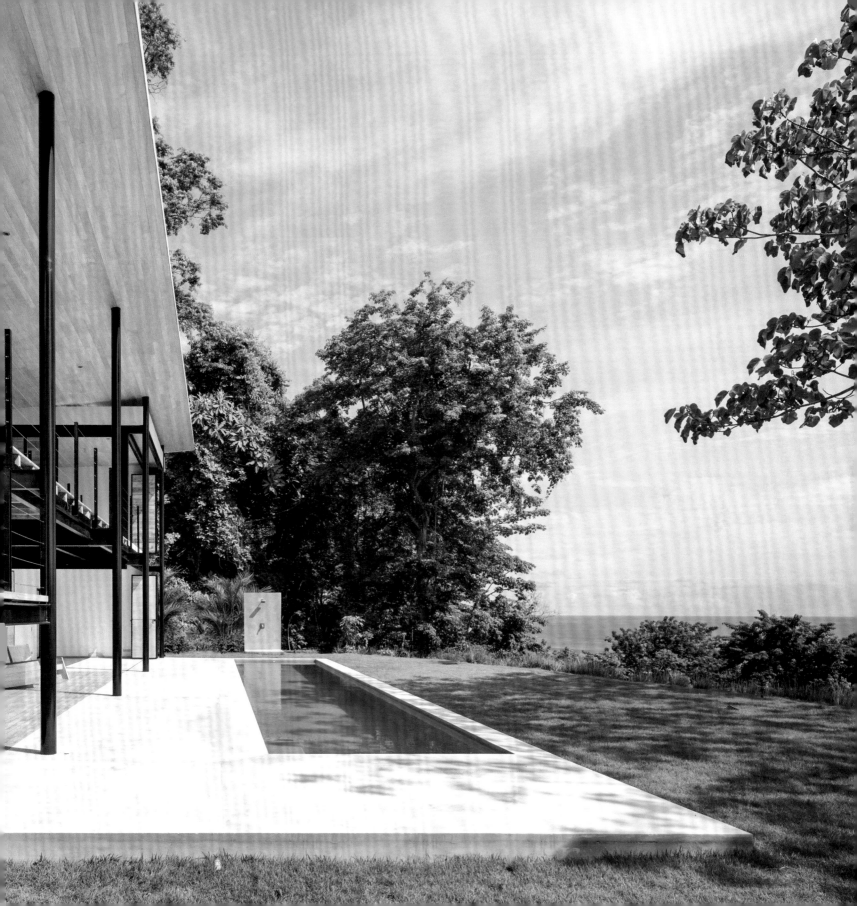

Ground Floor

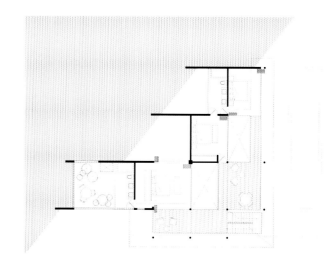

First Floor

Benjamin Garcia Saxe's Ocean Eye is blessed by a site awash in natural beauty, which boasts two distinct and breath-taking views: towards the ocean and out into the jungle. The structure itself has been situated against the back of the site's steep hill, in order to stabilize the soil and protect the house from falling debris.

Staunchly adhering to Corbusian modernist tenets, the structure's ocean-facing elevation manifests as an entirely open-air space, covered by a massive pilotis-raised, overhanging roof. Ocean Eye is a pure distillation of indoor/outdoor tropical modernism; an almost wholly outdoor house that boasts entirely open living spaces in their purest possible form.

Centred around an extra high, dual level open terrace which links an open-air ground-level seating area, dining area, kitchen, bathing area, and possible guest bedroom (the latter of which can be made private through a custom system of sliding wooden panels. The upper floor boasts multiple floating seating terraces and an open master bedroom, all surrounding a recessed area below a

louvred portion of the roof, which allows for sunlight on the lower dining area.

The house then transitions from a more solid and intimate construction at the back that holds bedrooms and bathrooms, towards a lightweight and ephemeral structure that points to the visual collapse of the ocean and jungle views.

The cumulative result manifests as a series of interwoven terraces that relate to each other in all dimensions, creating not only an internal dynamic interaction between levels, but also varied and sometimes unexpected relationships between the inhabitants and the natural landscape. In these interstitial terrace spaces, which are never truly inside or out, architecture comes to foster the relationship, enjoyment, and appreciation of the natural world by its inhabitants.

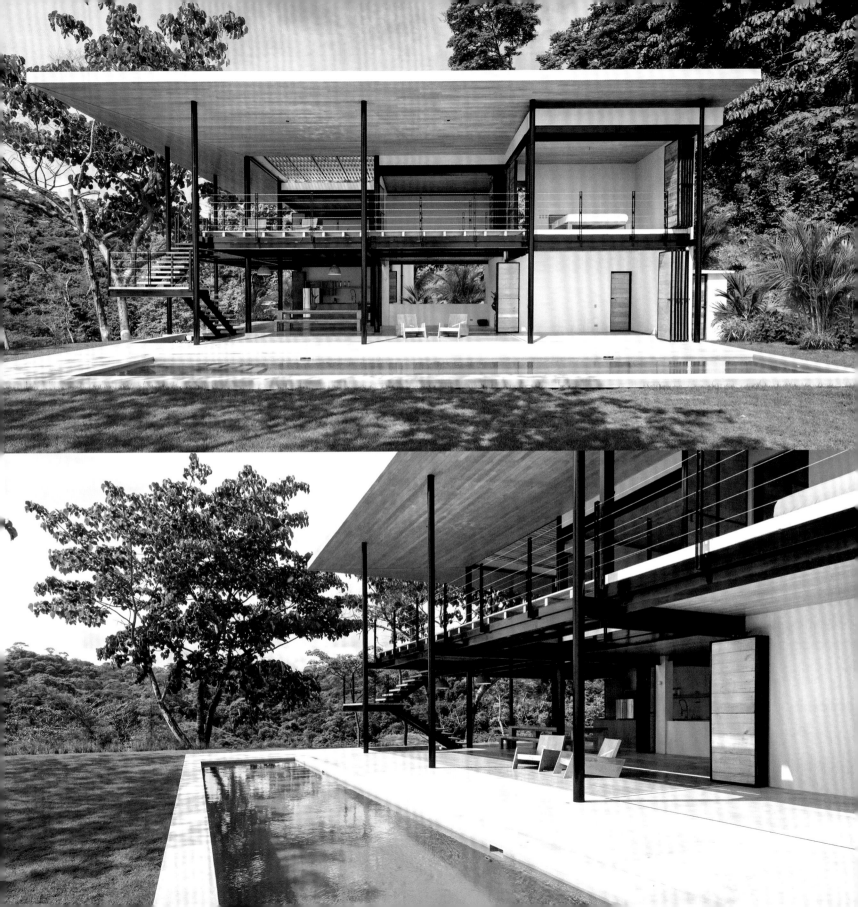

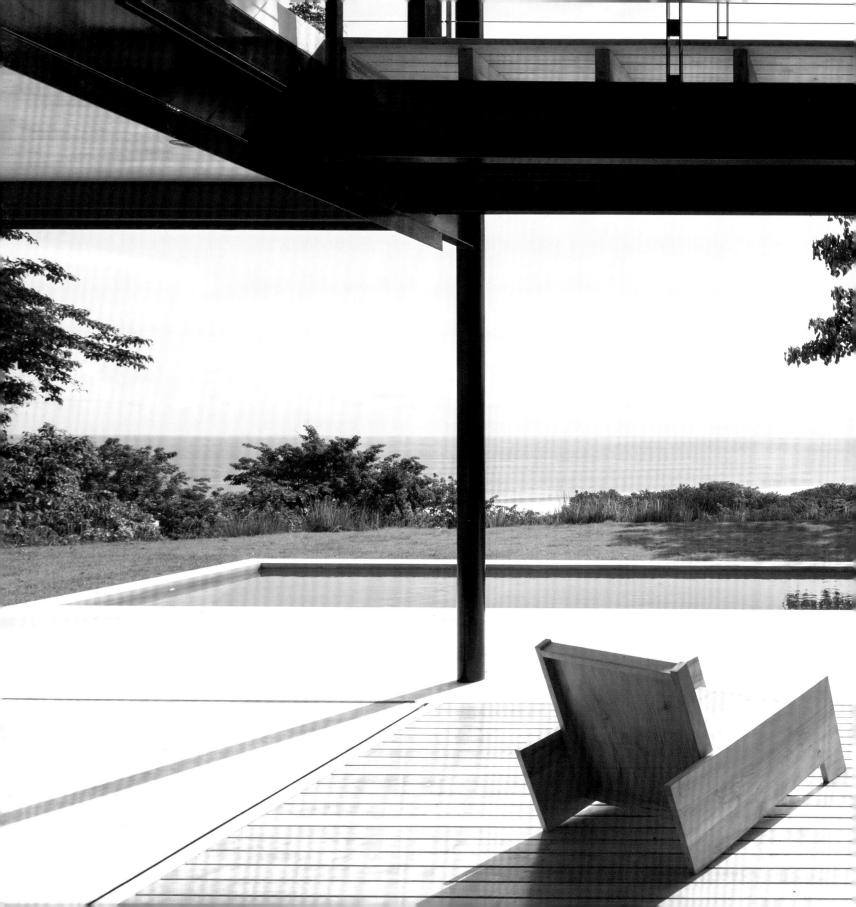

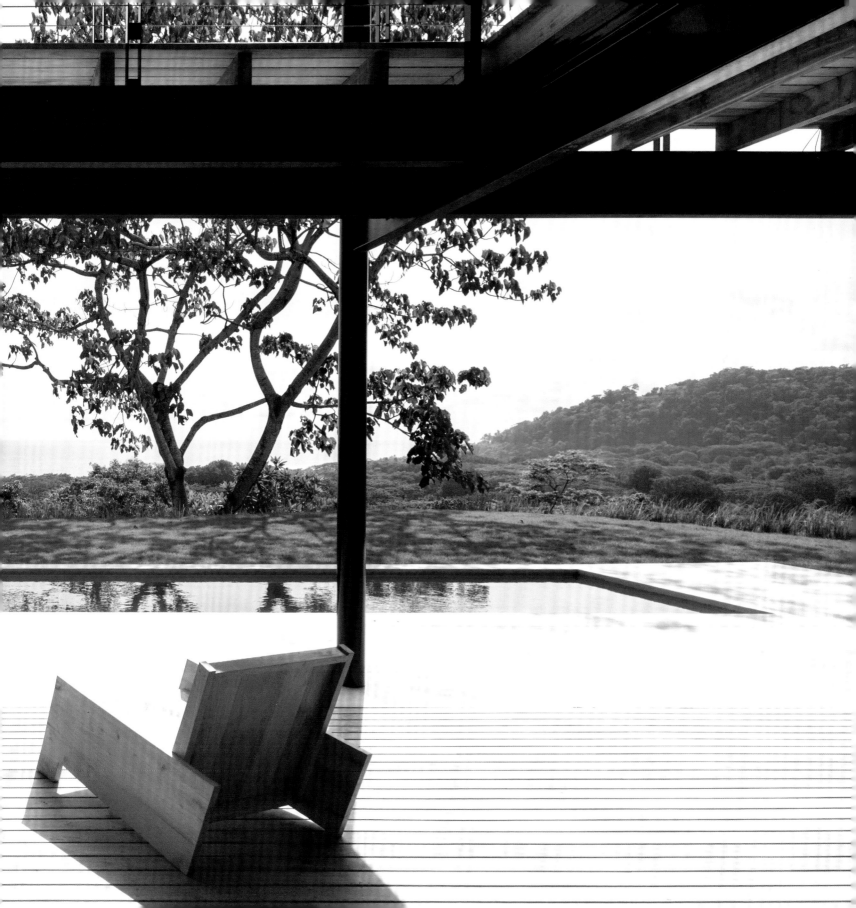

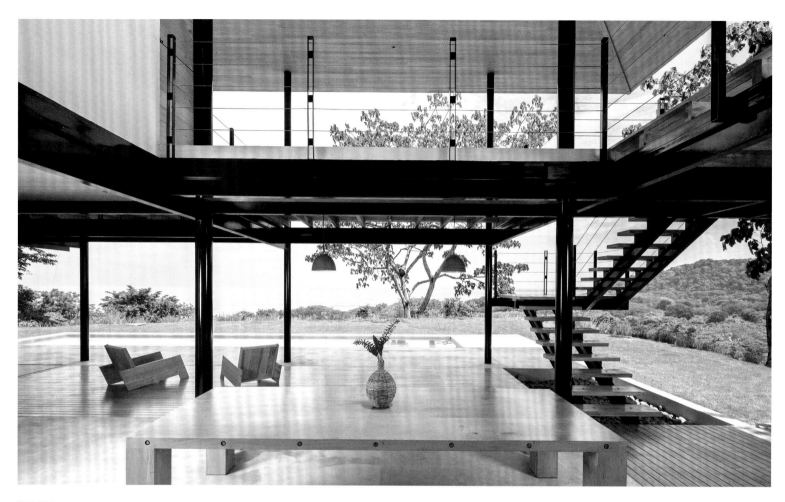

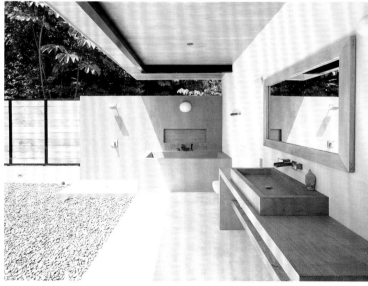

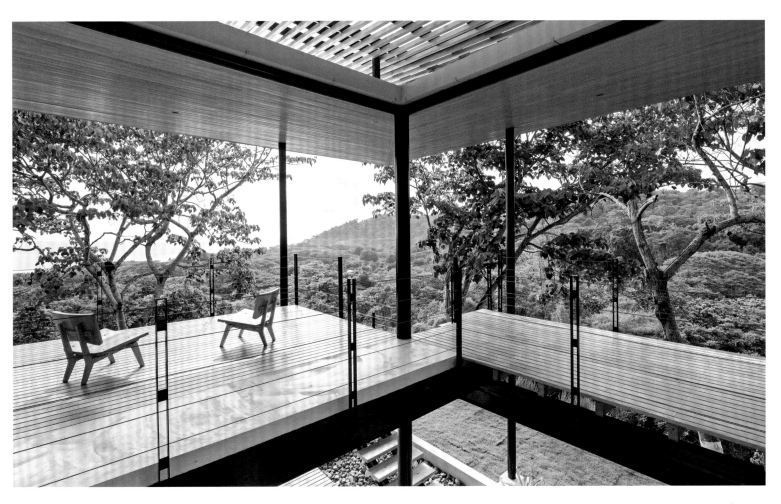

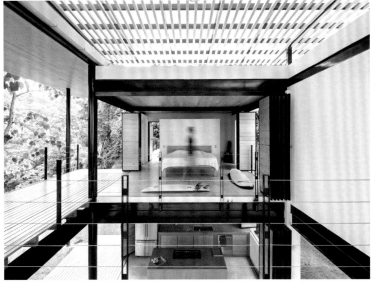

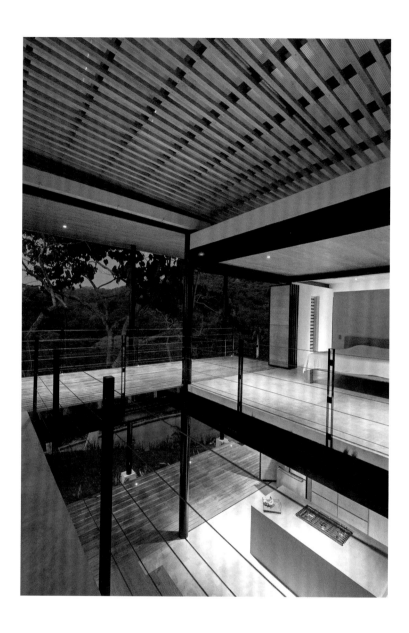

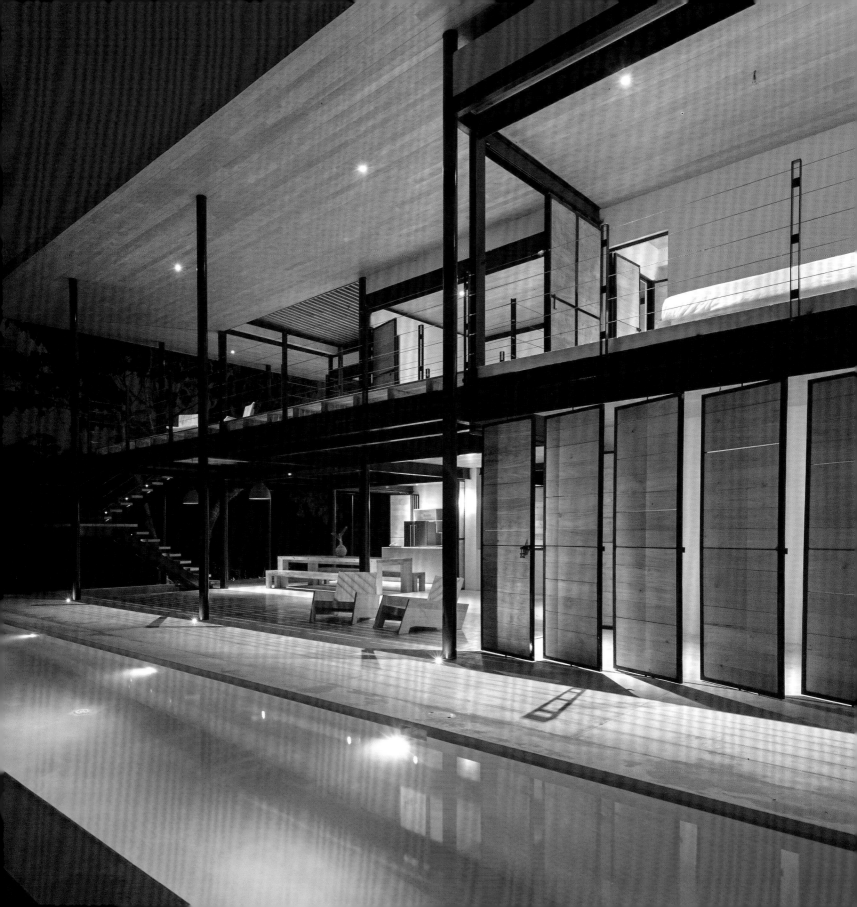

16.
GUNA HOUSE
PEZO VON ELLRICHS-HAUSEN

SAN PEDRO DE LA PAZ, CHILE

House Area:
410 m²

Plot Area:
3063 m²

Architect in Charge:
Mauricio Pezo, Sofia von Ellrichshausen

Project Team:
Diogo Porto, Joao Quintela,
Lena Johansen, Cecilia Madero

Photographer:
Pezo von Ellrichshausen

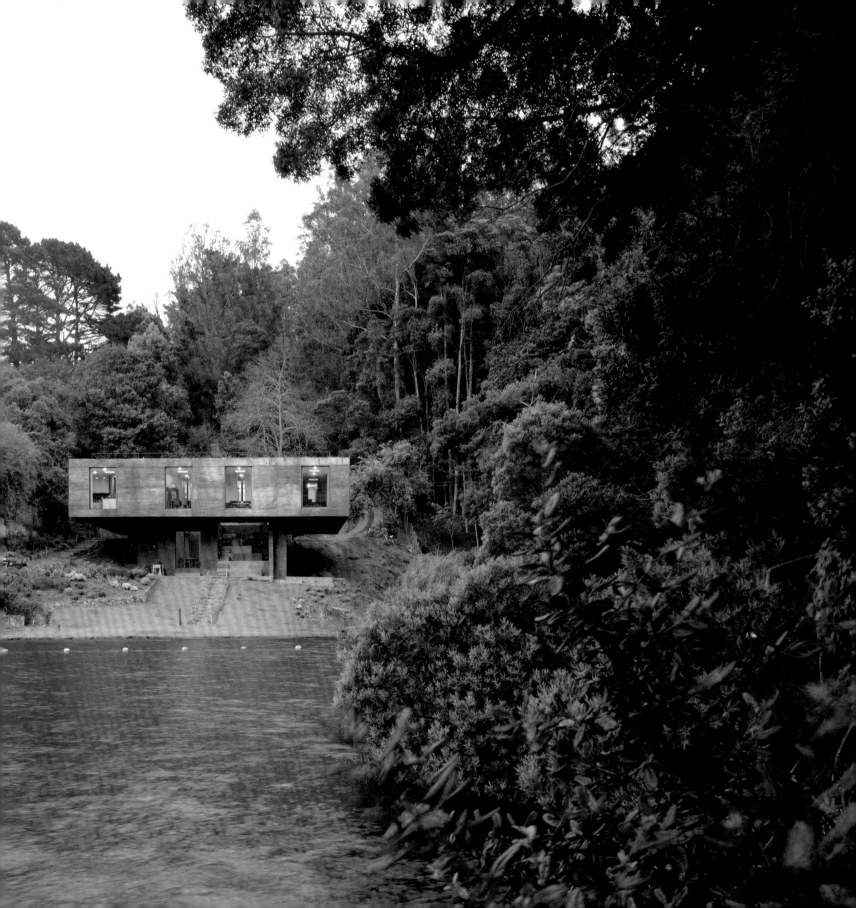

Ground Floor

First Floor

Hemmed in between a steeply sloping hillside and a wood of eucalyptus trees, the narrow plot of land compels one to cross the garden to arrive, descending at the apexofa small bay of a lagoon. Overlooking the landscape, a monolithic prism of concrete attempts to articulate the contradictions of the topography with a square top floor measuring 20mon each side, balanced on top of a compact bottom floor measuring 8.5m on each side.

Essentially a cantilevering single storey house, perched above a smaller, largely open-air communal viewing area, the upper floor boasts a central patio identically sized to the bottom floor. As such, all the suspended rooms are exposed to the outside by the four sides of their section. This upper floor, a dogmatic piano nobile that compensates for the inconvenience of the diagonally set natural terrain slope, is based on a grid of four modules per side. The middle rooms on each side face directly onto the central patio.

Overhead apertures in the centre of each enclosed space andat the ends of the circulation paths reinforce the vertical dimension of the layout, and also amplify the shimmering of the pond water. Less formal, the bottom floor house the more day-to-day-functions of the domestic realm; its square plan divided into four equal quadrants is cut back in the north corner, a subtraction that serves as a visual and functional short cut between the upper patio and the edge of the lagoon.

Matila Ghyka's described landscapes as a 'crystallization of a conflict of forces'. This house responds to that statement by manifesting the entire structure as a stony mass inapparent repose. The four walls of the patio act as Vierendeel girders, resting in balance on the podium. Almost as if they were diffusing the stress, the concrete surfaces have the coarse texture of fine formwork boards with a diluted black patina.

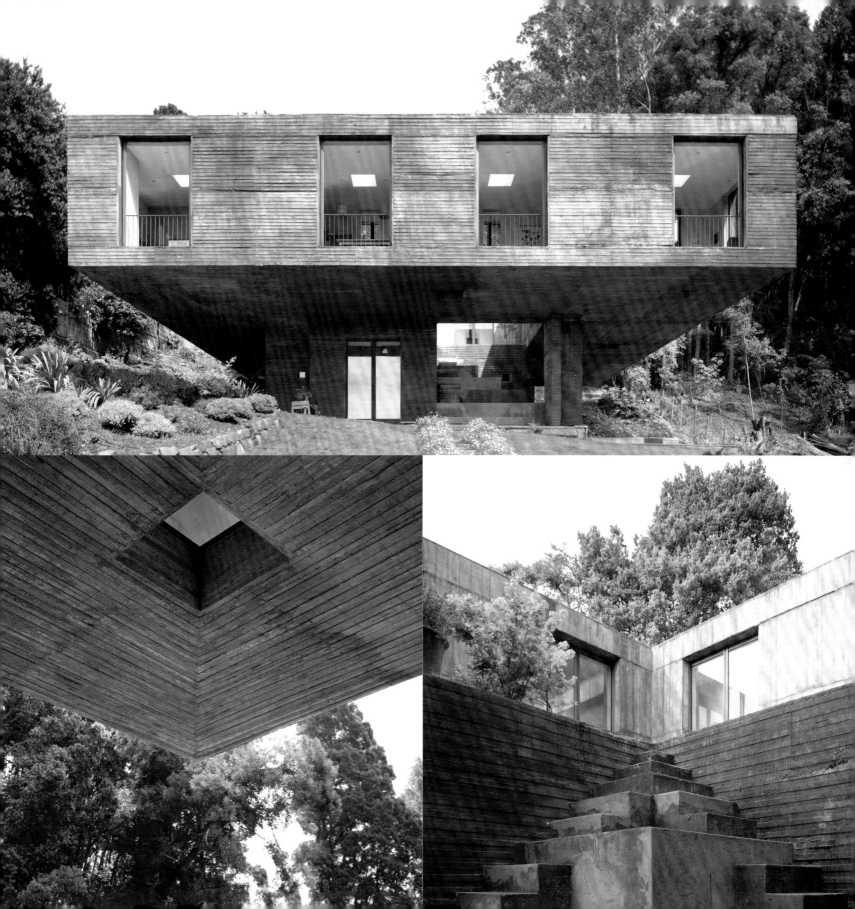

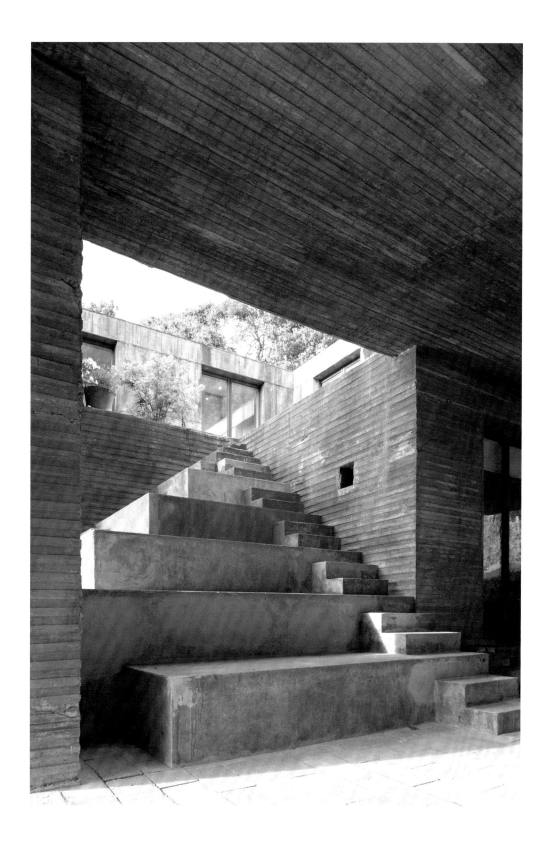

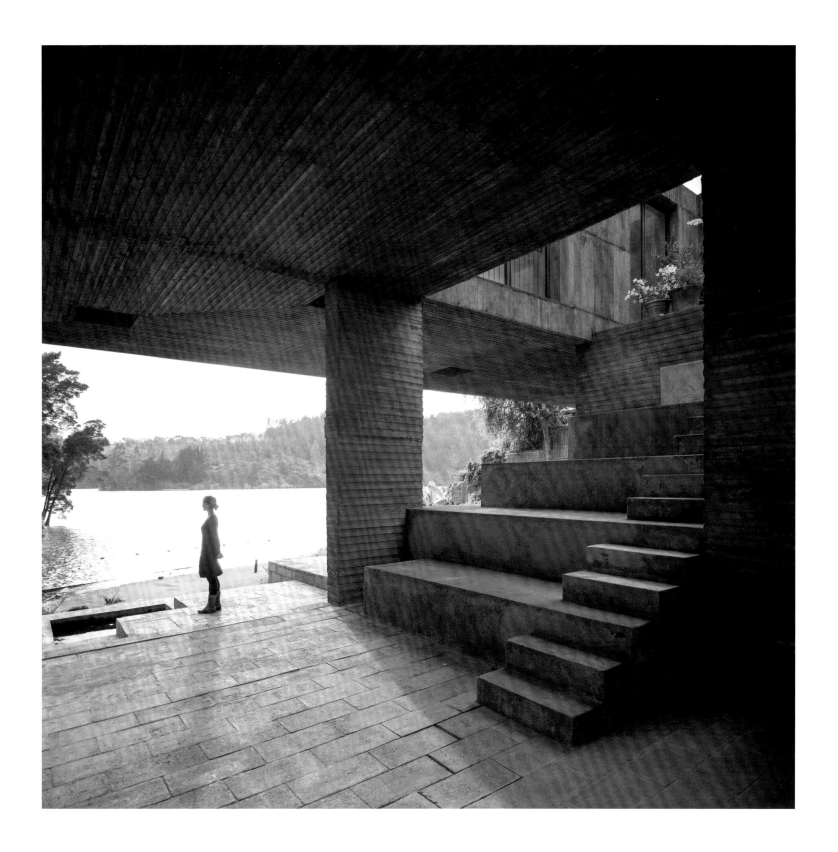

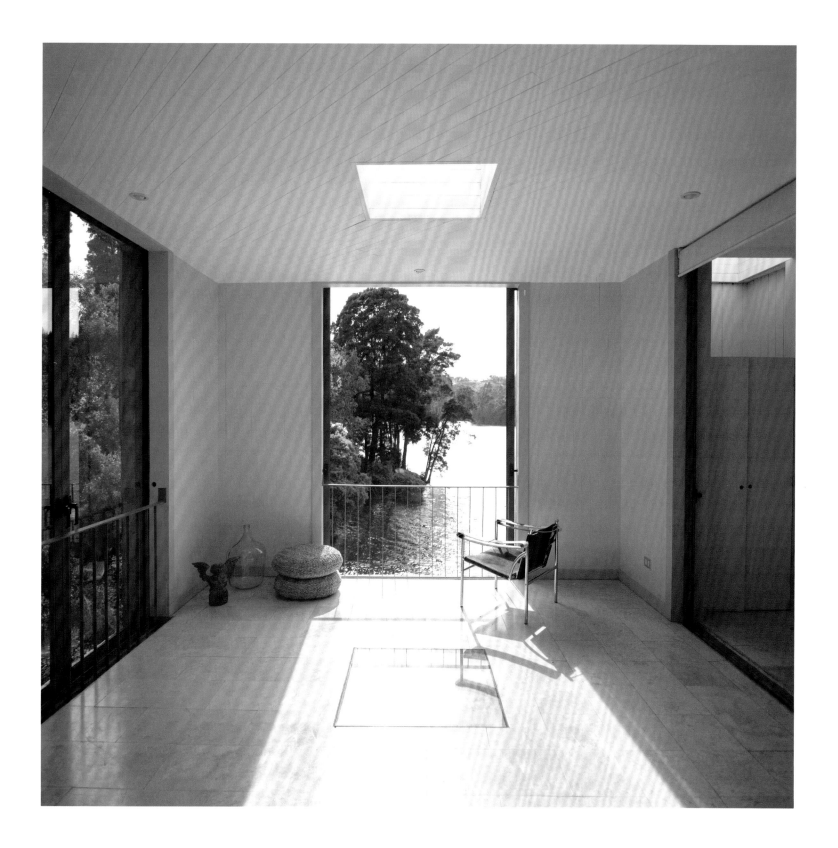

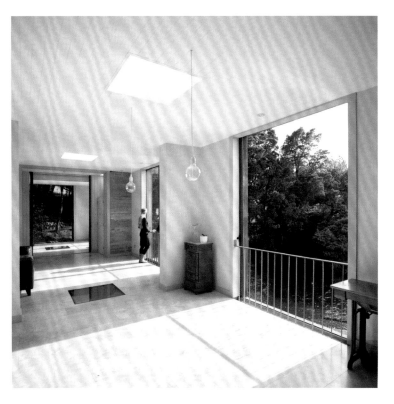

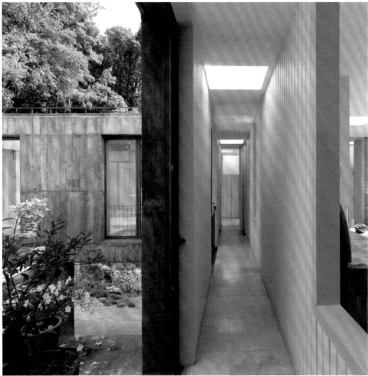

17.
PARAVICINI
HOUSE
CRISTIAN
HRDALO

CACHAGUA, CHILE

House Area:
700 m²

Plot Area:
2,500 m²

Architect in Charge:
Cristian Hrdalo

Project Team:
Jaime Bravo and Cristobal Langevin

Interior Designer:
Owners

Landscape Designer:
Alejandra Bosch

Photographer:
Nico Saieh

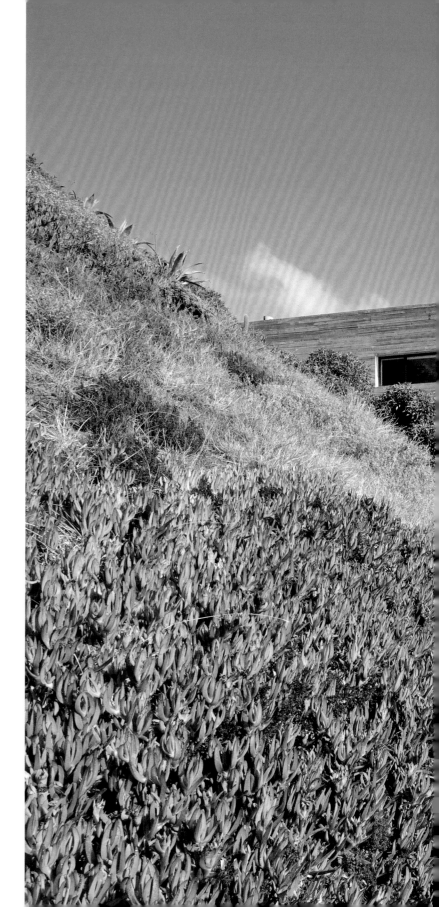

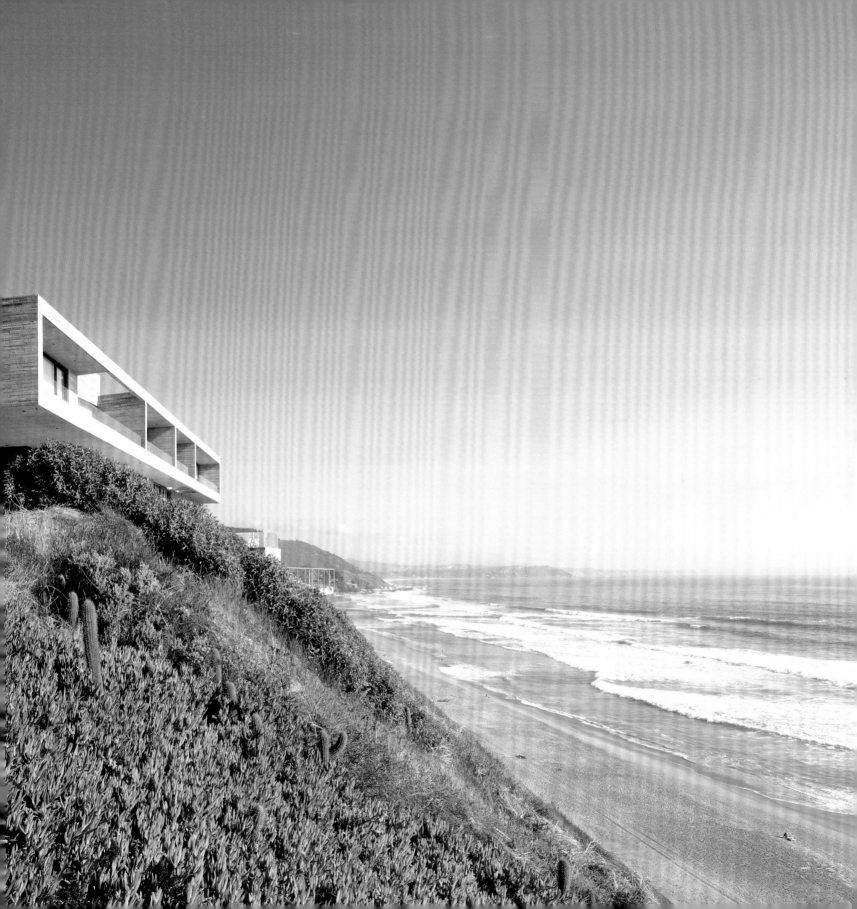

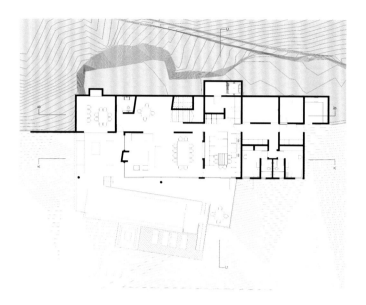

Ground Floor

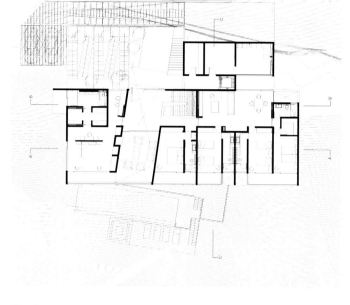

First Floor

Paravicini house is a beach front house located in the Chilean beach community of Beranda, located 150 km north of the country's capital city, Santiago. Located on a steep hillside site that boasts panoramic views of the beach below, the Pacific Ocean, and the village of Cachagua.

Built as a commission for a family who was seeking a quintessential beach house experience, the house boasts interconnected and informal spaces with an extensive programme across two floors that span the width of the property, allowing each room views of the sea.

Public areas, including the kitchen, dining, and living rooms, are placed on the first floor, allowing for a better connection with the exterior and terraces, while the second floor accommodates private areas including a family room and the bedrooms. Access from the roof is designed as a detached volume, shifting the traditional perspective of a roof as a simple sheltering agent; using it as a parking structure, as well as a space that shields private areas and allows views of Cachagua village.

The house is entirely built in a rough handmade concrete formwork, ensconced in natural wood, which contrasts with the roughness of the concrete while presenting a multi-hued and multi-textural effect through the interplay of indirect artificial light. Travertine marble flooring helps to hide errant sand from beach shoes, and walnut accents adds warmth to the interiors. A unified interior furnishing aesthetic ties all the rooms together, including the kitchen, which is incorporated into public areas.

The pool, which fronts the house at the edge of the sloping overhang above the beach, integrates into the ocean-facing common areas of the house, furthering the traditional indoor-outdoor interplay common in beach houses. The pool itself is stepped down a part-grade from the house's floor level, to avoid blocking views of the sea and the beach.

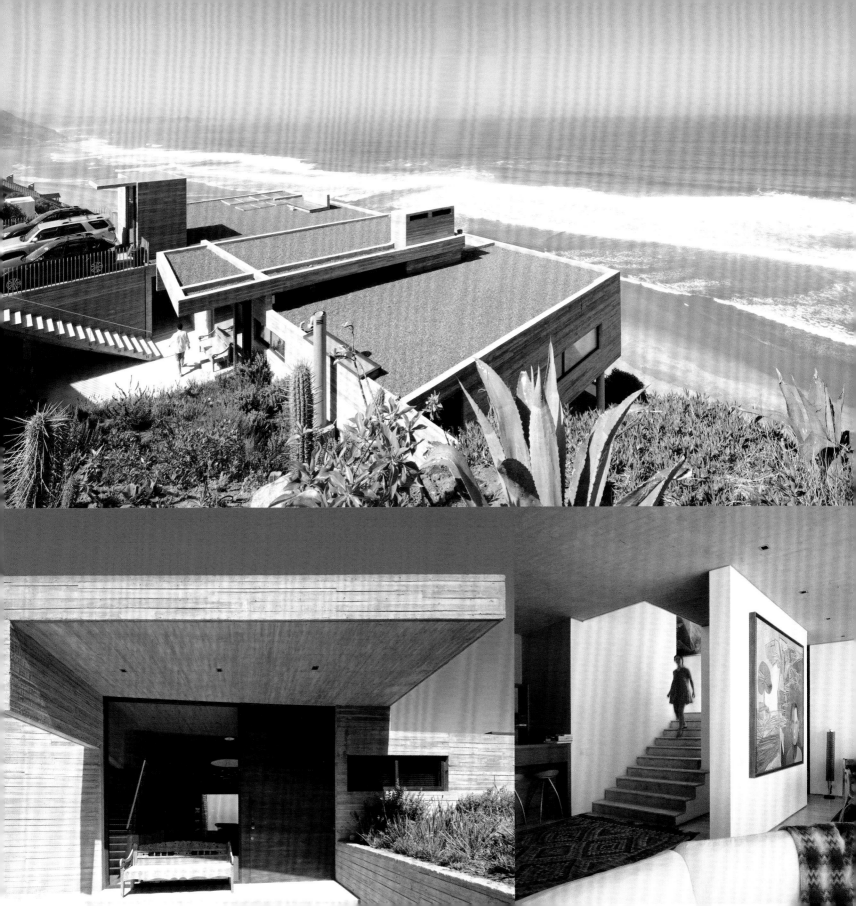

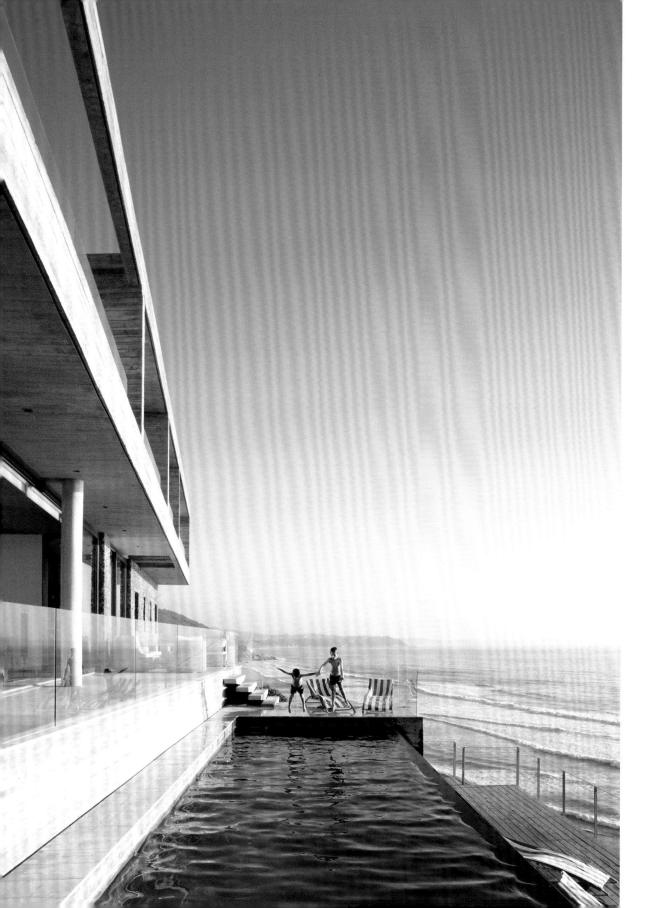

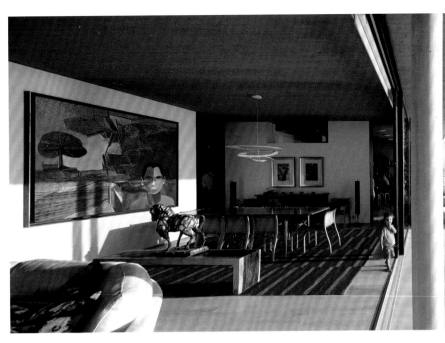

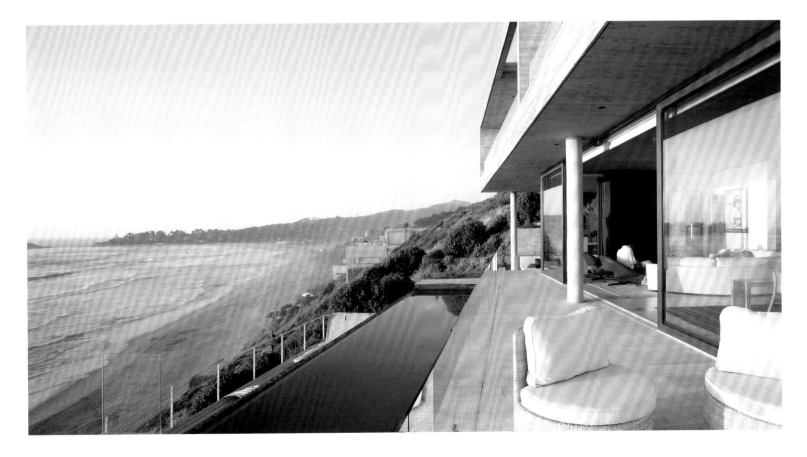

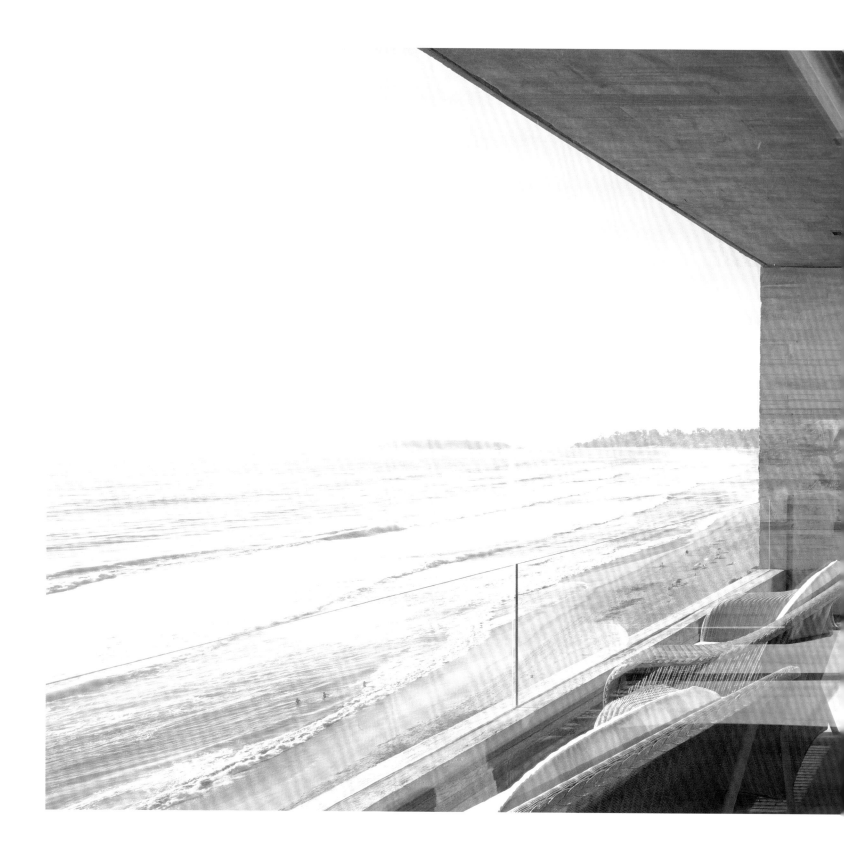

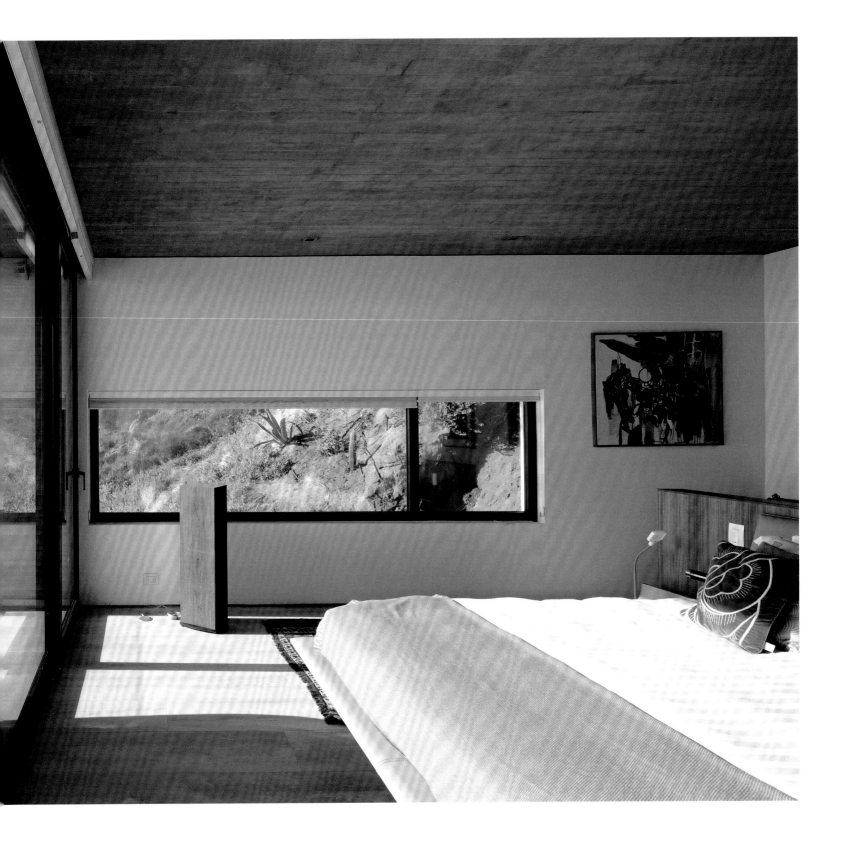

18.
BAHIA AZUL HOUSE
FELIPE ASSADI + FRANCISCA PULIDO

COQUIMBO, CHILE

House Area:
700 m²

Plot Area:
2,500 m²

Architect in Charge:
Felipe Assadi + Francisca Pulido

Project Team:
Felipe Assadi + Francisca Pulido, Alejandra Araya

Interior Designer:
Felipe Assadi + Francisca Pulido

Landscape Designer:
N/A

Photographer:
Fernando Alda

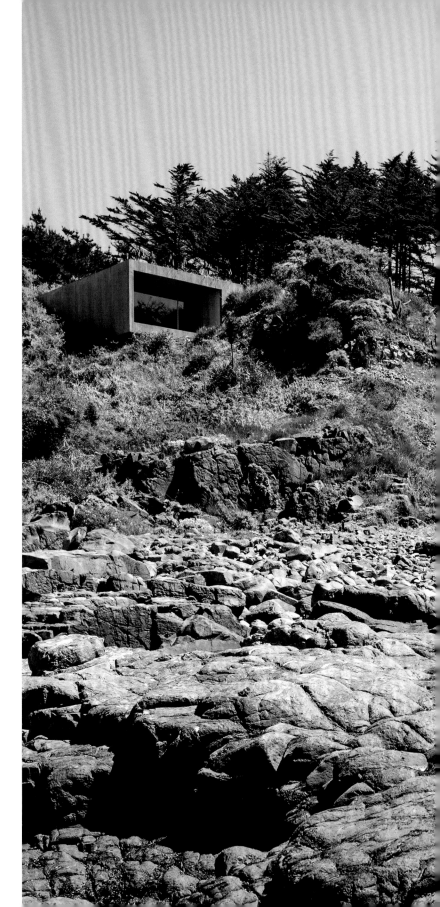

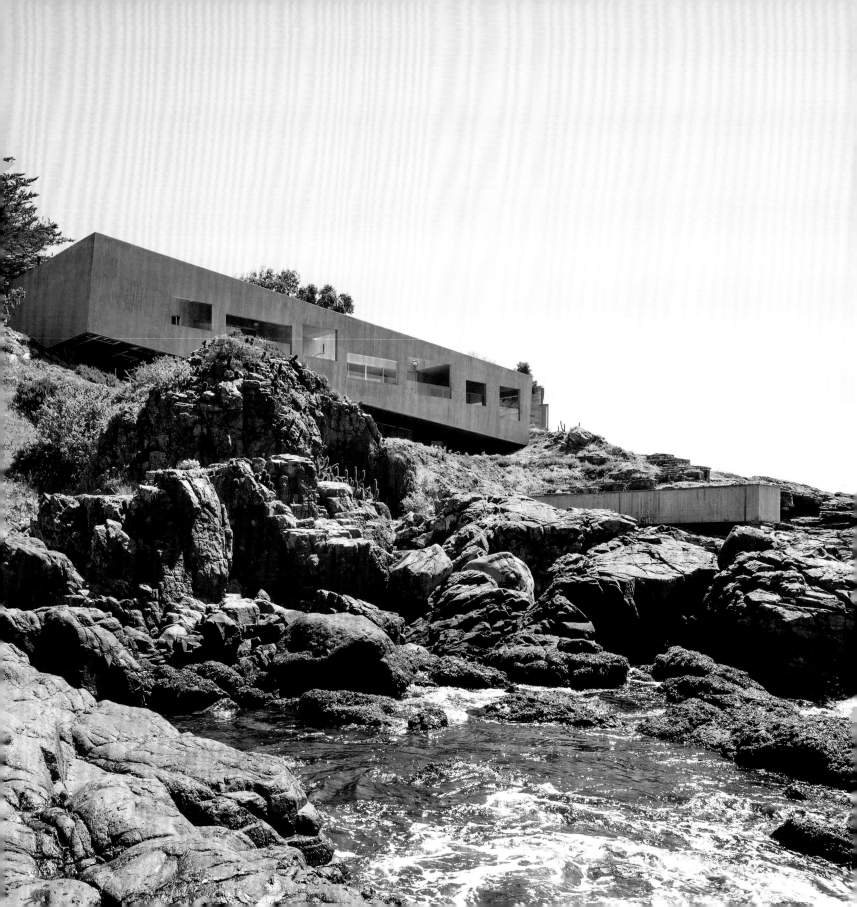

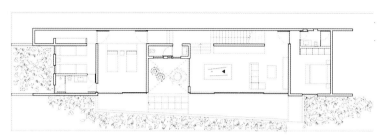

Basement Floor

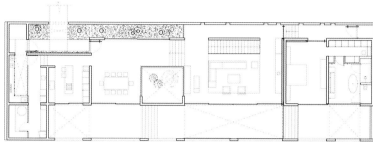

Ground Floor

Located on a cove nearby the Chilean coastal community of Los Vilos, Casa Bahia Azul rests atop a rocky promontory overlooking the Pacific; an experiment in designing residential architecture on a sloping plot (which tends to be cheaper than flat plots).

Seemingly reclining along the breadth of the site, the two-storey building is accessed from the hillside on the back, through an irregularly paved pathwa, and features anelongated plan that unfolds as a stepped sequence of spaces across multiple semi-levels, in what is a relatively conventional layout which the slanted facade subtly hides from the outside.

These 'levels' take into account that the house has two opposing readings: the interior, which is composed of relatively straightforward communal programmatic features, where in the views are arranged by a series of variegated-sized openings in an external wall of the house. The exterior contrasts the interior geometry, in that the synthetic, abstract object builds from the tension produced by the diagonal opposite to the irrevocable horizontality of the

sea. The openings, from afar, acquire a different relevance than they would as mere windows, mimicking the craggy terrain, and deforming the object as a whole, turning it into a sort of post-modern ruin.

On the lower level of the house, two bedrooms and a lounge area follow the stepped layout of the upper floor (which holds the master bedroom). These spaces boast views framed byan elongated, slanted opening which is formed by the upper storey's cantilevered balustrade.

Interior design exudes a minimalist modernism that echoes the sparse coastal landscape of the house's surroundings. Marble floors and exposed concrete walls are complemented by a muted palette that complements the rugged, rocky exteriors beyond.

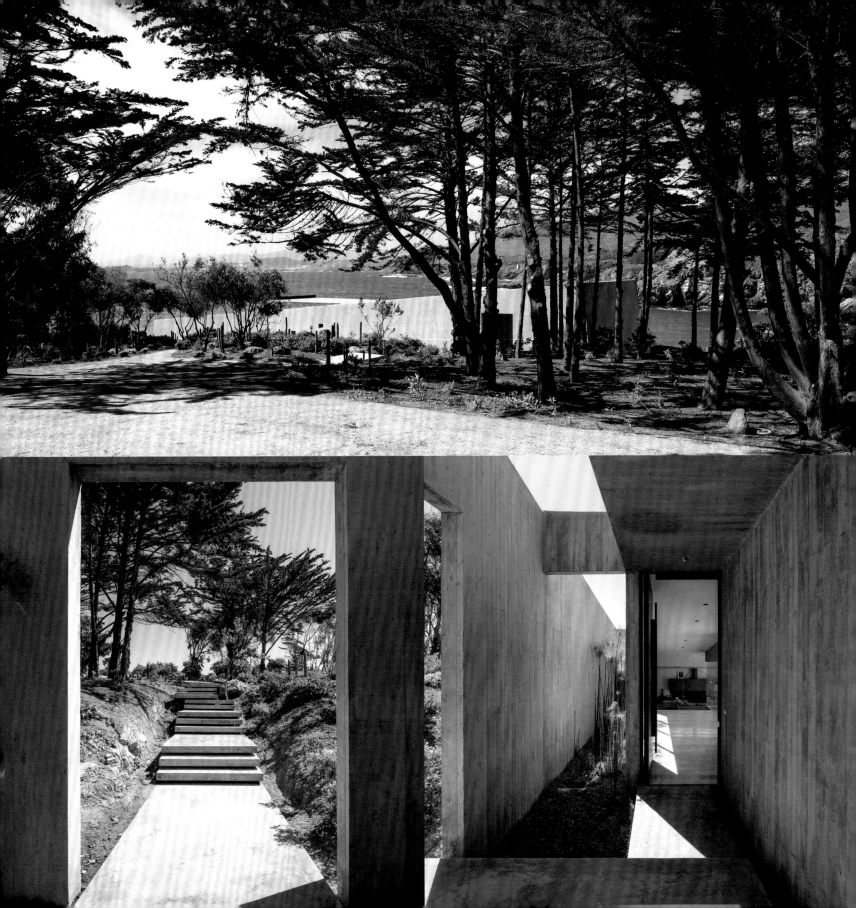

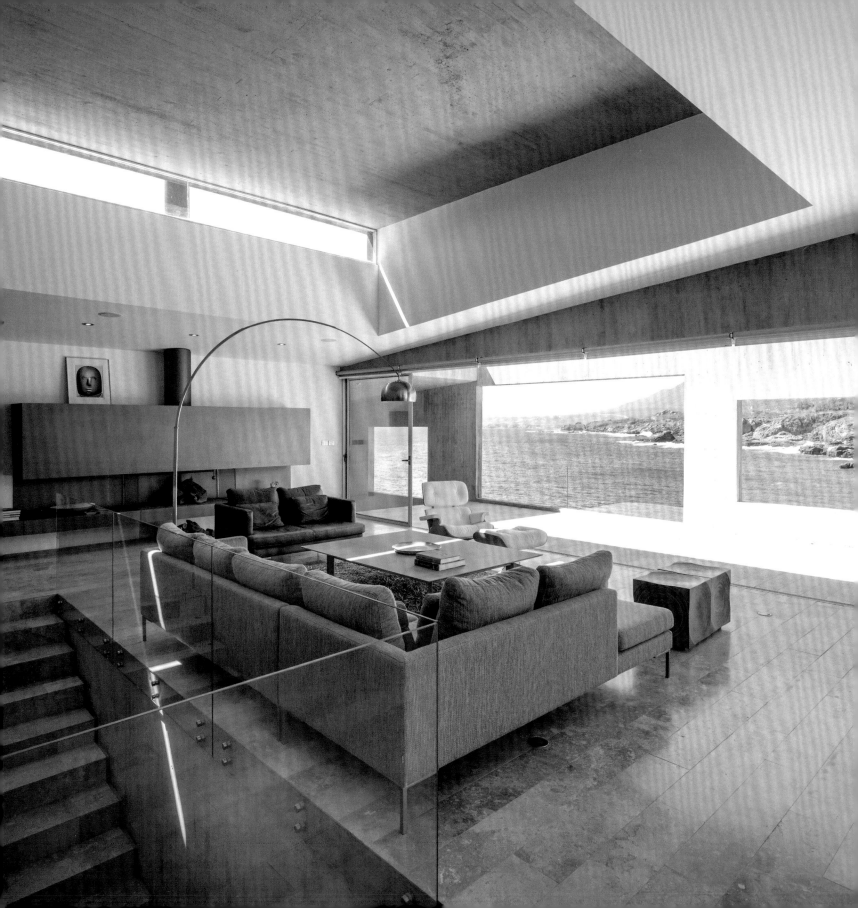

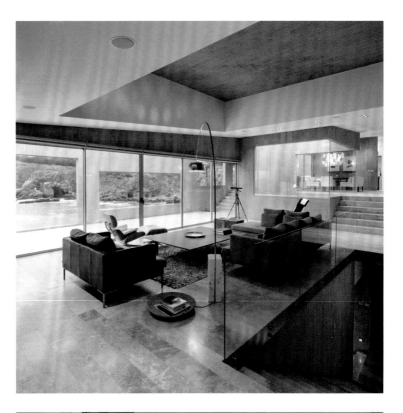

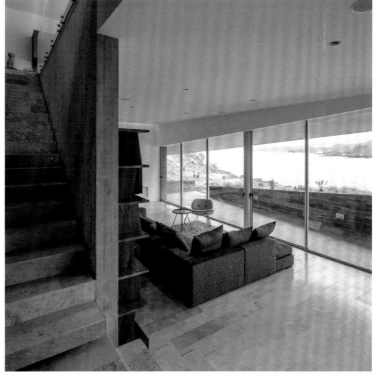

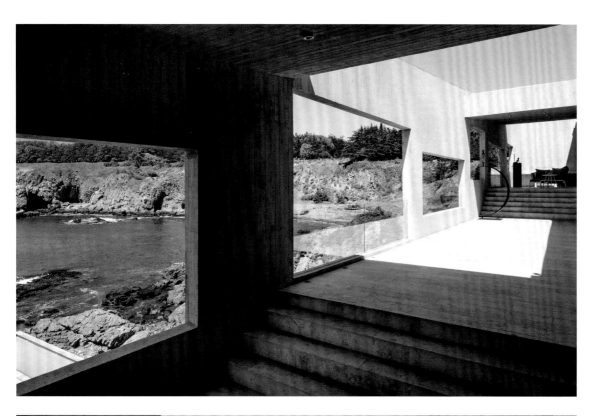

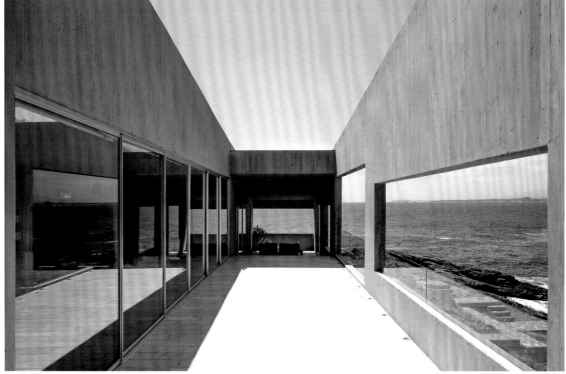

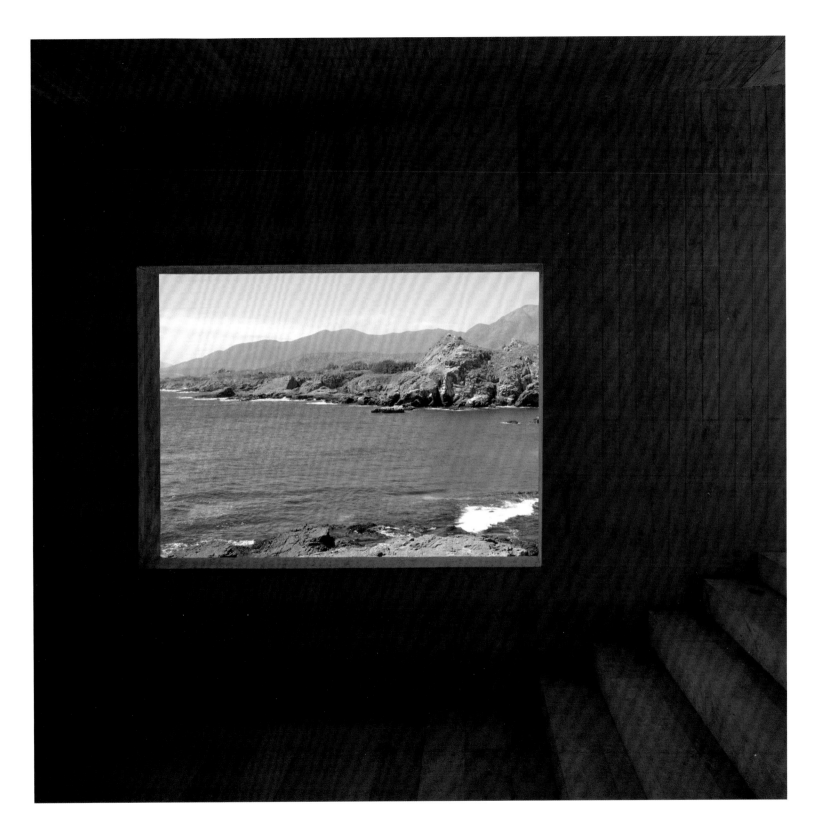

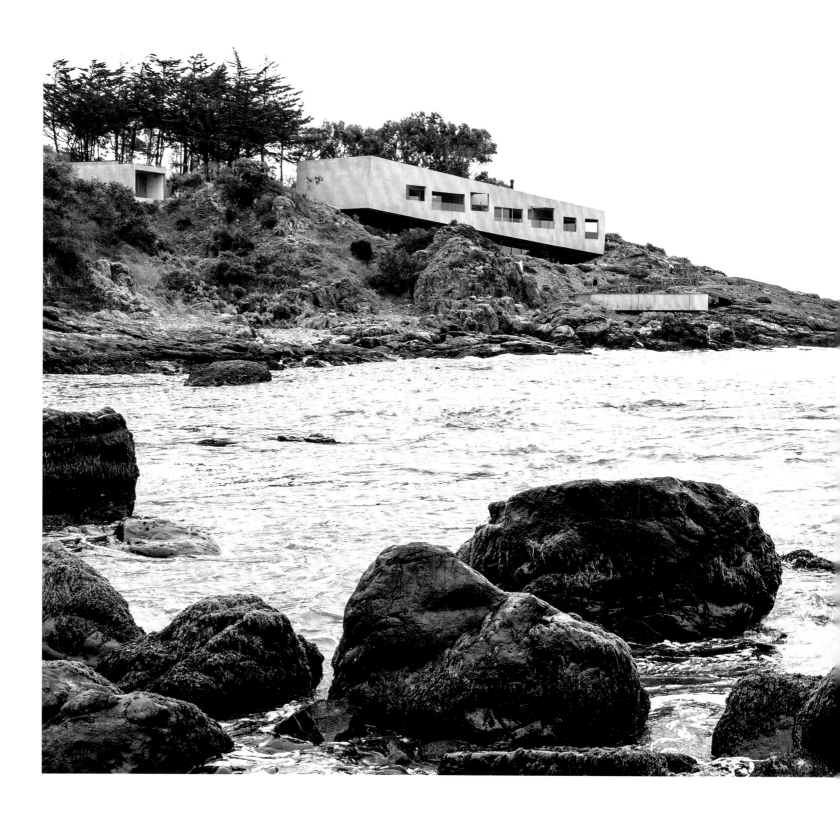

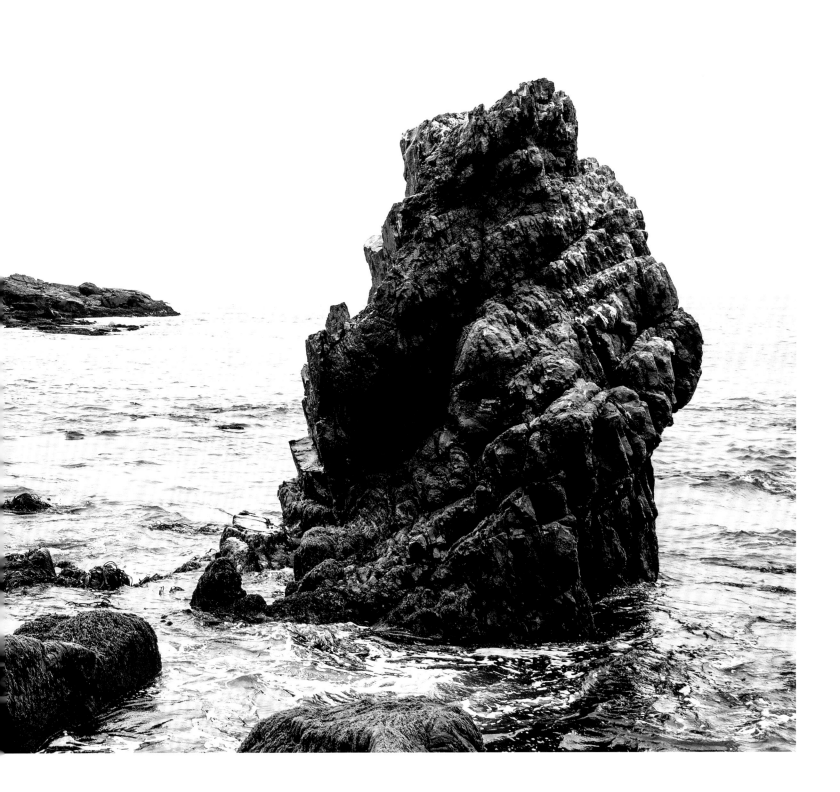

EUROPE

NESS POINT HOUSE | TONKIN LIU ARCHITECTS

BACKWATER | PLATFORM 5 ARCHITECTS

G-HOUSE | LAB32 ARCHITECTEN

VILLA BURESØ | METTE LANGE ARCHITECTS

ORNBERGET SPINE/PRECIPICE | PETRA GIPP ARKITEKTUR

PLASTIC HOUSE II | UNIT ARKITEKTUR AB

SUNFLOWER HOUSE | CADAVAL & SOLÀ-MORALES

PRIVATE HOLIDAY HOUSE | TITUS BERNHARD ARCHITEKTEN

SILVER HOUSE | OLIVIER DWEK ARCHITECTES

HOUSE IN ACHLADIES | LYDIA XYNOGALA

VILLA IN MESSINIA | MGXM ARCHITECTS

HOUSE IN ZAKYNTHOS | KATERINA VALSAMAKI ARCHITECTS

MA VIE LA | SELIM ERDIL

19.
NESS POINT HOUSE
TONKIN LIU ARCHITECTS

DOVER, UNITED KINGDOM

House Area:
250 m²

Plot Area:
300 m²

Architect in Charge:
Mike Tonkin, Anna Liu, Greg Storrar, Elio Bigi, Neil Charlton

Project Team:
Tonkin Liu, Aedas Interiors, Isometrix

Interior Designer:
Aedas Interiors

Landscape Designer:
Tonkin Liu

Photographer:
Nick Guttridge

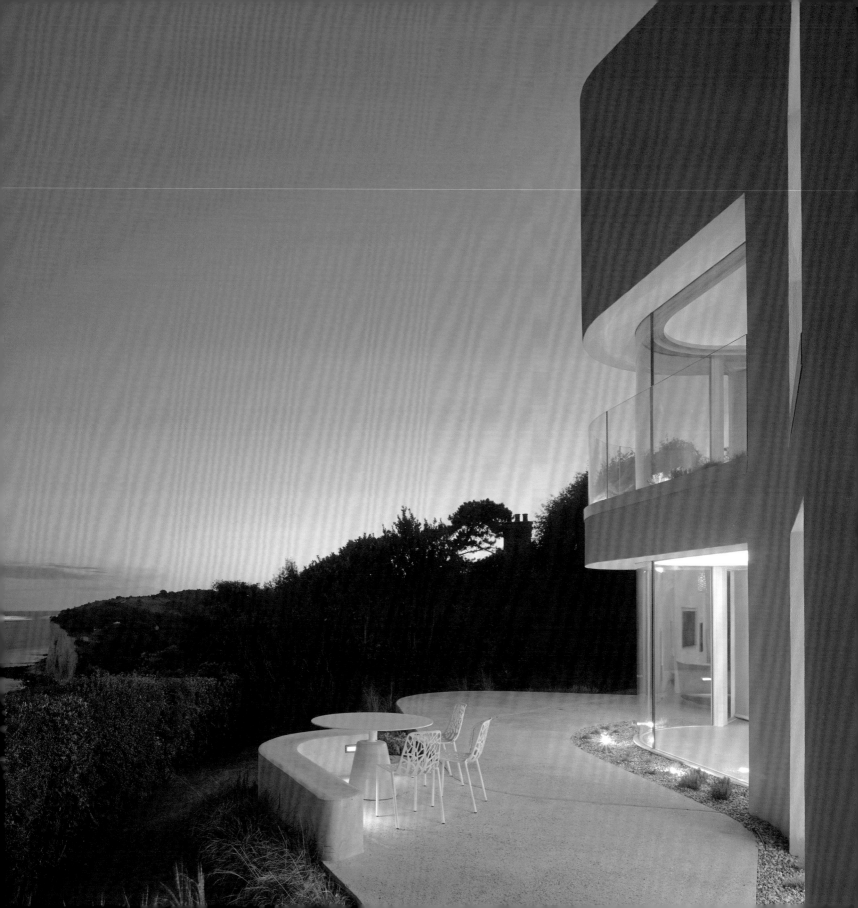

Ground Floor

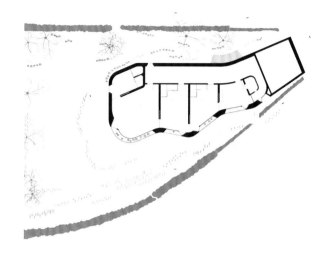

First Floor

Situated on the edge of the famed White Cliffs of Dover, Tonkin Liu Architects were commissioned to design a modern building that responded to the cultural heritage of the dramatic landmark setting.

Ensconced directly into the land, with undulating thick walls along its length, Ness Point is constructed as a journey with views that pull the surrounding landscape into the house. Each room is orientated specifically towards a unique aspect of the landscape: onto the passing ships of the English Channel, towards the sun rising out of the sea at the winter solstice, and out onto the coastal cliffs called Ness Point, after which the house is named.

In response to the exposed nature of such a site - a cliff top perched a full 65 metres above the sea - the house is designed as a highly sealed and insulated enclosure. The castle-like Ness Point House utilizes heat recovery and solar/thermal renewable systems to maximize energy efficiency in the winter, while the long gallery skylight and eco-vents enable passive cooling from the hot summer sun.

Despite the irregularity of the house's exterior form, Tonkin Liu utilized traditional construction techniques. The combined effect of the undulating plan and inclined sections creates a cavernous internal space that has been articulated to allow flexibility of use. The interior takes full advantage of the dynamism of the day's ever-changing light, allowing the building to become part of the larger canvas of ever-changing coastal weather.

Ness Point almost gives the impression that it has grown out of the land in which it is embedded. The bio-diverse green roof slopes downward into the land at the rear, retaining rainwater and harbouring local wildlife; merging the house, over time, into the landscape of the coastal cliff top. With Ness Point, Tonkin Liu have designed a house that fulfils the poetry of place.

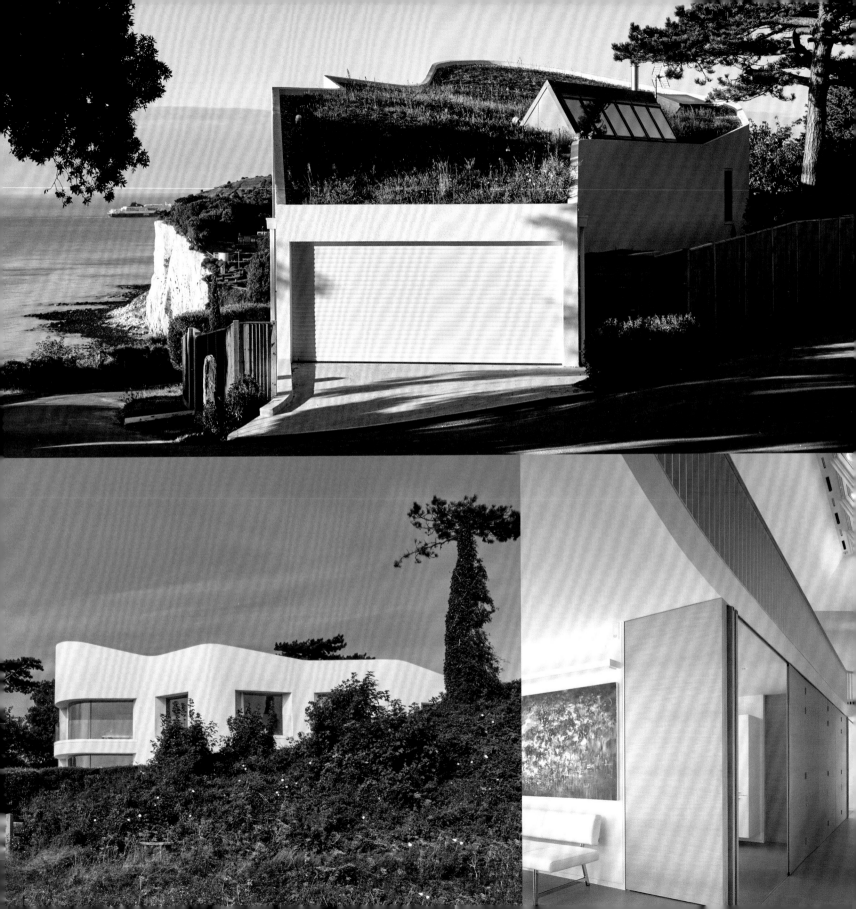

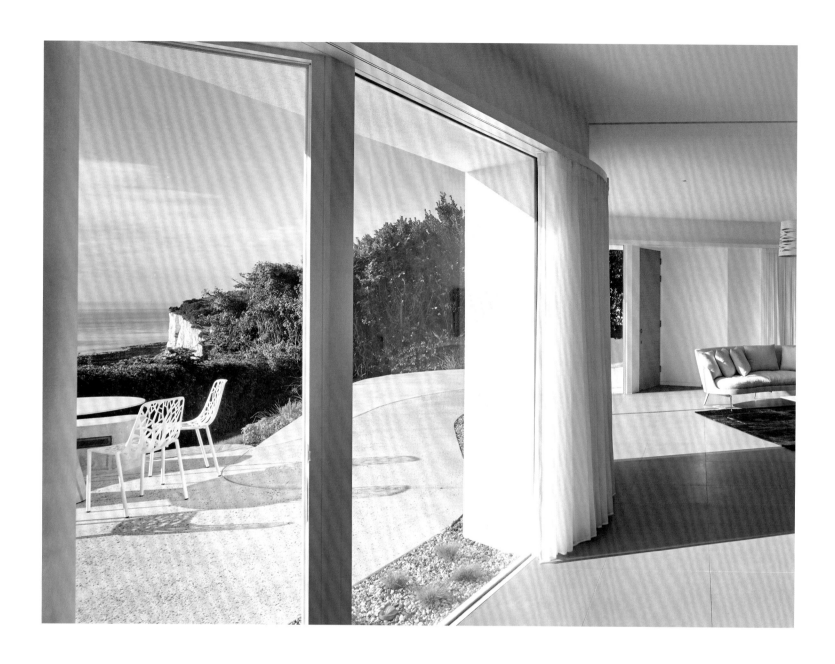

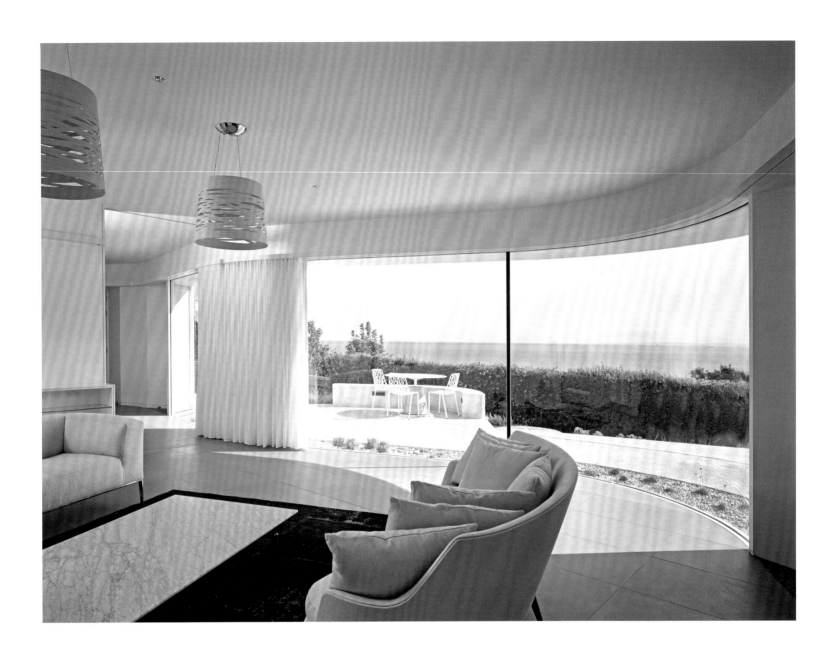

20.
BACKWATER
PLATFORM 5
ARCHITECTS

NORFOLK, UNITED KINGDOM

Area:
180 m²

Plot Area:
650 m²

Architect in Charge:
Patrick Michell

Project Team:
Patrick Michell, Claire Michell

Interior Designer:
Patrick Michell, Claire Michell

Landscape Designer:
Thomas Hoblyn Landscape, Garden Design

Photographer:
Alan Williams

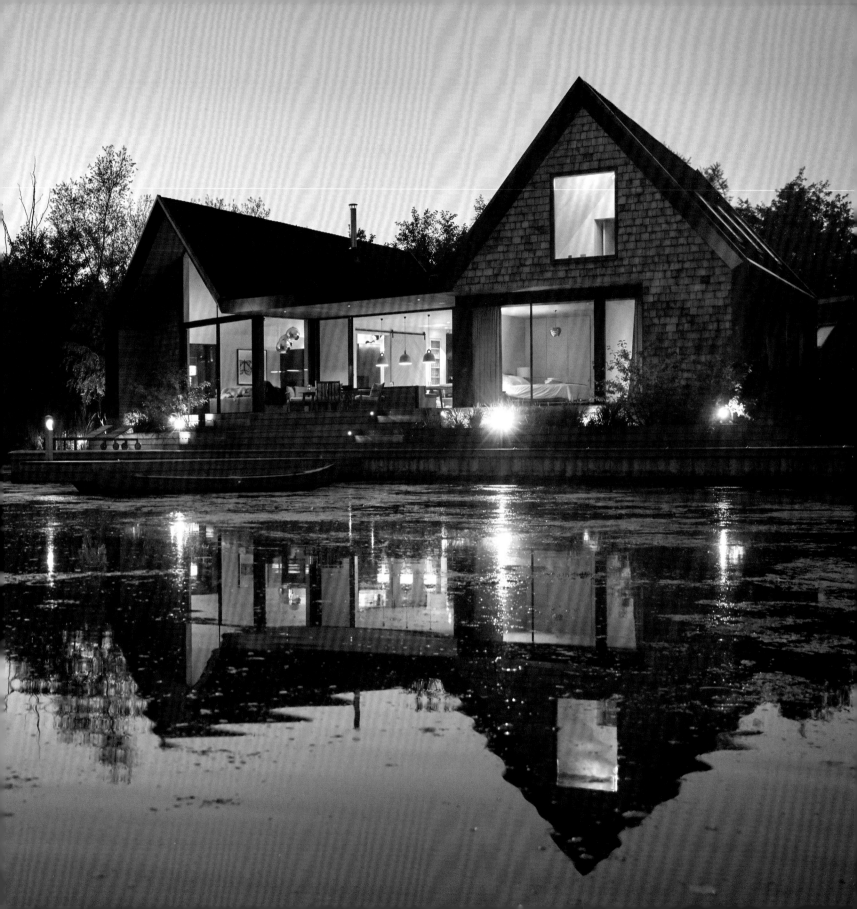

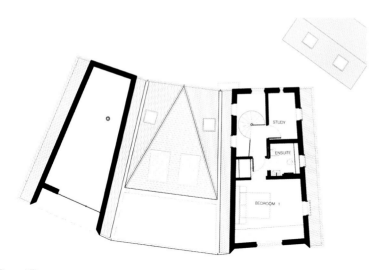

Ground Floor

Plaform 5 built Backwater as a new build, replacing an outdated bungalow on a promontory in a secluded lagoon in the Norfolk broad, for practice director Patrick Michell. Seeking simple, contemporary living spaces, the firm orientated the house's primary areas to benefit from the site's surrounding views.

The house is arranged as three low rise bays, whose pitched roofs echo the working boat sheds typically found on the Broads. Externally the roofscape and side walls have been clad in blackened timber shingles to express the form as an abstract folded plane. To the front and rear elevations the timber shingles are left untreated to allow them toweather and create a warm textured appearance full of natural patination.

Each distinct bay has a different volume and is orientated to address varying views across the wetland landscape that surrounds the house. The double-height vaulted living space faces onto Carr woodland, the central bay offers panoramic views across the private lagoon, and the bedroom wing has smaller framed views.

Inside, a simple broken plan arrangement allows for flexible living and accommodates family life by allowing different activities to take place simultaneously through the use of timber sliding doors. The central bay contains a large kitchen and dining area, and flows into the adjacent double height living space that is separated by a steel clad fireplace. The house's three bedrooms occupy the third bay and are split over two floors, connected byan impressive spiral staircase that rises from the entrance hallway.

Each space has a carefully designed layout with built in furniture to set the scene for family life. A considered material pallet is used throughout these spaces, where a range of colours and textures respond to each room's programme and create a cosy but varying atmosphere.

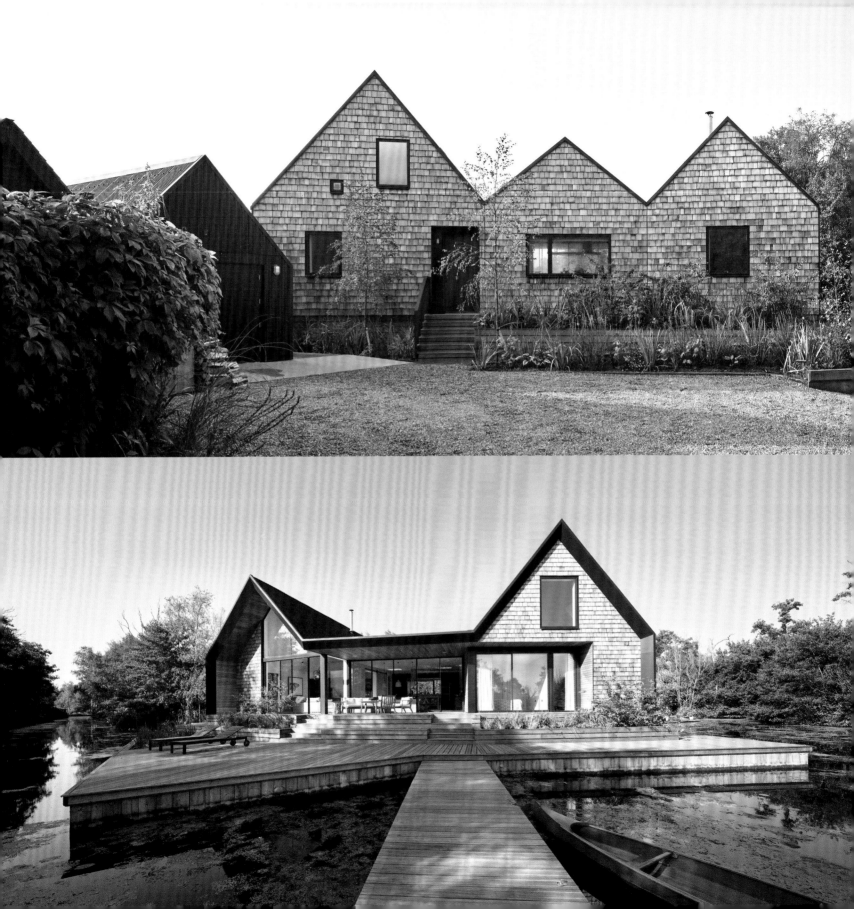

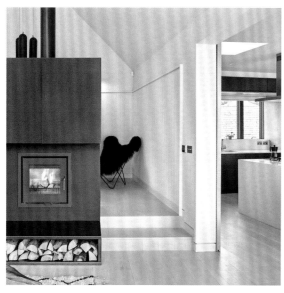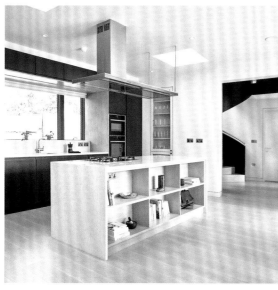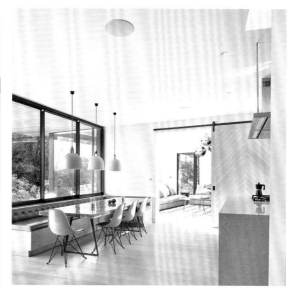

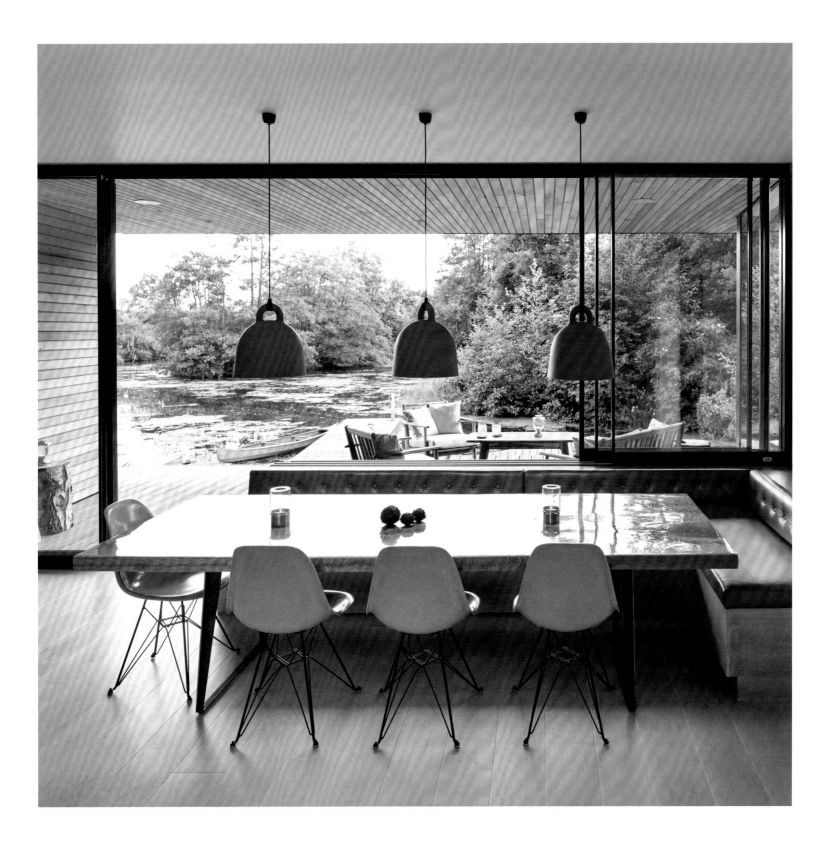

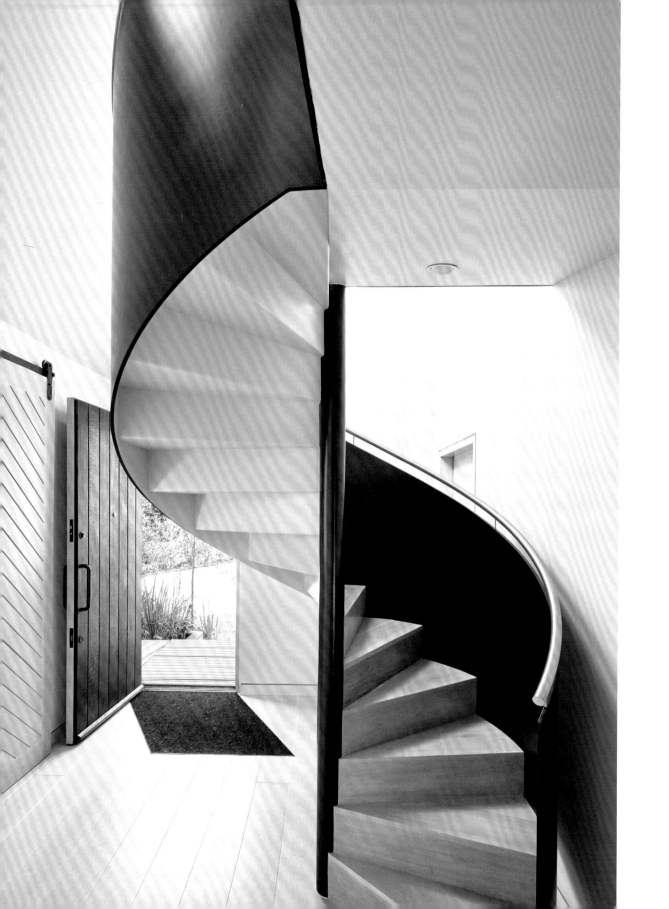

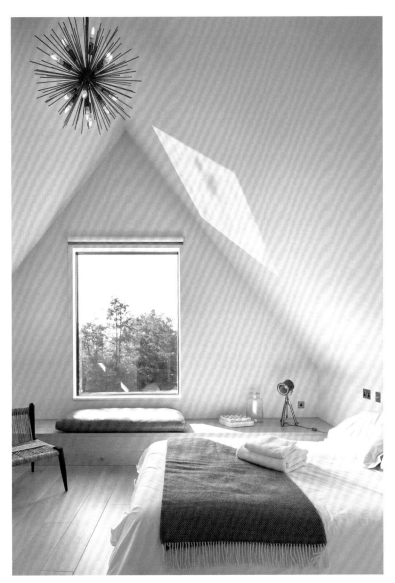

21.
G-HOUSE
LAB32
ARCHITECTEN

REEUWIJK, THE NETHERLANDS

House Area:
650 m²

Plot Area:
38,034 m²

Architect in Charge:
Loek Stijnen

Project Team:
Clark Teensma, Monique Lipsch

Interior Designer:
Jos van Zijl, Loek Stijnen, Domez

Landscape Designer:
Lab32 architects

Photographer:
René de Wit

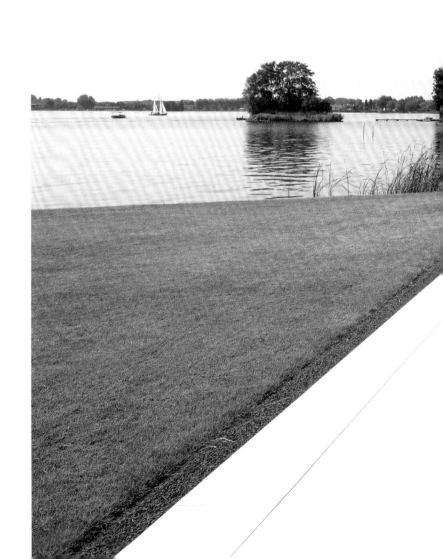

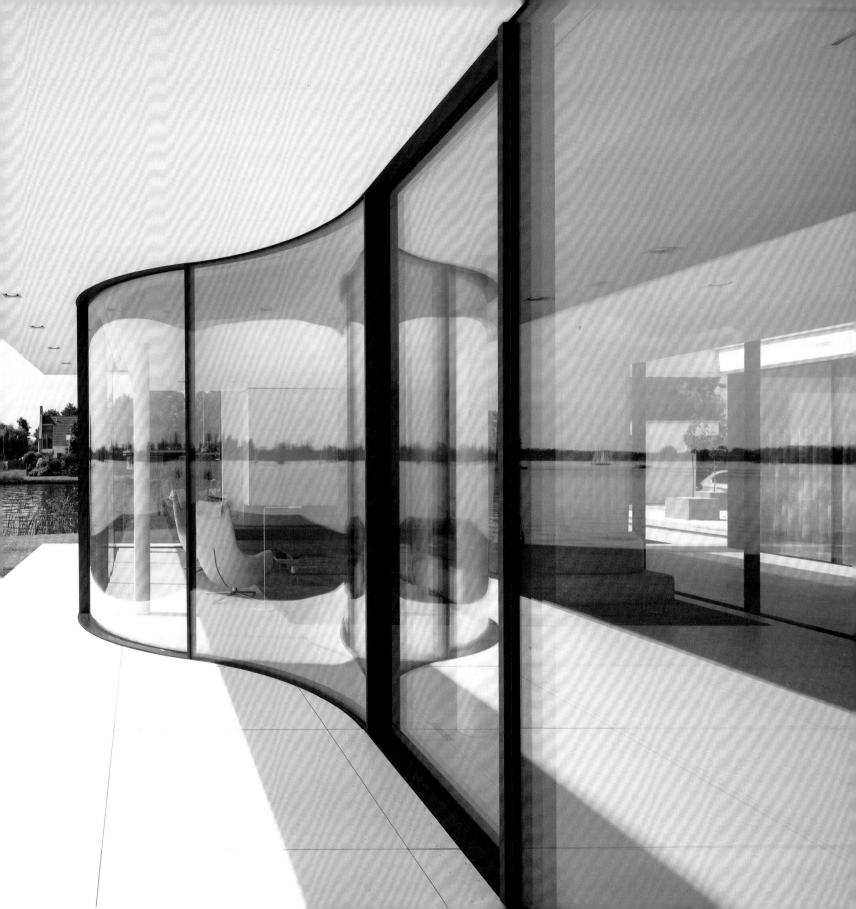

Basement

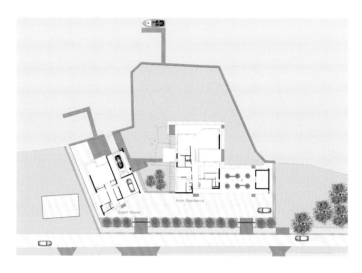

Ground Floor

G-House's design is situated on the waters of the Reeuwijkse Plassen in a small Dutch village, and was borne of the site's natural setting, and its relationship with the water. A timeless, minimalist design, which boasts state-of-the-art materials and a high level of detail.

The villa's programmatic layout is determined by the plot's waterside location. The main living areas - living room, dining room and kitchen - are on the south side, where they engagein a dialogue with the landscape via large, minimal windows. The cleverly designed patio uses glass on three sides, which not only allows for visual contact between living room and street, but also provides the bedroom with a view of the water. The patio is bordered by the master bedroom with walk-through closet and generous bathroom.

The basement contains technical equipment and storage space, as well as a third and fourth bedroom, plus a wellness area complete with swimming pool, jacuzzi, sauna anda shower and toilet.

The architecture is defined by floating, sculptural forms, wonderful sight lines, a luxurious sense of space, and a strong indoor/outdoor relationship. The combination of materials and the strong outlining of the large expanses of glass, as well as the overhangs and fluid curves are the focal points of this dream house. The materials are limited to a white insulated render façade system in combination with black aluminium frames, the only additional material being the pre-weathered pale grey zinc used in the guest quarters.

The internal finishing is tautly minimalist, with pale floors that continue outside in the terraces and edgings, toughened glass doors and custom-made wall units and matching adjacent doors, partly in a robust dark aluminium with a warm look and feel, but white where they were required to blend with the wall.

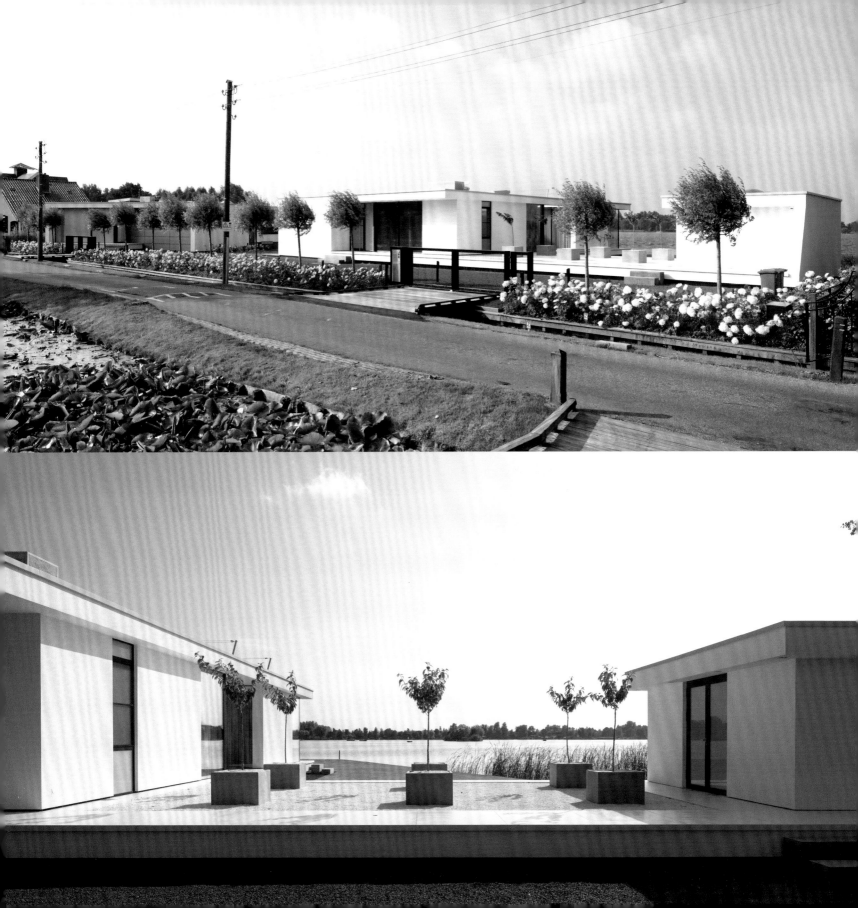

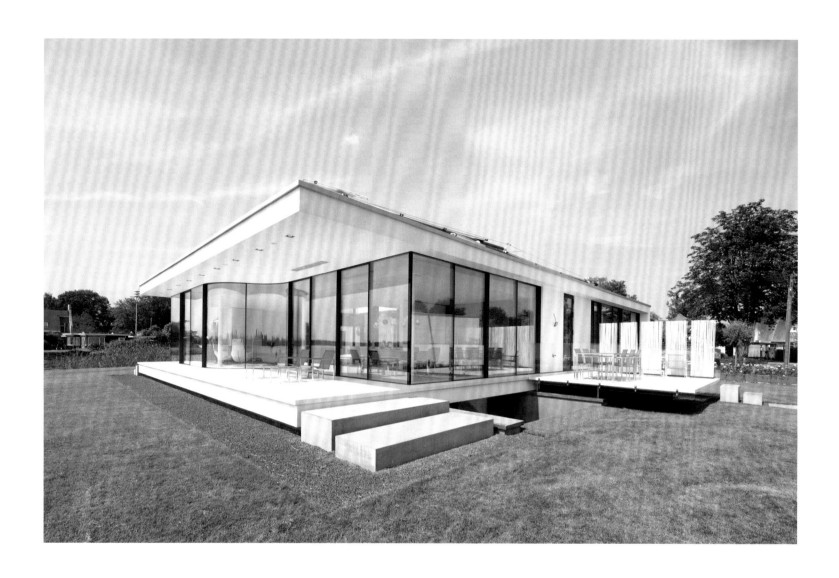

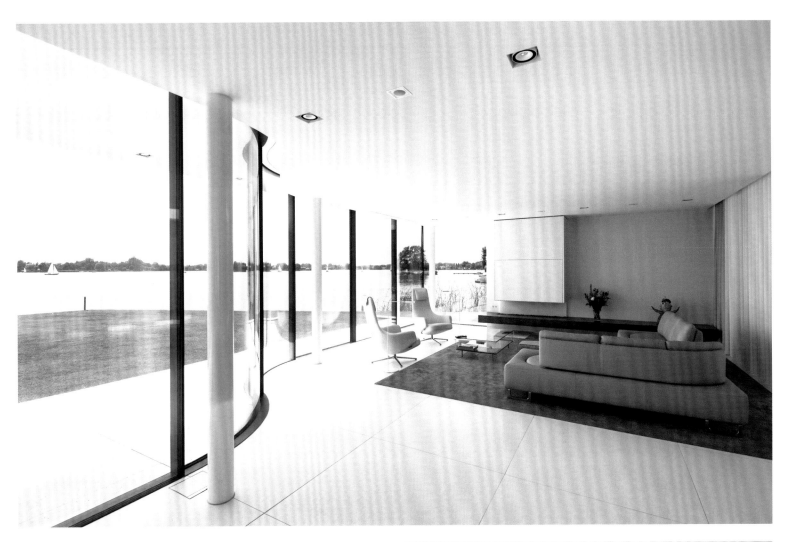

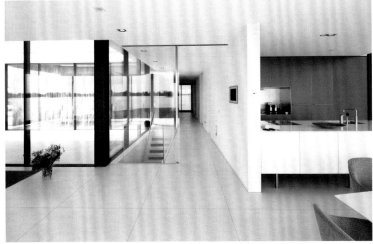

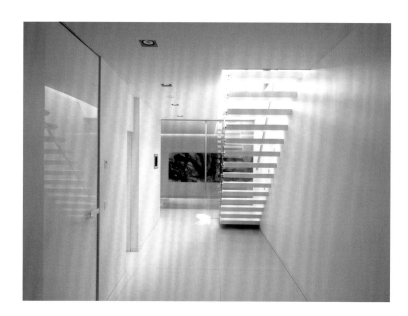

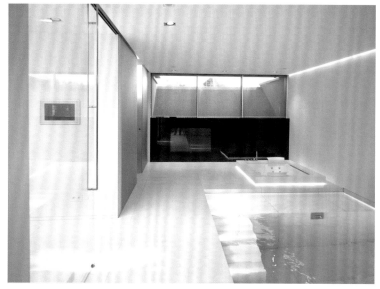

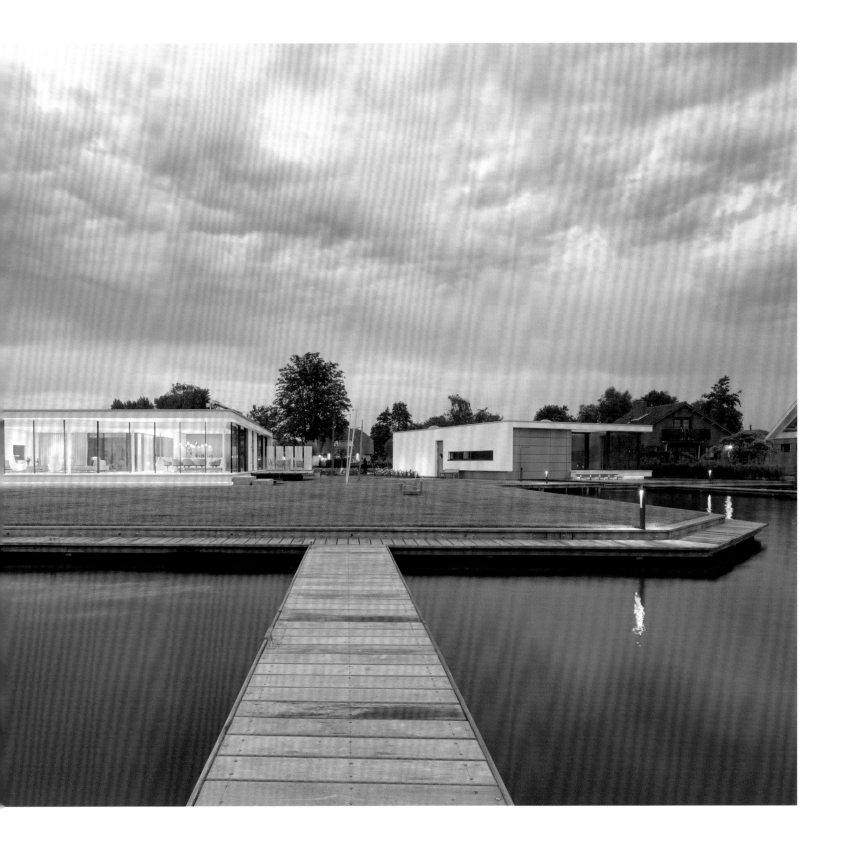

22.
VILLA BURESØ
METTE LANGE
ARCHITECTS

SLANGERUP, DENMARK

House Area:
239 m²

Plot Area:
4,400 m²

Architect in Charge:
Mette Lange Architects

Project Team:
Mette Lange, intern Michael Lynge Jensen

Photographer:
Hampus Berndtson

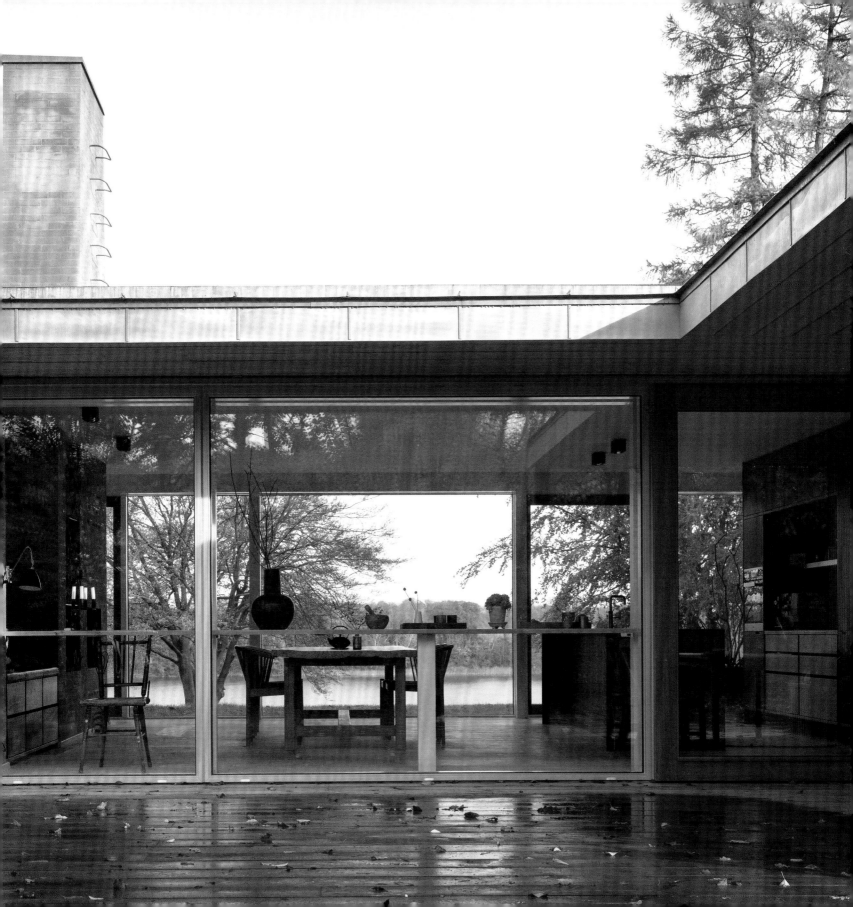

Ground Floor

Mette Lange's Villa Buresø is a perfect distillation of contemporary Scandinavian outdoor residential architecture, filtered through an impeccable understanding of mid-century modernist 'bungalows'.

The house is located on the edge of a slope at the south bank of Buresø. The huge site is covered in trees, and no neighbouring houses are visible. A long, narrow house constructed of wood and clad in Douglas pine, Villa Buresø is divided into a 208 sq/m main house with a 30 sq/m annex.

The north elevation is a long glazed glass façade with sliding doors opening out onto the expansive lake view. The south façade is closed, save for the kitchen and living room, which is also glazed, giving a view through the house and catching lake views. Interior skylights are periodically placed, which allows prodigious sunlight, and views of the sky and treetop canopies. They are placed nearly horizontal lyalong the roof, which renders them invisible from the outside, but are strategically placed to allow sunbeams to give off kaleidoscopic natural light throughout the interior.

While the main building boasts a flat, horizontal profile, the handsomely stained pine plans cladding the exterior are vertically oriented, allowing the house to seamlessly segue into its wooded surroundings. The residence is heated with geothermal energy tominimize its energy consumption, but also comes with two wood-burning stoves.

A simple, earthy palette of blonde woods, light bricks, and lightly stained exterior cladding keeps the home close to nature, bolstered by subtle hand-crafted furnishings. A waterfront hammock contributes to the idyllic nature of the retreat, as do the casually landscaped grounds.

Mette Lange has, in Villa Buresø, crafted a pinnacle of Nordic residential repose; one that will be acknowledged and studied as a representative of Scandinavian elegance.

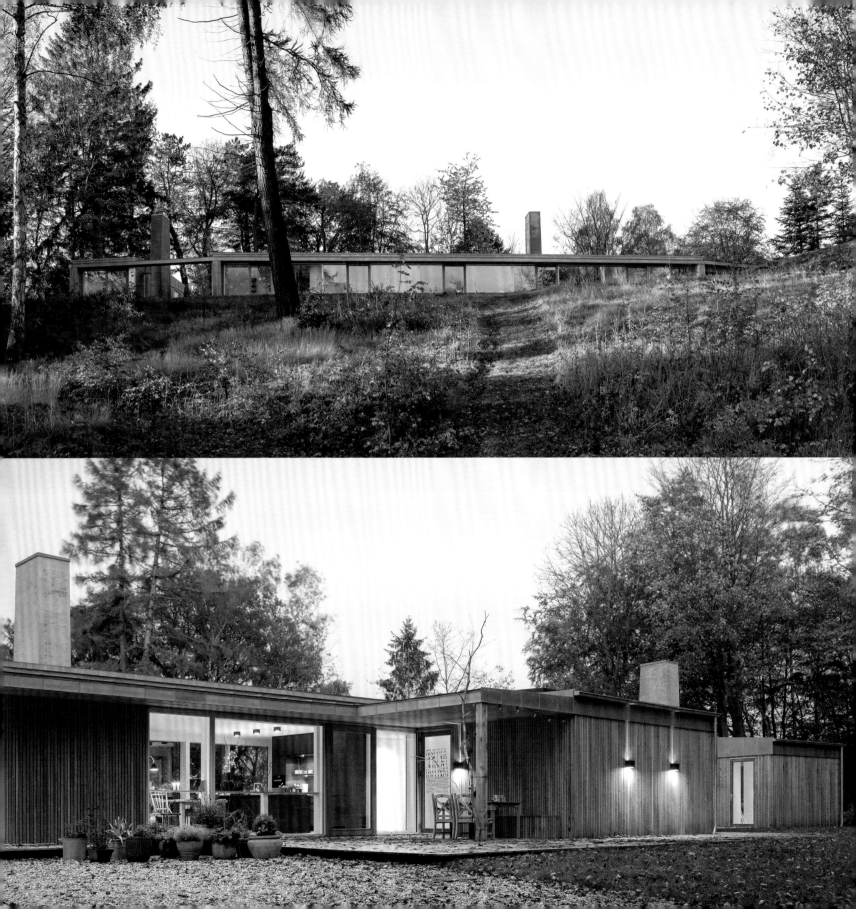

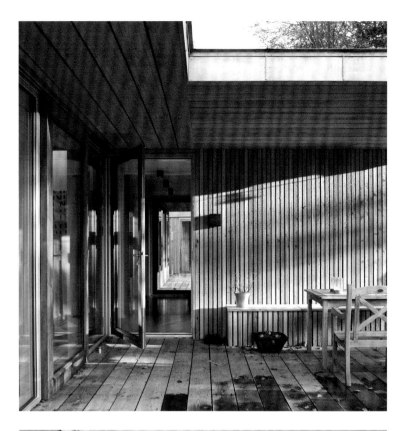

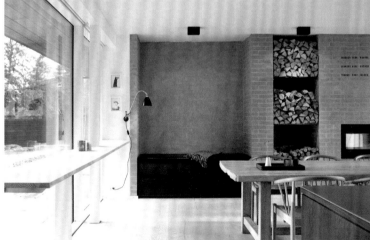

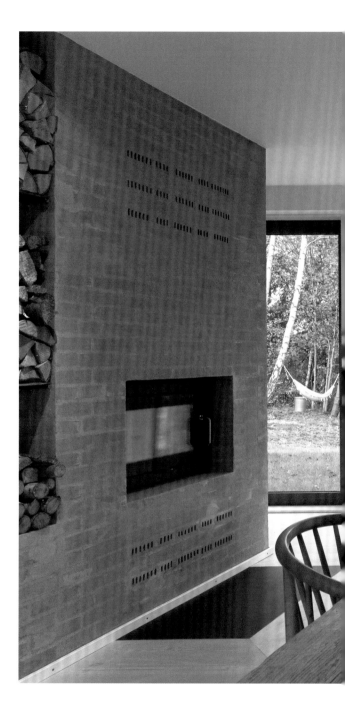

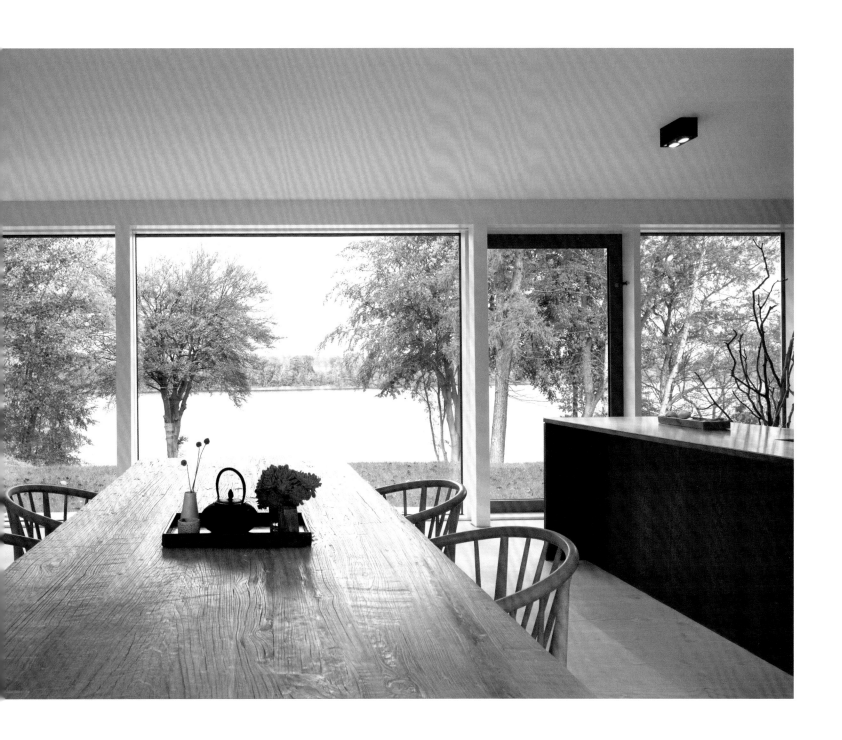

23.
ORNBERGET SPINE/ PRECIPICE PETRA GIPP ARKITEKTUR

ÄLGÖ Ö, SWEDEN

House Area:
150 m²

Plot Area:
225 m²

Architect in Charge:
Petra Gipp Arkitektur

Project Team:
Malin Heyman, Marco Nathansohn, Maria Cagnoli

Interior Designer:
Petra Gipp Arkitektur

Landscape Designer:
HORN.UGGLA, Maria Horn

Photographer:
Åke E:son Lindman

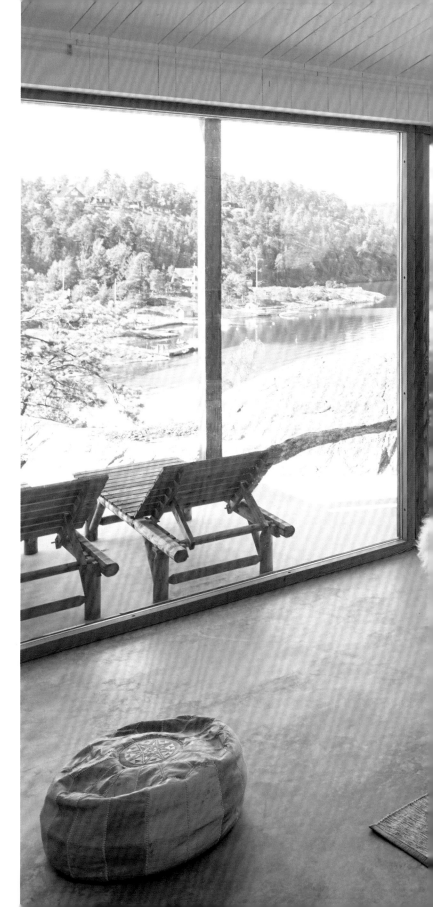

Ground Floor

Located in Älgö, Sweden, on a site overlooking the inner Stockholm archipelago, Petra Gipp Arkikektur's Örnberget is composed a series of geometric volumes; resembling a row of stocked boxes.

The site meets a dense row of pine trees to the west, and a softer grove of deciduous trees to the east. Visitors enter from the north, where a spacious staircase traverses the initial steep south-facing slope. The stairs follow a concrete wall that forms the base of the spine of the structure, and lead the visitor downwards to a gap in the wall which provides a glimpse of the garden on the other side. The promenade continues along the closed wall, towards the view and the water, now flanked to the west by the row of pine trees. A second opening in the wall presents the entrance to the house and extends a passage through and across it, into the garden.

Inside the house, the concrete wall winds its way further down the narrow site towards the water, and forms itself into bathrooms, a storage space, and a fireplace. Gathered around this concrete spine, wooden volumes hover just above the ground, that reach out into the garden, pushing the interior spaces into the cultivated landscape and creating exterior spaces protected from the wind. Each wooden interior space reaches upwards out through a skylight to the stars above.

Örnberget translates directly to spine (or precipice), referencing the concrete backbone of the space; the central spine principle being reminiscent of Charles Correa's Ismaili Centre in Toronto while various rooms act as floating wooden extensions, anchored to the main 'trunk'.

Rustic promontories echoing from their natural surroundings; the individual geometries flaunt large, recessed windows which bathe interior spaces with light, while the exterior timber integrates the structure with its natural environment.

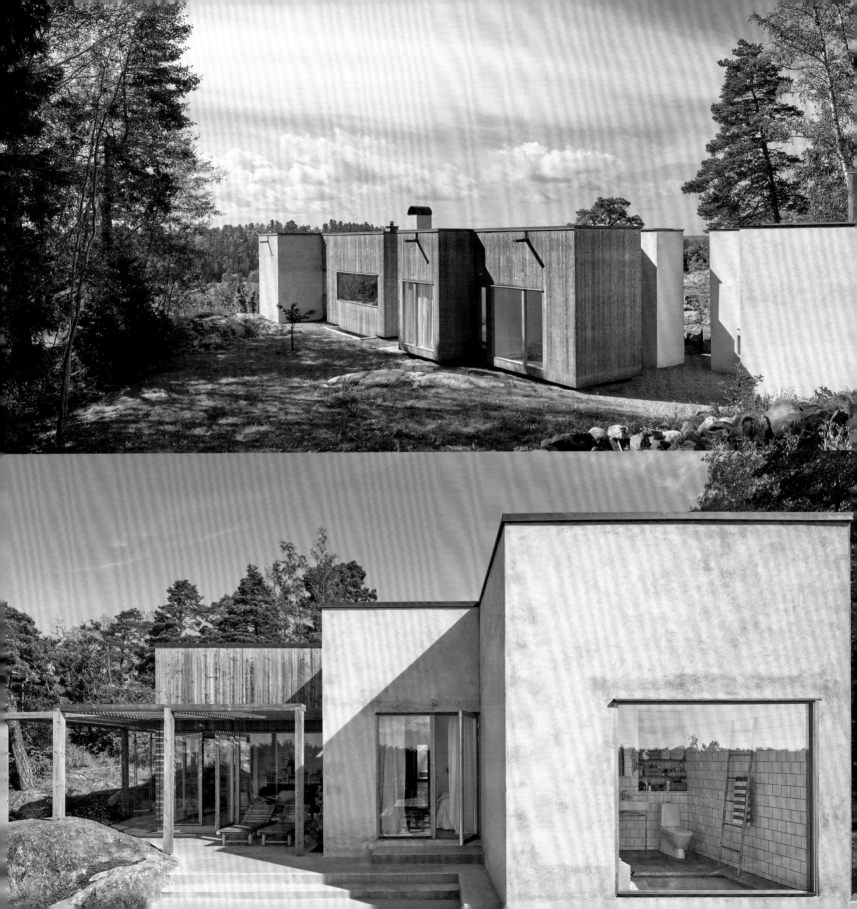

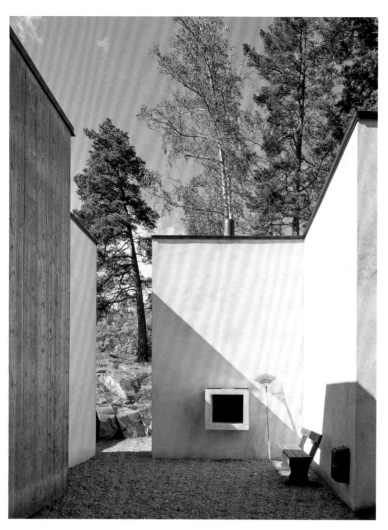
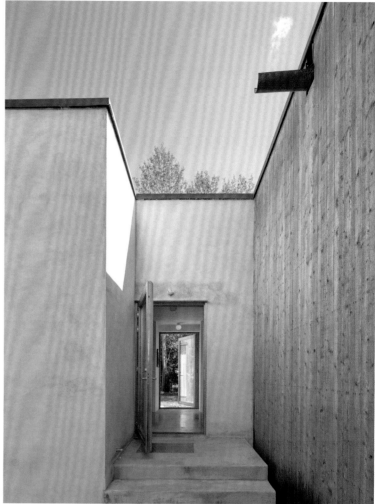

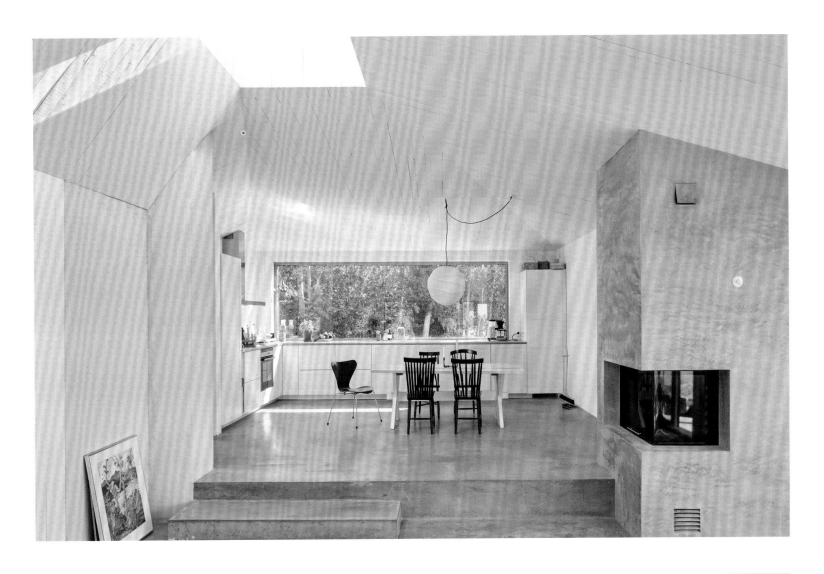

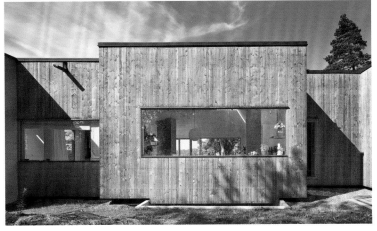

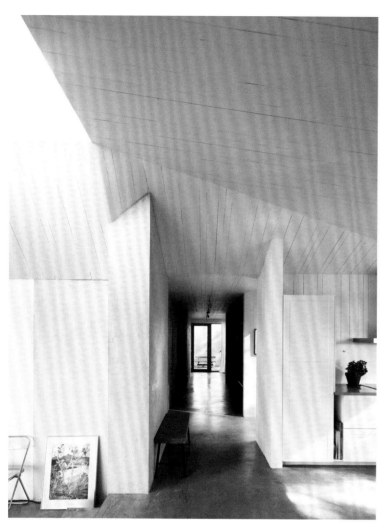
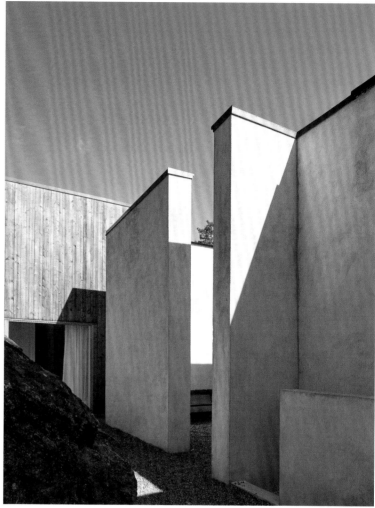

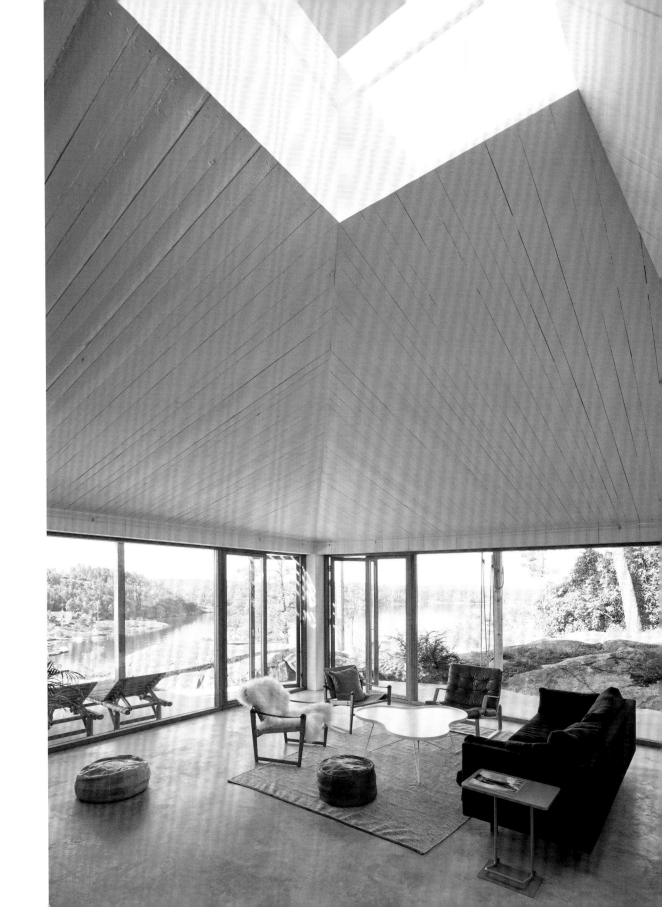

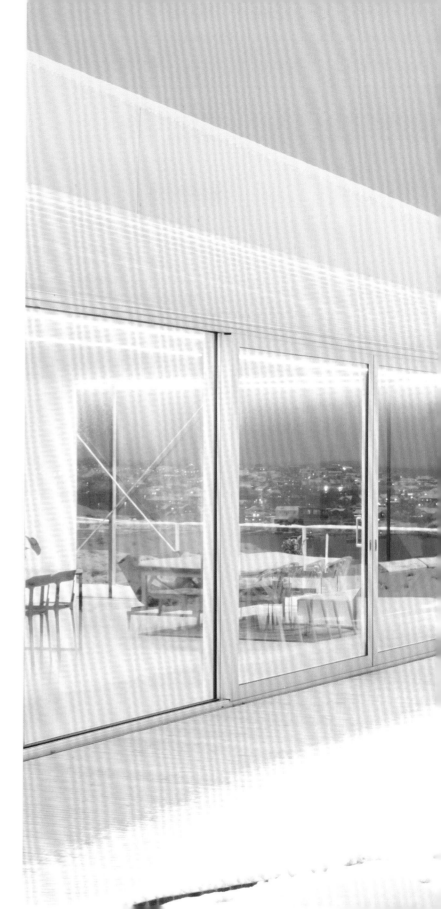

24.
PLASTIC
HOUSE II
UNIT
ARKITEKTUR AB

GOTHENBURG, SWEDEN

Area:
200 m²

Plot:
2,100 m²

Architect in Charge:
Mikael Frej, Klas Moberg

Project Team:
Mikael Frej & Klas Moberg

Interior Designer:
Mikael Frej & Klas Moberg

Photographer:
Per Nadén

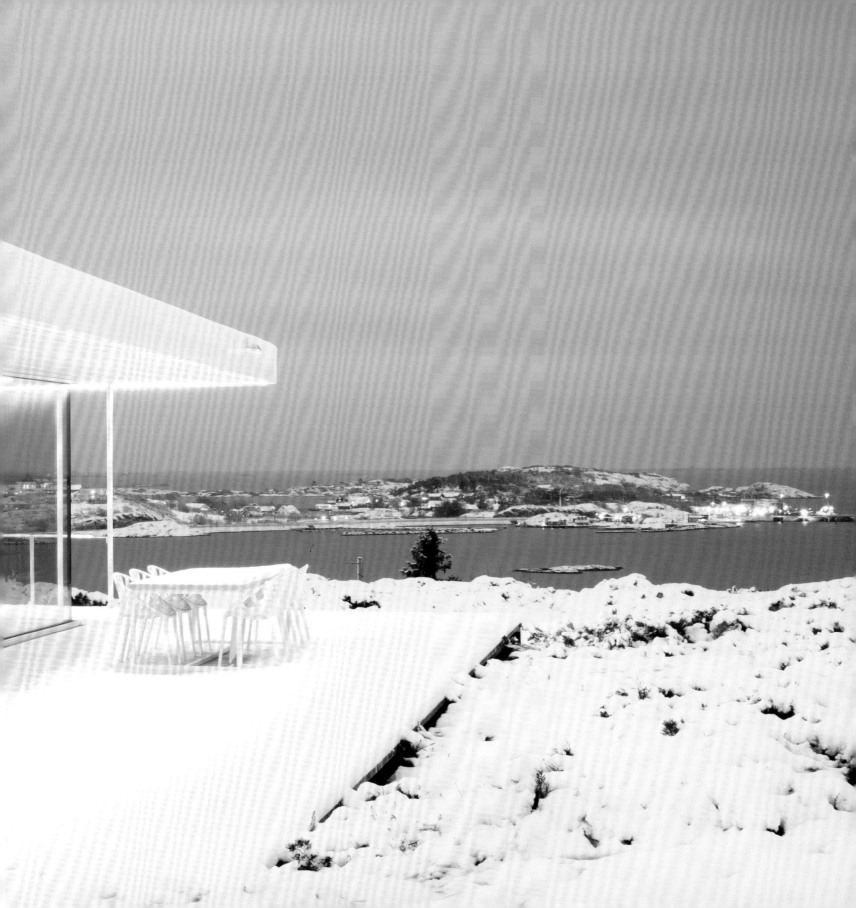

First Floor

Just to the west of Sweden's industrial town of Gothenburg lies Sweden's fourth biggest island – Hisingen. Just north of the Hjulvik ferry terminal to Gothenburg lies an area called Hästevik, its coastal landscape laden with ancient and sweeping outcrops of gneiss and granite. On this site, Unit Arkitektur's Plastic House II is situated, just a few short kilometres from their first ever built project: Plastic House I. It was even commissioned by the same clients.

As Hästevik gradually transitions from a bastion for weekend homes to a permanent residential area, building permits have been handed out liberally and smaller houses have been replaced with larger ones. As such, concerns about the effects on nature are considerable. Basements have been sunken into the mountains, and crevices and valleys levelled. The sweeping lines and the exposed mountains natural to the West coast have been blown away, bit by bit.

This led Unit Arkitektur to focus on two fundamentals while designing Plastic House II. Maximizing the view, and minimizing the

impact on nature. The house is laid foundational in such a way that it could be essentially demounted, and the only evidence of its existence would be 19 holes drilled in the mountain for the pillars. Toreduce the footprint further drains have been placed above ground and covered with a layer of earth.

They strove to keep the design simple yet luxurious, in the vein of the mid-century Californian Case Study Houses; a kind of glamour camping (glamping). They further endeavoured to build in dissonances both in material palette and actual geometric composition, to avoid a sense of classic modernism. The floor plan is simple - private areas facing east, and public areas, with direct access to the adjacent granite rocks, facing west. The division between the two parts lies at the centre of the house, along with the longitudinal axis.

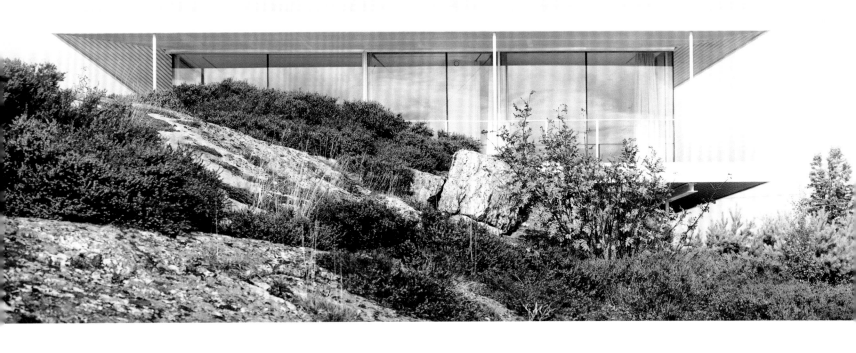
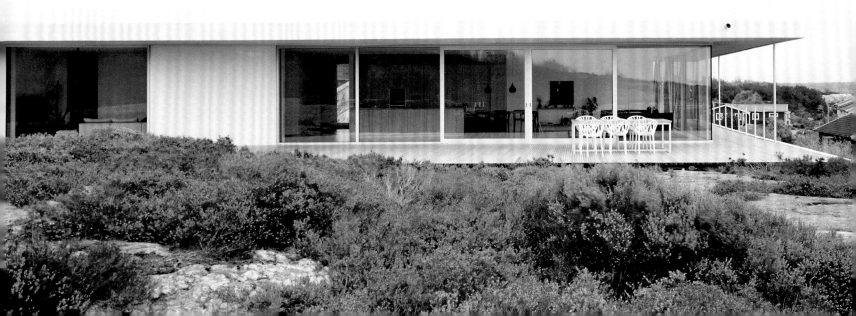

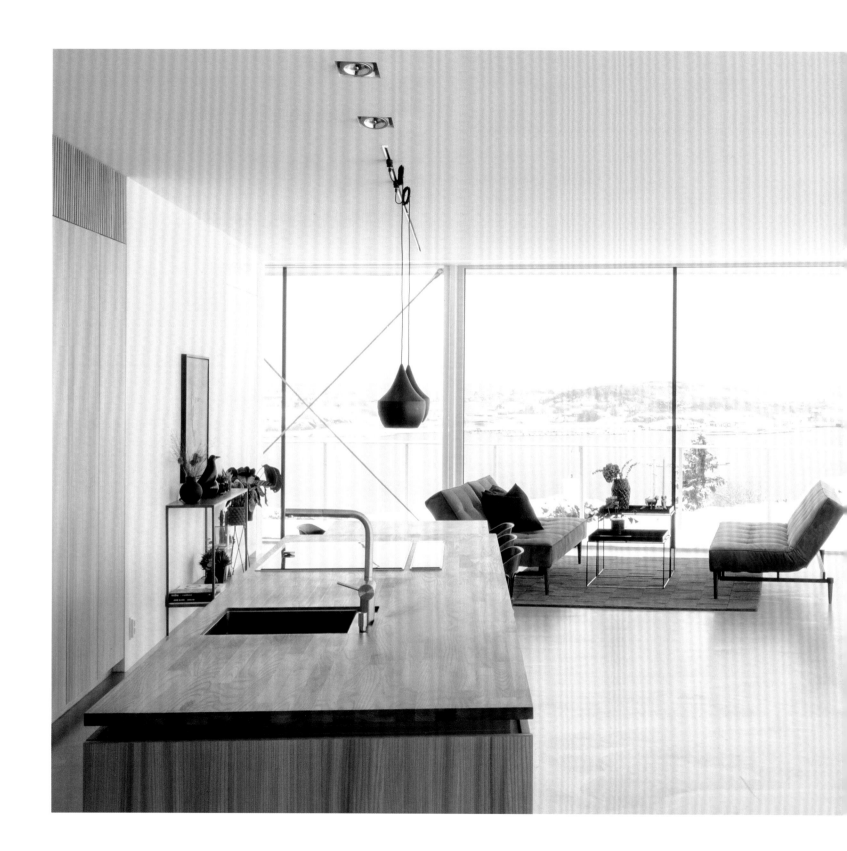

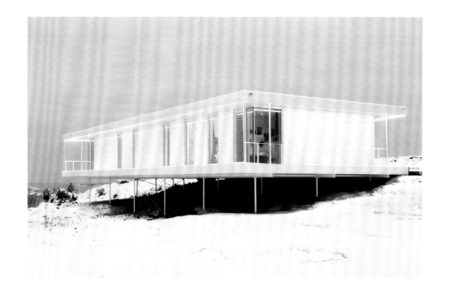

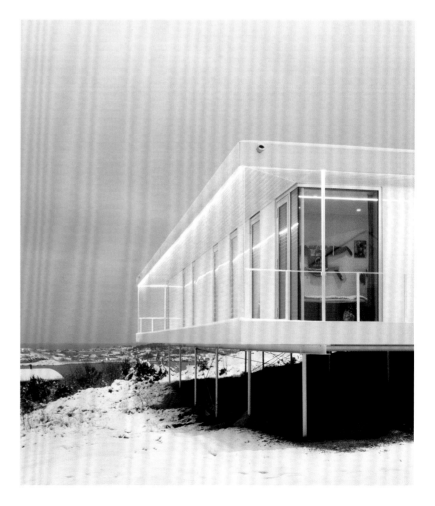

25.
SUNFLOWER
HOUSE
CADAVAL
& SOLÀ-
MORALES

GIRONA, CATALONIA

House Area:
250 m²

Plot Area:
300 m²

Architect in Charge:
Eduardo Cadaval & Clara Solà-Morales

Project Team:
Eduardo Cadaval & Clara Solà-Morales,
Moisés Gamus, Joanna Pierchala, Efstathios Kanios

Interior Designer:
Eduardo Cadaval & Clara Solà-Morales

Landscape Designer:
Eduardo Cadaval & Clara Solà-Morales

Photographer:
Sandra Pereznieto

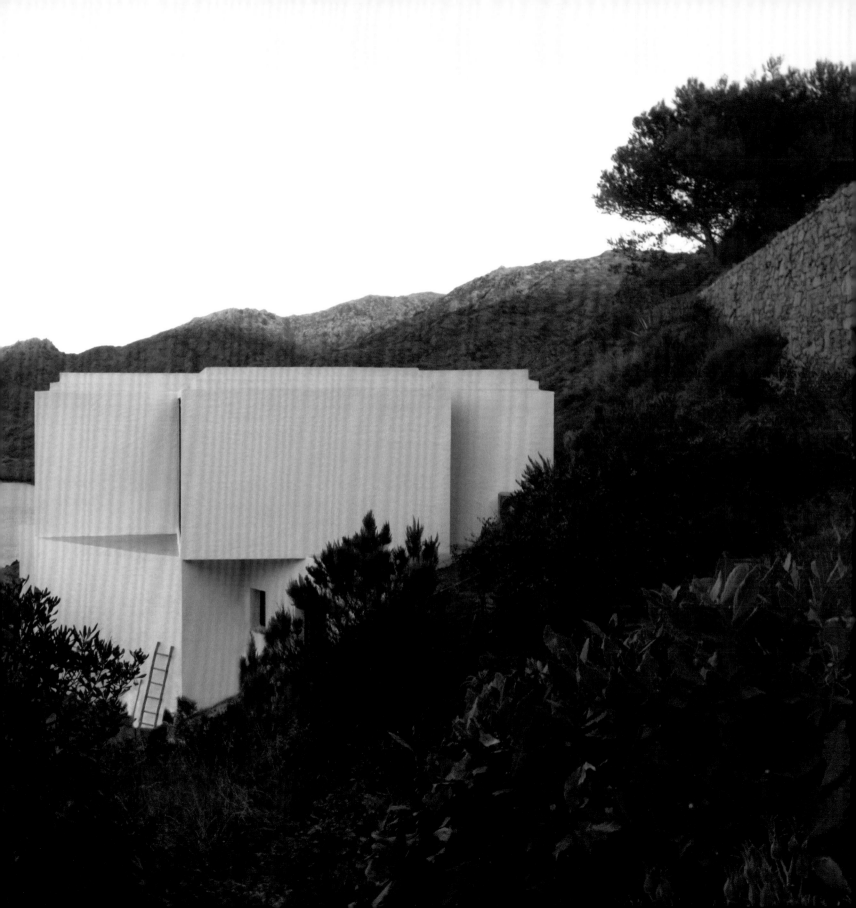

Ground Floor

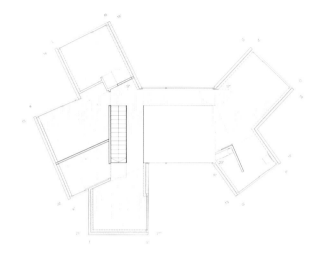

First Floor

Cadaval & Solà-Morales' Sunflower House sits in a surreal position; ensconced firmly between the pellucid waters of the Mediterranean and the temperamental, rocky coves of the Costa Brava. The site exists at a poetic intersection, where the Pyrenees swoop down to meet the water, generating a richness of wildlife, both on the coast and in the water.

The project was designed with the specific intention of breaking down, and utilizing, its panoramic interactions between the sea and the sky; interacting and interfacing directly with the immensity of the open sea, as well as both the rocky realities of the surrounding terrain andan ever changing sky that constantly shifts its texture due to the area's pervasive winds.

To achieve this, the entire project was designed as a series of small units that each frame a differentiated view, anditis through the transition from one unit to the other where the collective totality of the panoramic view is comprehended.

The name of the house comes via one of its central design tenets: the fact that it was cohesively designed as a mechanism for cultivating light and heat; like a giant sunflower. The overall composition of the house's varying volumes enables the sun's radiation to permeate the central communal living room, thereby heating the entire house.

Essentially composed of a series of stacked cubes, the residence is defined by a permeating relationship with the outdoors. From the interior, the experience of the house is continuous: from any point of the house one feels intrinsically related toone's surroundings, as the project's subtle spatial geometry ensures that the indoors are virtually indistinguishable from their environs. Meanwhile, all materials used in its construction are typical of the area, from the structure to the outdoor finishes of the walls.

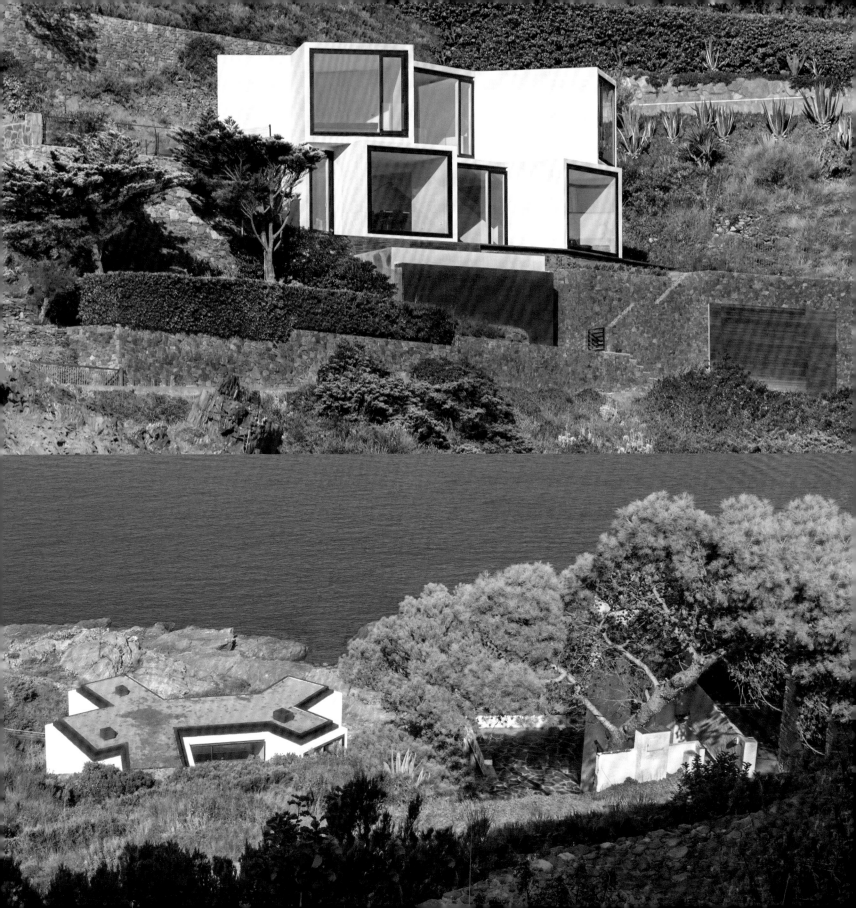

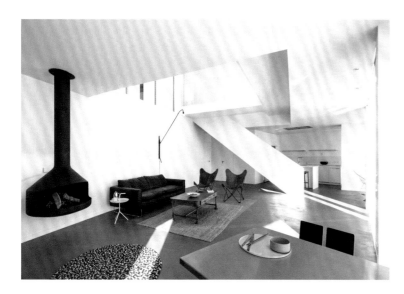
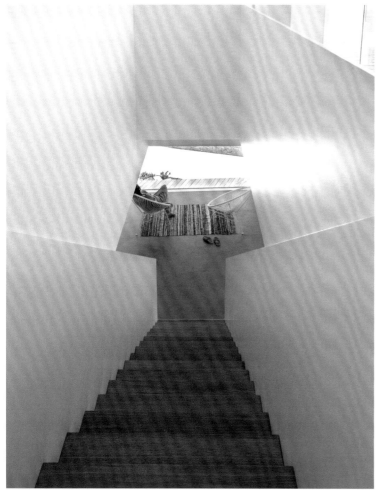
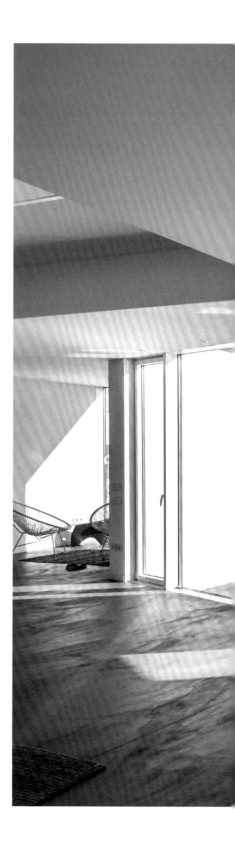

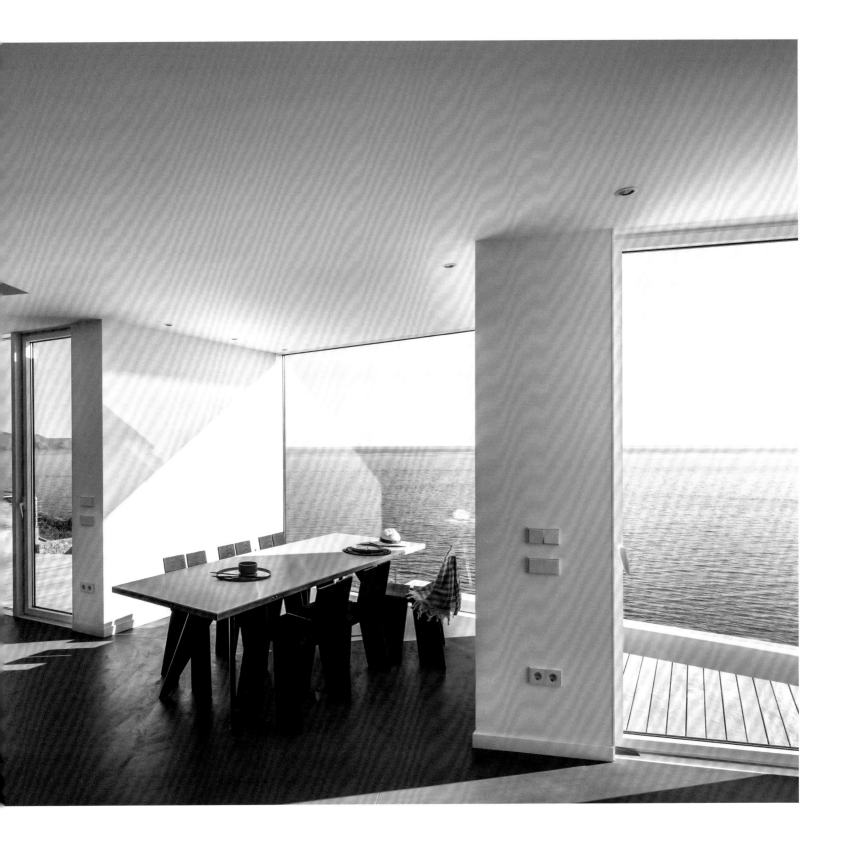

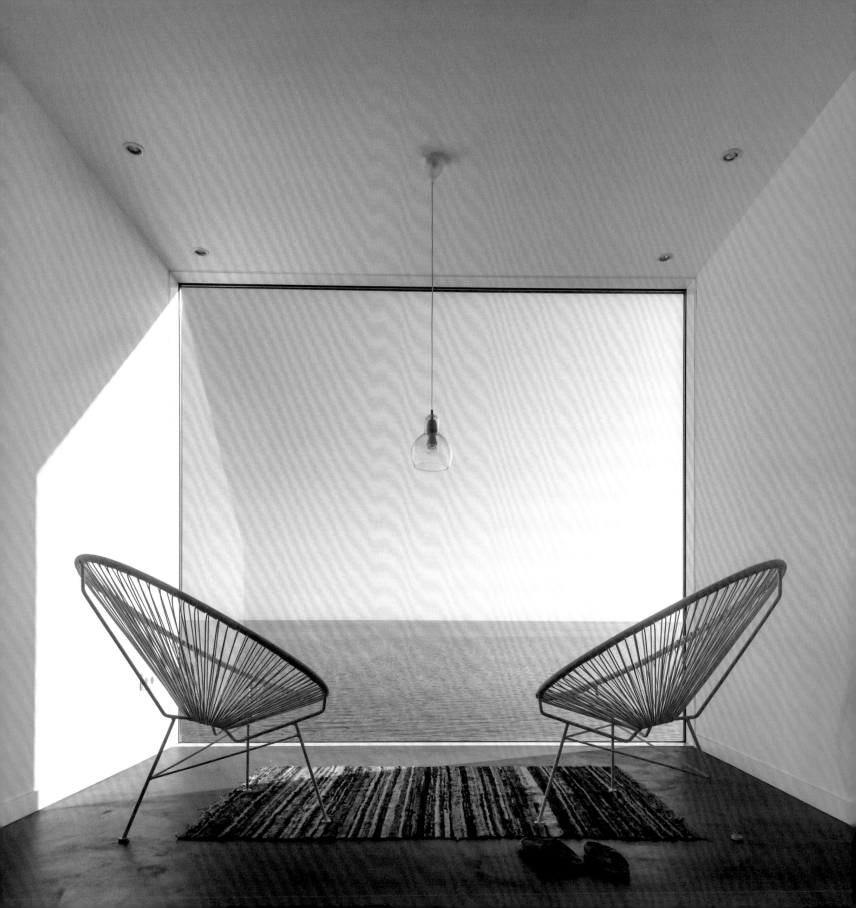

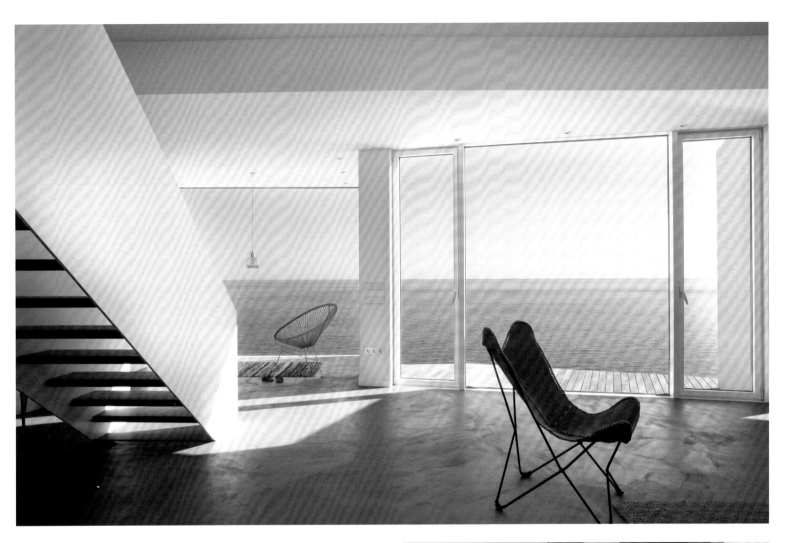

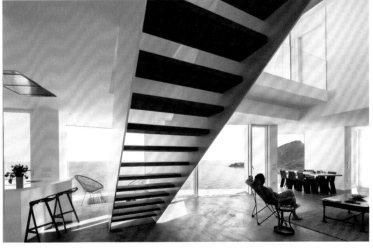

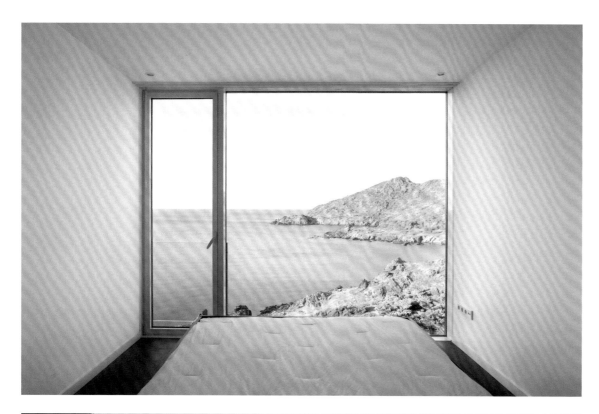

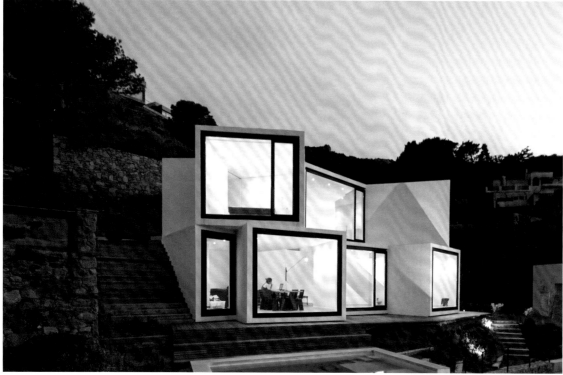

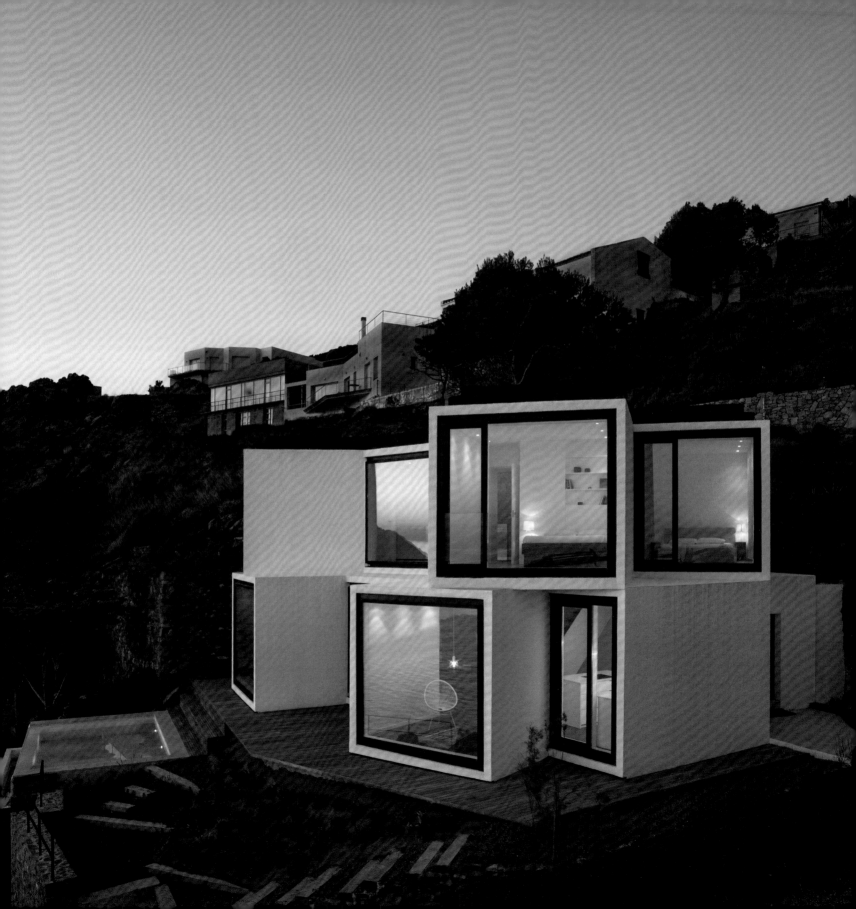

26.
PRIVATE HOLIDAY HOUSE TITUS BERNHARD ARCHITEKTEN

GARGNANO, ITALY

Area:
200 m²

Plot:
200 m²

Architect in Charge:
Titus Bernhard Architekten BDA II Dipl. Ing. Titus Bernhard

Project Team:
Dipl. Ing. Andreas Weissenbach

Interior Designer:
Titus Bernhard and Andreas Weissenbach

Landscape Designer:
Schleitzer baut Gärten creativ & innovativ GmbH

Photographer:
Florian Holzherr art & architectural documentations

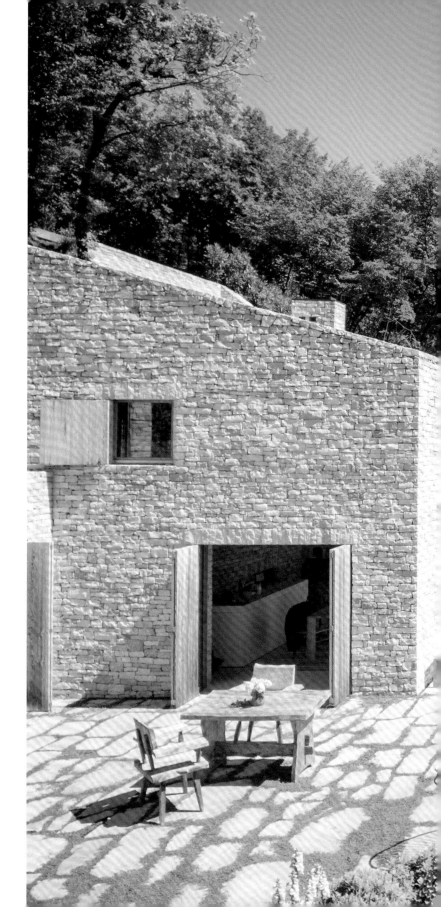

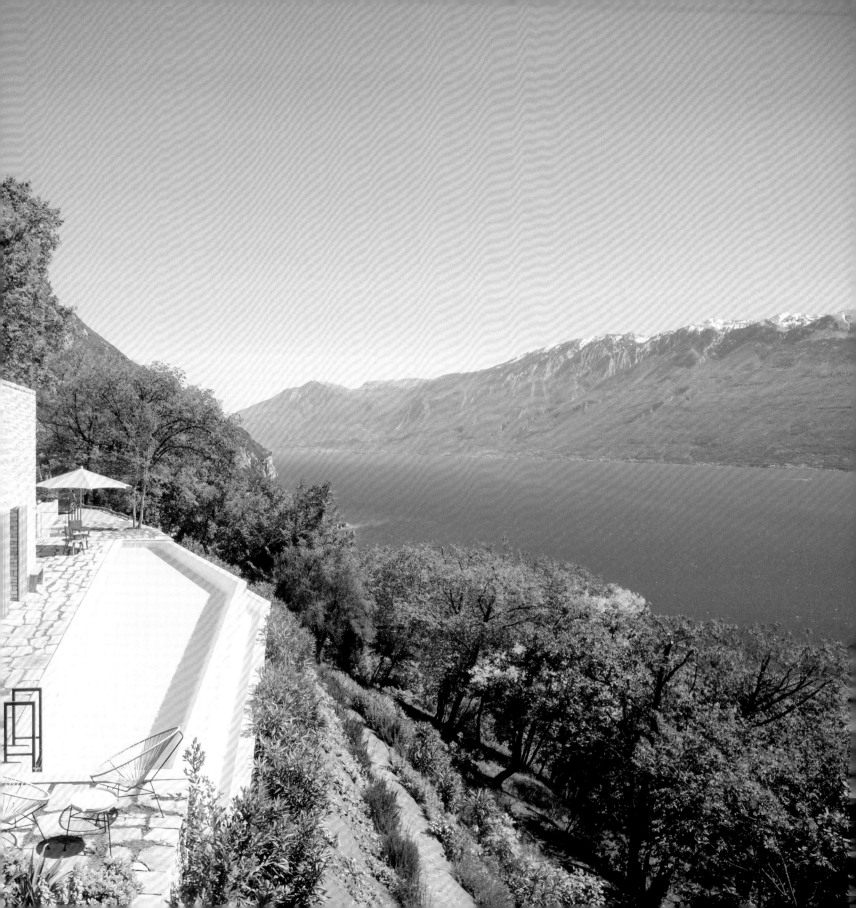

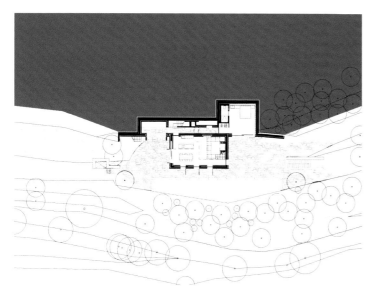

Ground Floor

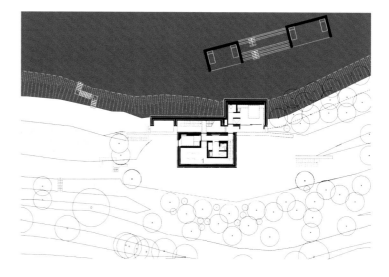

First Floor

Etched into a steep slope some 300 metres above the west shore of Lake Garda, in the small coastal Italian town of Gargnano, lies Titus Bernhard Architekten's sublime Private Holiday House, as aptly named a residence as ever there was.

Risen from the ashes of a forgotten ruin, which nonetheless boasted an extraordinary physical space, and stupendous lake views, the project essentially required a ground-up new build.

Endeavouring to remain faithful to the traditional aesthetics and material palettes of the neighbouring structures, Titus Bernhard Architekten crafted a simple, subtle symphony of locally sourced dry-stone construction; allowing what is essentially an wholly modern design to seamlessly blend into its surroundings. Mimicking the area's overarchingly rough, haptic character, the house flawlessly conveys a warm, rustic character, while concealing a thoroughly contemporary interior.

Built as a simple dual-height 'farmhouse' style main structure, with additional annexes hidden behind, the Private Holiday House revels in its 'wolf in sheep's clothing' stealth mission statement. Interiors are profound in their understatement, using earthy tones and unassuming designs that prioritize comfort and homeliness in lieu of pomp and circumstance.

The lone overt nodto the house's architectural underpinnings is an embedded pentahedron-shaped swimming pool, which sits on a barebones stone terrace, directly overlooking the lake below.

Private Holiday House is a breath of fresh air in the world of high-concept waterfront residential architecture. Espousing an ascetic understanding of the weekend pied-à-terre, it proves that eschewing glossy trappings doesn't need to mean a lesser experience.

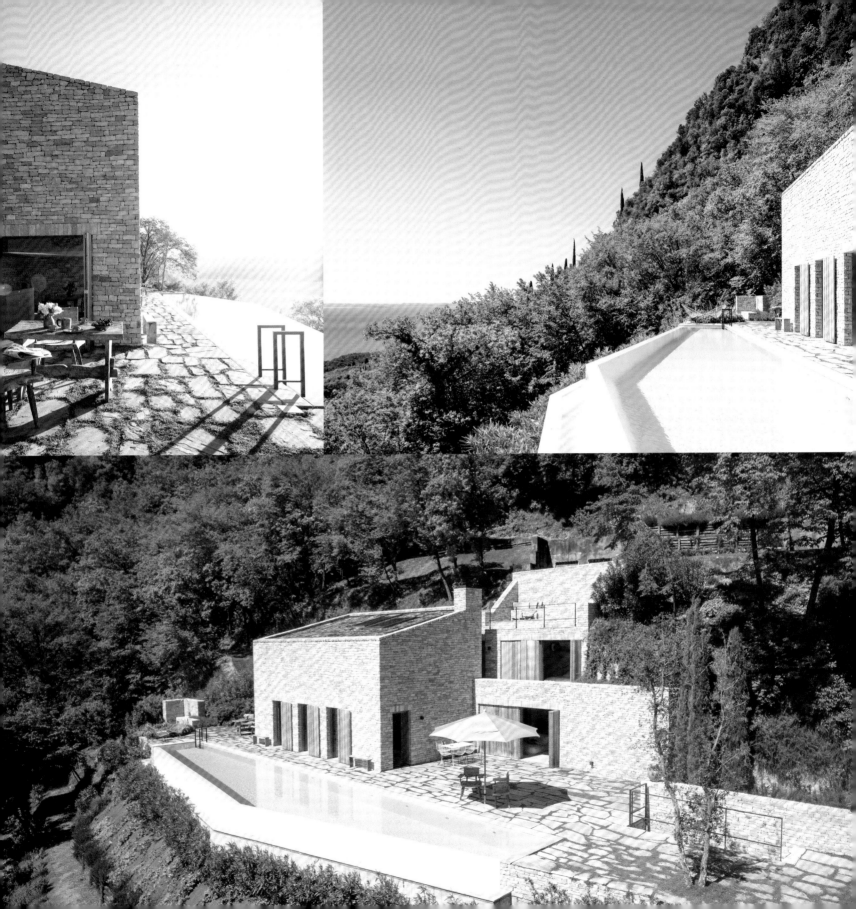

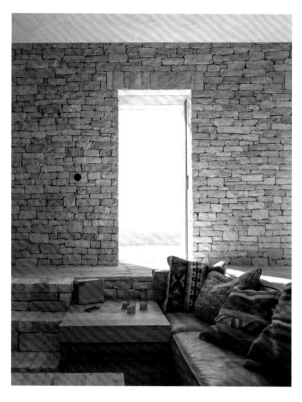

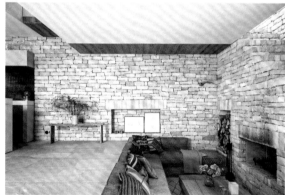

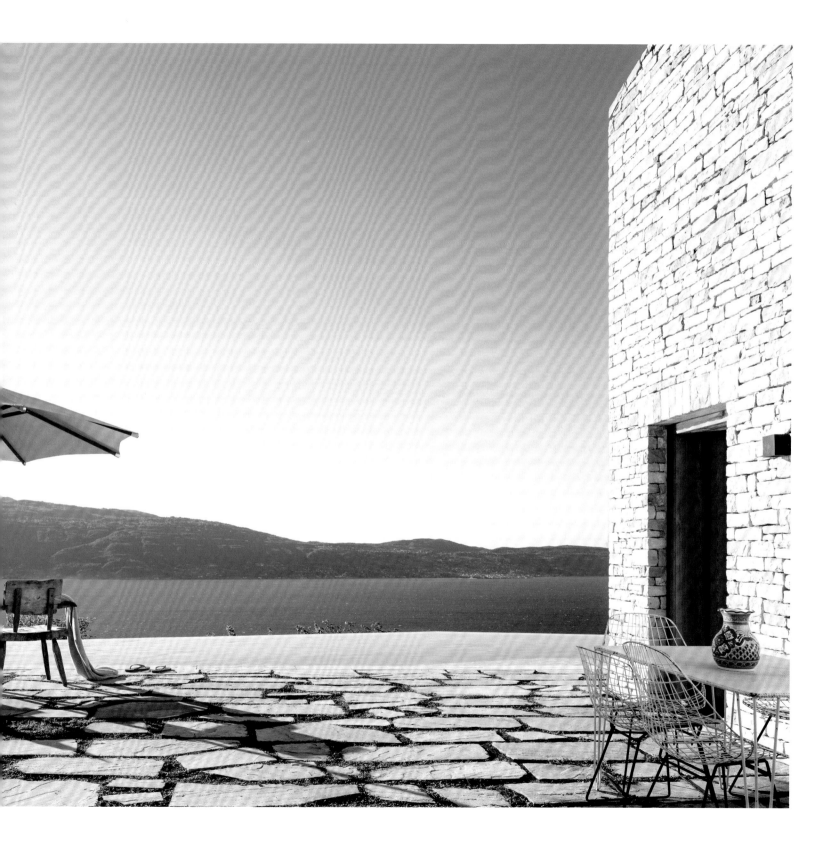

27.
SILVER HOUSE
OLIVIER DWEK
ARCHITECTES

IONIAN ISLANDS, GREECE

House Area:
315 m²

Plot Area:
4,035 m²

Architect in Charge:
Olivier Dwek Architects

Project Team:
Pierre Haccour, Thuy Vo,
Aristide Van Roy, Carl-Eric de Sivers

Interior Designer:
Olivier Dwek Architects

Photographer:
Serge Anton

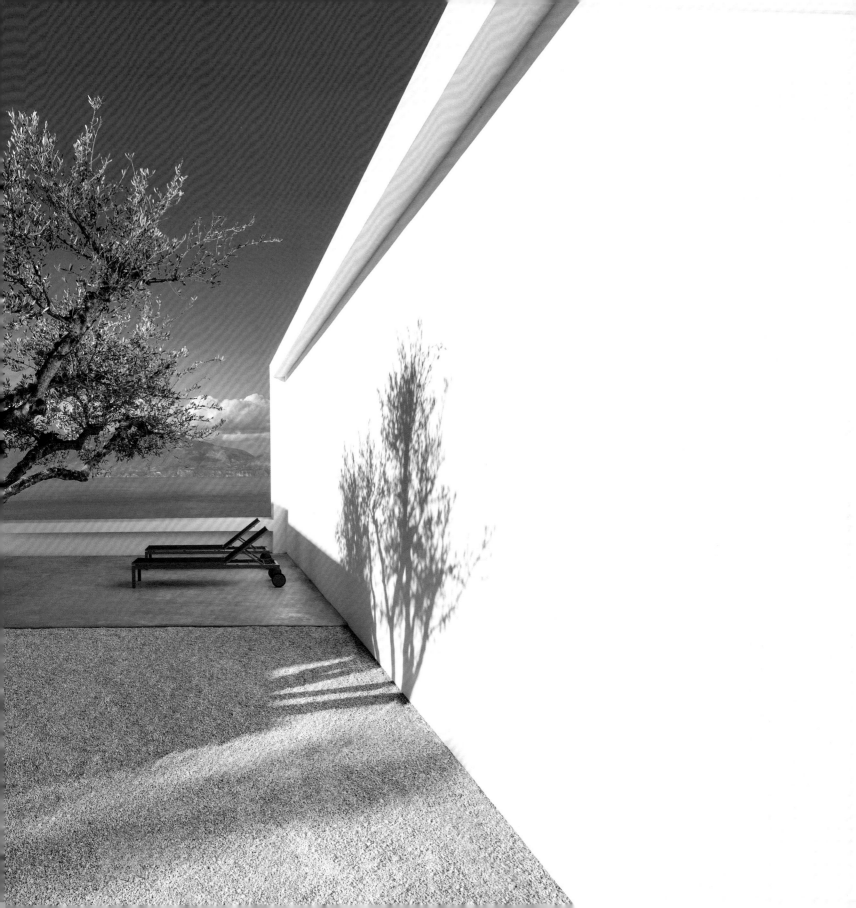

Ground Floor

First Floor

Belgium-based Dwek Architectes clearly revelled in the task set forth for them indesigning Silver House, an entirely fresh build on the small western Greek island of Zakynthos. A scarcely known, but historically rich environ (Homer wrote ofitin both the Iliad and the Odyssey), the island provides the sort of idyllic pastoral setting that simultaneously screams and whispers respite.

The firm took, as their conceptual mantra, a quote from the legendary French artist Yves Klein: 'blue has no dimensions, it is beyond dimensions'. Somehow eerily fitting, given the particular, and peculiar, shade of blue that the skies and waters of Zakynthos possess in abundance, and all the more so when considering just how reminiscent that blue is to Klein's most enduring legacy: a specific shade of lush and lurid blue nowknown simply as Klein Blue (or International Klein Blue).

The entirety of the residence was built with the panoramic views in mind. The terraces; sitting room; dining room; kitchen; bedrooms; even bathrooms were all designed with the view in mind.

The residence itself is divided between two levels, with the lower floor comprising an entrance hall, communal areas (living room, dining room, and kitchen), as well as the swimming pool, multiple terraces and patios, and a guest bedroom, while the entire second storey is given over to the master bedroom suite.

Continuing their intention to create a strong relationship between the site and its context, all living areas are oriented towards the seashore; while the ground floor living and dining rooms can be opened up to the outdoor areas via large sliding doors, creating a smooth and seamless transition between the interior and the exterior. To further highlight the stark, rich blues of the house's surroundings, the entire interior - from walls to cabinets to linens - is done in bright white.

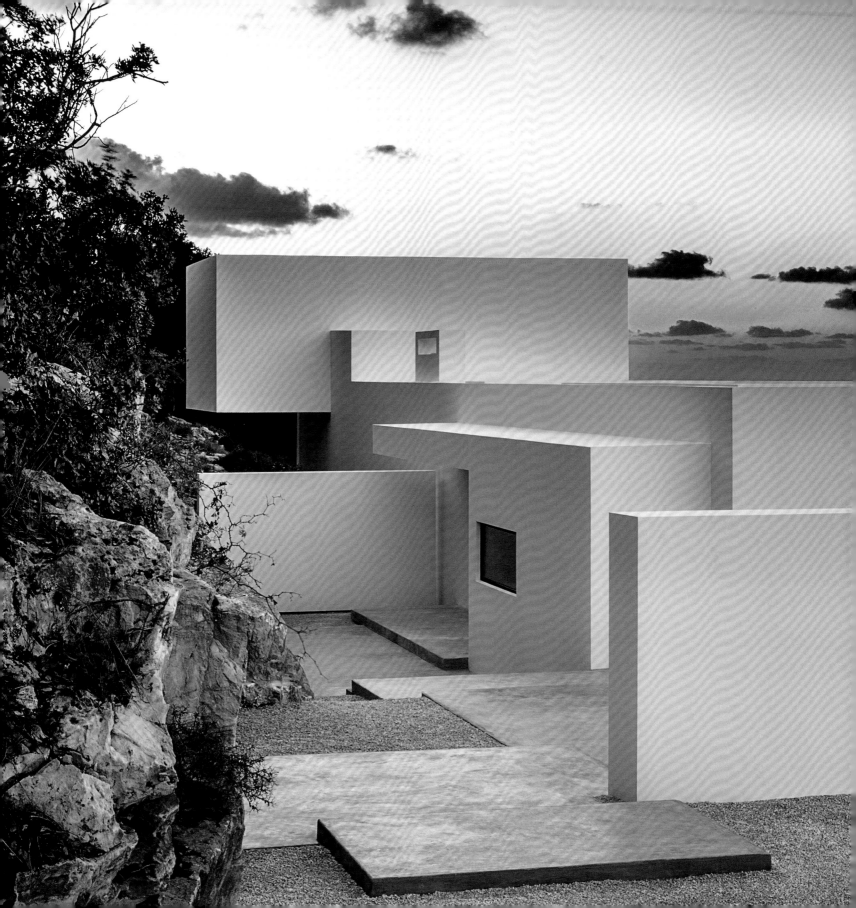

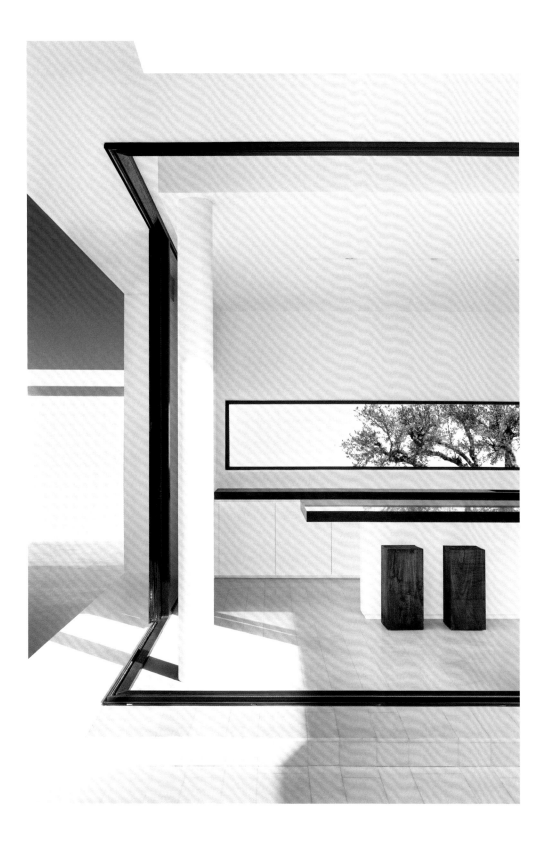

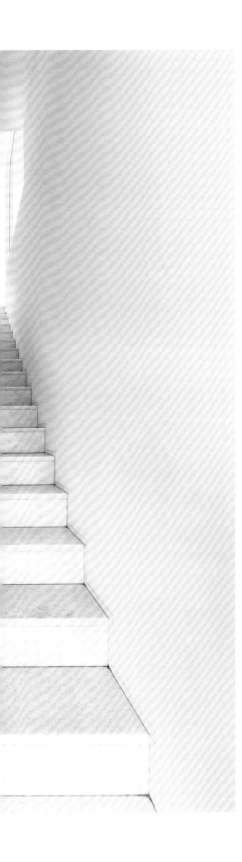
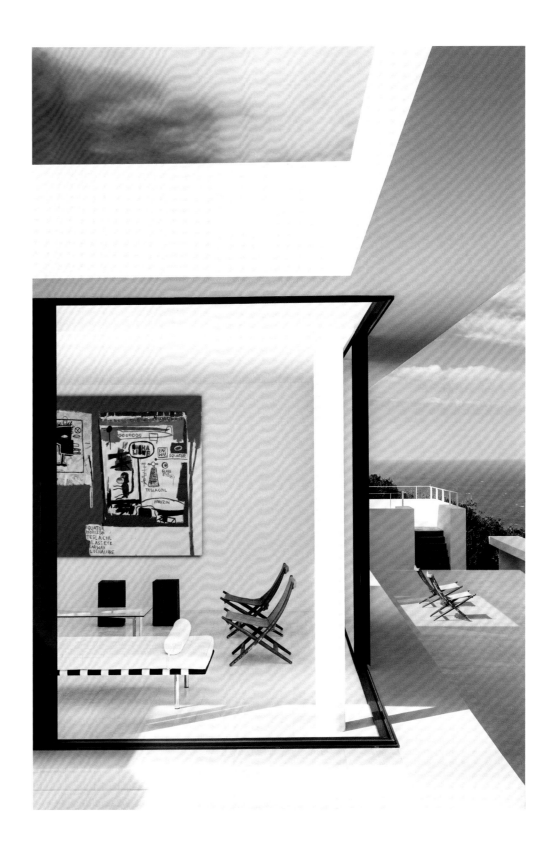

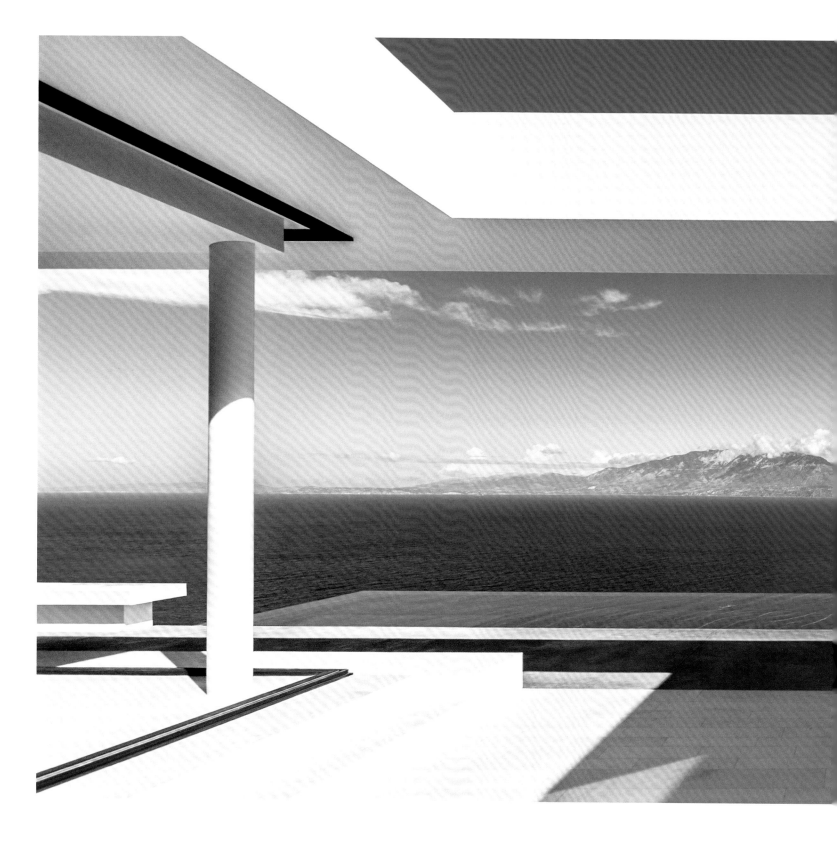

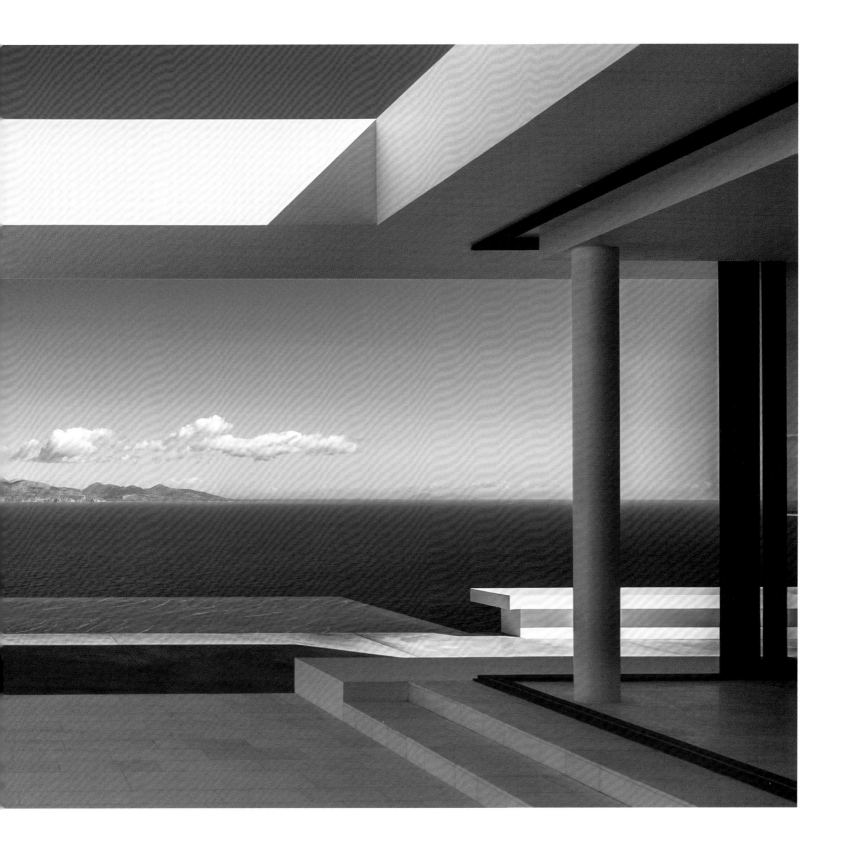

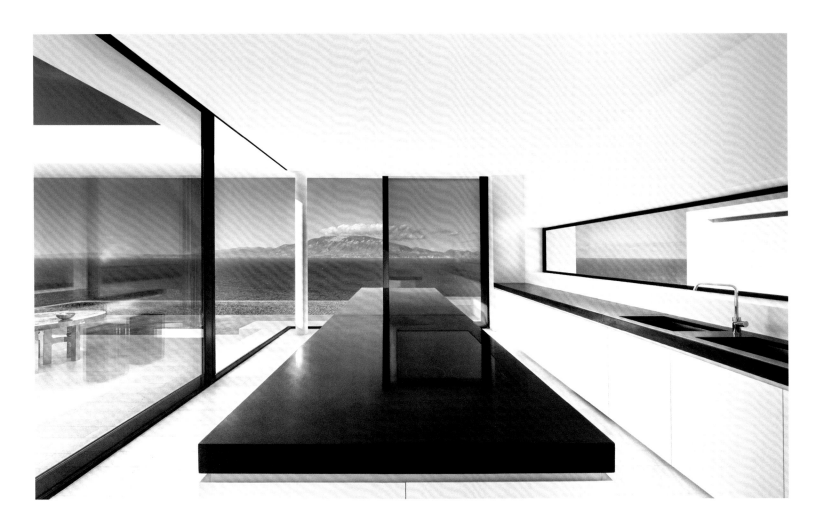

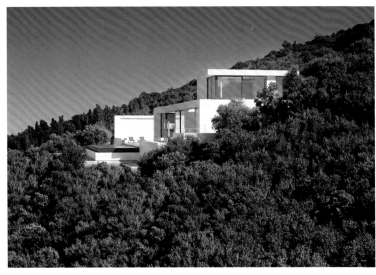

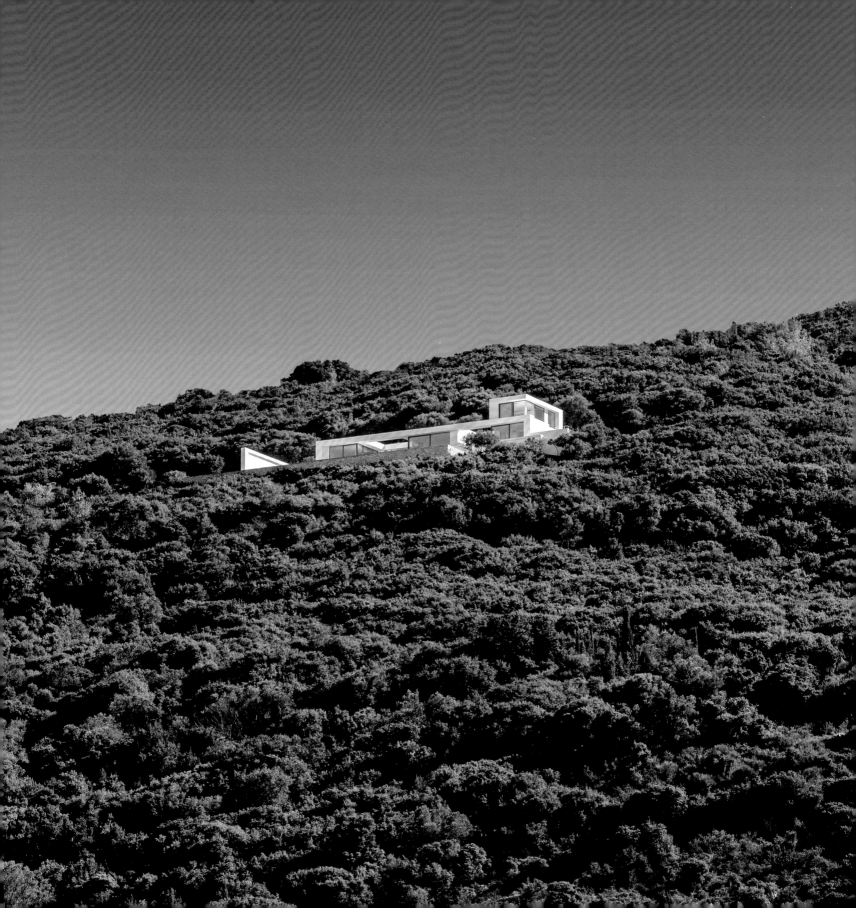

28.
HOUSE IN ACHLADIES LYDIA XYNOGALA

SKIATHOS ISLAND, GREECE

House Area:
200 m²

Plot Area:
895 m²

Architect in Charge:
Lydia Xynogala

Interior Designer:
Lydia Xynogala with Room Service

Landscape Designer:
Lydia Xynogala

Photographer:
Yiorgis Yerolymbos

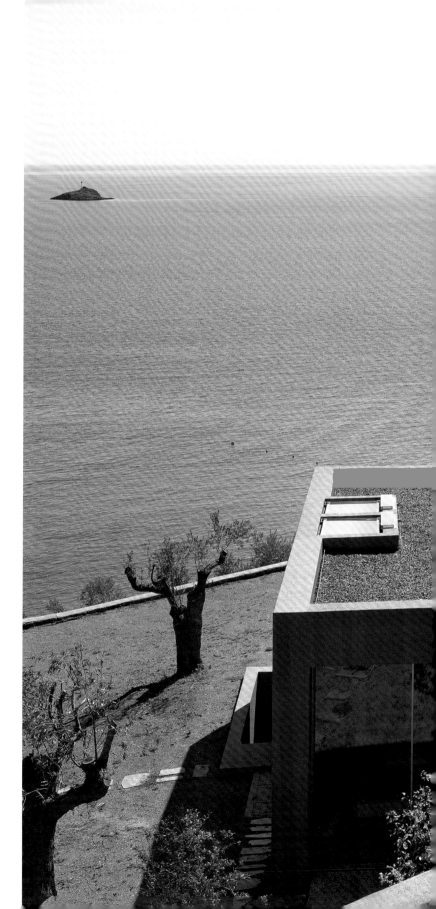

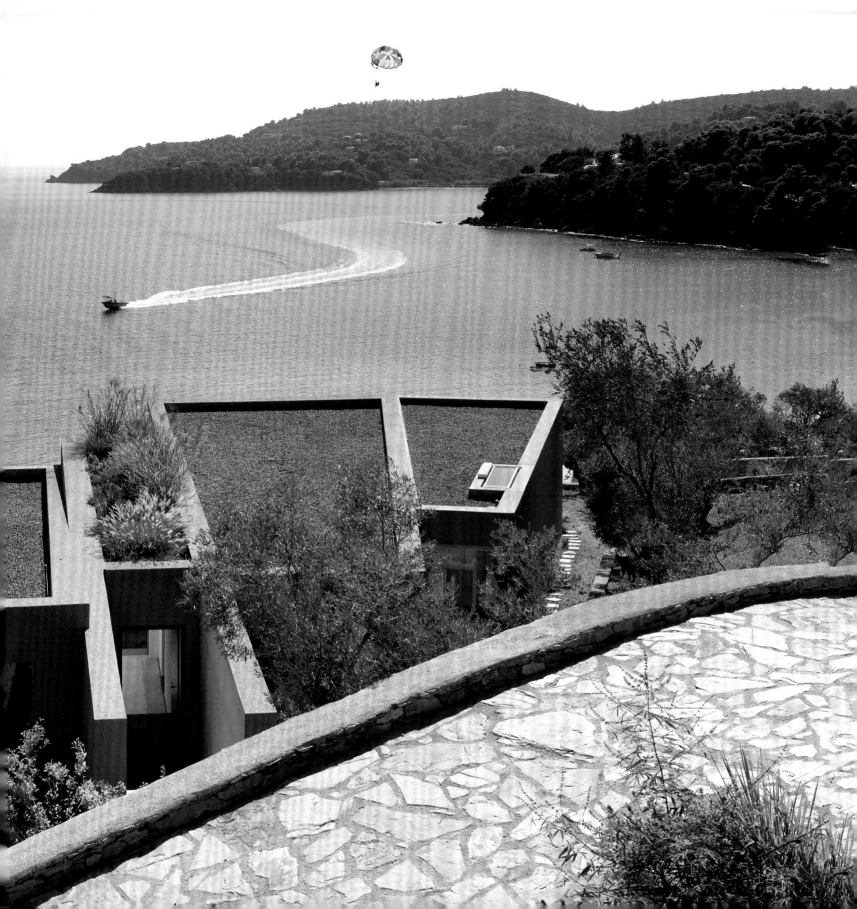

Ground Floor

Situated on a sloping triangular site facing the sea, House in Achladies is conceived asa series of parallel adjoining rooms, separated by retaining walls, a common feature in Mediterranean architecture.

Each 'room' sits at a different elevation following the natural topography, and contains a dedicated program. Access to the entry volume follows a staircase, which follows the sloping plot into the house. This entry condition introduces the primary interior intention of the house, that of a viewing apparatus looking out onto the sea.

The house's communal spaces are located in the centre volume, while the master bedroom and guest rooms are on either side. Each space is focused around a large opening to the south, contemplating the sea. These are complemented by smaller windows to the north, looking towards the slope. These openings also provide efficient cross ventilation for each room.

Sliding doors through the double walls which separate volumes allow passage from one space to the next. The walls themselves are constructed from solid concrete and provide significant thermal mass. The eastern and western façades that face the road and the neighbouring buildings have no openings. They protect the interior from the heat of the sun, as well as allowing for privacy.

Interior adjoining walls are custom-designed, and contain built-in furniture and storage spaces, including desks, bathroom sinks, and dressers. They are painted in a rich blue, which provides a dose of colour to the muted interior palette of concrete and cream paint.

Further material selections mimic those found in traditional Greek residential interiors, including sparkling terrazzo floors, which are used throughout the house both inside and out, as well as marble and plaster.

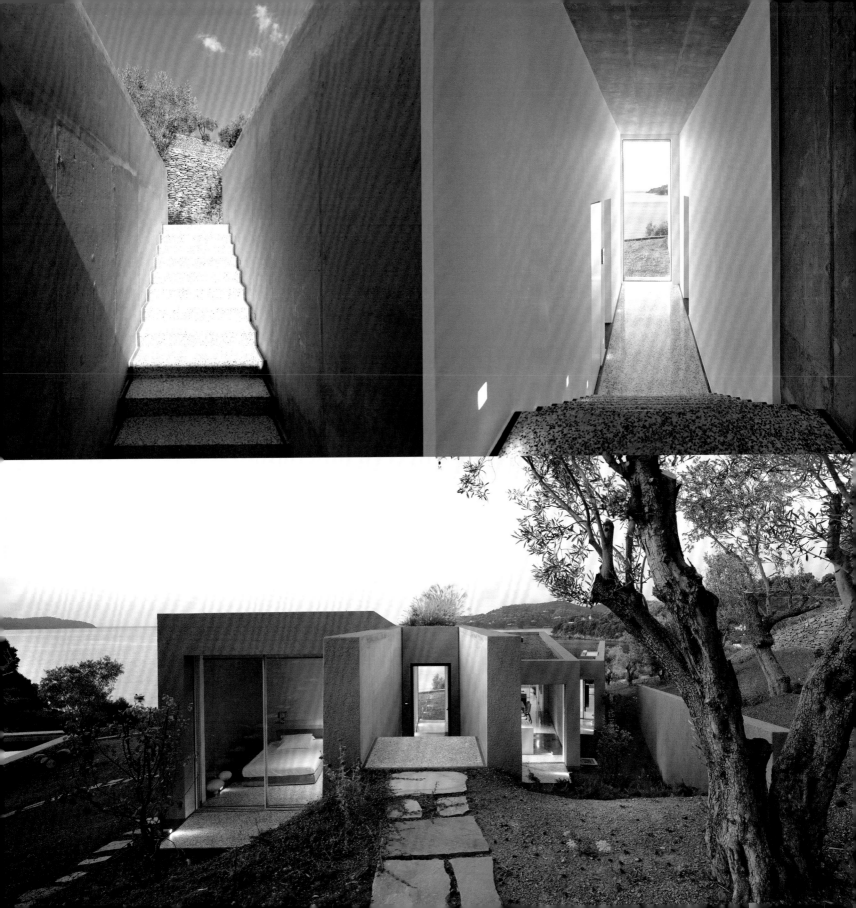

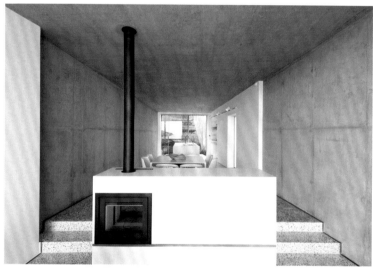

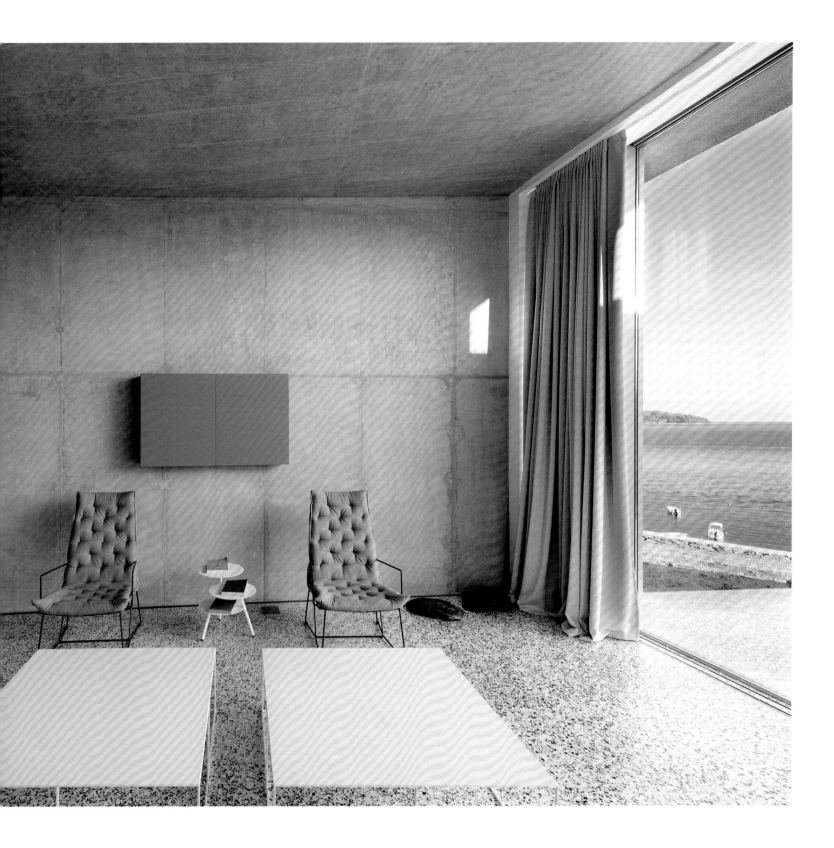

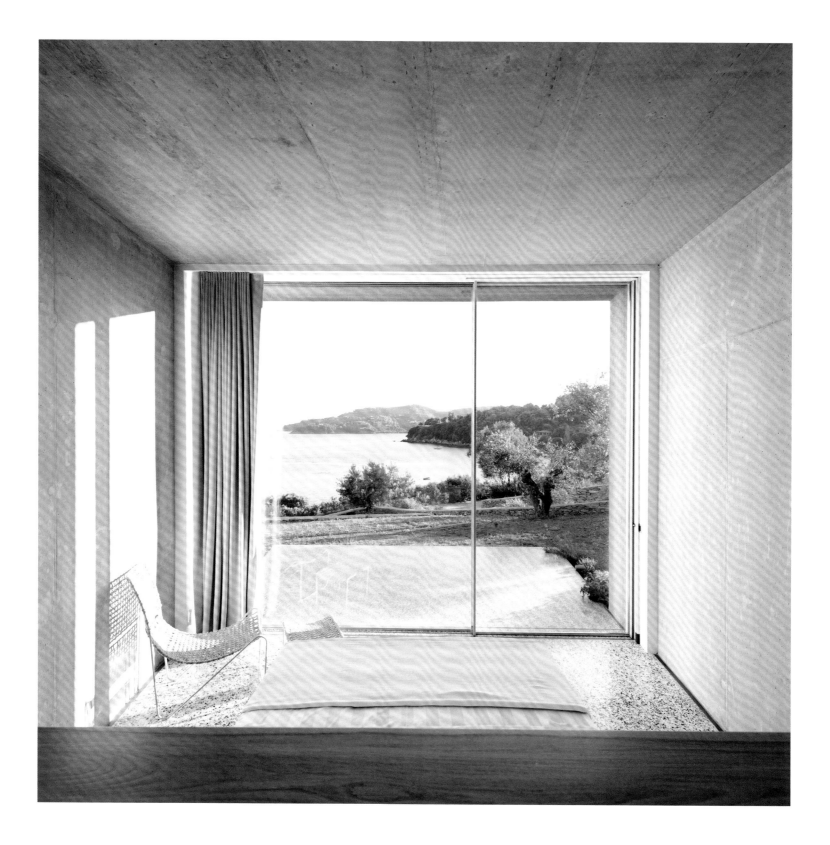

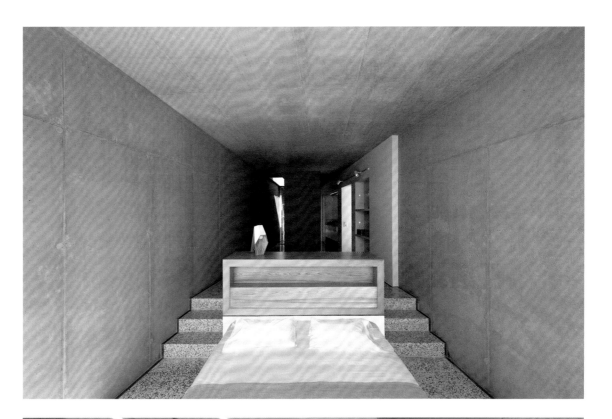

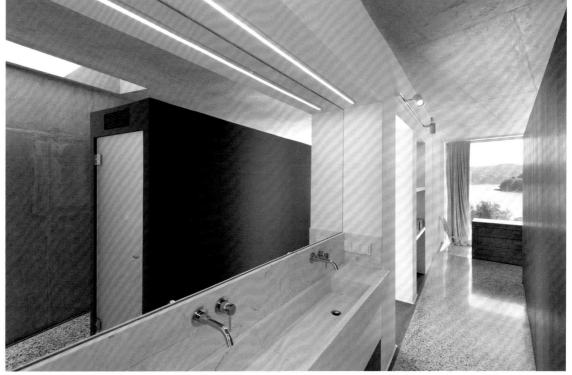

29.
VILLA IN MESSINIA
MGXM ARCHITECTS

MESSENIA, GREECE

House Area:
330 m²

Plot Area:
6,000 m²

Architect in Charge:
Mario Gonzalez, Christina Malama

Project Team:
M. Gonzalez, C. Malama, M. Grigoropoulou

Interior Designer:
MGXM Architects

Landscape Designer:
MGXM Architects

Photographer:
Panagiotis Voumvakis

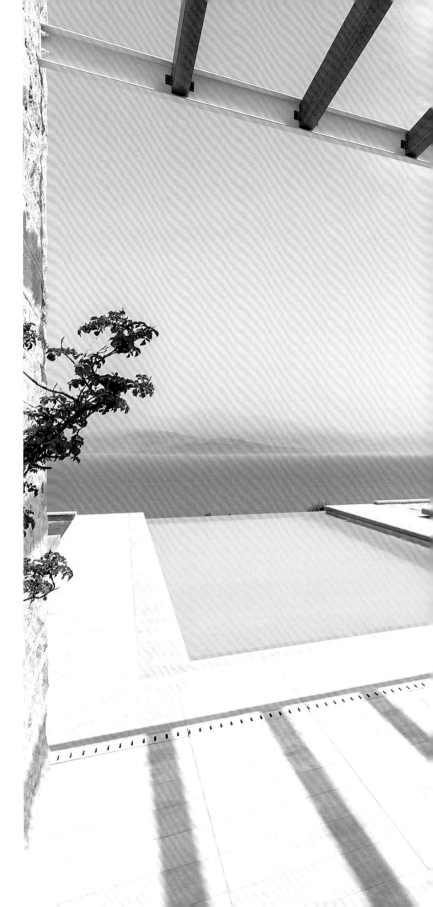

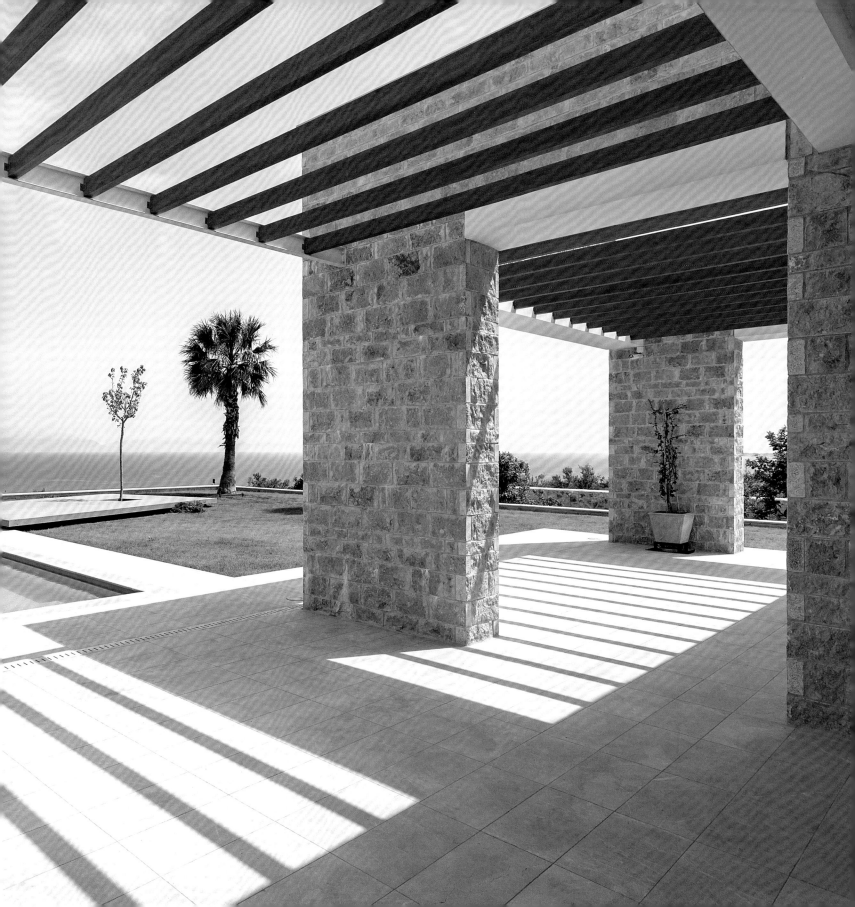

Ground Floor

First Floor

MGXM's Villa is situated in the foothills a short distance from the western coast of the Messinian Gulf.

The building itself is comprised of two main volumes, which are linked via a large outdoor patio, which functions as a living area during the summer. A narrow rectangular swimming pool is situated perpendicularly to the house, and is laid out in such a way that upon entering the house, guests are presented with a frame of the infinity pool leading the gaze to a strip of sea and the Taygetus Mountains beyond.

This situational harmony is further highlighted by the material palette. A single marble isused for the entrance path leading from the driveway through to the patio, and borders the pool. Local materials from the Peloponnese region were used wherever possible, including the predominant exterior palette of marble and stone, while walls are kept minimal in gloss white, which reflects light and highlights the juxtaposition of the primary materials.

The main residence's two storeys follows a traditional programme, with the living areas at ground level and bedrooms on the floor above. Large openings looking out towards the water on both levels provide a sense of open space throughout the residence's interior. On the first floor, the master bedroom's en suite bathroom resembles a wooden cube, which has been placed centrally in the bedroom. This detail is echoed by the wide-set louvers at the near edge of the outdoor patio, which bring to mind E. Stewart Williams' Twin Palms House.

As mentioned, usage of natural local materials runs throughout the project. Argolis Marble (Lygourio Dark) is the primary material; being used for everything from accent blocks at the entranceway to flooring to tiles for the bathroom walls. Areas are cleverly delineated within a single material by alternating between polished or matte or grip finish, depending on the area.

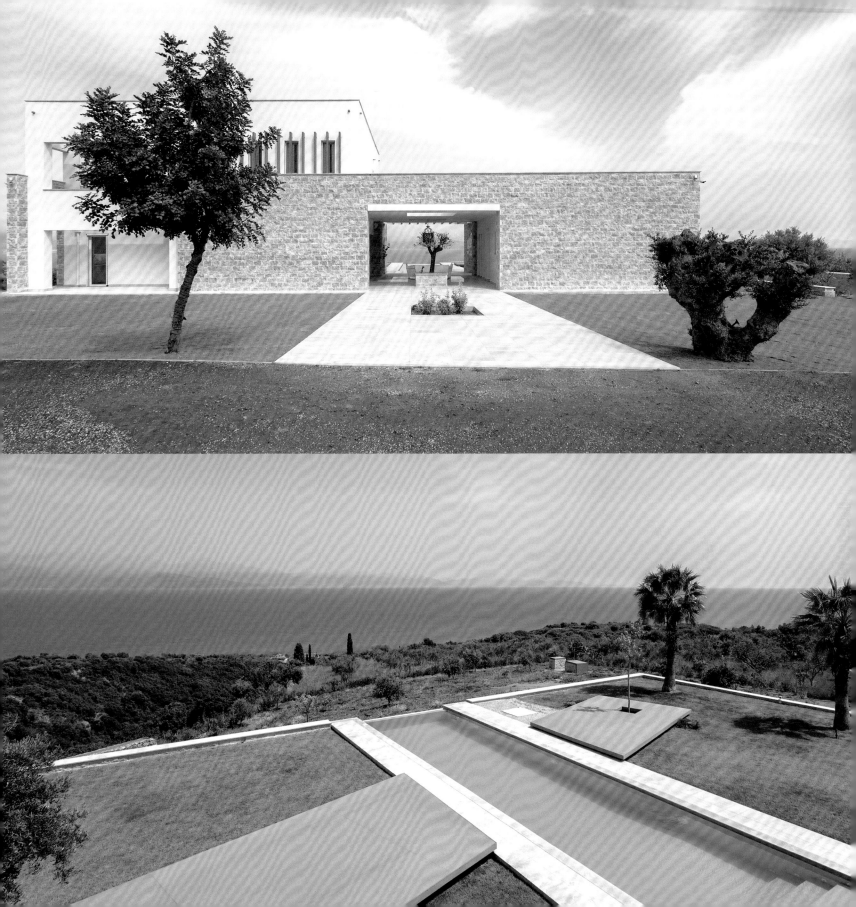

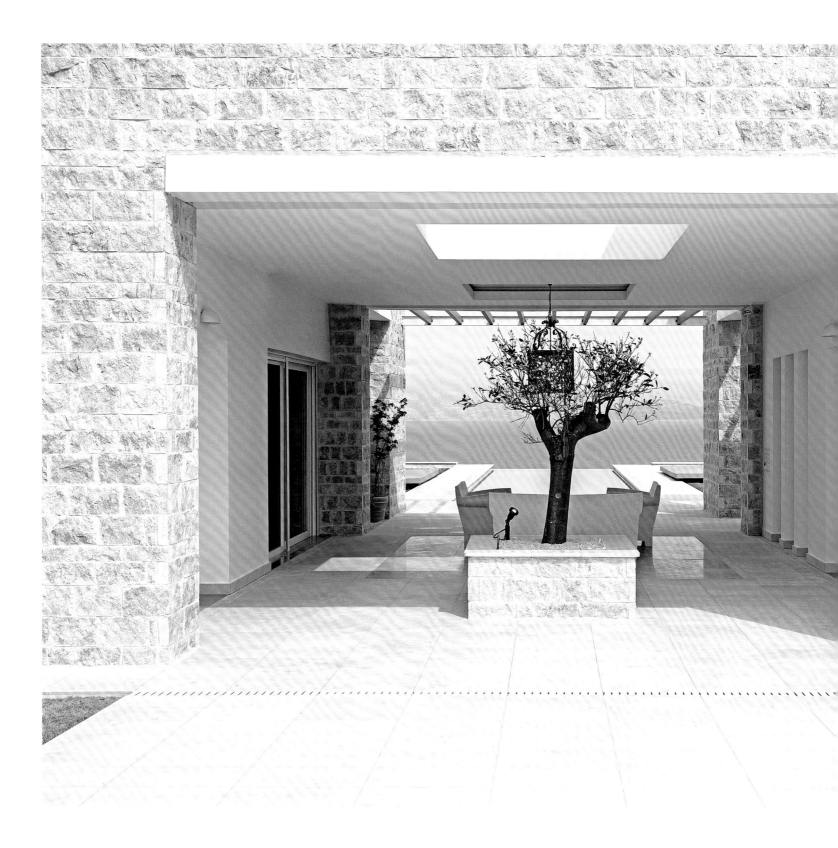

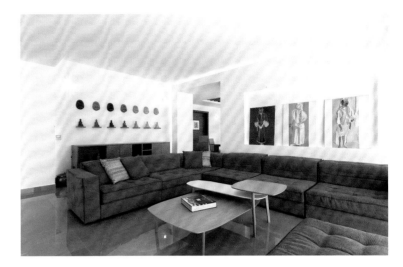

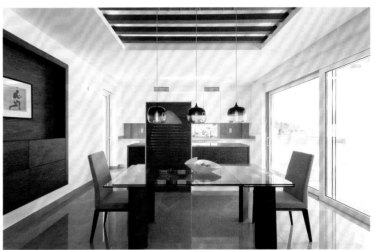

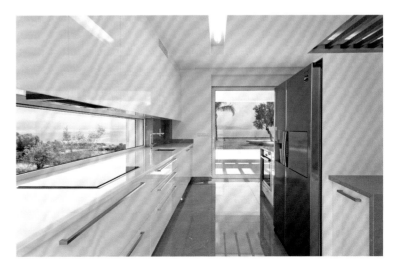

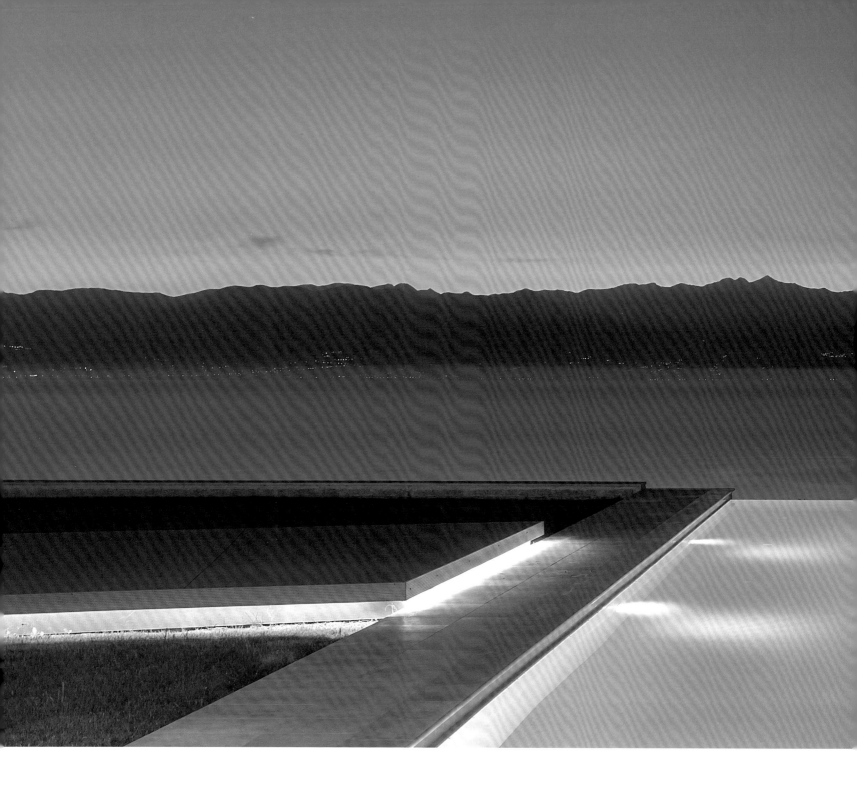

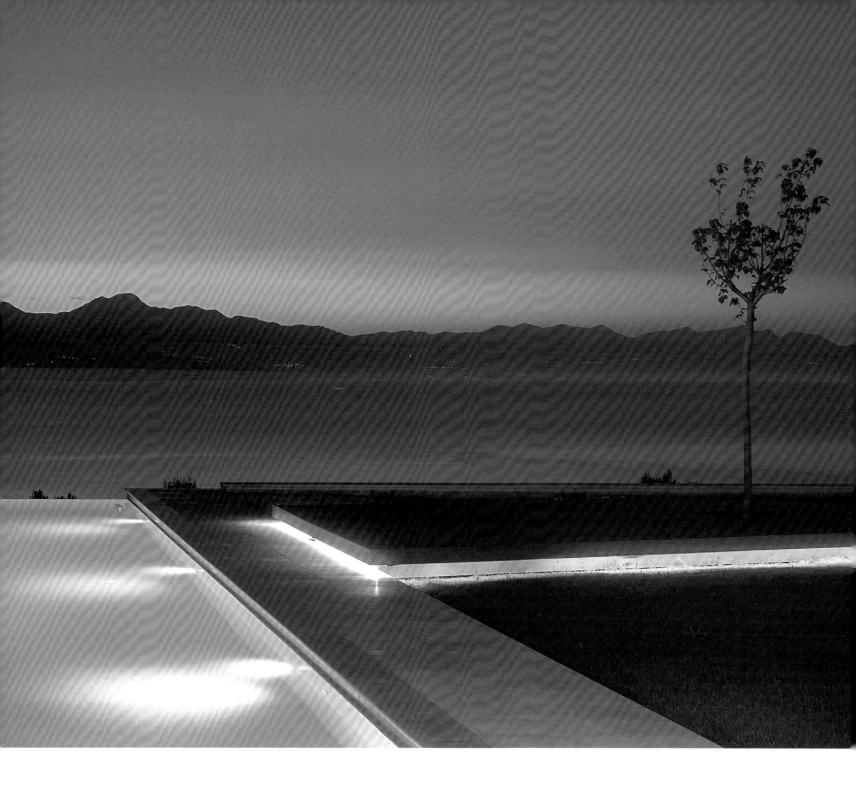

30.
HOUSE IN ZAKYNTHOS KATERINA VALSAMAKI ARCHITECTS

AMMOUDI, GREECE

House Area:
275 m²

Plot Area:
2,500 m²

Architect in Charge:
Katerina Valsamaki

Project Team:
Nikos Ioannou, Alexandra Baklatzi, Elena Ifanti,
Vilma Agrafioti, Katerina Charisiadou

Interior Designer:
Katerina Valsamaki

Landscape Designer:
Katerina Valsamaki

Photographer:
Konstantinos Thomopoulos

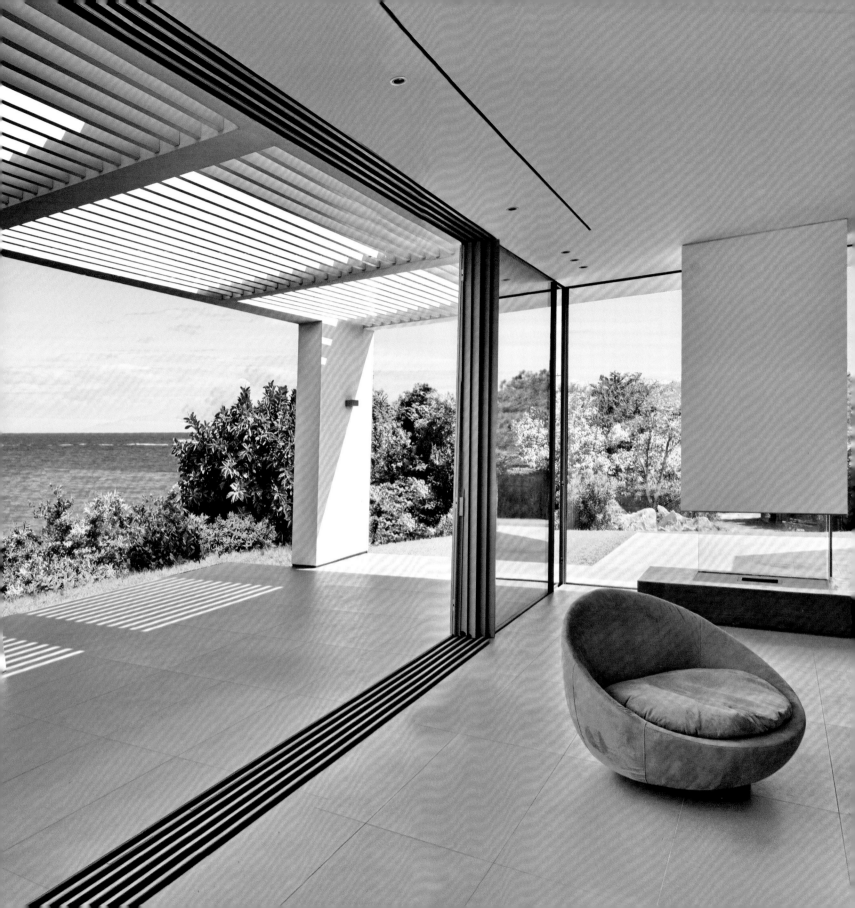

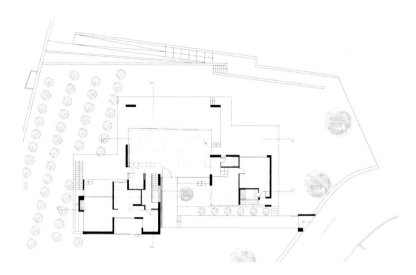

Ground Floor

Located on the northeast corner of the Greek island of Zakynthos, in the summer village Ammoudi (which appropriately translates to sandy beach), this stunning vacation residence incorporates sufficient programmatic accessibility to eventually translate to full-time home. The 2.5 plot opens up to the sea to the east, and is densely planted with trees and vines, which creates a private garden.

Valsamaki's design is focussed on integrating the building into the surrounding landscape of low vegetation, vineyards, and olive trees, whilst simultaneously ensuring that all significant areas of the house have a sea view. This dictated a largely linear planning arrangement, with the living spaces are developed in the centre and the sleeping areas are located on either side of the central communal space. The position, orientation, and height of the building make it almost invisible from the street, while it opens up completely to the sea.

The house is composed of three low volume sections following the gentle natural slope of the site, and its height gradually increas-

es from the road into the plot. The lowest section is integrated with the southwest pergola that defines the entrance and it also connects all various sections together. A catwalk parallel to the southwest façade extends through a semi-covered courtyard into the entrance of the house. The courtyard acts as part of the garden and it is directly accessible from the office/guestroom.

The main-central volume, which accommodates the communal areas, opens outt hrough the large glazed screens to the sea, and the stepped garden on the east and the courtyard and olive garden on the west.

All internal living areas can be converted into a large outdoor covered space when the sliding glass panels are opened. Overhead louvers shield the outdoor terrace from direct sunlight, and cut-outs call to mind Sarasota modernist architecture.

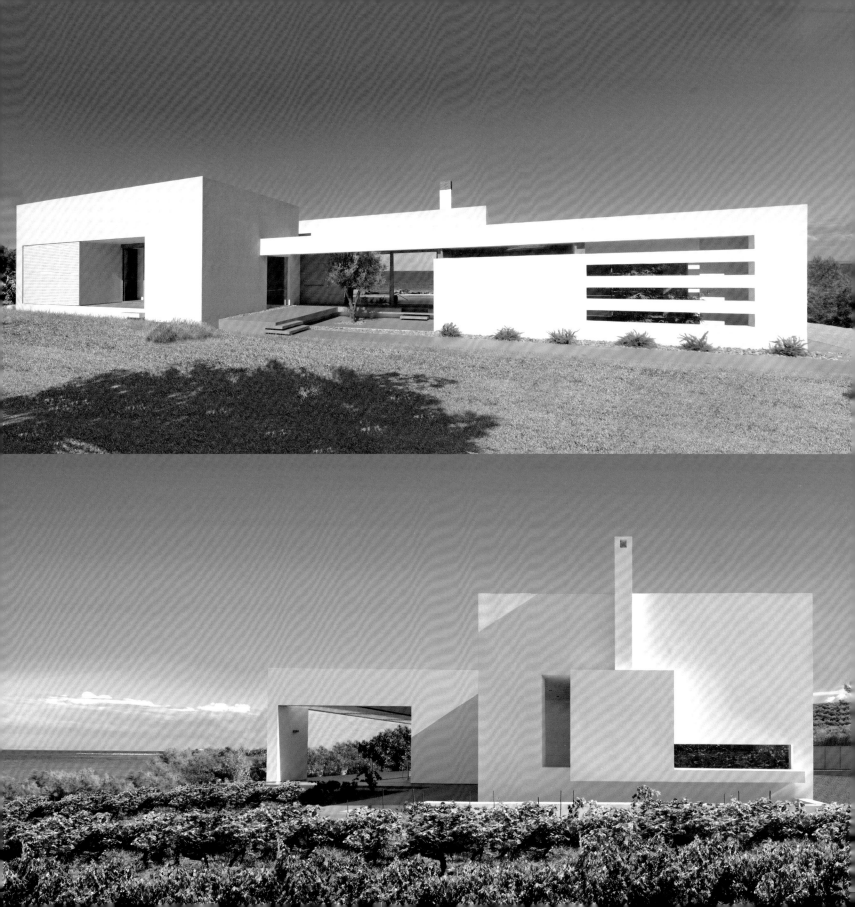

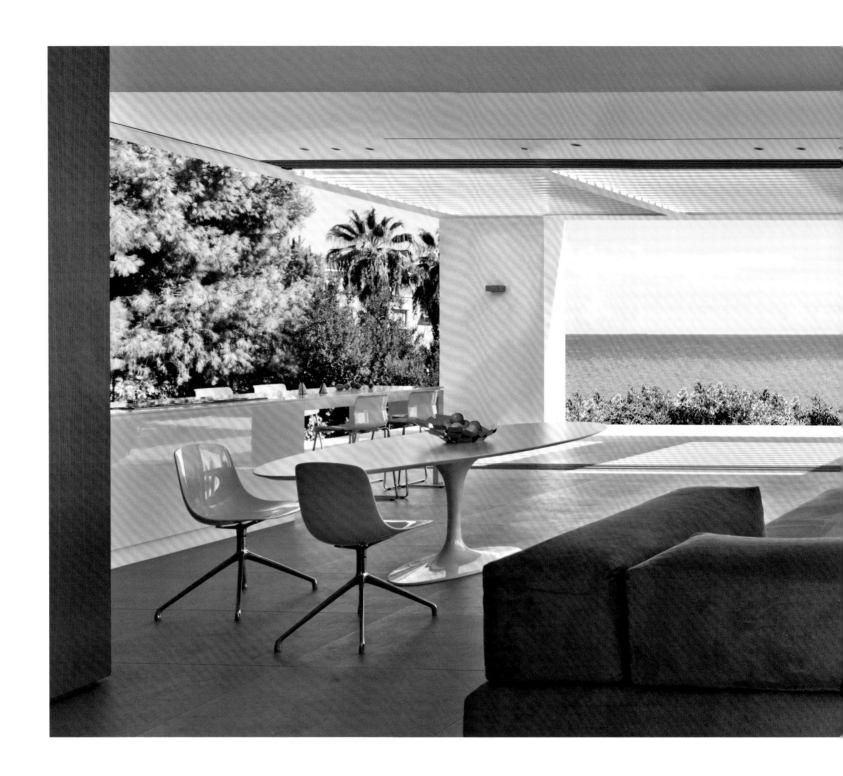

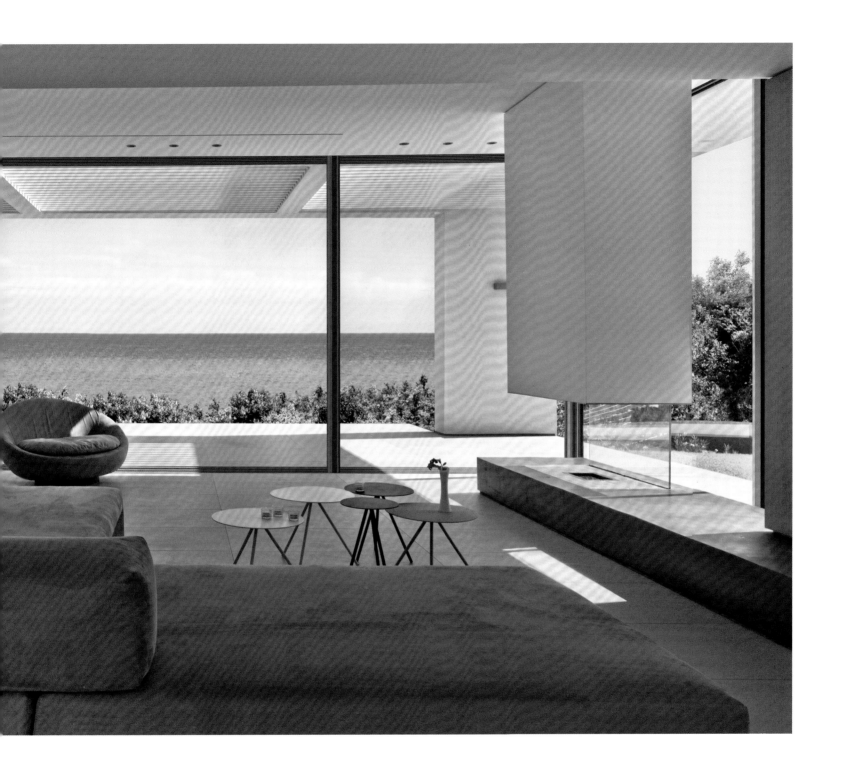

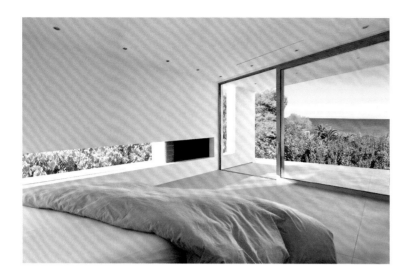

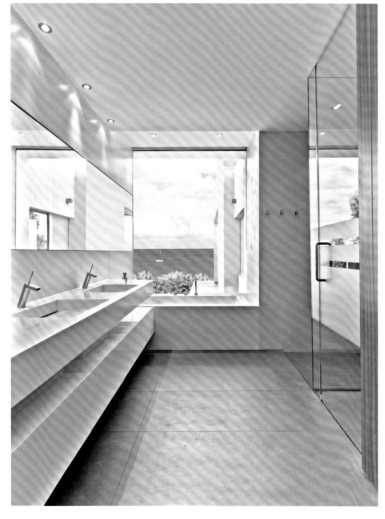

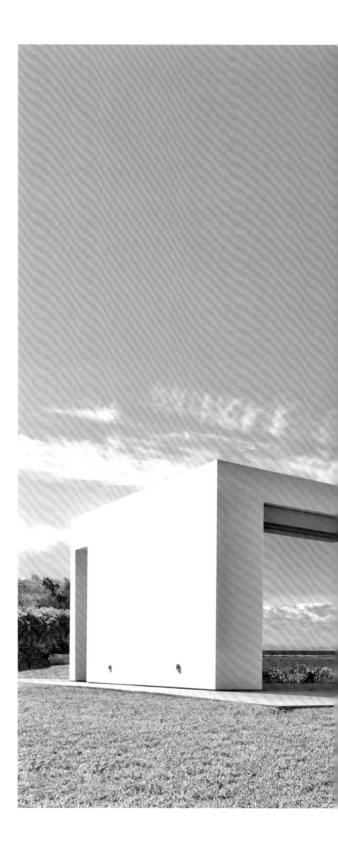

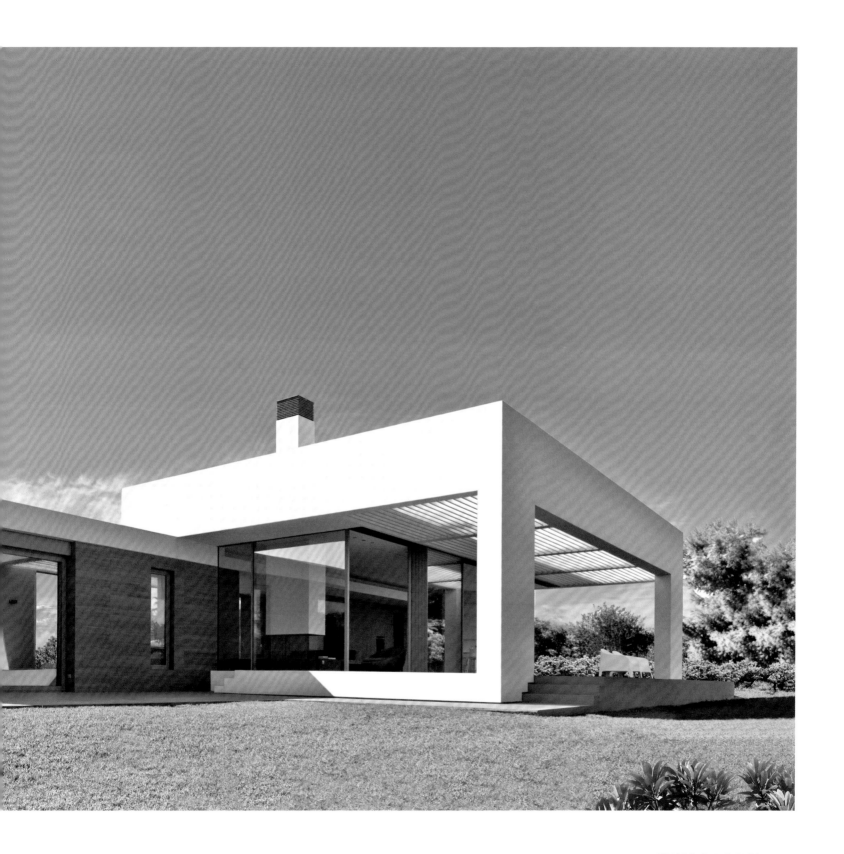

31.
MA VIE LA
SELIM ERDIL

ÇESME, TURKEY

House Area:
400 m²

Plot Area:
520 m²

Architect in Charge:
Selim Erdil

Project Team:
Selim Erdil, Gözde Özder, Izgi Yazıcı, Edip Sincer

Interior Designer:
Selim Erdil

Landscape Designer:
Selim Erdil

Photographer:
Tunç Suerda

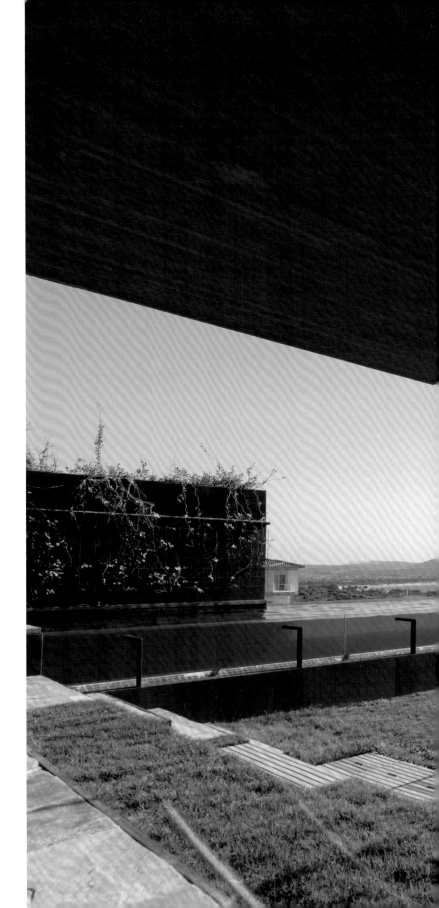

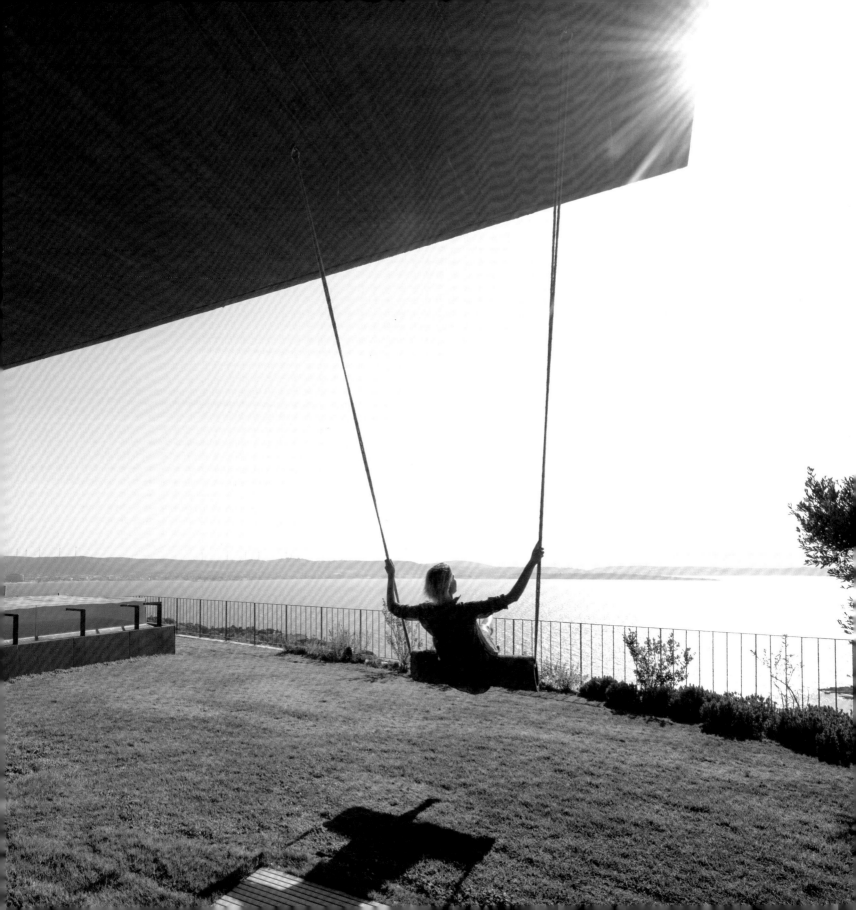

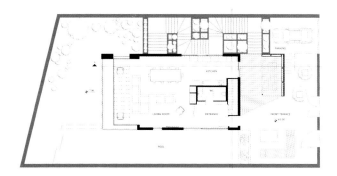

Ground Floor

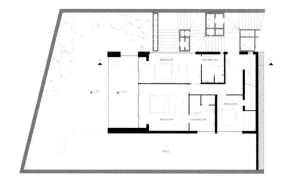

First Floor

Selim Erdil's Ma Vie Lais a cantilevered vision of varying volumes, overlooking the waterfront of the lovely Turkish town of Çe me, built with a strict minimalist approach.

Five primary materials were used: concrete, steel, stone, wood, and glass. Materials are used in the pursuit of subtle aesthetics, while allowing a variety of open spaces that can be closed or opened depending on the wind and weather conditions. The folding/sliding window anddoor systems, the 8 metre long cantilever, and the pool placement on the side of the house were all conceived with the intention of maximizing communal living areas.

Half of the visible structure is covered byan 8 metre cantilevered overhang. The cantilever was designed to minimize the footprint while maximizing open areas. It also serves to push the building mass toward the sea, creating a large roadside terrace and plenty of shade by the pool and garden.

The steep grade of the site would naturally dictate large, long, narrow, and unusable side gardens terminated by tall retaining walls. To combat this, Erdil used the building's side façade and the retaining walls bordering the property as a pool basin, connecting the ends with L shaped wall. This, combined with the cantilevered design, created the opportunity for a large pool and a sizable garden.

The building façade is raw concrete cast in a textured wooden formwork, bolstered by wooden shutters. Common areas and bathrooms are floored in marble, while the bedroom floors are rustic oak wood.

The landscaping was done entirely with local plants, such as olive, mastic, and cypress trees, in custom made Cor-ten steel clad planters. The site's irrigation is done with an 80 metric tonne cistern that collects rain water year-round, providing a simple, elegant, and environmentally conscious solution to water collection.

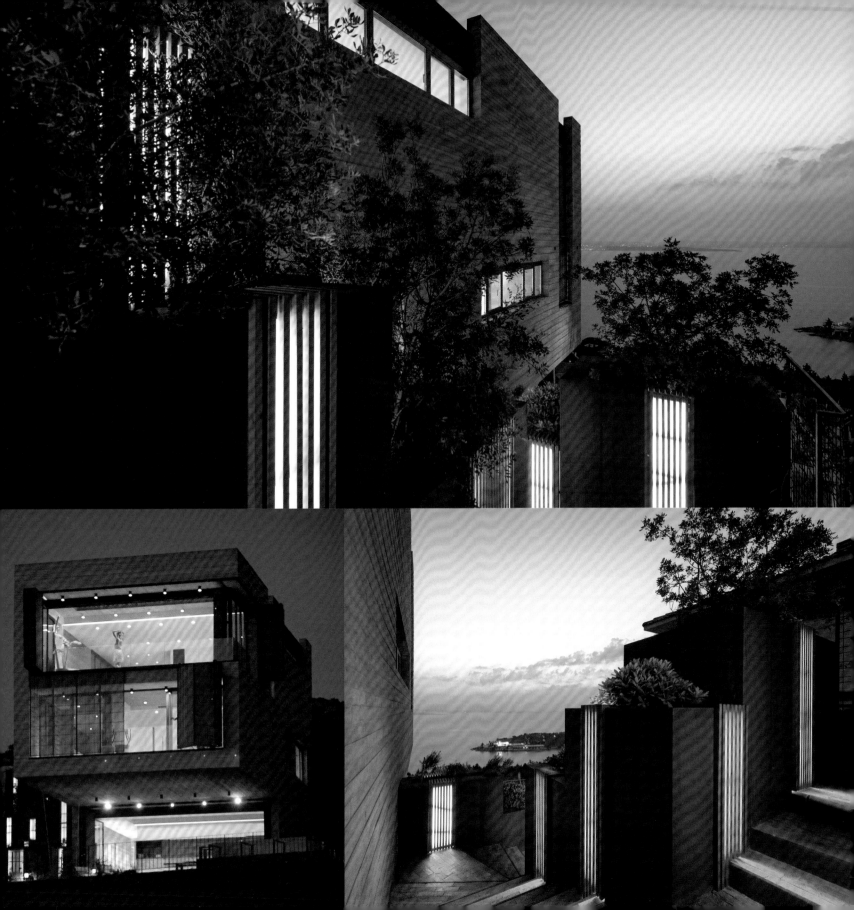

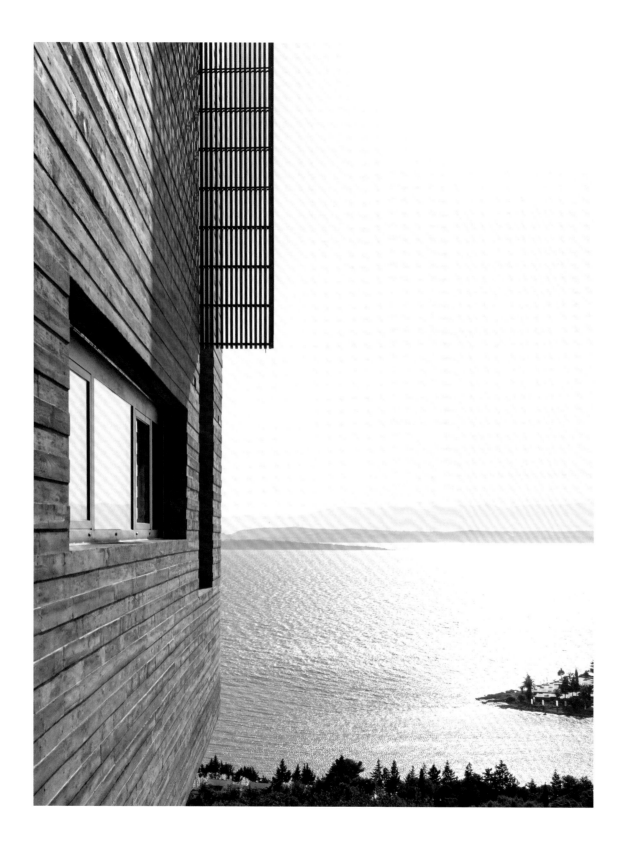

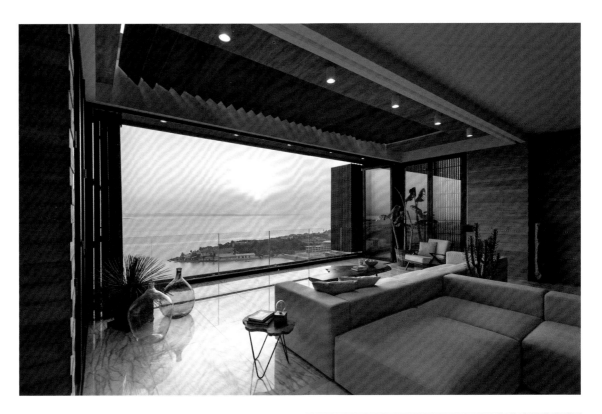

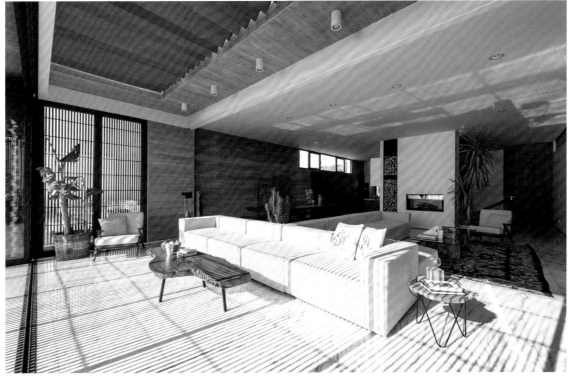

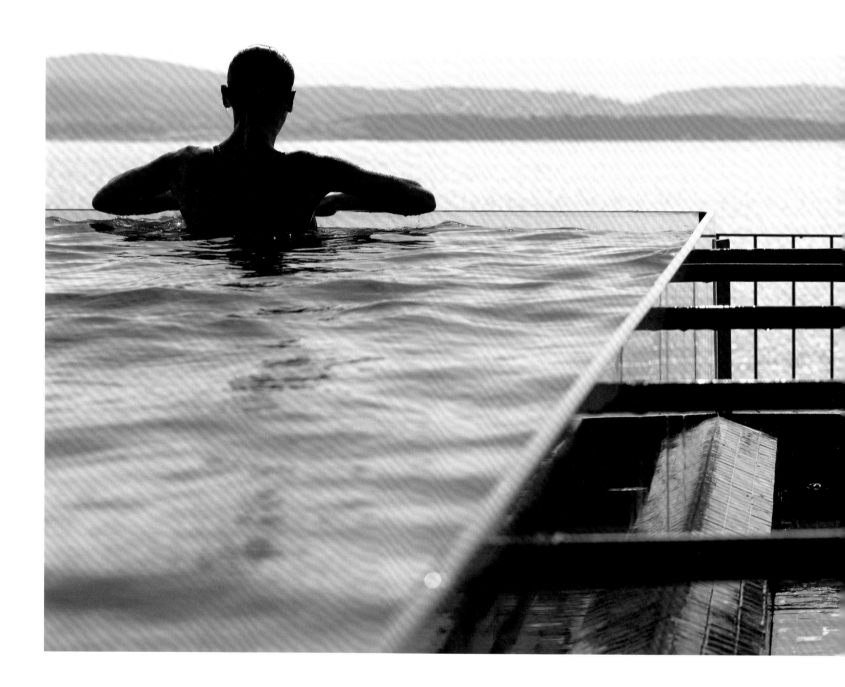

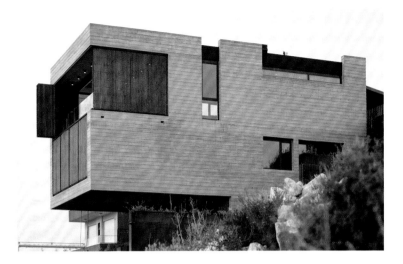

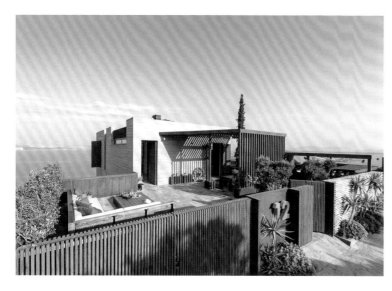

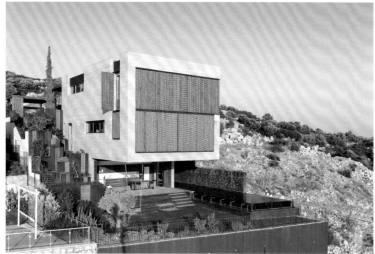

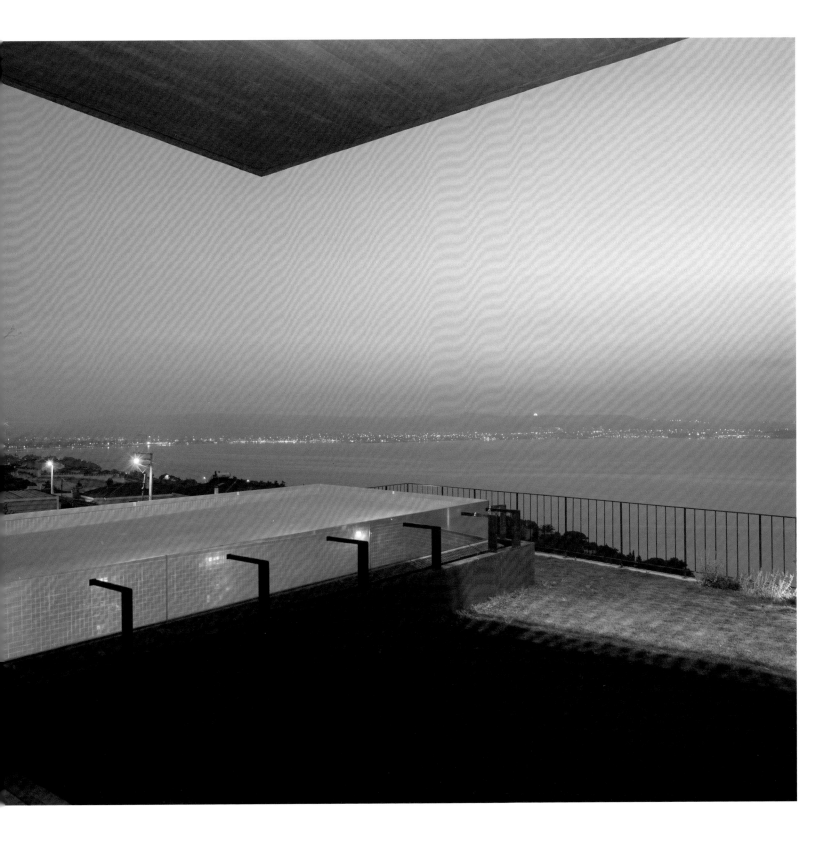

AFRICA

OVD 919 | SAOTA
CLIFTON 2A | SAOTA

32.
OVD 919
SAOTA

CAPE TOWN, SOUTH AFRICA

House Area:
2,023 m²

Plot Area:
2,879 m²

Architect in Charge:
SAOTA

Project Team:
Philip Olmesdahl, Tamaryn Fourie,
Joe Schützer-Weissmann

Interior Designer:
Studio Parkington Design Consult

Photographer:
Adam Letch

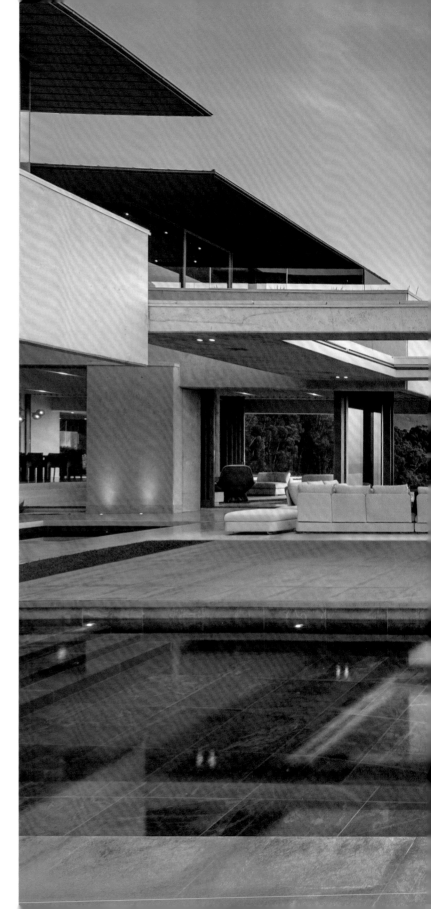

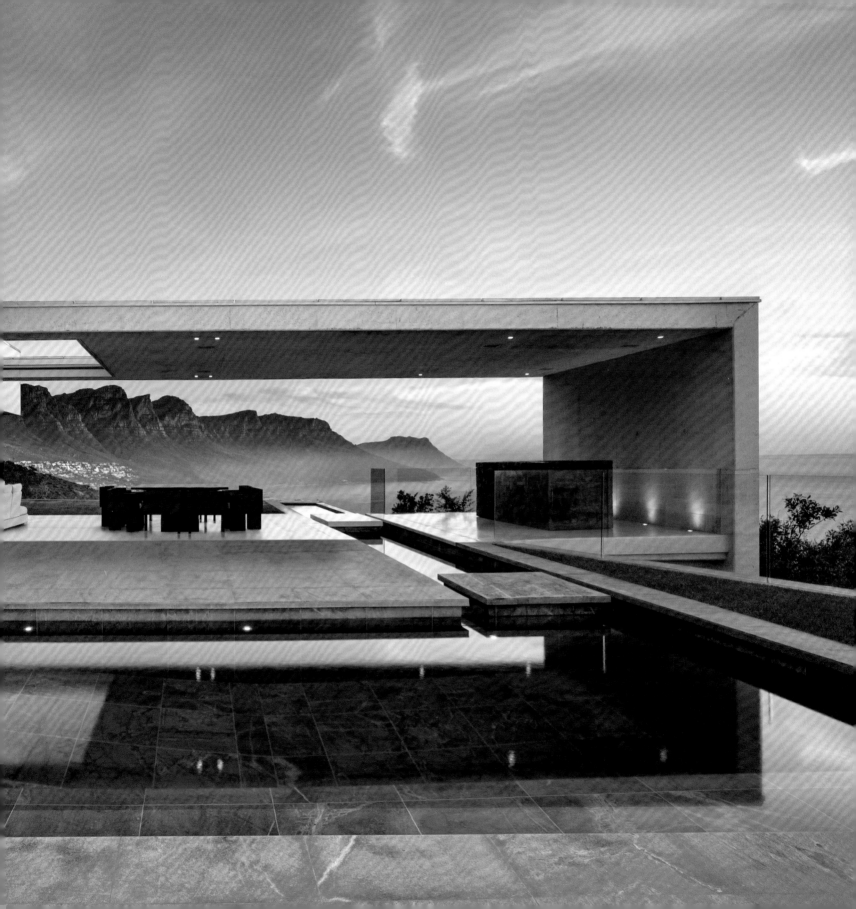

Second Floor

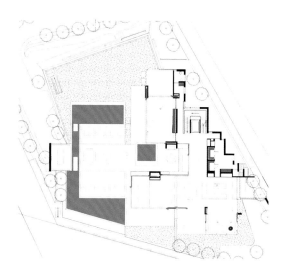

Third Floor

Starting with a brief to encapsulate the site's expansive 360 degree mountain and sea views, SAOTA took full advantage of a spectacular position on the mountain ridge below Lions Head, with views of Robben Island to the North and Camps Bay and the Twelve Apostles to the South.

On arrival oneis lured through the main garage with its double volume and graffiti walls towards the shaft of light and splash of landscaping emanating from the glazed Entrance Area beyond. The 'layering'of the house permits different experiences indifferent spaces. From the main stairs the linearity of the customized cast bronze coffee bar leads one into the heart of the home - the kitchen. The kitchen in turn spills into the dining room and the summer lounge with its high ceiling of ribbed concrete.

A courtyard 'cuts' into main living areas – its water feature and delicate weathered Cor-ten screen ensures a tranquil and sheltered space. The base of the water feature is glazed to scoop refracted light into the main garage below. The 'woven' Cor-

Ten screen playfully reflects light and shadows internally, while also providing privacy to the bedroom level above.

A ribbed pre-cast concrete soffit creates continuity between the living spaces with all services being carefully co-ordinated so as to disappear within recesses. The thin eaves of the zinc roof are also delicate in contrast to the massive beams below and appears to hover above the upper level.

The polished concrete floors of both the internal and external living areas ensure their seamless continuity. Natural oakis artfully combined with feature brass insets for bedroom floors and all internal joinery. The master bedroom is set back from the boundary line to increase privacy from the mountain paths, and an expansive planter off the main bedroom reiterates the importance of the natural surroundings and their connection with the sea beyond.

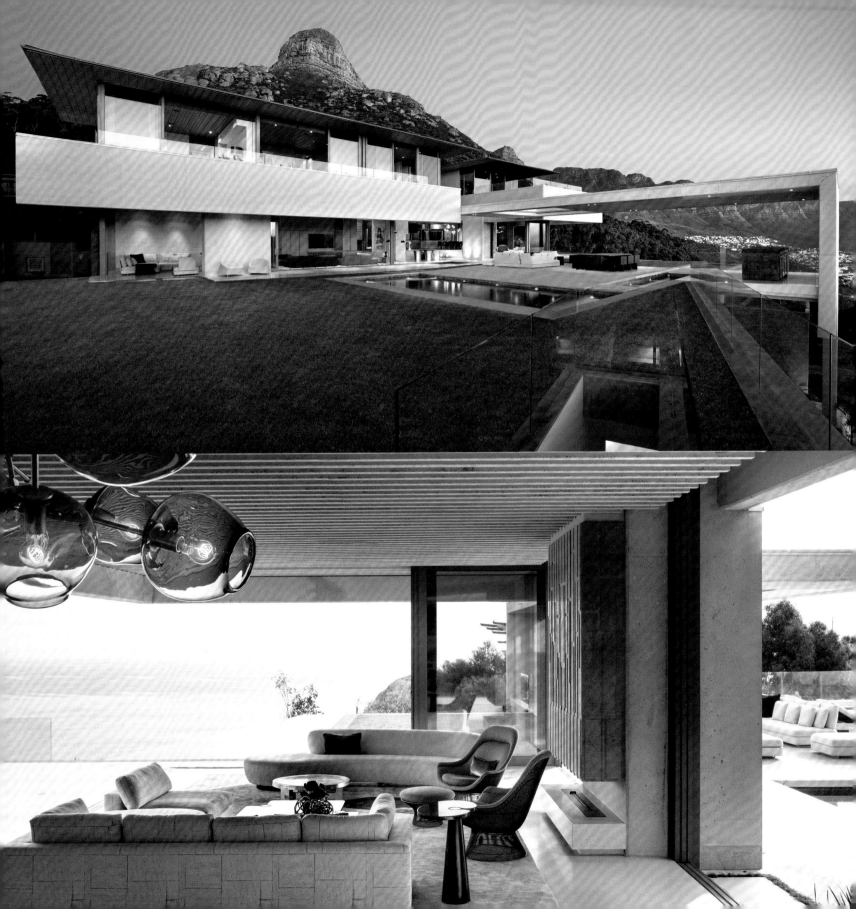

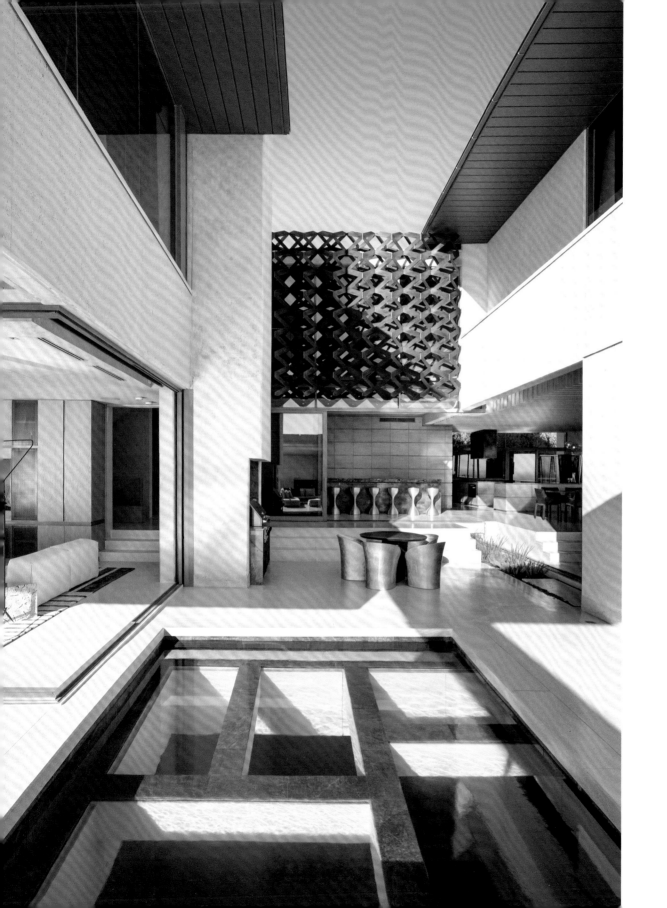

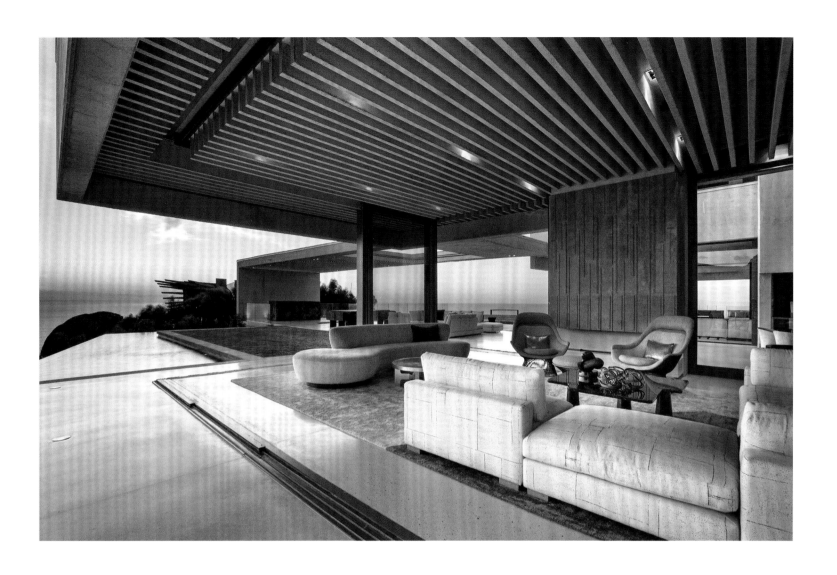

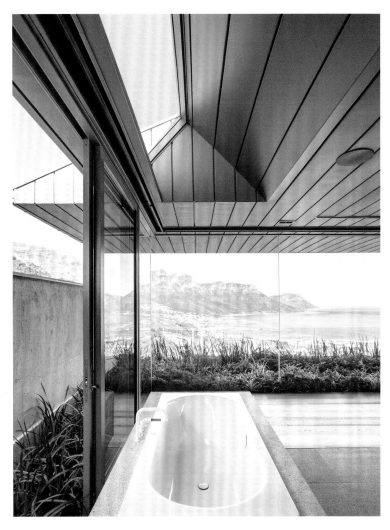

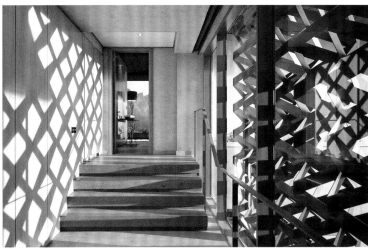

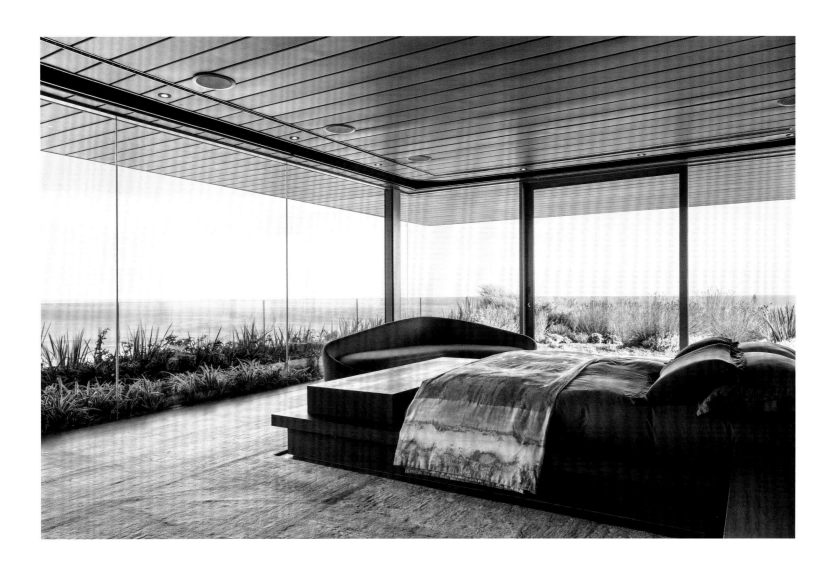

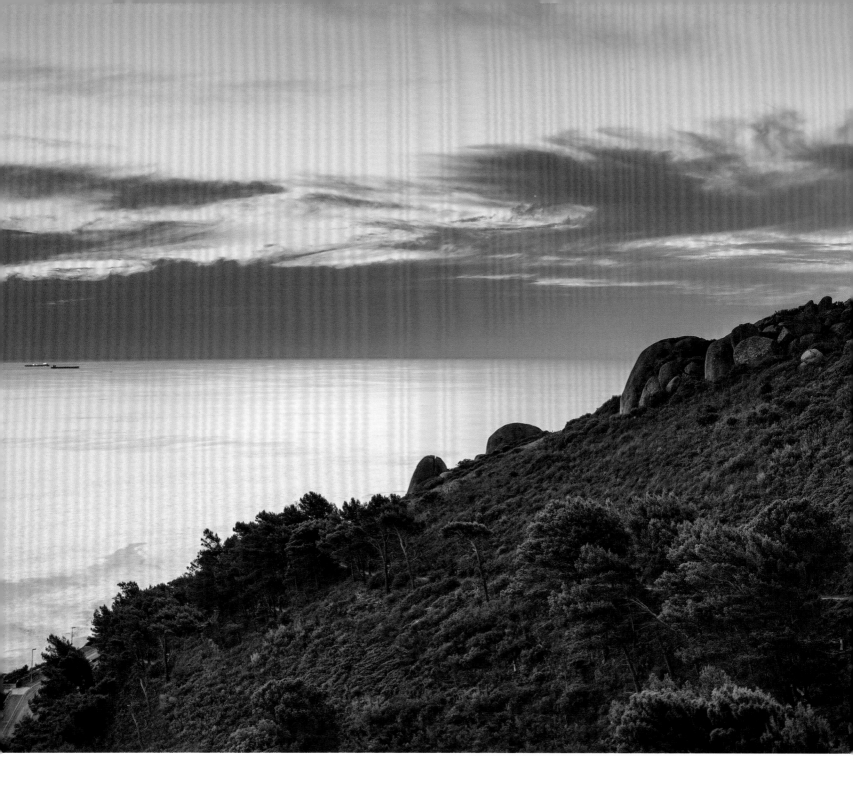

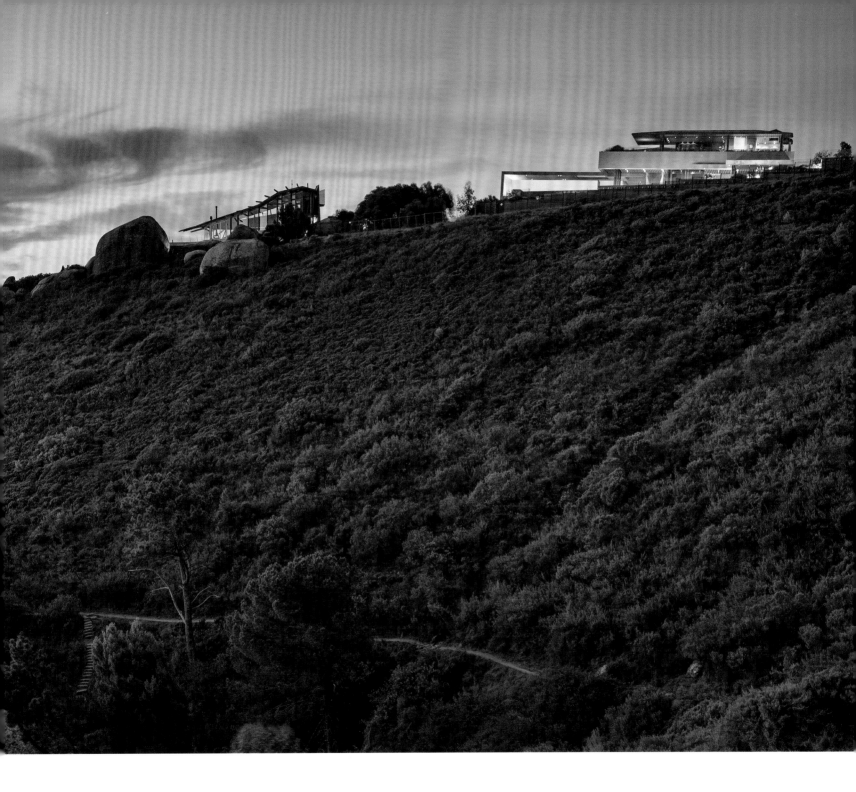

33.
CLIFTON 2A
SAOTA

CAPE TOWN, SOUTH AFRICA

House Area:
1,120 m²

Plot Area:
N/A

Architect in Charge:
SAOTA

Project Team:
Philip Olmesdahl, Tamaryn Fourie,
Thaabe Ramabina

Interior Designer:
Janine Lazard Interiors

Photographer:
Adam Letch

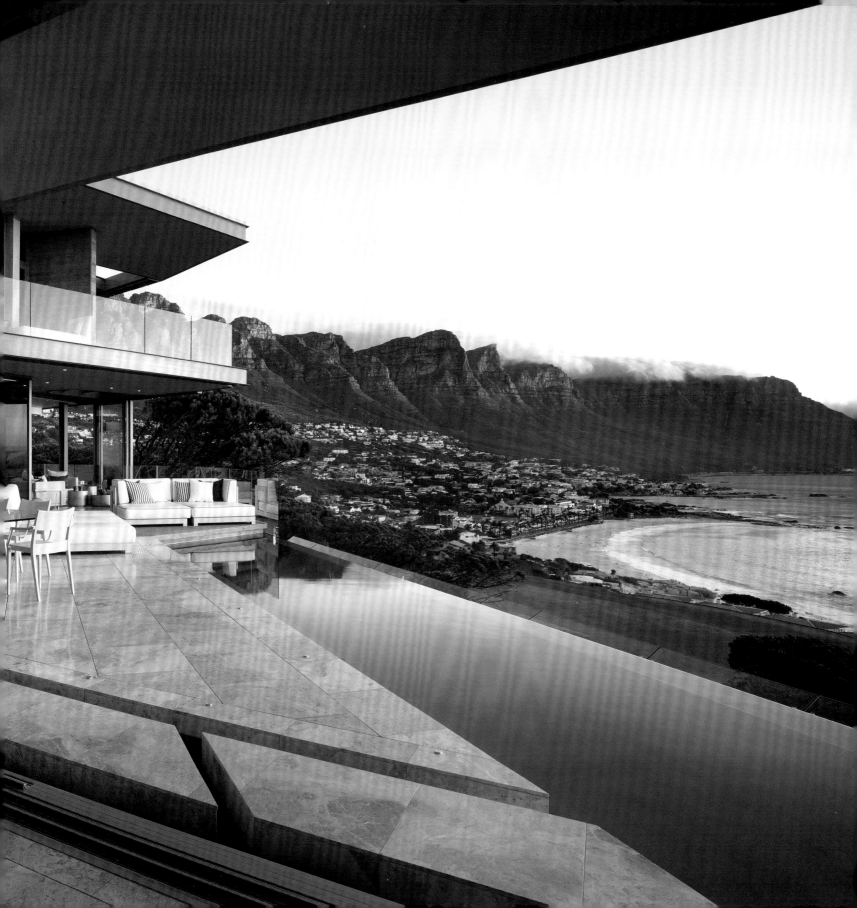

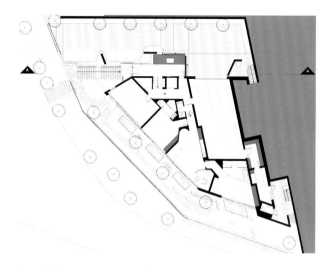

Ground Floor

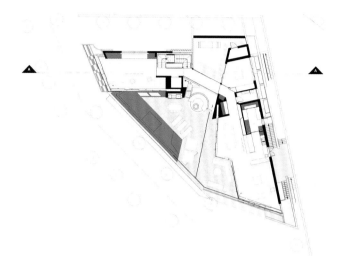

First Floor

Positioned on a ridge below Capetown's Lions Head mountain range, with 270° views of the Atlantic Ocean, Camps Bay, and the Twelve Apostles beyond, SAOTA's Clifton 2A takes full advantage of an sloping triangular plot with expansive panoramas below, to create a modern classic.

The main level rests on a plinth, and comprises of guest bedrooms and secondary spaces such as the gym, study, and garage. This ground floor is partially set into the steep site, allowing the first and second floors tobe set back, fragmented, and rotated to create a central but sheltered external terrace. A glass bridge forms a link between the fragmented structures at the upper levels and permits northern sunlight to shine between the bedroom wings and into the central areas on the south elevation.

Generous overhangs, external sliding shutters, and perforated steel and aluminium eaves assist with naturally shading the various façades, while allowing the magnificent views to be optimized for all rooms.

On arrival one is lead up delicate cantilevering concrete stairs. In the central communal space, monolithic stairs are suspended above and filter shafts of refracted morning light, creating a sense of calm.

The family room, kitchen, dining and lounge are to the South and all flow seamlessly onto the centrally positioned external terrace which is sheltered by the carefully rotated bedroom wings above. A blue mosaic pool runs the length of the terrace and brings sea and sky into the living spaces.

All bedrooms have private terraces and bathrooms, while the master bedroom is set forward as if propelled towards the view of the coast, whilst clerestory glazing perfectly captures views up towards Table Mountain. The main en-suite enjoys a lush tranquillity of purely white finishes, as well as an outside shower with views onto the neighbouring National Park.

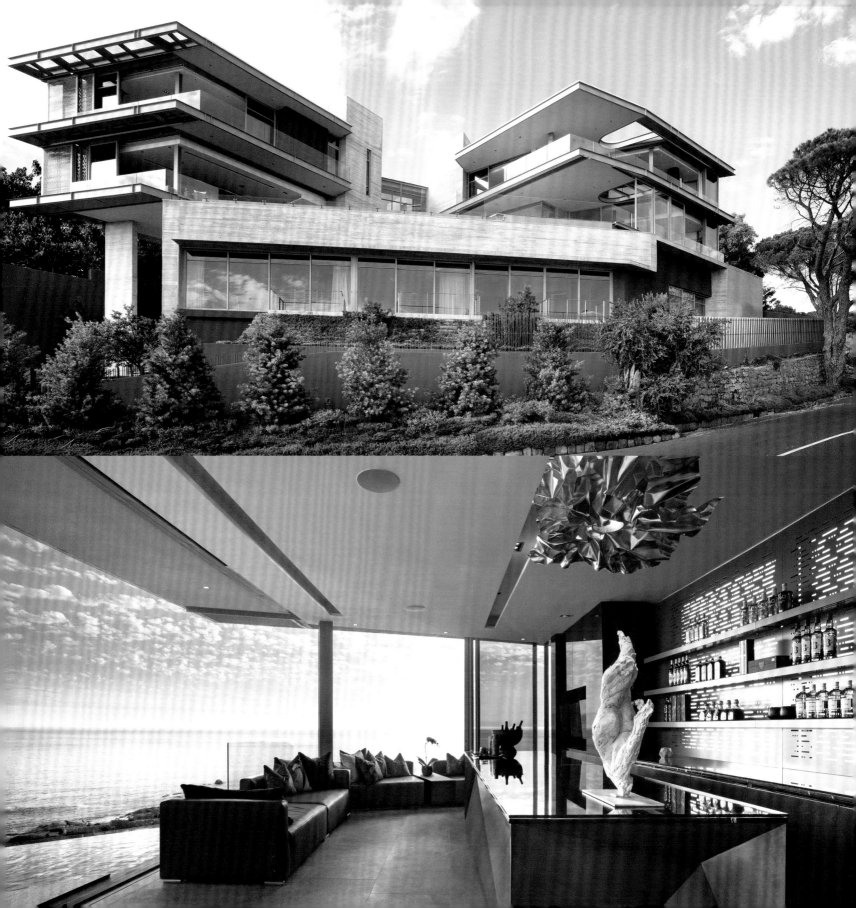

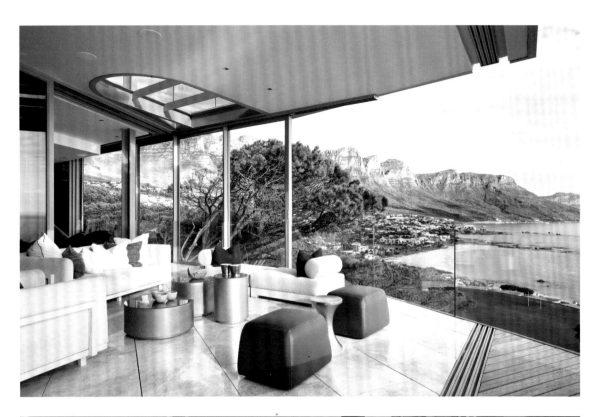

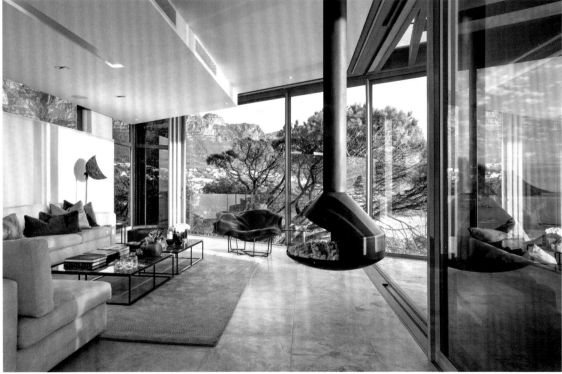

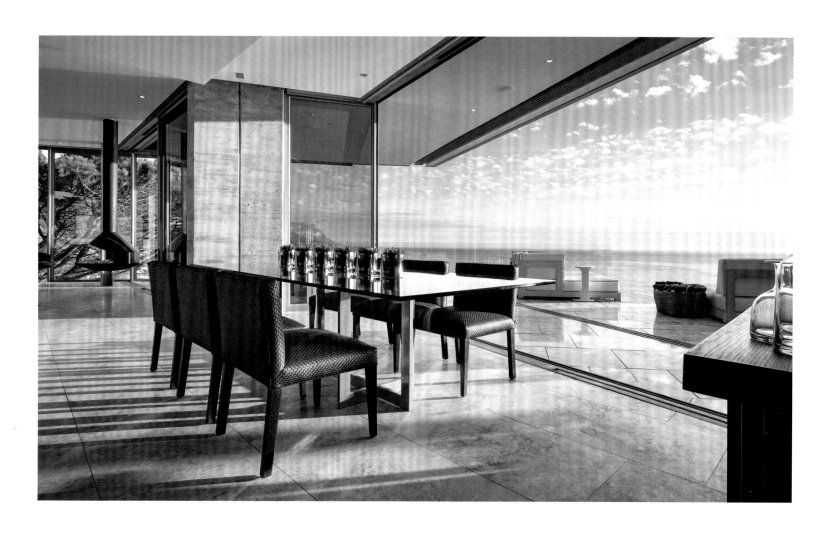

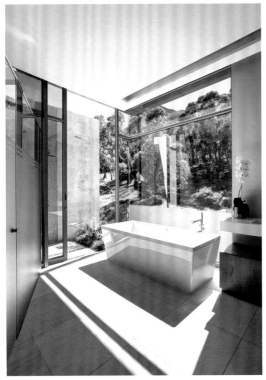

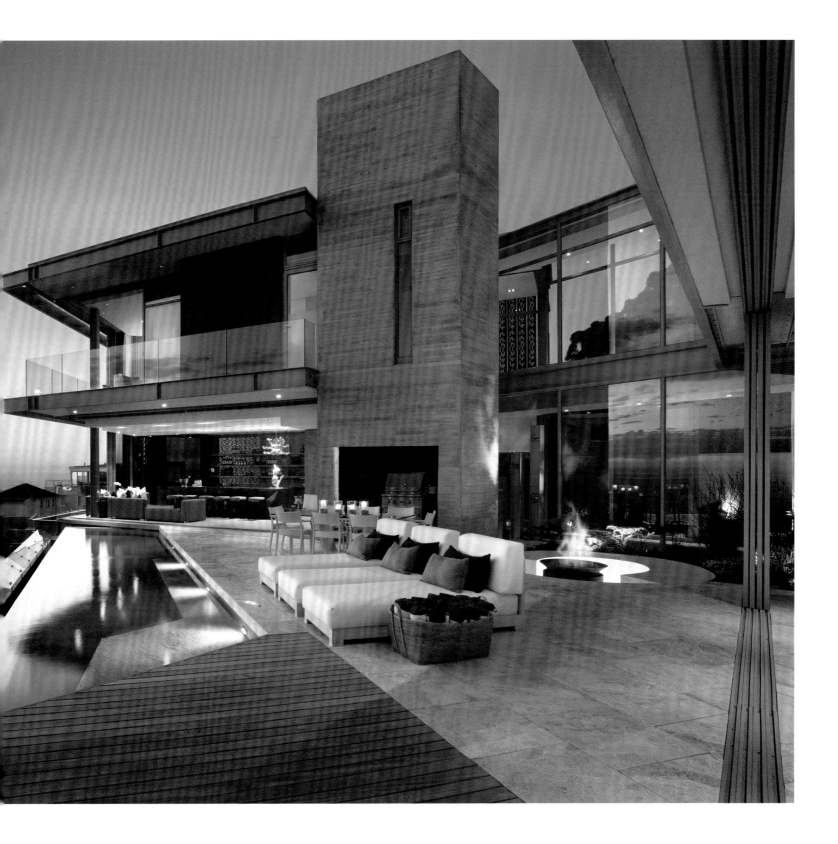

HOUSE IN AKITSU | KAZUNORI FUJIMOTO
GERRINGONG RESIDENCE | SMART DESIGN STUDIO

34.
HOUSE IN AKITSU KAZUNORI FUJIMOTO ARCHITECT & ASSOCIATES

HIGASHI HIROSHIMA, JAPAN

House Area:
81 m²

Plot Area:
316 m²

Architect in Charge:
Kazunori Fujimoto

Project Team:
François Nahory

Photographer:
Kazunori Fujimoto

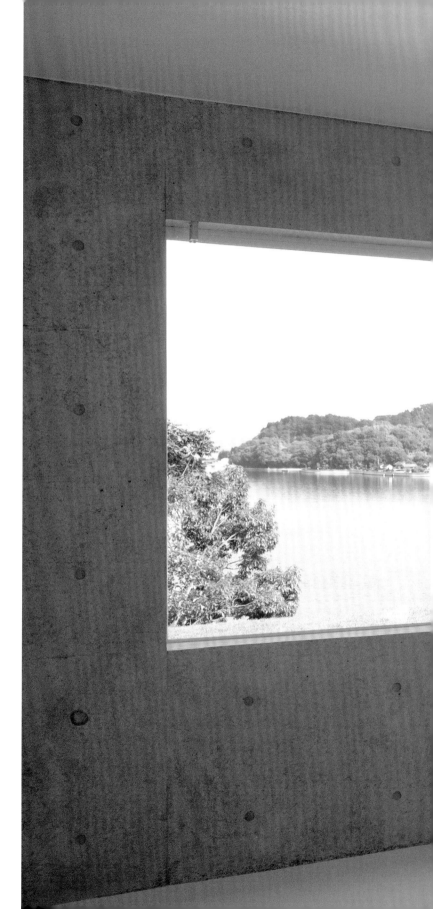

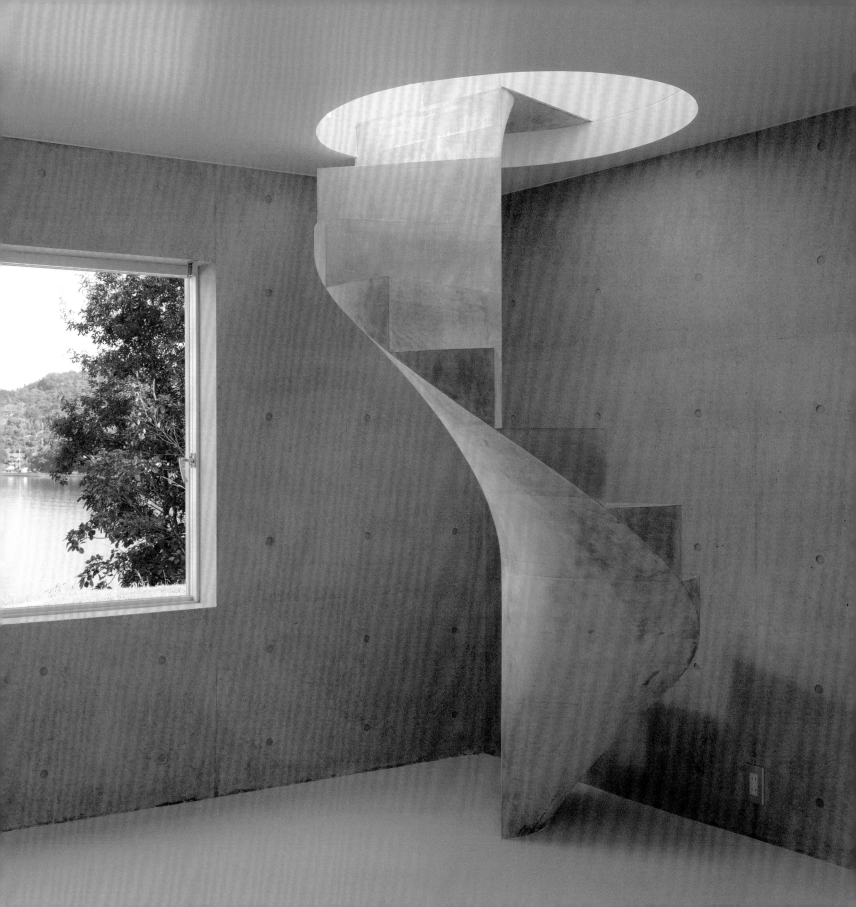

Ground Floor

First Floor

Located on a small peninsula is located on a small peninsula near the small city of Higashihiroshima, House in Akitsu overlooks the beautiful scenery of the Seto Inland Sea.

Composed of two concrete cubes, which intersect to form the residence's body, which stands on a matching concrete plinth. A wide-set set of stairs leads upto the raised entranceway, while a narrow floating concrete staircase oscillates off the front door upto a roof terrace which provides unfettered sea views.

The moving line inside the house becomes fluid thanks to the use of variegating grades on the main floor, via short stairs that connect the living area with the sleeping rooms. Interior construction is entirely done in béton brut concrete, polished to reflect natural light, which floods through the myriad windows.

The residence itself is extraordinarily, almost ruthlessly, minimalist; calling to mind both early Le Corbusier sketches and the works of Ando Tadao. The first floor is slightly buried, and its ceil-

ing was set lower rather than the living room in order to achieve a more private and cosy feeling, while furnishings are kept to a bare minimum, further highlighting the property's stark minimal perfection.

The centrepiece of the house is a thickset curvilinear spiral staircase, done, as with the majority of the house, entirely out of cast concrete. The thickness of the supporting slab becomes invisible to its outer and inner end, and it was designed in order to avoid any necessity of a central pillar. As such, from its central axis it appears as a single, perfect straight line.

The guardless staircase twists its way between bedrooms located in the base of the structure, and communal living spaces placed on the upper floor.

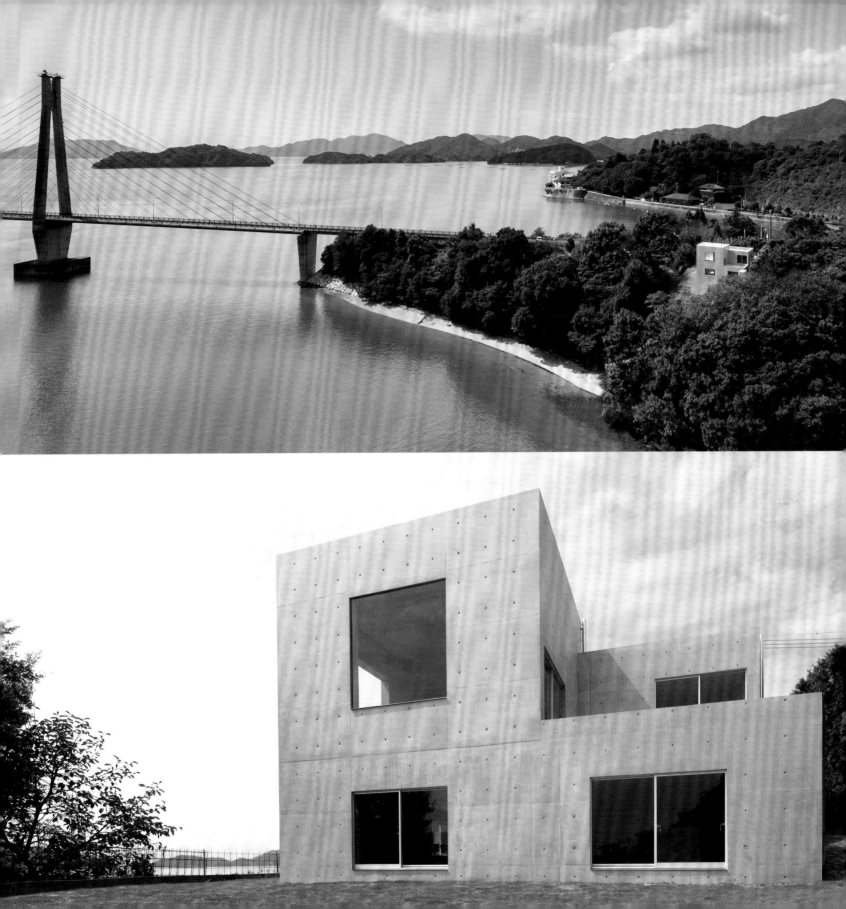

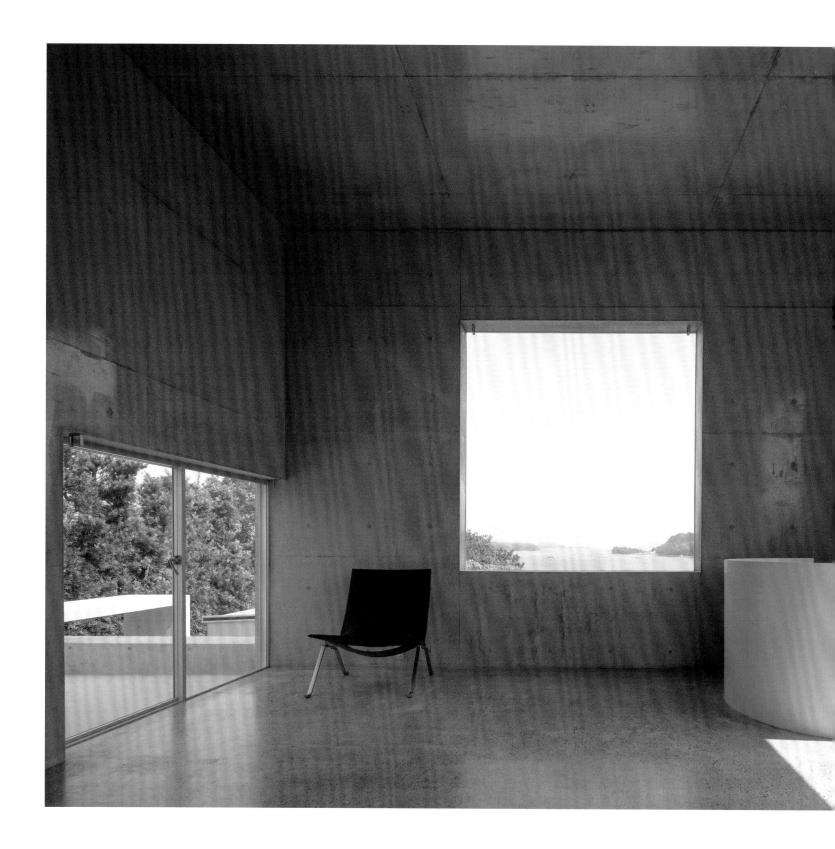

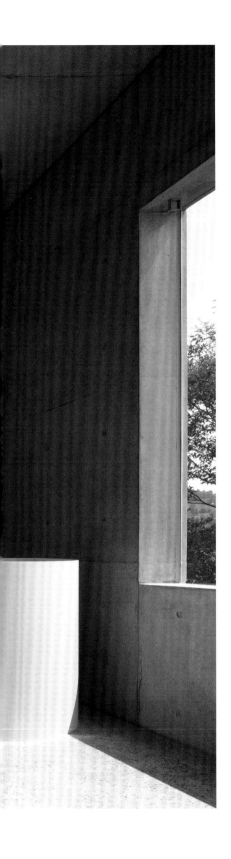

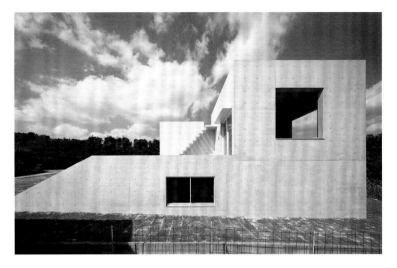

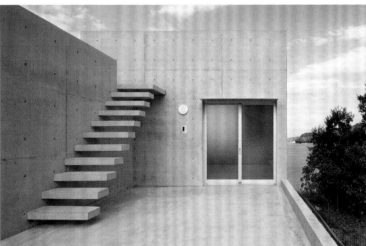

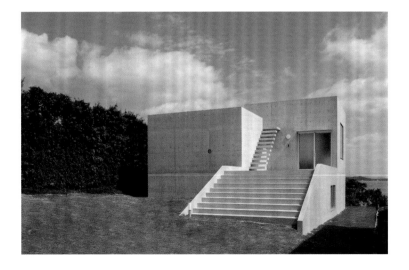

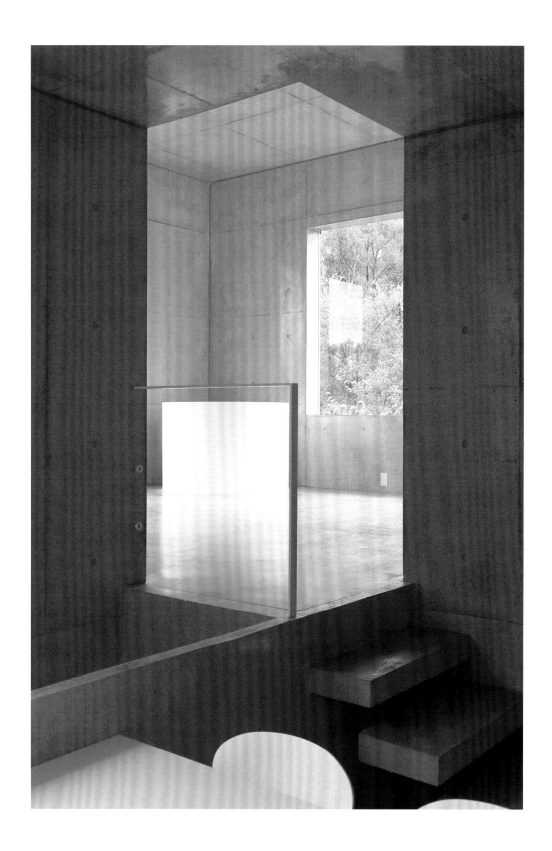

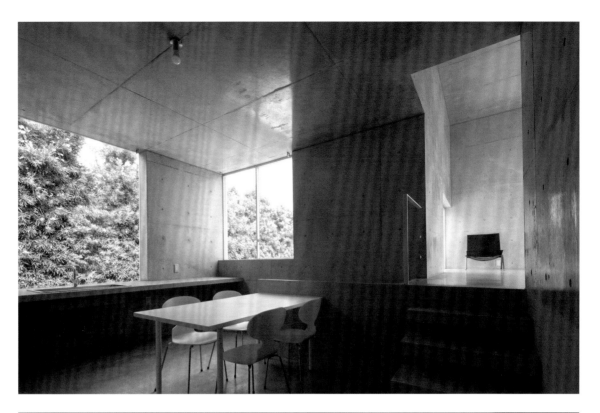

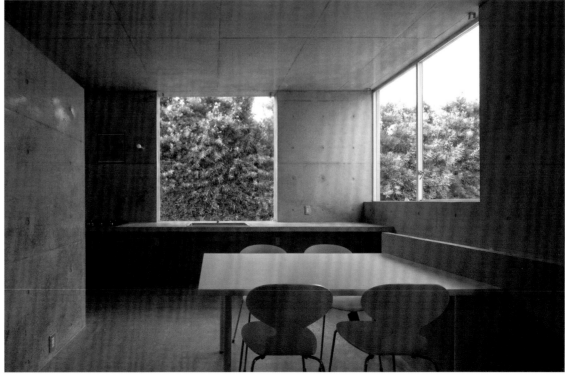

35.
GERRINGONG
RESIDENCE
SMART DESIGN
STUDIO

NEW SOUTH WALES, AUSTRALIA

House Area:
850 m²

Plot Area:
754 m²

Architect in Charge:
William Smart

Project Team:
Edmund Spencer, Jeremy Unger, James Ho

Interior Designer:
William Smart

Landscape Designer:
Janet Lamble

Photographer:
Sharrin Rees

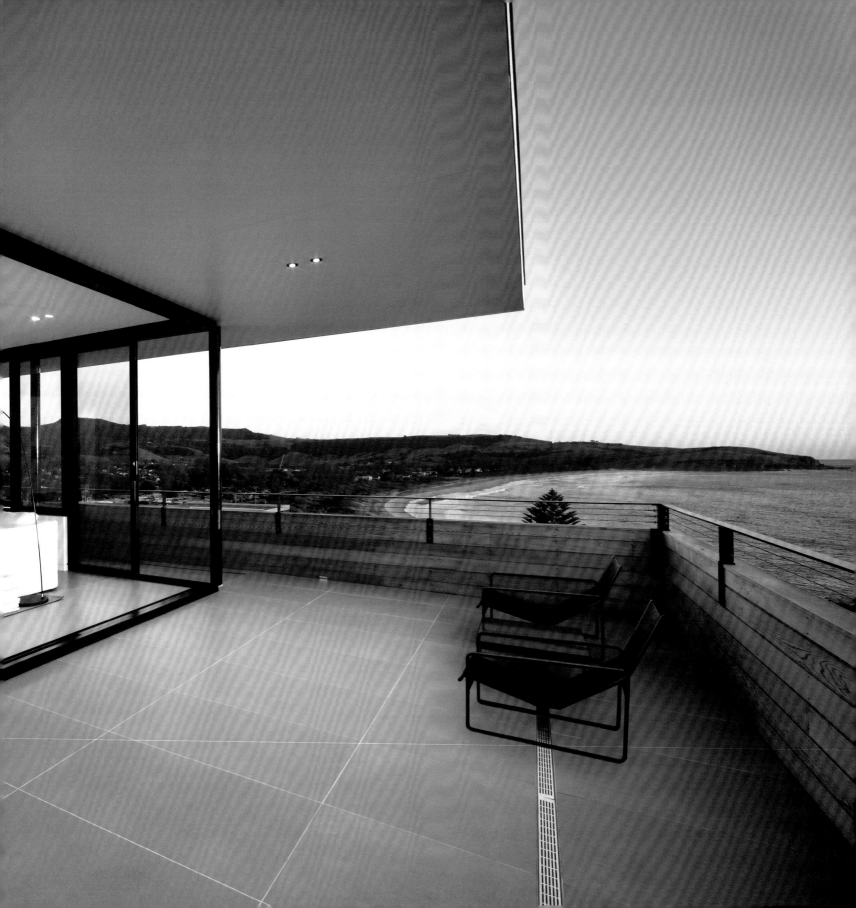

Ground Floor

First Floor

This house on the south coast of New South Wales was designed as one of a pair of modern beach houses occupying a greenfield site overlooking beautiful Gerringong beach. The site is part of a new land release on the edge of a sleepy coastal town. From its elevated position, the house enjoys 270° views of the ocean, adjacent headland and evergreen hinterland beyond, which form part of the Great Dividing Range. The setting is breathtaking.

The design deliberately challenged local planning provisions, which strictly dictated how to configure the building's rooms within the site. We chose to make the most of the views as well as the sunny and protected northern aspect by locating the living and sleeping spaces on that side. This relegated the service rooms including the bathrooms, laundry and garage to the south. Surprisingly, this logical approach resulted in the local council refusing the first development application, which was later realized achieved through an appeal and minor modifications.

The form is extremely simple and the façade has a very confident approach to solid and void. Large walls of glass on the upper floor and deep shaded terraces are afforded by the generous cantilever roof. These hover over the cedar-clad 'box' below, which has either deep reveals or timber adjustable louvres to temper the environment. Naturally, the use of glass and solid relates to the rooms contained within, where more private spaces are more protected than the more public areas.

The timber cladding, a classic beach house material, folds to create a solid balustrade to further improve privacy. With time, the strong coastal light will cause the timber to fade like a piece of driftwood, and the house will settle into the harsh landscape.

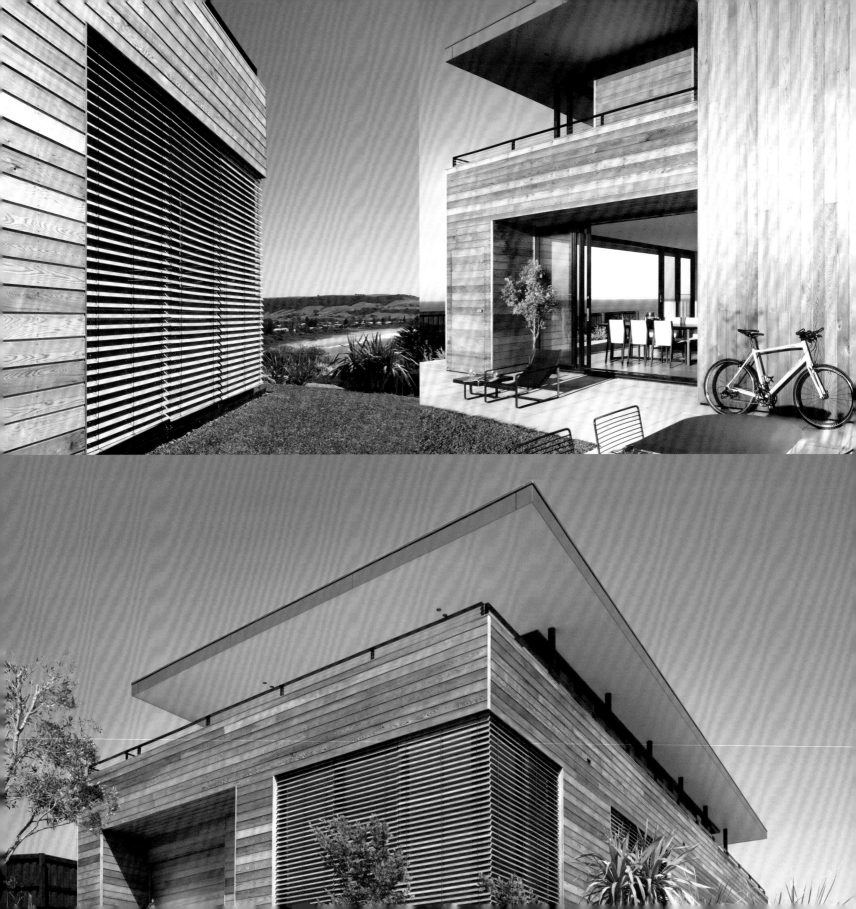

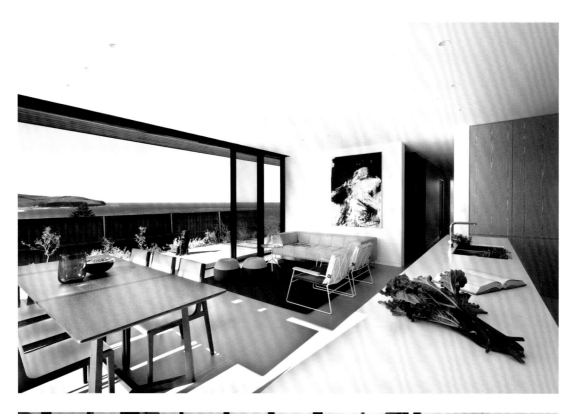

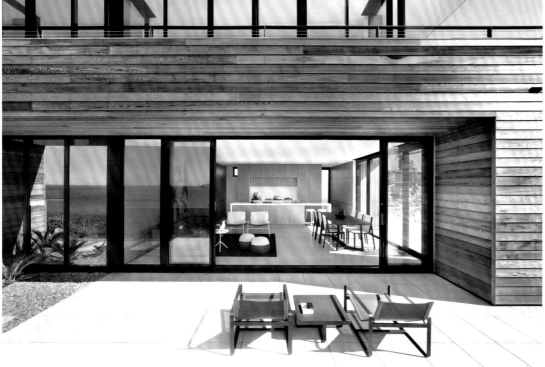

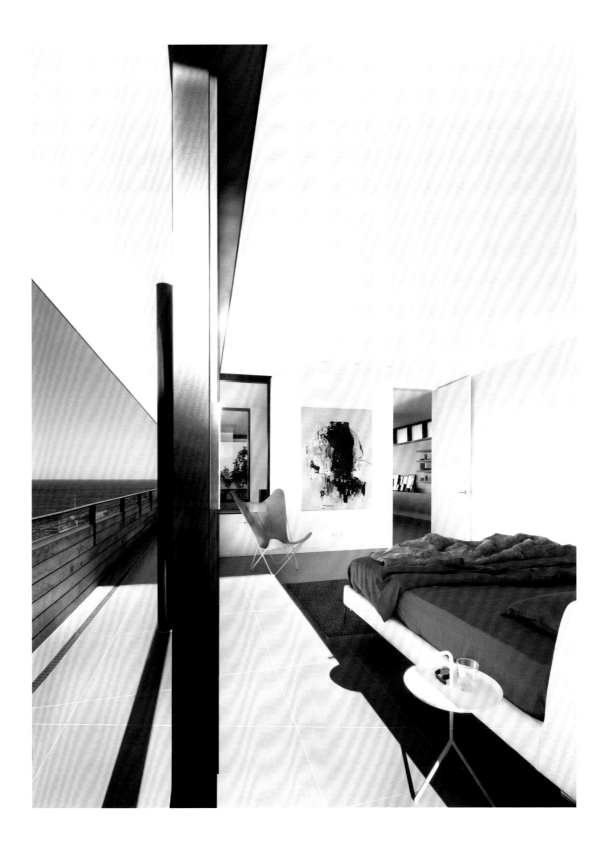

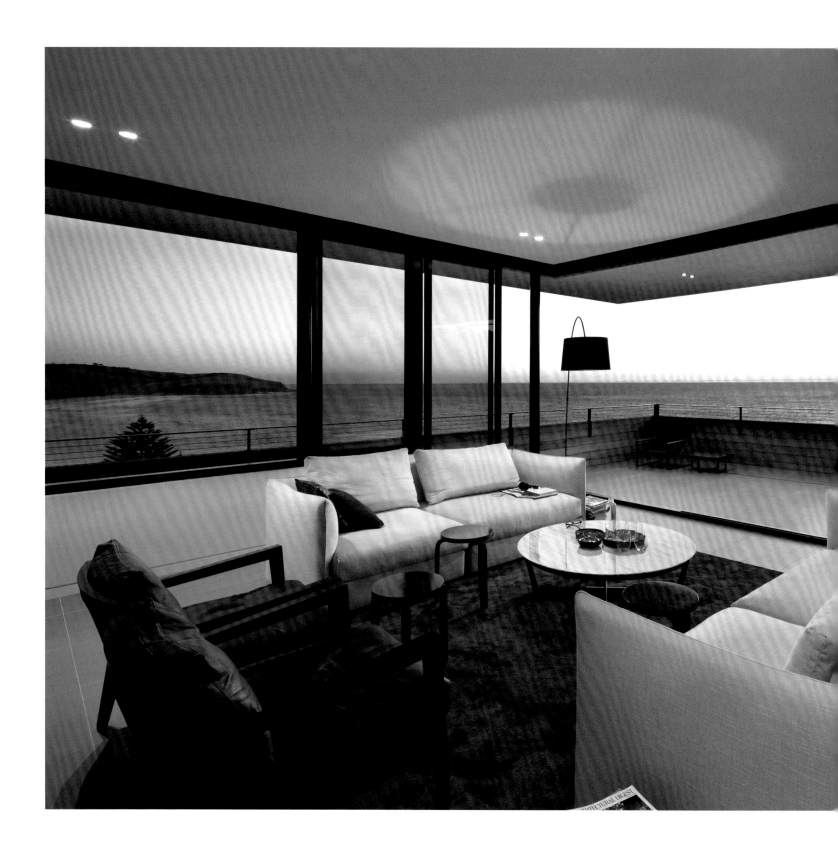

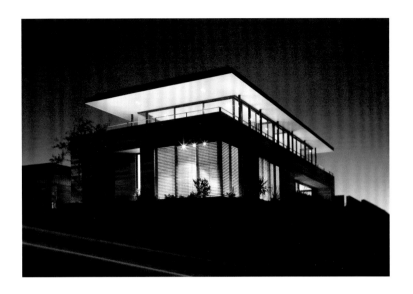

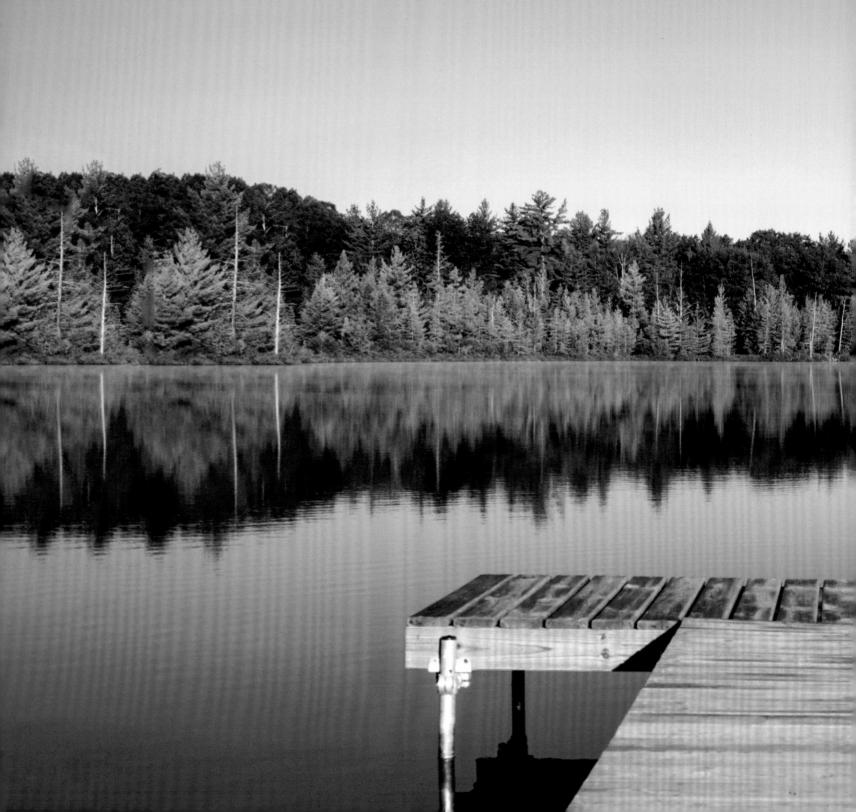

APPENDIX

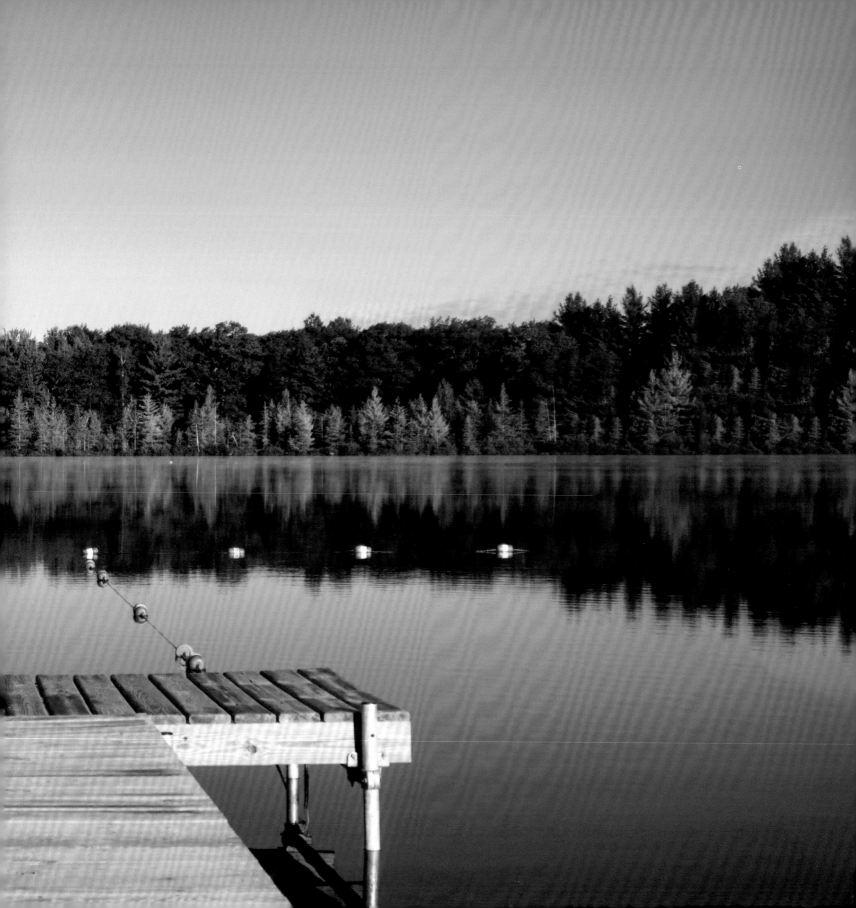

ARCHITECTS PROFILES

ALIABADI, REZA received a Master's degree in Architecture from University of Tehran. He founded the 'Reza Aliabadi Building Workshop'. After completing a post-professional Master's of Architecture at McGill University, and obtaining an OAA licence, the workshop was re-established as atelier Reza Aliabadi 'rzlbd'. Reza has been invited to install in Toronto's Harbourfront Centre, as well as sit on the peer assessment committee of Canada Council for Art and Architecture. He taught at the School of Fine Arts at the University of Tehran, and was a guest lecturer in the PhD Program. He also publishes a zine called rzlbdPOST.

ANTONI, STEFAN completed his Bachelors of Architecture degree at the University of Capetown in 1985, with a first class pass. In 1987 he set up the architectural practice Stefan Antoni architects, which today is known as SAOTA (Stefan Antoni Olmesdahl Truen Architects). Antoni is regarded as one of a number of architects who have contributed to setting a new standard of design and professionalism in the top end of the domestic market in South Africa.

ASSADI, FELIPE graduated as an architect from the Universidad Finis Terrae, and earned a master's degree from the Pontificia Universidad Católica de Chile. He has taught at universities in Chile, Mexico, Brazil, Italy, Colombia, and the United States. Since 2011, he has been the Dean of the Architecture School of the Universidad Finis Terrae. He has lectured in Latin America, the USA, and Europe. His work has been published in Wallpaper and the Architectural Review (London), Architectural Record (New York), as well as in specialized publications across the globe. He has also participated in exhibitions globally.

BERNHARD, TITUS has been active both nationally and internationally in architecture since 1995. Among his awards: the Erich-Schelling Medal 2006; the BDA Prize in Bavaria 2006; best architects awards 2007, 2009, 2010, and 2012; as well as exhibitions at AEDES in Berlin in 2004 and 2013, Architekturgalerie Munich, and the Galerie d'Architecture in Paris. He has also shown twice at the Venice Biennale. Bernhard is considered a strong addition to the young avant-garde in Germany. From 2005 to 2007 he was a visiting professor for design and construction at the Constance University of Applied Sciences (HTWG Konstanz).

BOVELL, LISA Born in 1972, in Kingston, Jamaica. She holds a Bachelors of Architecture, as well as a Master of Architecture from the University of British Columbia, Canada (1994 and 2000). MCLEOD, MATT Born in 1972, in Chilliwack, British Columbia, Canada. He holds a Bachelors of Science, as well as a Master of Architecture degree from University of British Columbia, Canada (1994 and 2000). McLeod and Bovell have a combined 30 years of experience designing complete residential environments - building, interiors, and landscapes.

CADAVAL, EDUARDO holds a B.A. from the National University of Mexico, and a Master of Architecture (specializing in Urban Design) from Harvard University. Since 2006 he has been an Associate Professor of Urbanism at Barcelona's School of Architecture ETSAB, UPC. He has also taught at the University of Pennsylvania, Calgary University's Barcelona Program, Harvard University's Career Discovery program, the Boston Architectural Center, and the National University of Mexico. He was awarded the National Council for the Arts Young Creators Award and the National Council for Science and Technology Grant, both from the Mexican government. He is co-editor of the book Projects & Plans, published by Barcelona City Hall. SOLÀ MORALES, CLARA is a

licensed architect with a degree in Architecture from Barcelona's School of Architecture, and a Master in Architecture (MArchII) from Harvard University; she is also a PHD Candidate for Barcelona's school of Architecture, ETSAB. She is an associate professor of architecture at Barcelona's School of Architecture ETSAB, UPC. She has taught at the Massachusetts Institute of Technology (MIT), Tarragona University, and at Calgary University's Barcelona Program. She was also co-editor of the book Plans and Projects, published by Barcelona City Hall.

CHIA, KATHERINE earned her Master of Architecture degree from M.I.T. and received her Bachelor of Arts degree from Amherst College. Prior to co-founding Desai Chia Architecture, she worked for Maya Lin on numerous art and architecture commissions. Chia is a registered architect in the states of New York and Connecticut. She has also served as a faculty member in the architecture department at Parsons The New School of Design. She is Co-Chair of the Van Alen Institute's Program Leadership Council, an elected member of the AIA NY Finance Committee, and Trustee Emerita of Amherst College. DESAI, ARJUN grew up in New Delhi and Mumbai, India. Prior to co-founding Desai Chia Architecture, he worked at SHCA/NY on numerous civic projects in New York and Washington, D.C. He earned his Master of Architecture degree from M.I.T., and received his Bachelor of Arts degree from Bennington College. Desai is a registered architect in the state of New York and an active member of the AIA NY. Desai Chia's projects have been published extensively, and received many accolades including numerous American Architecture Awards, American Institute of Architects Design Awards, Interior Design Best of Year Awards, the IDEA Award, and several Good Design Awards.

DWEK, OLIVIER was born in Brussels in 1970. His early passion for the visual arts led him to the Académie des Beaux-Arts, before beginning his studies in 1990 at the Faculty of Architecture Victor Horta at the Free University of Brussels. Continuing his apprenticeship at Art & Build, a renowned Brussels agency specializing in large-scale projects, this self-taught artist was entrusted with his first major project as early as 1997. Three years later, Olivier Dwek founded his eponymous architecture workshop, housed in the heart of the European Union's capital.

EHRLICH, STEVEN Upon graduating from Rensselaer Polytechnic Institute with a Bachelor of Science and a Bachelor of Architecture, he spent six years working in Africa, serving for two years with the Peace Corps as their first architect in Marrakech. He later traveled across the Sahara and taught architecture at Ahmadu Bello University in Nigeria. Ehrlich is a recipient of the AIA California's Maybeck Award and the 2015 AIA Los Angeles Gold Medal for outstanding lifelong achievement in architectural design. He has lectured and taught as a visiting professor both nationally and abroad; currently as a visiting professor at the University of Southern California.

ERDIL, SELIM has studied Civil Engineering at the University of Houston. Later, he moved to New York to take up positions at LZA - Thornton Tomasetti and Urbitran where he worked on various architectural and engineering projects including the Petronas Towers. Upon returning to his home town, Izmir (Turkey), he began designing and building multi-story residential, commercial building as well as custom designer homes. He has won the popular vote in the 'Concrete' category in the international 2016 Architizer A+ Award with his 'Ma Vie La' villa project. Erdil leads an architecture and construction firm in Izmir, Turkey.

FOUGERON, ANNE is a French-American architect, lecturer and author. Fougeron has a varied body of works, including commercial, civic, residential and multi-family housing. The Princeton Architectural Press described her style as 'embrac[ing] architectural opportunities found in opposition, creating buildings that redefine program, reinvent historical building types, and reinvigorate civic centers. Each project is a careful consideration of context, light and structure'. She is known for taking on difficult projects 'without sacrificing aesthetics'. She is a Fellow of the American Institute of Architects.

FREJ, MIKAEL Studied at the Bauhaus School, Dessau, Germany and at the University of Chalmers in Gothenburg, Sweden. Worked for CGC Arkitektkontor in Gothenburg, Dipl. Ing. Hannes Sauer in Berlin, Cullberg Arkitektkontor AB in Gothenburg, HRTB Arkitekter AS in Oslo, Lund & Slaatto Arkitekter AS in Oslo and Wingårdh Arkitektkontor AB in Gothenburg before founding Unit Arkitektur in 2005 together with Klas Moberg. Teaching at the University of Chalmers in Gothenburg since 2008. MOBERG, KLAS Studied at the University of Chalmers in Gothenburg, Sweden. Worked for Jörgen Berg Arkitektkontor AB Gothenburg and Wingårdh Arkitektkontor AB in Gothenburg before founding Unit Arkitektur in 2005 together with Mikael Frej. Teaching at the University of Chalmers in Gothenburg since 2008.

FUJIMOTO, KAZUNORI Graduated from Waseda University. After graduation, Kazanori worked at Tadao Ando Architect & Associates, and at NASCA. In 1998 he established Kazunori Fujimoto Architect & Associates.

GARCIA SAXE, BENJAMIN Benjamin's belief in the positive role architecture can play in society around the world stems from his studies in Costa Rica and the USA, as well as his work in Europe on a number of large international projects. This experience is combined with a long-held desire to use design to 'do more with less', and ensure that craft and technology work seamlessly together to create buildings and spaces for all. He believes that architecture should not be reserved as a luxury but instead provide a platform for experimentation and unbridled creativity.

GIPP, PETRA studied at The Royal Danish Academy of Fine Arts in Copenhagen, and has exhibited widely, notably at the Venice Architectural Biennale in both 2012 and 2014. Her work has been published in many leading books and magazines. She is a teacher and external critic at the KTH Royal Institute of Technology - architecture, in Stockholm, and an examiner at The Aarhus School of Architecture, Kolding School of Design, and The Royal Danish Academy of Fine Arts; Schools of Architecture, Design, and Conservation. She is member of important competition juries, including the Kasper Salin Award 2015-2016 of the Swedish Association of Architects. She designed the award-winning Kivik Art Center and The Cathedral Inventor's studio.

GLUCK, PETER L. received a Bachelor of Arts from Yale University and a Master of Architecture from the Yale School of Art and Architecture in 1965. After designing a series of houses from New York to Newfoundland, he went to Tokyo to design large projects for a leading Japanese construction consortium. Exhibitions of Gluck's award-winning work have been held in the U.S. and Japan, and he is widely published in architectural journals around the world. He has taught at Columbia and Yale schools of architecture, and curated exhibitions at the Museum of Modern Art and the Milan Triennale.

GONZALEZ, MARIO graduated from the Architecture School of the Aristotle University of Thessaloniki in 2005. Since 2003 he has worked asan architect inserious design firms in Thessaloniki and Athens. He often attends lectures and seminars related to architecture, sustainable design and contemporary construction methods. In 2007 he founded MGXM Architects alongside Christina Malama. MALAMA, CHRISTINA Sraduated from the Architecture School of the Aristotle University of Thessaloniki in 2007. Since 2004 she has worked asan architect, interior designer, and 3d representation maker in serious design firms. She has designed various furniture and objects in collaboration with famous designers. She often attends lectures and seminars related to architecture, sustainable design, and contemporary construction methods. She is one of the founding members of MGXM Architects.

GRIFFIN, MARY received her Masters of Architecture degree from M.I.T., where she studied and worked with Donlyn Lyndon. After five years in Washington D.C. with Hartman-Cox Architects, she moved to San Francisco to marry William Turnbull and join his architectural practice. Mary has served on many juries, including the AIA National institute Honor Awards for Architecture. She has taught architectural design atUC Berkeley and was the Friedman Visiting Professor of Professional Practice in 2008. Mary became a Fellow of the American Institute of Architects in 2006. HAESLOOP, ERIC graduated from Washington University and then received his Masters of Architecture from Yale, where he studied under Charles Moore, James Stirling, and Aldo Rossi. After graduating he worked at Cesar Pelli & Associates in New Haven for three years. Eric joined William Turnbull Associates in 1985 and worked closely with Turnbull until his death in 1997. Eric and partners Griffin and Hastrup continue Turnbull's commitment to site sensitive, sustainable architecture. Eric has taught architectural design at Yale College, Stanford, and UC Berkeley and was the Friedman Visiting Professor of Professional Practice in 2008. HASTRUP, STEFAN studied art and architecture as an undergraduate at Brown University and at the Institute for Architecture & Urban Studies in New York City. Hethen attended Yale School of Architecture, where he studied under visiting professor William Turnbull. After receiving a Masters of Architecture from Yale in 1983, Hastrup joined Beyer Blinder Belle in New York. He continued to focus on the design of museums and other institutional projects at Robinson Mills + Williams, and later at Polshek and Partners. He joined Turnbull Griffin Haesloop in 1999. Stefan has been an active participant in community efforts to replace San Francisco's earthquake damaged Central Freeway with a surface boulevard and new housing.

HO, ALAN E. received his Bachelors of Architecture from the University of Washington and his Master of Architecture from the Rhode Island School of Design, receiving distinctions and design awards including the Floyd Naramore Scholarship, RISD Graduate Design Award Scholar, and the RISD Graduate Travel AchievementAward. Before this, Ho worked for the offices of Rafael Viñoly, Perkins + Will, and SPAN Architecture. He has also been an invited critic for art, architecture, and design studios at Pratt Institute, Parsons the New School for Design, and RISD. STEPHENS, DUSTIN received his Master of Architecture from the Harvard Graduate School of Design, where he received distinction for his work in both architectural design and structural design. He holds a Bachelor of Architecture from University of Washington where he received the Faculty Design Award and Award for Highest Scholarship. He has worked as a teaching assistant at the Harvard Graduate School of Design. He worked at the Miller|Hull Partnership and Hutchison and Maul, and was a core team member for the South Lake Union Discovery Center in Seattle. Stephens has been an invited critic for architectural design studios at University of Southern California, Woodbury University, University of Washington, UC Berkeley, and the UCLA Suprastudio.

HRDALO, CRISTIAN GARCIA was born in Santiago, Chile in 1977, and in 2002 obtained the title of architect from the School of Architecture of Finis Terrae University. After working in architecture firms in Chile and the United States, in 2005 he founded Hrdalo Architects, an eponymous firm dedicated to the development of residential, industrial, commercial, and institutional projects. His projects have been published in architectural magazines, as well as featured in national and international biennials.

KEARNS, LARRY joined Wheeler Kearns Architects in 1988. He graduated Magna Cum Laude from the University of Miami, and went to Chicago to work for SOM. Previously, Kearns worked in the offices of Jan Hochstim. He has lectured on Building Systems and Materials and Methods for AIA Chicago and UIC. He has lectured at the Chicago offices of the AIA, the Chicago Architectural Club, the University of Miami, the University of Illinois at Chicago, the Chicago Art Deco Society, and at multiple AIA Professional Development Conferences. He presented at the 2016 SXSWedu Conference, the 2016 HEQCO Conference, and at the 2014 SCUP annual conference. Recently completed projects include a new home for The Chicago Children's Theatre, The Wolcott School, and Inspiration Kitchens Garfield Park. WHEELER, DAN is a founding principal of Wheeler Kearns Architects, and is a Professor of Architecture at the University of Illinois at Chicago. Wheeler received his education at the Rhode Island School of Design. Prior to establishing his own practice, he was an Associate and Studio head at Skidmore Owings and Merrill. He is the recipient of a National Endowment for the Arts Traveling Fellowship, the CCAIA Young Architect Award, AIA Fellowship, and the Chicago Tribune's 'Chicago an of the Year' in Architecture. In 2017 he received the AIA Illinois Nathan Ricker Clifford Award for Architectural Education.

LANGE, METTE graduated from the Royal Danish Academy of Fine Arts. She married fellow architect Anders Linnet, and then set up Linnet & Lange ApS in 1996. In 2002, she established her eponymous studio, Mette Lange Architects. She divides her time between Denmark and Goa in India. Her main occupation in Goa has been the Moving Schools project, for which she has received many awards and recognitions, such as the Nykredit's Motivational Prize. In 2013, she also received a grant from the Henning Larsen Foundation. Lange has also designed homes in Denmark, including summer houses and holiday homes built of sustainable local materials.

LIU, ANNA 's architectural experience includes practices in the US, Japan, and the UK. Having previously worked for Arup Associates in both Hong Kong and London, Liu became a qualified architect in the UK in 2002, establishing Tonkin Liu architects with Mike Tonkin. She is a Fellow at the Royal Society of Arts, member of the RIBA and ARB, and has acted as a juror for the RIBA Awards, RIBA Sustainability by Design Award, and the RIBA President's Medals. Her architectural academic experience includes one year at the North London University (now London Met), four years at the Architectural Association School of Architecture, and giving lectures in architectural universities in Taiwan. She is currently conducting a Masters in Architecture Design Studio at the University of Westminster. TONKIN, MIKE was educated at the Royal College of Art in London. An Architect and Landscape Architect with over 20 years of experience, Tonkin's professional practice has been based in both China and the UK, and has been consistently informed by a distinctive pursuit of form and lessons observed from the natural world. The result has been a number of award winning projects and pioneering structural techniques. Tonkin has taught and lectured at schools of architecture in England and the Far East. He is currently a Teaching Fellow at the University of Bath. He lectures on a number of subjects including world vernacular architecture.

MCKEOWN, CLAIRE leads Platform 5 Consultants. She is a qualified architect and has advised both private and public sector companies on achieving design quality. Claire studied at Cambridge, The Royal College of Art and The Bartlett School of Architecture. She started her career as an architect in the private residential sector later progressing to education projects. She is an Enabling Advisor at CABE, where her chief role was the maintenance of design quality in the Building Schools for the Future (BSF) programme. MICHELL, PATRICK 's previous experience includes time as a Project Architect with Walter Menteth Architects, where he completed a social housing scheme in Peckham, and later at Nick Evans Architects where he worked on a number of education, social, and private housing projects, including Barton Peveril Sixth Form College's new Sport and Drama block in Hampshire. Educated at the University of Edinburgh, University of East London, and London Metropolitan University, Michell combines excellent technical skills with an approach to design that draws on intuition and process-based methodologies.

PEZO, MAURICIO completed a Master in Architecture at the Universidad Católica de Chile and a degree in Architecture at the Universidad del Bio-Bio. He has been awarded the Young Architect Prize by the Chilean Architects Association and the Municipal Art Prize by the Concepcion City Hall. VON ELLRICHSHAUSEN, SOFIA holds a degree in Architecture from the Universidad de Buenos Aires, where she was distinguished with the FADU-UBA Honors Diploma. Pezo and von Ellrichshausen were chosen as the curators of the Chilean Pavilion at the 2008 Venice Biennale. They teach regularly in Chile, and have been Visiting Professors at both the University of Texas and Cornell University. Their work has been distinguished with the MCHAP Emerge Prize by the IIT (Chicago, 2014), the Rice Design Alliance Prize (Houston, 2012), among others. The work of the studio has been edited inmonographic issues of A+U (Tokyo, 2013), 2G (Barcelona, 2012) and ARQ (Santiago, 2007) and exhibited at the International Architecture Exhibition at La Biennale di Venezia (Venice, 2010), the Royal Academy of Arts (London, 2014), and as part of the Permanent Collection at the MoMA (New York, 2014).

QUIÑONES, ALFONSO developed his career in the area of housing development and architectural design, where he has been recognized in various publications and received an honorable mention in the 2012 Biennial of the Federation of Colleges of Architects of the Mexican Republic, for the Casa del Rio project. He was also invited by the architect Tadao Ando to act as local architect associated to the Casa Wabi project in Oaxaca's hidden port. In 2016 he was invited by the architect Alvaro Siza to collaborate on the development of the Mud Workshop project at Casa Wabi. He is currently developing, together with the architect Kengo Kuma, the design of a chicken coop with an experimental construction system.

SMART, WILLIAM is the founder and Creative Director of Smart Design Studio and is directly involved in every project, contributing at all stages from design to final delivery. His buildings have received critical acclaim, numerous prestigious awards, and have been widely published in architectural and other publications. His, and the Studio's, approach to design is holistic, combining both architectural and interior design with a passionate attention to detail. As Creative Director, he has been directly involved in each project, and is continuously exploring ideas relating to flexibility, contemporary living, and the merging of art and architecture.

STELLE, FREDERICK is the founding partner of Stelle Lomont Rouhani Architects. He has 40 years of design experience in institutional and residential projects that range from educational campuses, arts facilities, administrative centers, private, and multifamily residences. Stelle began his career in the office of Edward Larrabee Barnes, where he directed the renovation of the Yale University Old Campus dormitories. In 1976 Mr. Stelle founded his eponymously named office in Manhattan that later became the firm Frederick Stelle/Richard Gluckman Architects.

STIJNEN, LOEK Principal architect and founder of Lab32 architects. Loek Stijnen is an Dutch Architect with over 20 years of experience. He started Lab32 architects in 2004, and the studio is now working on a variety of architectural assignments throughout the Netherlands and Belgium. Lab32 architects' work is characterized by horizontal and length supporting elements, minimalistic design language, clear and honest materials, and recognizable proportions. It also pays a lot of attention to architectural qualitative design, sustainable and energy-efficient construction, customer-oriented service, and quality in detail.

STRANG, MAX is the founding principal of [STRANG], a Florida-based architecture firm acclaimed for its site-specific and climate-driven designs. Through his work and discourse, [STRANG] has consistently underscored the ongoing relevance and importance of regional modernism to an international audience. In 2016, he was elected to the prestigious College of Fellows of the American Institute of Architects (AIA), and in 2013 he received the Silver Medal from the Miami Chapter of the AIA, the highest honour the organization can bestow.

VALSAMAKI, KATERINA Architect AA Dipl. MTEE Architectural studies at the London Architectural Association, from where she graduated in 1984. Since 1989 she has run her own studio in Athens, focussing on the study and construction of private projects, residences, offices, and department stores. She has participated in the B&C Biennale of Young Greek Architects, Athens (1998 and 2001); the RIBA exhibition Athens-scape, London (2003); The Architectural Awards, Athens 2004 and 2008; the 10th Biennale, Venice 2006; the exhibition 'The House in Greece from 20th to 21st century' (Museum Benaki, Hellenic Institute of Architecture, 2009).

XYNOGALA, LYDIA holds a Masters degree from Princeton University where she received a Stanley Seeger Fellowship, a BArch from Cooper Union, where she was awarded the Irma Weiss Prize for exceptional creative potential, the George Leslie Design Prize and the Humanities Prize, and a BSc from Bartlett, UCL. For her work, she was awarded a Fellowship from the New York Foundation for the Arts. She has presented her work at the Museum of Modern Art, Van Alen Institute, Society of Architectural Historians, Chemical Heritage Foundation, History of Science Society and ACSA. Her projects have been in various exhibitions in New York, Valencia, Seoul, and Shanghai.

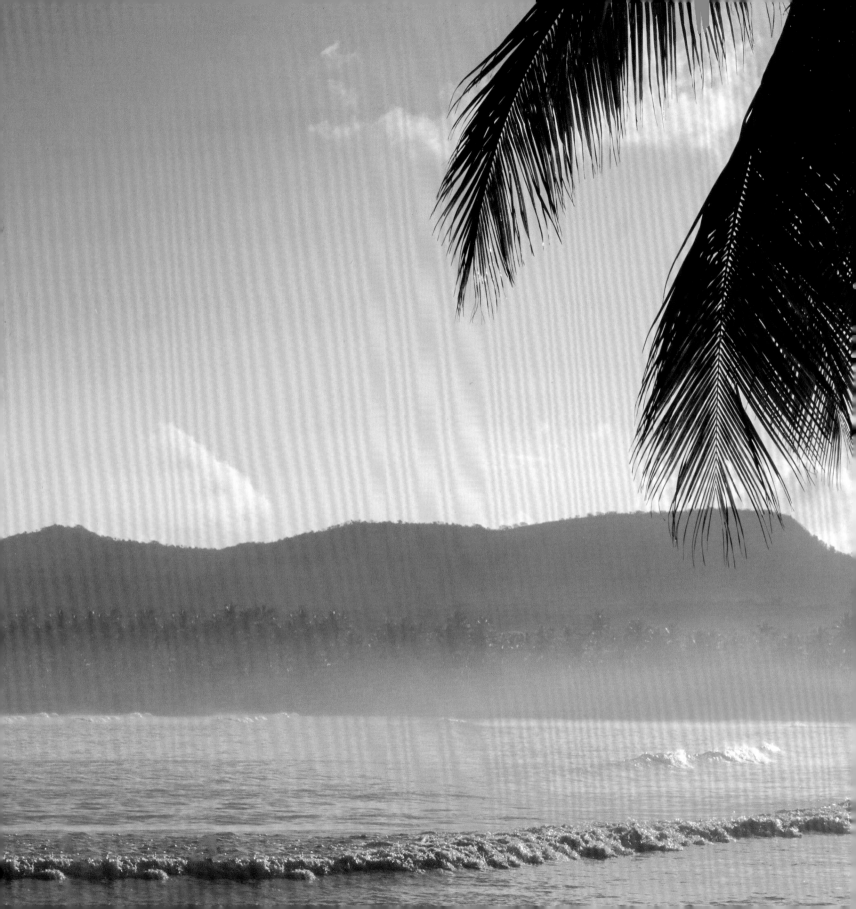

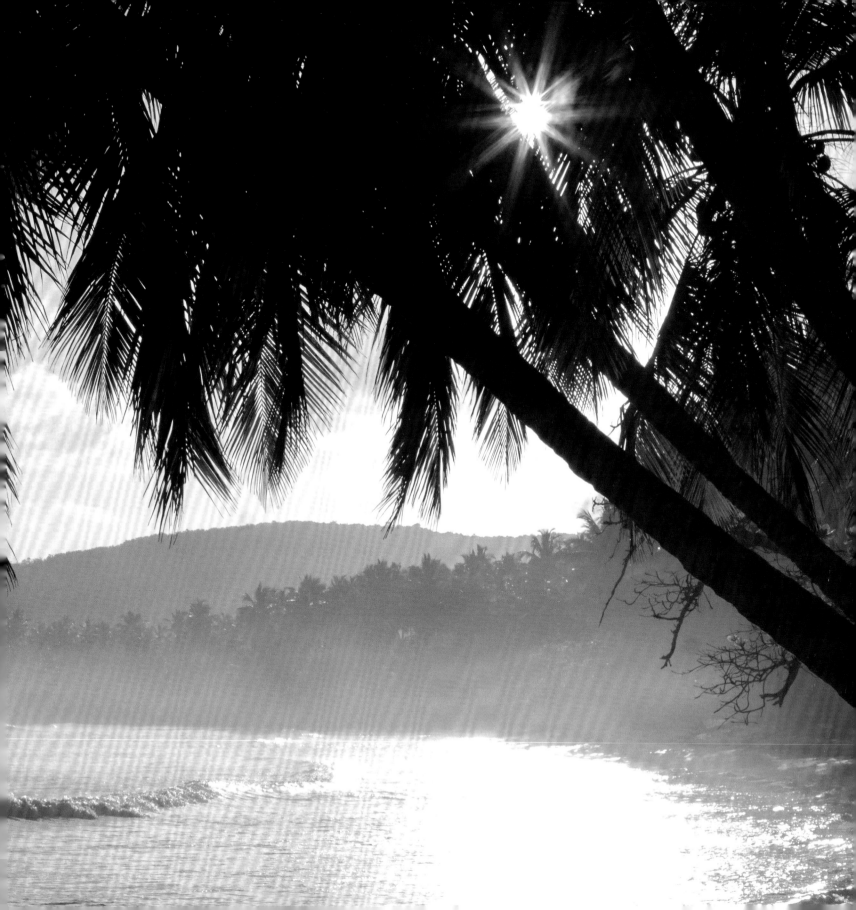

BOOK CREDITS

First Published in the United States of America in 2018 by
Rizzoli International Publications, Inc.
300 Park Avenue South
New York, NY 10010
www.rizzoliusa.com

Edited by Oscar Riera Ojeda & Byron Hawes
Texts by Byron Hawes
Art Director: Oscar Riera Ojeda
Graphic Design by Julia Miceli Pitta, Lucía Bauzá and Diego Pinilla Amaya

ISBN-13: 978-0-8478-6280-1

Library of Congress Control Number: 2018943923

Distributed to the US Trade by Random House, New York

2018 2019 2020 2021 / 10 9 8 7 6 5 4 3 2 1

Printed in China

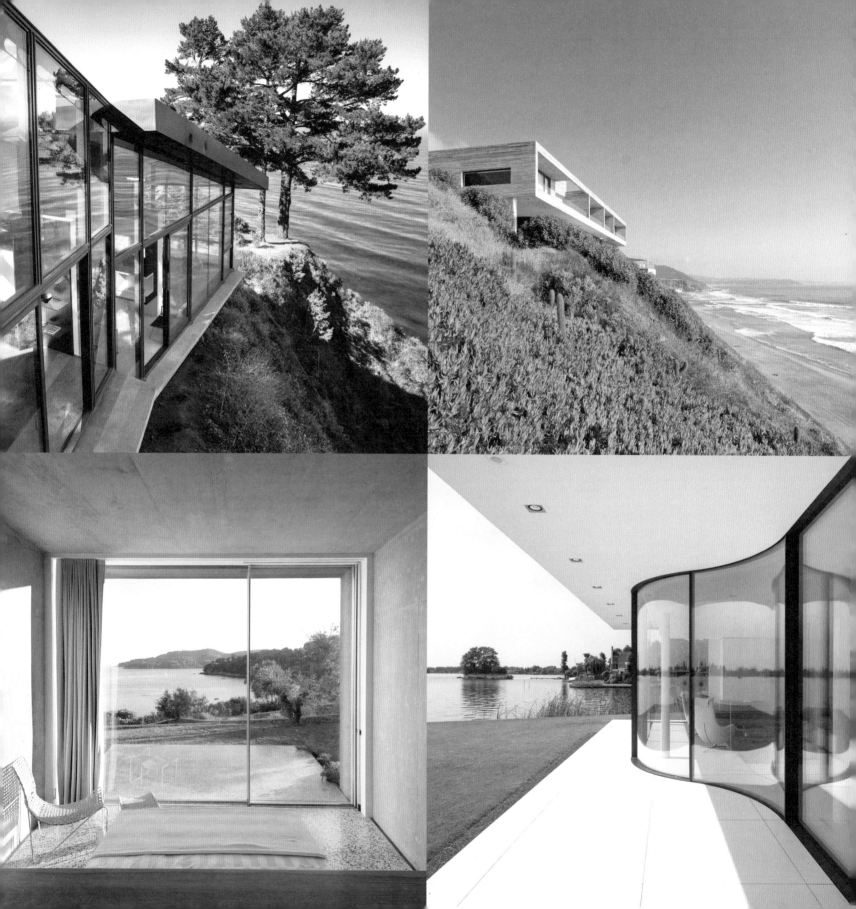